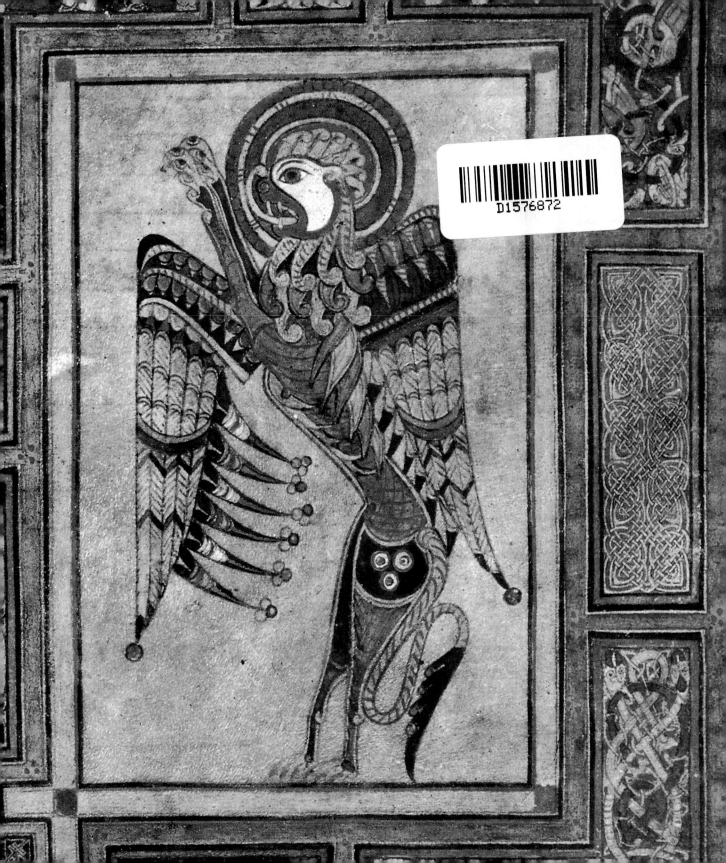

TREASURES OF IRELAND

IRISH ART 3000 B.C. - 1500 A.D.

*With 65 Colour
and 103 black and white illustrations*

ROYAL IRISH ACADEMY - DUBLIN

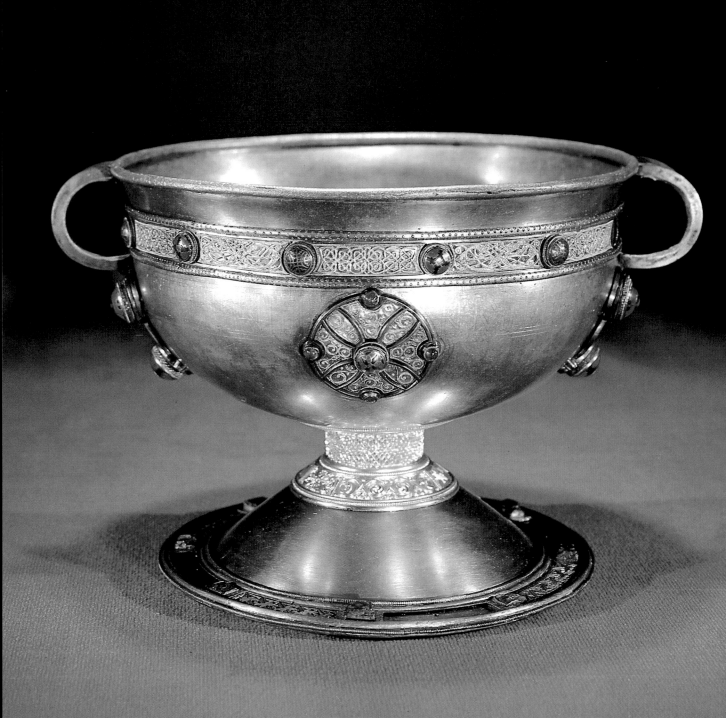

Contents

This publication by the Royal Irish Academy is a cooperative venture in association with the National Museum of Ireland and Trinity College, Dublin.

Cover picture · The Tara Brooch, Cat. 48 (Reverse)
Frontispiece · The Ardagh Chalice, Cat. 51a
Back cover · The High Cross of Drumcliffe, Co. Sligo, 11th century A.D. (photograph: Werner Neumeister, München).

Editor · Michael Ryan, National Museum of Ireland.

Acknowledgements:
The authors wish to thank Joan Jennings, Paula Harvey, Thaddeus Breen, Fionnbar Moore and John Sheehan for help in the preparation of the text and Dr. Hansgerd Hellenkemper and Herr Hansgeorg Stiegler, editor and co-ordinator of the German edition.

Photography · objects - Brendan Doyle, National Museum of Ireland; manuscripts - The Green Studio Ltd., Dublin; monuments and landscapes - The Commissioners of Public Works and Bord Fáilte; photographic services - Valerie Dowling, National Museum of Ireland.

Maps and drawings · Rosaline Murphy, Catherine Treacy, Reiltín Murphy, National Museum of Ireland.

© 1983 Royal Irish Academy, Dublin.
All rights reserved.
ISBN 0 901714 28 3

Typeset in Ireland by Computer Graphics Ltd., Dublin
Lithos · Witzemann and Schmidt, Wiesbaden
Paper · Papierfabrik Scheufelen, Lenningen
Binding · Klemme & Bleimund, Bielefeld
Printed in Germany by Verlag Philipp von Zabern, Mainz am Rhein

EDITOR'S NOTE

The text of the catalogue entries was originally prepared for publication in Paris under the title **Tresors d'Irlande** *(Association Francaise d'Action Artistique, 1982) accompanied by a single introductory essay by the editor. A second, revised edition of the entries together with new introductory essays was published in Germany as* **Irische Kunst Aus Drei Jahrtausenden***, Mainz, 1983. This present book, by the staff of the Irish Antiquities Division, National Museum of Ireland with contributions from the Department of Manuscripts, Trinity College, Dublin and the Librarian of the Royal Irish Academy, incorporates the material of the German publication together with some corrections and revisions.*

MICHAEL RYAN

Introduction

It gives me great pleasure as President of the Royal Irish Academy and as Provost of Trinity College to introduce this book, the "Treasures of Ireland 3000 B.C. - 1500 A.D.", particularly because as a natural scientist my work has often taken me into the province of the archaeologist and cultural historian. This publication stems from an exhibition arranged as a cooperative venture between the National Museum of Ireland, Trinity College and the Academy with the generous co-operation of various Government departments, Aer Lingus and Bord Fáilte, and much of the material in it deals with treasures originally acquired by the Academy and now in the Museum. The Academy has always taken great pride in the fact that it was entirely through its voluntary efforts that the aim of assembling a collection of Irish Antiquities became accepted by Government as a major cultural objective. The Academy is no longer a primary collecting museum but still promotes the study of the past through the publication of its Proceedings, occasional special publications, and the encouragement of research through its National Committee for Archeology. When a Catalogue was prepared for the tour of the "Treasures of Ireland" exhibition in Europe it was felt that it would be a pity if the information compiled for it were to be published only in limited foreign language editions and remain largely inaccessible to a wide readership in Ireland. Accordingly, the Academy has taken this initiative with the ready consent of the Director of the National Museum and the cooperation of his colleagues in the Irish Antiquities Division and the Board of Trinity College, with the active participation of the College Librarian and his colleagues of the Department of Manuscripts. Some well known objects such as the Cross of Cong were not included in the exhibition because it was considered that they were too fragile to travel - but they are discussed in the introductory essays.

It is a particular pleasure for the Academy to see new descriptions of many of the great objects which we strove so hard to preserve published here under our imprint for the first time. We hope that the book will be enjoyed by layman and scholar alike and that it will bring about a deeper appreciation of the central importance of our national archaeological collections and our libraries to the reconstruction and understanding of our heritage. The acclaim with which the exhibition has been greeted abroad should remind us - and we need reminding - that we have in our learned institutions objects and manuscripts of the first importance to European cultural history. I feel sure that this publication will contribute to our awareness of that fact.

William A. Watts,
March 1983.

Foreword

The earliest evidence of man in Ireland dates to the Mesolithic period but it is in the Neolithic period and the Bronze Age which followed it that the artistic endeavours of the inhabitants became noteworthy. The material presented in this publication ranges in date from the Neolithic period to Medieval times and includes many of the more outstanding archaeological artefacts and illuminated manuscripts of Ireland. These 'Treasures of Ireland' drawn from the collections of the National Museum of Ireland, the Royal Irish Academy and Trinity College Dublin provide an insight into the story of human activity in this island and they are also a record of the achievement of craftsmen and artists from prehistoric times onwards.

The most noteworthy artistic motifs of the Neolithic period are those pecked or carved on the slabs and stones of Passage Grave tombs at Newgrange and Knowth in the Boyne Valley, Co. Meath and at Loughcrew, near Oldcastle, Co. Meath. In the Bronze Age, a variety of objects in copper, bronze and gold as well as pottery vessels found in association with burials are among the many objects of the period on which artistic motifs occur. A greater number of objects made from prehistoric gold is recorded from Ireland than from any other country in western or northern Europe and it is therefore appropriate that this compilation should include a comprehensive selection of gold objects dating to the earlier and later phases of the Bronze Age in Ireland.

The Early Iron Age objects are decorated with curvilinear designs which derive, mainly, from the continental La Tène style, many of which are also used on objects and manuscripts of the succeeding Early Christian period.

Roman influences -from Britain and from continental Europe - are also present although no Roman conquest of Ireland occurred. The introduction of Christianity in the 5th century was followed by the rapid spread of monasticism and at a later stage by Irish missionary activity in Europe. These developments gave the impetus for outstanding achievements in artistic production in the service of the Church and this is best illustrated in the manuscript illumination, metalwork and sculpture of the 7th to 9th centuries and includes such masterpieces as the Book of Durrow, Book of Kells, 'Tara' Brooch and Ardagh Chalice.

The earliest record of Viking invaders in Ireland dates to 796 A.D. and, as in other European countries, plundering of monasteries and churches ensued. Nevertheless, it must be acknowledged that our first towns, Dublin, Cork, Waterford, Wexford and Limerick owe their origins to Viking settlements in the 9th and later centuries. The influence of Scandinavian art styles becomes noticeable in Irish art of this period and recent excavation by the National Museum of Ireland in the old city of Dublin has provided a wealth of information on the many facets of art, trades and crafts in the town in the 10th and later centuries. Some of the Dublin excavation finds are included here, most notably the 'trial pieces' which are so important for art-history viewpoint; these discoveries have added considerably to the known repertoire in Ireland of motifs associated with the Scandinavian Ringerike and Urnes art styles.

The Norman conquest of England in 1066 lead, a century later, to the Anglo-Norman invasion of Ireland. This event, together with the introduction of continental

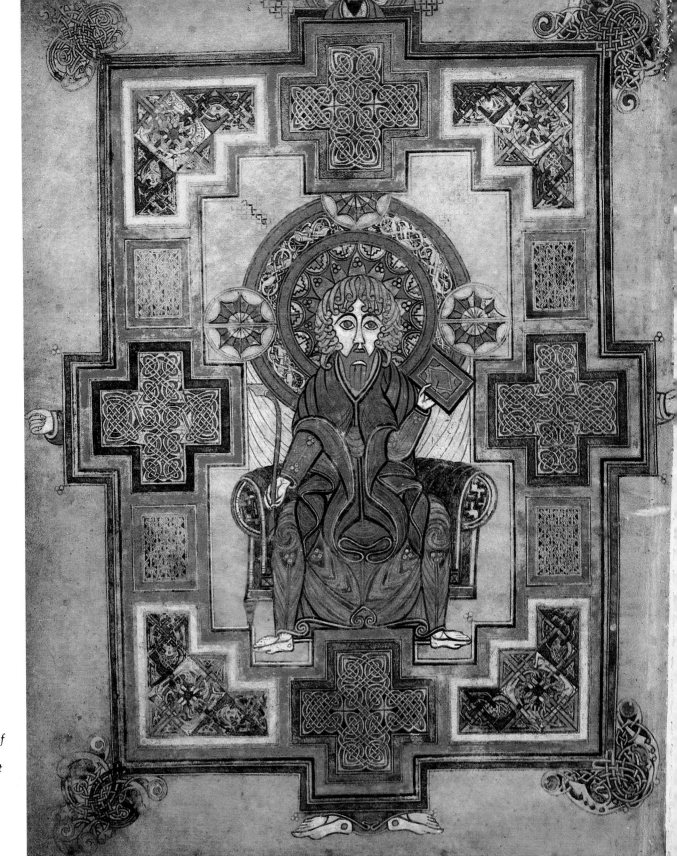

Book of
Kells,
Portrait of
the
Evangelist
John, fol.
291v

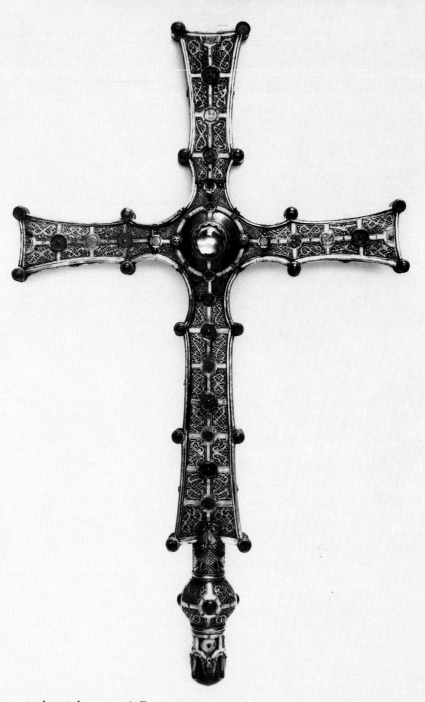

The Cross of Cong, early 12th cent. A.D.,
National Museum of Ireland.

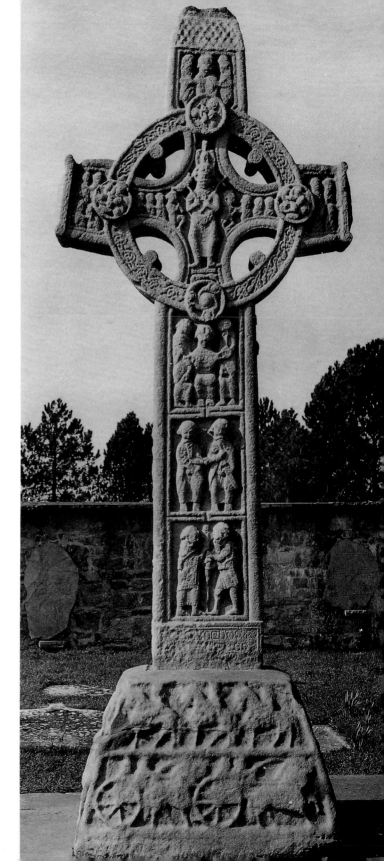

*High Cross ("Cross of the Scriptures"), Clonmacnoise,
Co. Offaly, 9th/10th century A.D.*

monastic orders, Cistercian, Franciscan, Dominican and
others was responsible for the decline of native Irish
traditions and techniques and for the development of
styles of art and architecture more in keeping with those
of continental Europe.

The essays and entries in this book form an up-to-date
corpus of information and comment on the objects and
manuscripts described; their compilation and the task of
preparation of the material for exhibition was a major
project coordinated by the National Museum of Ireland
in recent years. Mr. Michael Ryan, Keeper of Irish
Antiquities, (who acted as editor) together with his co-
authors in the Irish Antiquities Division of the National
Museum, Mr. Patrick F. Wallace, Mr. Eamon P. Kelly,
Mr. Raghnall Ó Floinn, Ms. Mary Cahill and Miss Nessa
O'Connor are responsible for the essays and catalogue
entries on the archaeological artifacts. The majority of
the manuscripts are described and introduced by Dr.
Bernard Meehan of the Department of Manuscripts,
Trinity College, Dublin and the entry on the Stowe
Missal has been contributed by Mrs. Brigid Dolan,
Librarian of the Royal Irish Academy.

I wish to express thanks to these colleagues through
whose cooperation it has been made possible to publish
this work relating to some of the more outstanding
objects of the archaeological, historical and artistic
heritage of Ireland.

Antoine Breandán Ó Ríordáin,
Director, National Museum of Ireland.

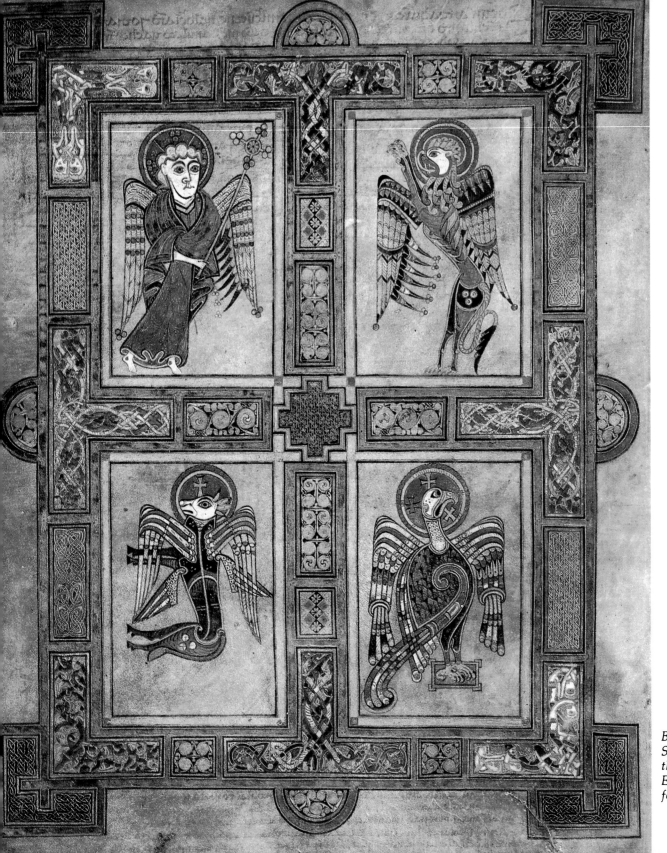

Book of Kells
Symbols of
the
Evangelists,
fol. 27v

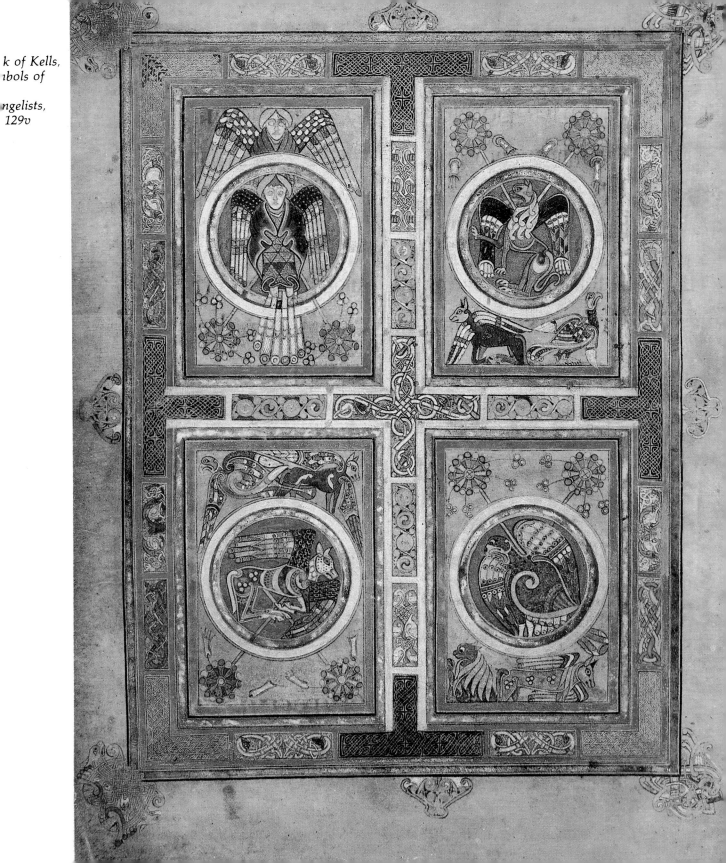

*k of Kells,
ibols of

ngelists,
129v*

The Early Prehistoric Period

Michael Ryan and Nessa O'Connor

The Mesolithic Period c. 7000 - c. 4000 B.C.

Man seems to have been a latecomer to Ireland - there is no convincing evidence for his presence before about 7000 B.C. during what is generally called the Mesolithic (or Middle Stone Age) elsewhere in Western Europe. A hut site at Mount Sandel, Co. Derry, and a hunting camp at Broughal, Lough Boora, Co. Offaly, provide the most comprehensive information on the economy and material equipment of the people of that time. They were hunters and food gatherers - wild pig was especially favoured but deer and smaller mammals were also eaten. Wildfowl, fish and edible plant foods were also included in the diet. Tools consisted in the main of small flint and chert blades and microliths (diminutive flint and chert points and barbs slotted into wooden shafts to arm arrows and other projectiles). Ground pebble and small chipped flint axeheads were made for heavier work. There is little direct evidence for utensils of wood, bone, skins or natural fibres but these may in part be assumed. No evidence has yet come to light of artistic activity of any kind, although sketches and paintings are attested in other mesolithic cultures.

Where did these first Irishmen come from? In the past it was assumed that Ireland had been colonised from the south western part of Scotland where the shortest sea crossing is now about 22 km. This view is however no longer tenable because no closely comparable archaeological culture has been identified in the nearer part of Scotland at a stage contemporary with the earliest mesolithic settlement of Ireland. It is now more likely that the earliest settlers were drawn from northern England at a time when sea level was relatively low and when crossings to the east coast of Ireland may have been relatively easy. Because of subsequent changes in relative sea level, our earliest sites are likely to be covered by the Irish Sea.

After the initial colonisation, the population of the country appears to have become isolated and the later developments in material equipment reflect this. The tool kit became transformed in the period after ca. 5000 B.C. into one of heavy blades and picks, retouching of the artifacts after striking is rarely noted and the microlithic

tradition appears to have died out. Our evidence for later developments comes mainly from coastal sites, for example Larne and Cushendun, Co. Antrim, where it is difficult to be sure at times if the material is in its original position or not and from inland, lakeside sites, in the northern half of the country. Some later settlements -Dalkey Island and Sutton, Co. Dublin - were established at the point of maximum encroachment of the sea on the land. They contain a mixture of elements of mesolithic and neolithic tradition and date to the centuries about 3500 B.C.

We must envisage Ireland - or at least the northern two-thirds of it - as being sparsely inhabited during the Mesolithic period by small bands of hunters and food collectors. Their impact on the natural environment would have been minimal; their opportunities for major cultural developments would have been limited alike by the scattered pattern of settlements as by the dependence on naturally occurring food supplies.

The Neolithic Period (circa 4000 - 2500 B.C.)

Current research suggests that farming began in Ireland sometime around the beginning of the fourth millennium B.C. It is probable that this major change in economy may have resulted, at least to some extent, from the arrival of new peoples from Britain and the continent of Europe. It is clear that this new skill in raising crops had a profound effect both on the landscape and on the organisation of society. The first evidence of art, pottery, substantial houses and organised industry - axe factories -all date from this period. The most enduring remains are however the great megalithic tombs many of which are outstanding examples of engineering and architectural design. Court cairns, passage graves and portal dolmens were all in use at this time. The tombs were used for collective burial but may also have fulfilled a variety of social purposes. Radiocarbon dating indicates that megalithic tombs were in use over a very long period -the societies for which they were built probably survived for fifteen hundred years or more. One of the most

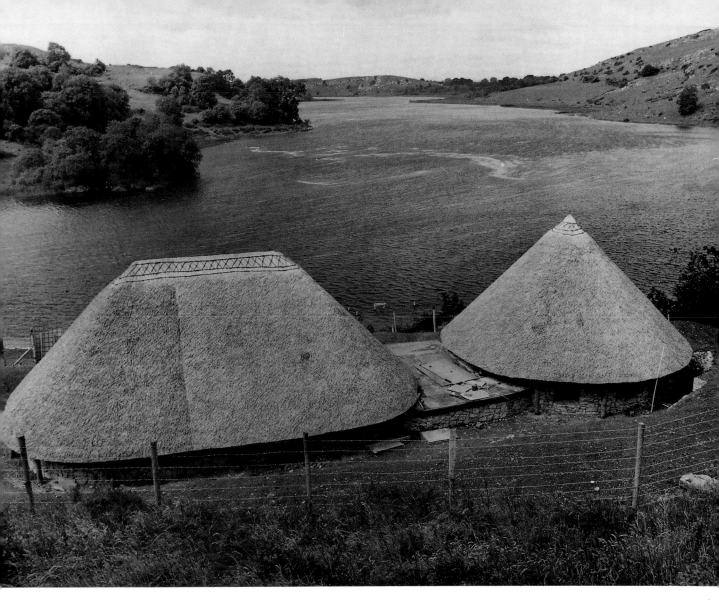

Reconstruction of a Neolithic house (left) and a Bronze Age house (right), Lough Gur, Co. Limerick

distinctive elements in the megalithic tradition is the sophisticated mural art of the passage graves. The orthostats, kerbstones and roofing slabs of many examples are incised with a range of decorative motifs which include spirals, chevrons and concentric circles. In general, it is an abstract art style although some stylised human representations have been claimed.

In addition to the megalithic tombs a number of other burial traditions existed in the neolithic period. The interment of individuals or small numbers in stone cists as well as in pit graves has been recorded. These are often accompanied by highly decorated pottery vessels similar to examples which have also been found in some court cairns. Differences in tomb type and other material attributes are suggestive of the presence of regional groups. Nevertheless, common pottery and flint types for instance, provide evidence of an underlying cultural unity.

While considerable evidence of burial rite survives, there is as yet relatively little known of the types of houses or settlements occupied by Neolithic peoples. Only a very small number of house-sites datable to this period, have come to light.

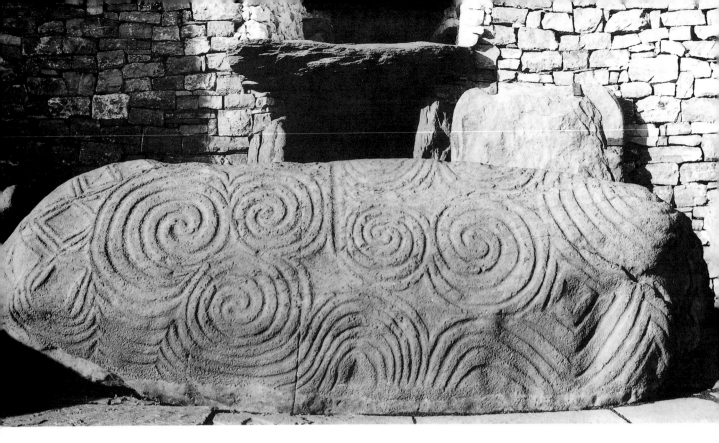

Entrance stone of the passage grave at Newgrange, Co. Meath (ca. 3000 B.C.)

The Earlier Bronze Age (circa 2500 - 1200 B.C.)

The defining characteristic of this period was the introduction of metal-working. It may well have reached the country in the course of developing contacts with the rest of Europe and not necessarily as a result of a major influx of new peoples. Ireland is rich in copper deposits and these were exploited early on. Among the first metal artifacts were copper and bronze flat axes which were cast in open stone moulds. Technology developed rapidly and improved versions of the axe were devised. Later, casting was carried out in bivalve moulds which allowed for the provision of a socket enabling more efficient hafting and midribs which strengthened implements. Spearheads, dirks and palstaves - a type of axehead - cast in such moulds were characteristic of the more advanced phases of the period.

There is evidence for extensive gold-working in the Irish Earlier Bronze Age. The objects were usually fashioned in sheet metal and included lunulae, sun discs and basket-shaped earrings.

Megalithic tombs continued in use during the earlier part of this period. The wedge tomb - a type of small gallery grave - was characteristic of the time. Stone circles -probably ritual in purpose - were apparently also constructed. The origins of both monument types are obscure; some exotic influences may partly account for them but there is strong evidence of continuity with neolithic traditions also

Pottery-making, especially of funerary wares, reached high standards. The Food Vessel and the Cinerary Urn were the most usual types, occasionally accompanied other smaller vessels known as Pygmy Cups. The pots are normally found accompanying burials of individuals or restricted numbers of individuals, in stone lined cists or in pit-graves.

Settlements of people using so-called 'Beaker' pottery - a variety of ceramic widely distributed in earliest Bronze Age Europe - appear to have been more common in the east of the country - they may have been responsible for the construction of banked enclosures known as henges. Little habitation evidence for the period has as yet come to light, although a few circular hut sites are known.

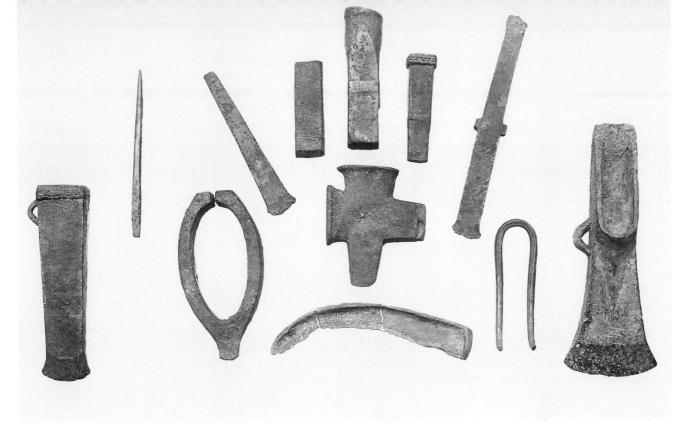

Later Bronze Age hoard, Bishopsland, Co. Kildare (ca. 1200 B.C.)

The Later Bronze Age (circa 1200 - 600 B.C.)

Ireland, along with the rest of Europe, underwent considerable industrial and economic change in this period. From about 1200 B.C. onwards, a number of new metal types made their appearance many of which had their origins in the Tumulus cultures of Germanic lands. These included hammers, sickles, anvils, chisels, gouges and ribbed bracelets. Irish industries were however under the more immediate influence of the so-called south British "ornament horizon" and both tools and personal ornaments often have their closest parallels there. Earlier established varieties of implement such as socketed spearheads and palstaves also continued in use.

Most of our knowledge of the period derives from hoards, a number of which consist of ranges of craftsmens' tools and give evidence of highly developed specialist production. In the later part of the period, Irish smiths further broadened the scope of their work and produced local adaptations of imported continental types such as bronze cauldrons, buckets and shields in sheet bronze. Gold was widely used for personal ornaments.

The achievements of the Irish gold-smith reached considerable heights particularly in the latter half of the period. Some ornaments such as 'gorgets' and 'lock rings' were characteristically Irish, while others stand closer to analogues on mainland of Europe. Little evidence of habitation has yet been uncovered. Domestic animals were kept and grain was grown. Coarse undecorated pottery, probably domestic ware, is known from some occupied sites however and from a small number of graves. Only a couple of burials can be securely dated to the period and these provide evidence that the rite of cremation was practised.

The period is important in that it shows a sharp change in economic emphasis and organisation. The scale of production of metal objects appears to have increased dramatically and the presence of Irish types in hoards in England and in Europe suggests that an active export trade was in existence. New techniques, including solder and repoussé were mastered and both native and foreign traditions combined to produce an assemblage of distinctively Irish objects.

15

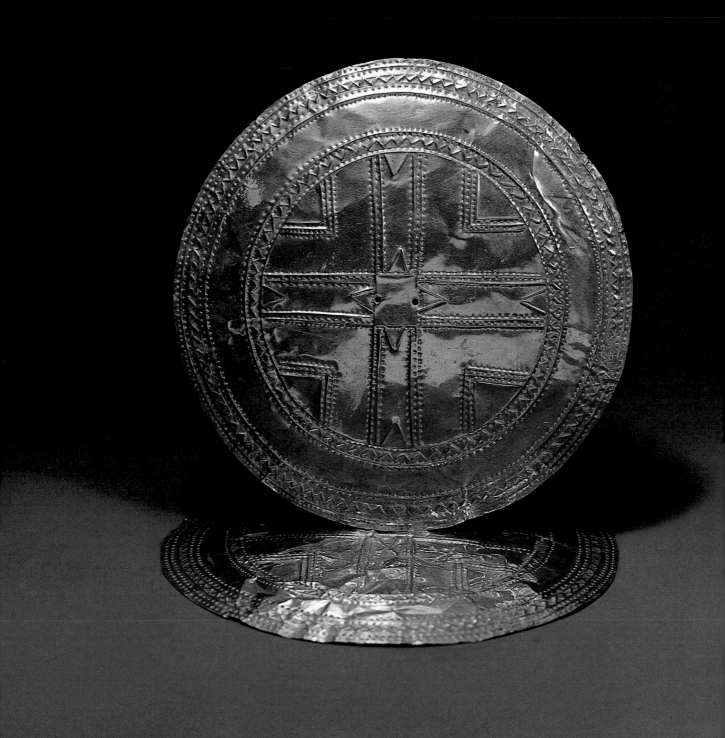

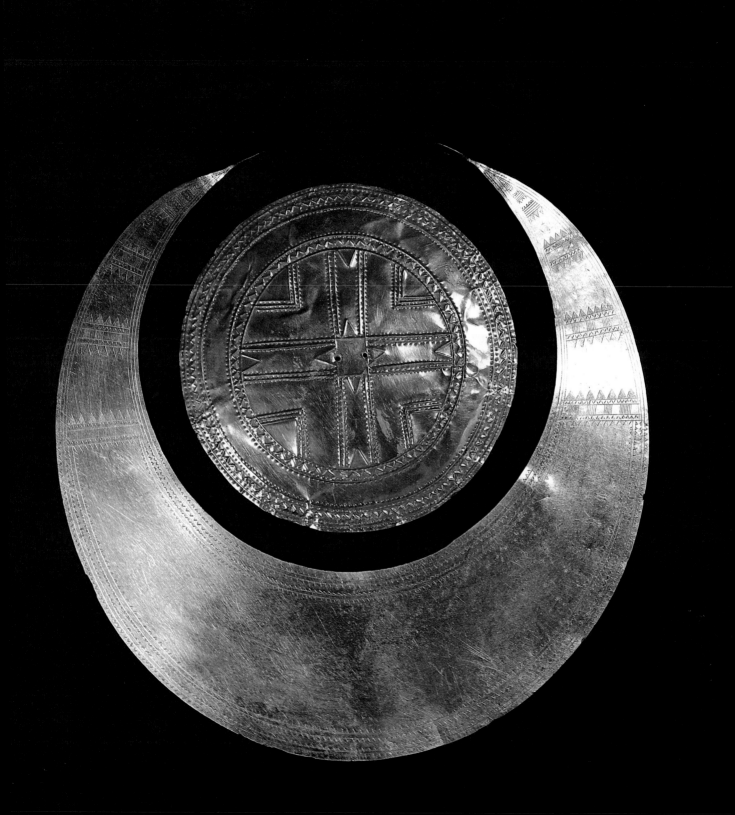

Irish Prehistoric Gold-working

Mary Cahill

The method and means of the establishment of a gold working industry in Ireland at the beginning of the Earlier Bronze Age are not very well known. No mine or goldsmith's workshop of this period is known to Irish archaeology and so the precise procedures by which the precious metal was gathered, worked and traded remain unclear. However, it seems certain that along with the influences which resulted in the production of copper and later, bronze tools and weapons, came the realisation that the application of many of the same techniques could produce objects of another class which would be made, prized and exported throughout the entire Bronze Age period.

2000 - 1500 B.C.

The most striking feature of Earlier Bronze Age gold-working in Ireland is the restricted nature of the types of ornaments which were produced. The gold-workers were apparently confined to the manufacture of simple flat shapes represented overwhelmingly by lunulae (crescentic sheets of gold), discs and earrings. This meagre repertoire is probably equally indicative of the level of gold-working technique, restricted availability of gold and cultural constraints which demanded simply-executed objects and which, in some cases, may have replaced similar ornaments previously made from humbler materials.

The earliest phases of gold-working are probably represented by the so-called "sun-discs" decorated with simple patterns incorporating cruciform motifs and radial lines. These have been found frequently in pairs and appear to have been stitched to an organic backing by means of central perforations and rim notches. Among the other sheet-gold objects of this phase are two basket-shaped earrings of unknown provenance and another decorated object of uncertain use (but certainly a personal ornament) from Deehommed, Co. Down which

seems to have been imported from Iberia. A number of simply decorated strips of gold with rounded ends may also belong to this early period but as exact parallels are lacking, it is difficult to indicate their relationship to other sheet-gold objects.

The main product of earlier bronze age goldsmiths over a period of perhaps five hundred years is the lunula. Of one hundred or so recorded examples, at least eighty-one have been found in Ireland, either singly or in hoards of up to four lunulae. Recent typological studies have identified three types - *Classical, Unaccomplished* and *Provincial*. Those which have been found on the Continent, with the exception of the *Provincial* type, appear to be Irish exports. While it is certain that the gold lunula developed as a type in Ireland the main difficulty has been to identify a prototype from which it might have evolved. Among those suggested are amber and jet spacer-plate necklaces which display similar zonal decoration and early Continental copper neck ornaments. The converse has however also been argued. The fact that the artifactual associations of lunulae, other than lunulae themselves are few and unreliable has presented its own difficulties. This has led Taylor (1970) to compare the decorative motifs of the lunulae to the range and sequence of ornament on early bronze age beaker pottery of British and Irish origin. The links with Irish beaker pottery seem somewhat tenuous and the suggestion that the *Classical* lunula, which is the most refined and skilled type, is the earliest, allows for no period of experimentation and development. *Unaccomplished* lunulae are only found in Ireland suggesting that the better pieces were selected for export. As both types have been found together in hoards they may simply reflect variations in standards of technique and workmanship.

Until a satisfactory prototype and sequence of development has been established it will remain difficult to establish reliable date brackets for lunulae. However, the production of a single type of sheet-gold object over an extensive period does suggest an unusually conservative or perhaps unimaginative group of workers whose output was restricted for a particular reason. As we have no real evidence of how or on what occasions lunulae were used it may be suggested that their use was confined to events of particular significance or to

◁*Gold lunula, Cat. 4, p. 78 and gold disc, Cat. 6, p. 80*
◁◁*A pair of gold discs, Cat. 6, p. 80*

exceptional persons. The *Classical* lunulae also show that in skilled hands extremely economical use could be made of small quantities of gold. The supply of ore may have been very limited which in itself would have restricted output and discouraged experimentation.

1500 - 1000 B.C.

It is difficult to trace the links between the simple sheet-gold objects of the early period and the heavier ornaments of the succeeding centuries. Sometime after 1500 B.C. the range of ornaments increased considerably - the new types owing little in terms of style or technique to their predecessors. Among the innovations of this period are several types of bracelet of heavy sheet-gold and twisted ornaments of immense variation in size, style and technique ranging from earrings to waist torcs. Many of these objects required considerable quantities of metal which suggests that new sources of gold had been found or new methods of extraction of existing supplies had been developed.

Recent studies have tried to demonstrate a continuation between the earlier bronze age sheet work and the sheet work of this period. While many of the basic techniques are similar, the decorative motifs and their method of execution - in many cases repoussé - are quite different and it is difficult to see any direct linkage. One significant hoard - that from Saintjohn's, Co. Kildare contains all three aspects of the gold-working methods of this early stage of the Later Bronze Age as it includes two penannular bands of incised sheet gold, a plain bracelet of circular cross-section and two loosely twisted bracelets of square sectioned gold rods. The Vesnoy, Co. Roscommon hoard contains four plain, flat penannular bands and one bracelet of round cross-section.

The range and variation of twisted ornaments in Ireland at this period is very considerable. Once the basic notion of twisting a strip or bar of gold had been introduced at about 1200 B.C. goldsmiths devoted themselves to developing a range of ornaments of particular sophistication and refinement. They can be divided into two main groups - ribbon torcs i.e. those made from a simple strip or band of gold and bar torcs i.e. those made from bars of gold of varying cross-section which may be further elaborated by flanging.

Much discussion has centred on the extent of the influences which introduced the principle of the twisting technique to Britain and Ireland and on the methods by which the insular smiths modified the European methods.

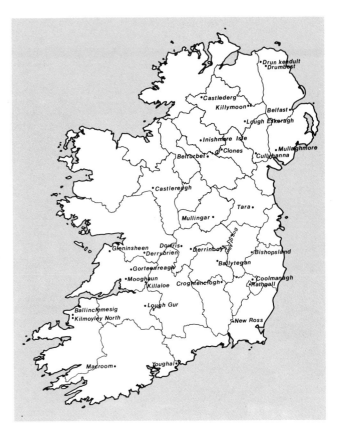

Later Bronze Age sites mentioned in the text.

The extent of the morphological and chronological relationship between ribbon torcs and other types has also been discussed. The main difficulty in placing the ribbon torcs within the general framework of torc development has been the fact that the only reliable associations, heretofore, have been other ribbon torcs or material of Iron Age (La Tène) date. However, it has been remarked that the terminals of the torcs from Clonmacnoise (Cat. No. 27) and Somerset (Cat. No. 28) differ from those which have been dated to the period under discussion (Cat. No. 10). The dating of ribbon torcs to the period 1200 - 1000 B.C. would seem to have been finally established by the recent discovery of two torcs - one of ribbon type, the other an untwisted three-flanged torc at Coolmanagh, Co. Carlow.

The production of a ribbon torc can of course be seen as an extension of sheet gold working and as such it should not be in any way surprising that a technique already firmly established should have been quickly adapted to the manufacture of twisted ornaments, the Continental

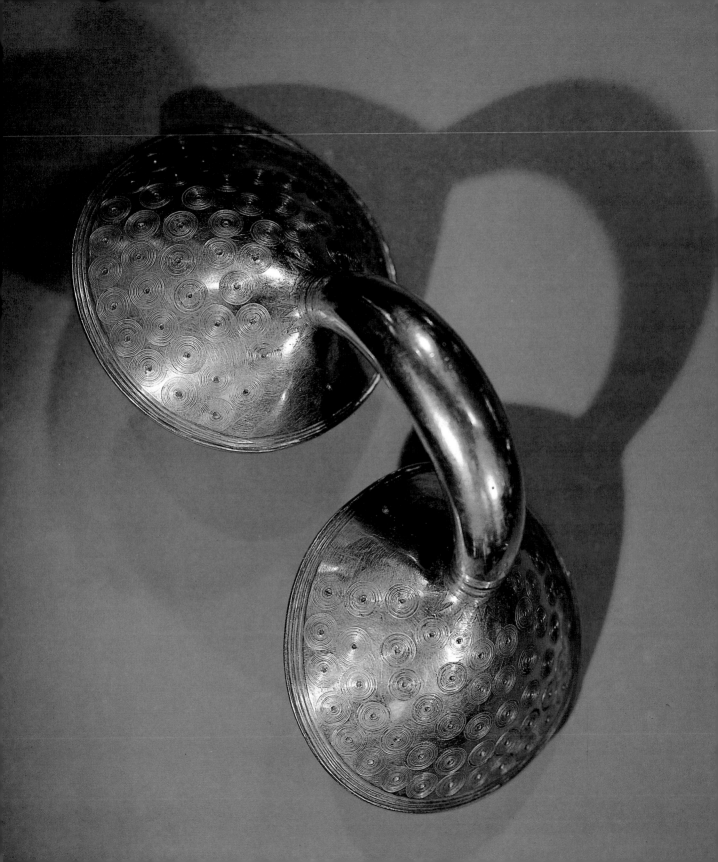

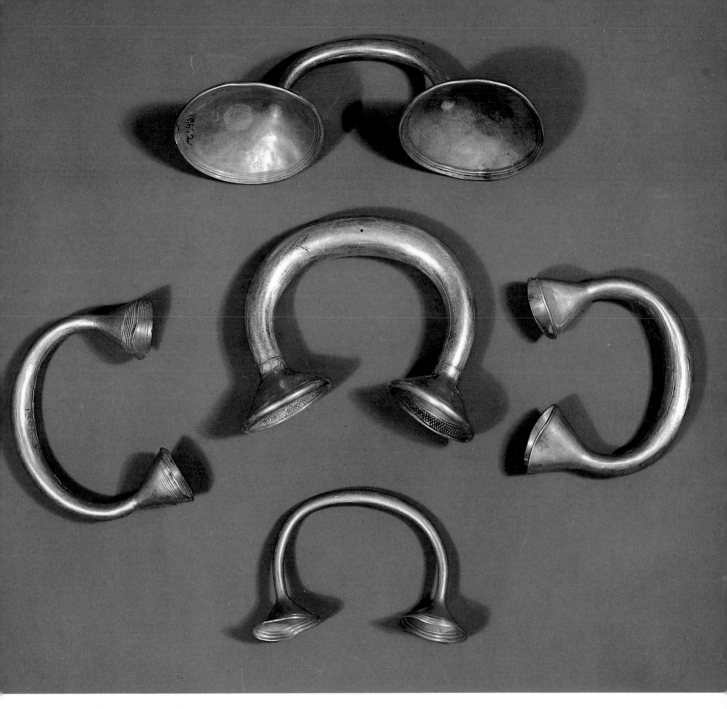

Hoard of gold ornaments, Cat. 18a-e, p. 90

◁ *Gold dress-fastener, Cat. 12, p. 83*

prototype for which may have been either cast or produced by strip-twisting (i.e. by soldering strips of gold together to form x- or y- sectioned forms which could then be twisted).

While it is possible to produce ornaments of considerable variety by using the ribbon method it is nonetheless a very limited technique when compared to the bar-twist method. It must be said that the rudimentary notion of twisting a bar of gold was developed and refined by Irish smiths into a highly sophisticated gold-working technique which surpassed the Continental strip-twisting method which it had initially attempted to reproduce. Bars of circular, square, rectangular and y-shaped section were used to produce ornaments which with the addition of elaborate terminals, as in one of the Tara torcs (Cat. No. 9B), weigh over three-quarters of a kilogramme. These large ornaments contrast sharply with the simplicity of a torc such as that from Athlone, Co. Westmeath which was made from a narrow square sectioned bar loosely twisted. In a further attempt to achieve the desired twist effect, Irish smiths bound a bar of round section with gold wire to give the impression of a closely twisted ornament.

Earrings of this period are limited to bar-twisted types, both flanged and unflanged with the exception of two which resemble a number of biconical beads strung together. A small number of composite (ribbed) rings and spiral rings are known and although the importance of these in establishing the date for the introduction of twisted ornaments has been stressed their associations are confined, in Ireland, to the ribbed rings found with the Skelly, Co. Tyrone torc and to a bar-twisted earring found with a spiral (finger) ring from Ardmayle, Co. Tipperary.

1000 - 500 B.C.

Based on largely negative evidence the period from 1000 -800 B.C. seems to have been one in which the "decorative art" of gold working was unimportant. Innovations in metalworking are restricted to the introduction of some new types of bronze tools and weapons such as flange-hilted swords and socketed sickles. Influence from Britain and north-western France is clear but it seems that during this period more attention was paid to improving techniques than to developing new types.

Towards the eighth century it appears that an upsurge in this, the last phase of the Irish Later Bronze Age economy

resulted in increased production of both bronze tools and weapons and of gold ornaments of exceptional quality. Technologically, gold-working reached new standards of craftmanship in both sheet and ingot work. Casting of objects to be finished by hand was also introduced and especially fine work was undertaken during this period, the willingness to experiment and innovate and the overall quality of the workmanship indicates that gold was in plentiful supply and that a sufficiency of wealthy patrons existed to support goldsmiths of immense skill and ingenuity.

The sheet-gold work of the seventh and eighth centuries B.C. shows considerable advancement in terms of range and execution in comparison with similar work of any other period in the bronze age. Objects such as the magnificent collars of gold (Cat. No. 21) are unique to Ireland and are masterpieces of their craft. They are the primary exponents of the new style of geometric decoration which is such a distinguishing feature of this late period and which contrasts so markedly with work of the preceeding centuries. The conical bosses, concentric circles and cable patterns which cover the gorget terminals, gold box lids and discs are executed in several different ways including repoussé, chasing and stamping. Gold wires, twisted to blend rather than contrast with the cable motifs are used to attach the pairs of terminal discs to the gold collars. Gold wire was also used to make the ornaments called "lock-rings". The ability to manufacture the large quantities of wire necessary to make the Gorteenreagh examples (Cat. No. 22) is in itself a technological achievement of considerable merit which is only surpassed by the coiling and soldering (or perhaps fusing) of the wires. Decorated gold foil is also used to cover bullae and penannular rings of lead and pinheads of bronze (Cat. Nos. 16, 20).

This period is also remarkable for its vast production of bracelets, dress-fasteners and cuff-fasteners of varying type and size. In one hoard - that from Mooghaun, Co. Clare - over 137 bracelets were found. Most of the bracelets and dress-fasteners are solid, made from ingots of gold, shaped to a circular bar with the extremities worked into solid or hollow terminals. In others, the bow is cast and the terminals are attached by soldering or fusing. The fibulae or dress-fasteners seem to have functioned by using loops or double button-holes. The largest of them from Clones, Co. Monaghan, is finely decorated with dot-in-circle motifs and weighs over one kilogramme. This and several other Irish ornaments of this period including a hollow fibula from Castlekelly, Co. Roscommon and a bracelet from Kilcommon, Co. Tipperary are so heavy that they could not have been

worn comfortably for very long. Many of them also show little sign of wear suggesting that their use was severely restricted. Unfortunately the purpose and significance of these massive ornaments can only be the subject of speculation, as for the most part, the circumstances of their finding is such that no useful information can be gained.

The search for prototypes for Irish gold ornaments of this period has largely centred on Northern Europe. Neumarkische Halskragen and multi-strand bead necklaces are suggested to have influenced the design of the massive gold collars. The dress fasteners are considered by some authorities to be an Irish version of the Scandinavian 'spectacle' fibula. There were undoubtedly strong connections between Ireland and these areas as the amber trade indicates and discovery of an Irish gold bracelet at Gahlstorf confirms. However, recent work has tended to underplay the extent of continental influences and has stressed the originality and inventiveness in such Irish ornaments as the gold collars and boxes.

The latter stages of the Irish Later Bronze Age are remarkable for the immense quantity, variety and quality of the gold ornaments which it produced. From the simplest beginnings of discs and lunulae, Irish goldsmiths developed their skills over a period of fifteen hundred years reaching a peak of technical achievement combined with a highly sophisticated sense of design and decoration at around 700 B.C. Many factors seem to have affected this progression. These include influences from Britain and the Continent, parallel developments in metal-working technology in copper and bronze and the availability of gold supplies.

The question of where the gold used by Irish smiths came from has been discussed on numerous occasions. A recent programme of analyses has identified six groups of Irish gold objects determined according to the percentages of gold, silver, copper and other minerals in each object. The identification of these groups has led to the suggestion that much of the gold used in Ireland during the Bronze Age was imported. However as it has not been possible to identify Continental sources for the gold and as the only comparisons made were with ore from a single location in Ireland it cannot be said with certainty that the gold was imported. It is difficult to know what commodity Irish smiths might have bartered in return for the large quantities of gold used particularly during the Later Bronze Age. Further examination of these analyses, recently, has suggested that deliberate alloying of copper and tin occurred also in the late Bronze Age.

The Iron Age ca. 300 B.C. - 450 A.D.

Michael Ryan

When the Iron Age may be deemed to have begun - if indeed it is meaningful to speak in those terms - is uncertain. It seems now that there was a great deal of continuity with the final Bronze Age. The appearance of iron-working - probably established by the third century B.C. - and of elements of culture associated elsewhere with the Celts of history present a confusing pattern. All that can safely be said at present is that in the centuries immediately before Christ, objects decorated in the Celtic La Tène style were current in Ireland. This was an abstract ornamental style of great sophistication. Based in part on minor themes of classical ornament, stylised vegetal designs and curvilinear motifs were common. It is found widely distributed amongst the lands known to have been occupied by Celtic peoples in later prehistoric Europe. Stone monuments decorated in that manner were carved at various localities and demonstrate that the art of the continental Celts was practised in Ireland and not merely imported on luxury goods. Mentioned casually by some classical authors, Ireland gradually emerged into the light of history. What little we learn from historical sources shows that overseas trade was carried on and that placenames where reported appear to be uniformly Celtic. By early historical times its inhabitants spoke a Celtic language and possessed a hierarchical social structure which can be paralleled closely in the accounts of the continental Celts given by classical authors.

Ancient customary laws, sagas and early annals all

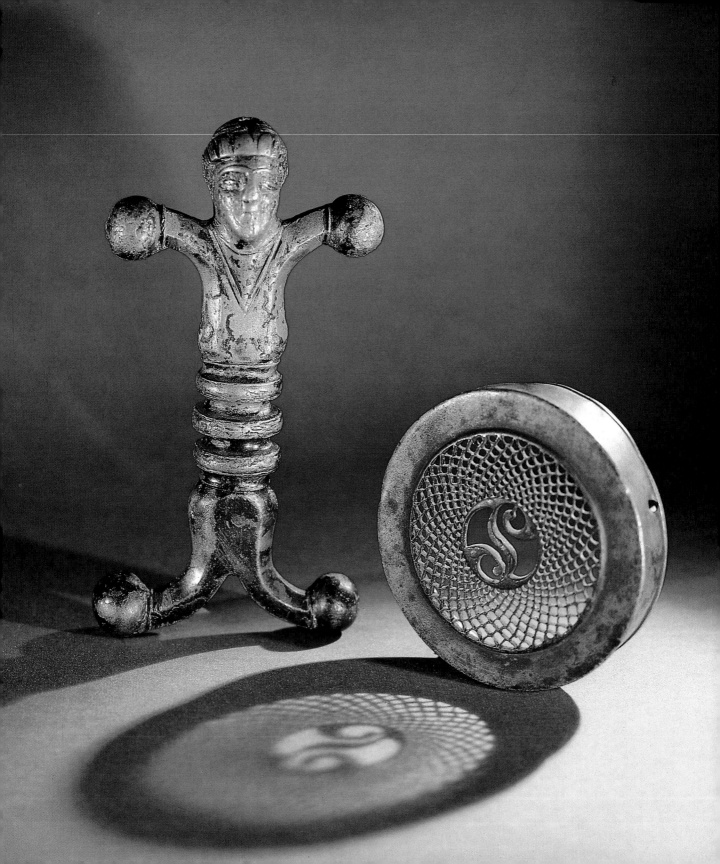

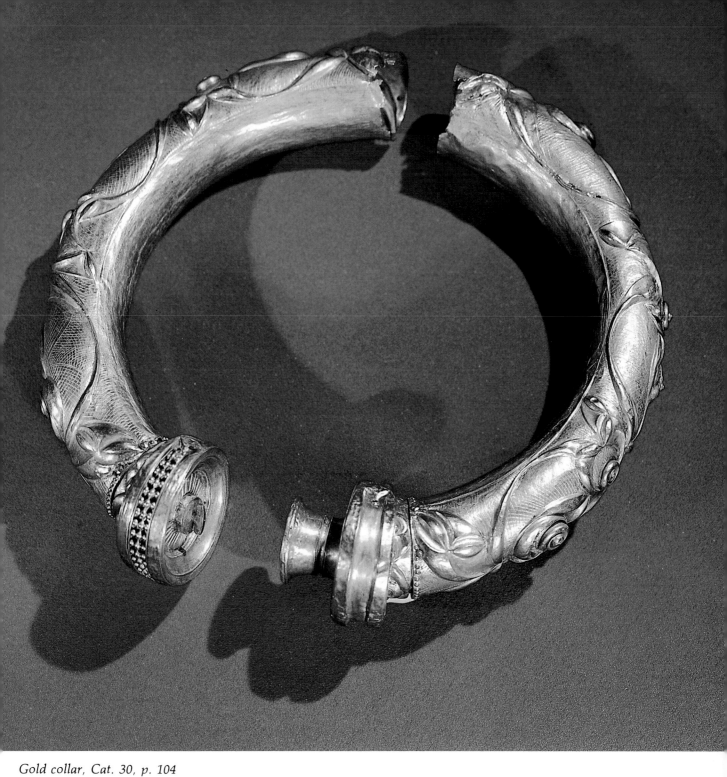

Gold collar, Cat. 30, p. 104

◁*Bronze sword hilt, Cat. 29, p. 104 and bronze box-lid, Cat. 32, p. 106*

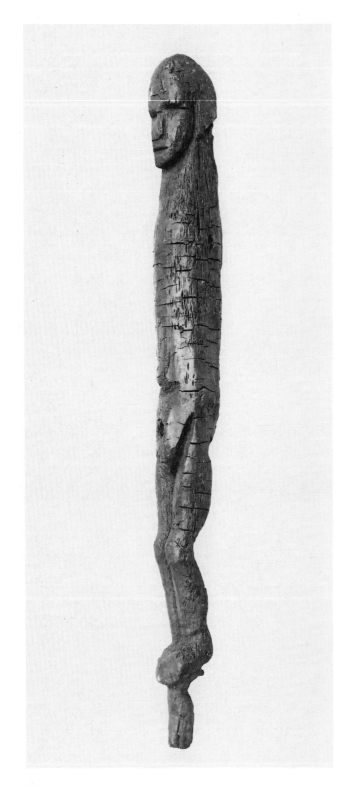

combine to shed a faint light on the later prehistoric period in Ireland. The society of the time has in a celebrated phrase been described as 'tribal, rural, familiar and hierarchical'. Divided into many petty tribal units, led in battle by kings, the people live largely by agriculture and stockraising. Wealth in cattle was especially important. The individual's legal standing was based very much on family relationships or dependency (clientship) and society was stratified but not rigidly so. Traditional wisdom was preserved orally by learned men. Wars appear to have been frequent and by the dawn of history the process of grouping smaller units into larger overkingdoms was well advanced and some of the centres of the larger groups such as Emain Macha, in Co. Armagh, Cruachan in Co. Roscommon and, especially, Tara in Co. Meath retained their prestige until well into the historical period.

Archaeologically the Irish Iron Age can be roughly divided into two periods - the first being the centuries from the final Bronze Age until the end of the first century A.D. and the second from the beginning of the second century A.D. until the establishment of Christianity during the late 4th and early 5th centuries. The essential characteristics of the first phase are the appearance of the Celtic La Tène style of decoration in the country - known from a variety of stray finds - and the occupation, if not the construction, of large hilltop enclosures such as Tara, and Emain Macha (Navan Fort). These latter may have been major refuges and, in their way, are a reflection of the hill fort tradition of Europe. An interesting feature of Irish hill forts is the fact that they are often built on sites which had already been important in more ancient times. Thus Tara contains a neolithic passage grave within its principal enclosure. The mound of the tomb was reused for an important series of burials in the Earlier Bronze Age and further activity, this time in the Bishopsland phase of the Later Bronze Age, is evidenced by the finding of the great torcs nearby. The mound with its small menhir - the *Lia fáil* ('Stone of Destiny') - together with other earthworks on the hill were identified and explained in ancient Irish place lore and accorded important roles in the pagan ceremonies of inauguration of Kings of Tara. It is possible that promontory forts also began to be built at this time but evidence of date for them is scanty. Crannógs or dwellings on artificial islands in lakes were certainly occupied in the earlier part of the Iron Age as

Wooden figure, probably Iron Age, Ralaghan, Co. Cavan

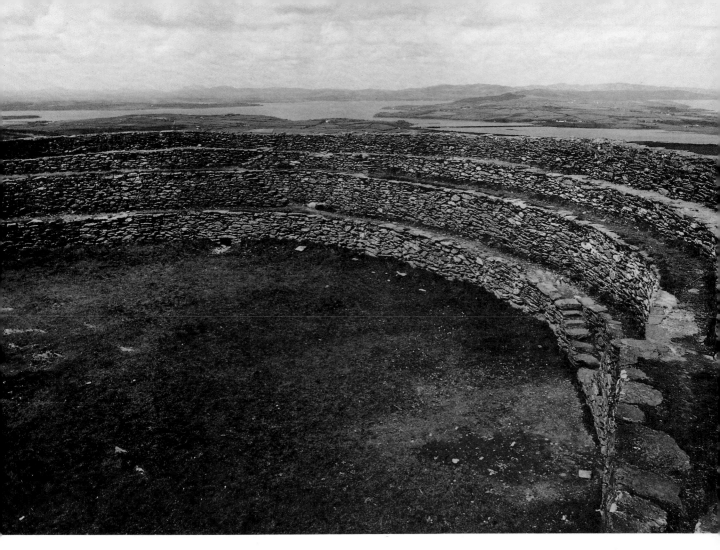

Stone cashel, "Grianan Aileach", Co. Donegal

well as later. One of them, Lisnacrogher, Co. Antrim, produced a splendid series of engraved bronze scabbard plates.

Decoration on objects of the Iron Age follows a familiar pattern for Ireland, the art style is introduced but is executed in a modified highly characteristic Irish style. Two early gold ornaments in the La Tène style are known: both are collars made of hollow tubes and both carry repoussé ornament. One from Clonmacnoise, Co. Offaly, dates to the 3rd century B.C. It is modelled in imitation of a fairly common European form of penannular collar with buffer-terminals. The second is the great gold collar of the 1st century B.C. from Broighter, Co. Derry. Found in a hoard with, amongst

other things, a gold boat, bowl and a decorative chain, recent research suggests that it was already old when deposited. It may have been a votive offering. Ribbon torcs of gold were also made during the Iron Age as the find of the 1st century A.D. from Somerset, Co. Galway, shows. It is, however, in bronze that fine craftsmanship is most widely represented at this period - the scabbard plates from Lisnacrogher and that from near the River Bann at Toome with their finely engraved decoration and the series of decorative 'boxes' of uncertain use document the sophisticated taste of the times. By the first and second centuries A.D. objects of great refinement were being made, some of unknown purpose such as the 'Petrie Crown' - an elaborate composition of bronze where the

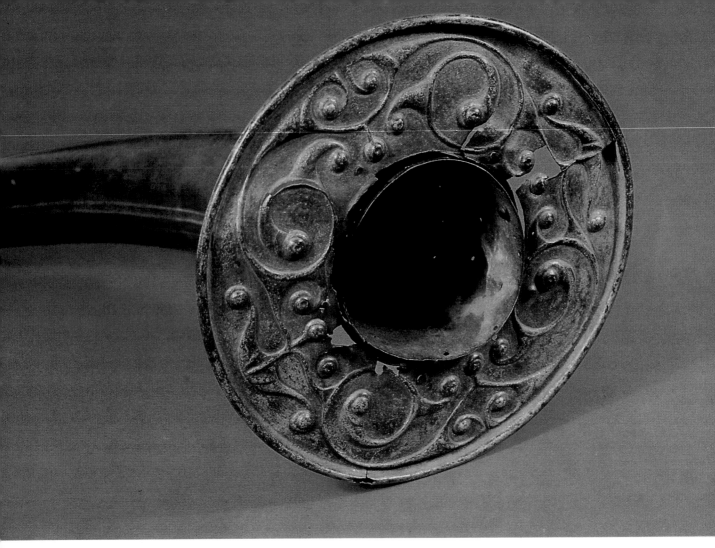

Bronze horn, Loughnashade, Co. Armagh, Cat. 31, p. 105

ornament appears in relief in a particularly sharp and subtle manner. Most of the decorated metalwork comes from the north and centre west of Ireland and this gives an impression of regionalism at this period.

Stone-carving is represented by a small number of decorated monoliths in the La Tène style. They are distantly related to examples in Brittany although the decoration has closest links with the British La Tène style of about the beginning of the Christian era. Three early examples are known, the finest being the Turoe Stone in Co. Galway. The monoliths had, presumably, a cult significance. Functional stone objects were also decorated - a number of quernstones bearing simplified La Tène designs has been found. Carved stone heads, some of them such as the well-known threefaced idol from Corleck, Co. Cavan, or the Beltany, Co. Donegal, head, echo the traditions of Celtic idols found in Britain, France and Germany - undoubtedly pagan, their dating within the Iron Age of Ireland in uncertain.

The evidence of burials is growing as modern research brings to light new finds. Both simple pit burials and more elaborate graves are known. Small, round, embanked earthen mounds are fairly common. Cremation was generally practised and the burial of grave goods is well attested - glass beads and small bronze fibulae (safety-pin brooches) are the most noteworthy objects found in the burials.

The second part of the Iron Age is that period roughly

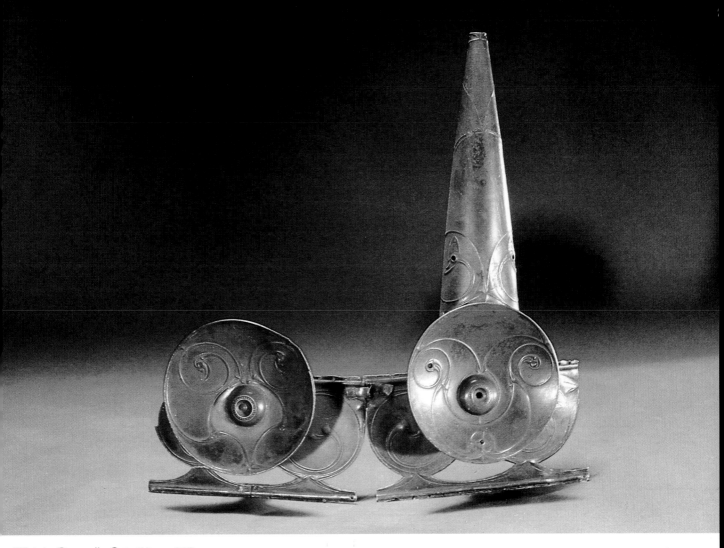

"Petrie Crown", Cat. 36, p. 108

extending from the Roman invasion of Britain to the introduction of Christianity to Ireland. Ireland was not invaded or annexed by the empire but there is no doubt that trading contacts were well-developed - a scattering of imported Roman coins, pottery and other objects appears at an early stage. Refugees from the conquest may have settled in Ireland - a 1st century A.D. cemetery at Lambay Island, Co. Dublin, contained exotic British material together with local imitations. Later, in the third and fourth centuries, as the empire weakened, raiders from Ireland augmented legitimate imports with the booty of piracy. By the end of the period, Irish colonies had been established at a number of points along the western seaboard of Britain - inside the Roman province

in north and south Wales, and, perhaps, Cornwall: outside the province at two places in Scotland of which the kingdom of Dál Riada in Argyll proved the most enduring.

The relations between Ireland and the Roman empire are not well understood and were almost certainly very complex. It is possible that Irish men served in the imperial army. It may also be that some Irish chieftains together with their levies served as *foederati* - or had been bribed with wealth and official honours to stay away - in times of difficulty for the colony in Britain. A present of the sort customary in these cases may be represented by the large hoard of silver from Ballinrees near Coleraine, Co. Derry. A smaller hoard of hacksilver and ingots of

Gaulish origin, from Balline, Co. Limerick, was more probably loot.

The evidence of settlements is scanty in this period. It is probably at this time that the ring-fort or *rath* - a circular embanked homestead became the most common form of dwelling for the well-to-do. The type remained in use throughout the Early Historic and into the Mediaeval Period - almost 30,000 of them survived in Ireland until the first comprehensive mapping of the country in the early 19th century. While many still exist, they are being destroyed at an increasing rate as a result of modern development. Made commonly of earthen banks sometimes revetted with stone, they vary in size from simple, small single-banked forms about 30 m. in diameter to large and imposing examples with a number of banks and ditches and elaborate entrance features. Inside them, round and rectangular houses have been excavated. Most yield evidence for the practice of various crafts - iron-working is especially frequently noted - and produce a variety of tools and fragments of agricultural implements. In stoney parts of the country, especially in the west, the equivalent of raths are made of stone and are referred to as 'cashels' a word of Latin derivation. We know from historical sources that the size of the house within the rath and the number of enclosing banks related to the status of the occupant. The Rath of the Synods at Tara was occupied in the 1st or 2nd century A.D. Some of the ringforts at Cush, Co. Limerick, may have been built and occupied in late pre-Christian times. Most of our information about the raths comes, however, from sites of later date.

It is difficult to understand artistic developments in this period. The pennanular brooch - together with other pin forms - of bronze seems to have been adopted during this phase, probably from contacts with southern Scotland. The earliest brooches are plain, and their terminals are cast so as to suggest stylised animal heads hence they are often referred to as 'zoomorphic'. Later examples often bear elaborate champlevé enamelled La Tène derived decoration but it is by no means certain that these were being produced in pre-Christian Ireland. A small buckle from Rathgall together with the Mullaghmast stone, from Co. Kildare, certainly suggest the tenuous continuance of La Tène decoration in Ireland but there is no independently dated evidence of it. This is a serious problem because the Ultimate La Tène style is a major component of later Christian art as indeed it is in parts of Britain also. The problem of direct continuity with native sources versus refreshment from contacts with Britain is unresolved. It is possibly a meaningless argument at this period because intercourse between the two islands was common and some community of culture existed between the Irish and their neighbours in Western Britain.

Earthworks on the Hill of Tara, Co. Meath

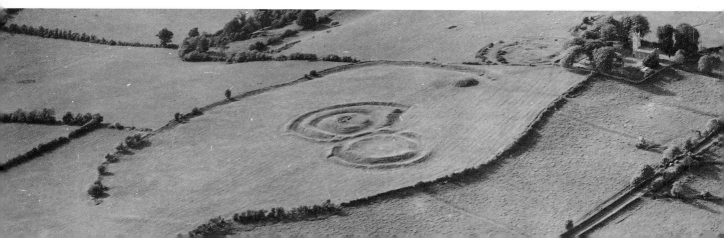

Early Christian Ireland ca. 400 A.D. - ca. 1000 A.D.

Michael Ryan

Christianity reached Ireland sometime in the 4th century as a natural consequence of trade and other contacts with the Roman world. In the early 5th, Pope Celestine found it necessary to appoint a bishop, Palladius, to the Irish 'already believing in Christ' the community had grown so large. The most successful missionary was however, Patrick, a Briton, who in the 5th century converted most of the northern half of the country. His principal foundation, Armagh, strategically located near the ancient prestigious heroic capital of Ulster, Emain Macha, grew to be the premier church of Ireland and is today the primatial see.

The early church in Ireland was episcopal in organisation but by the late 6th/early 7th century when we can begin to rely on native historical sources, the church was largely transformed into a monastic one. This was due in part probably to influence from the monastic traditions on the east, especially Egypt, stimulated by the need to adapt to a dispersed rural population, tribally organised. The Church rapidly became assimilated to lay society and monasteries became large and important centres of population, wealth and cultural activity although there was also a strong eremetical and devotional tradition.

Missionary activity became important and Irish monks in the 6th and 7th centuries founded important monasteries in Britain (Iona, Lindisfarne) and Europe (e.g. Pérrone, St. Gallen, Bobbio) and participated in the work of converting parts of modern France, Italy, Germany.

The lay society in this period was extremely complex. Customary law preserved in oral tradition regulated the individual and his kin in their social relationships. Lineage and wealth determined social standing. The exchange of goods was originally by barter although this was gradually becoming obsolete as the period advanced, the first native coinage was not struck until the later tenth century in the Viking Kingdom of Dublin. Warfare was frequent and tribal war bands were led by their kings. Although the country was divided into many small kingdoms, powerful overkingdoms were gradually becoming the effective political units in the Early Historic Period although the sacral mystical nature of kingship remained important.

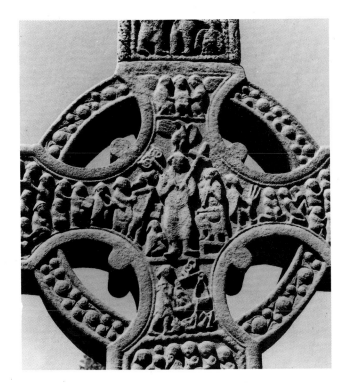

Muiredach's Cross, 9th/10th centuries A.D., Monasterboice, Co. Louth

The economy was based on stockraising (especially cattle) and on agriculture. Trade with other countries was carried on both for luxuries and also, probably, for some raw materials. Although essentially rural, the functions of towns in the exchange of goods were to some extent fulfilled by the great monasteries such as Armagh, Kildare and Clonmacnoise: it is their secular wealth which made them such attractive targets for the Vikings. The period is chiefly marked by the splendour of its religious art of manuscript illumination and stone sculpture and by the magnificence and virtuosity of its metalworking.

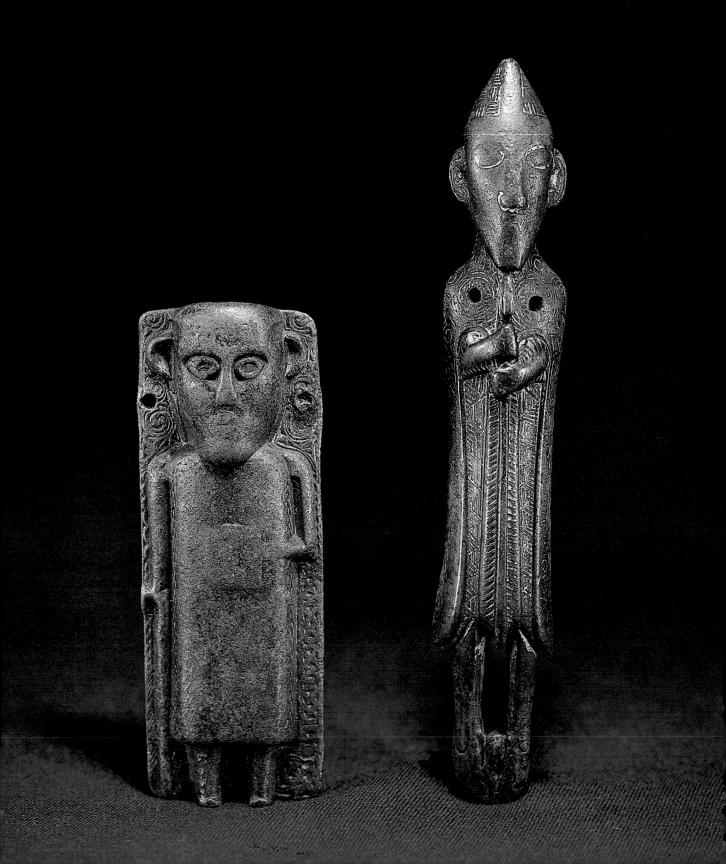

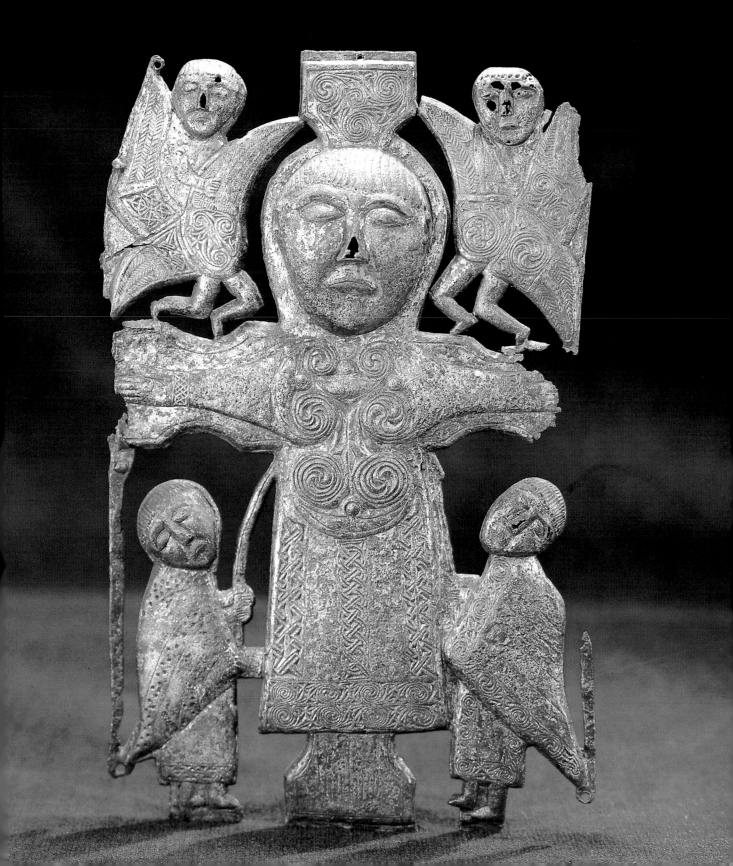

Metalwork and Style in the Early Christian Period 7th-10th centuries A.D.

Michael Ryan

Christianity had a profound effect on Irish life generally. The traditional learned class *(aos dána)* had their intellectual horizons greatly widened, one of the chief results of which was the early appearance of a secular vernacular literature which is amongst the oldest in Europe. The organisation of the Church brought about gradual changes in law while the development of monasteries modified political and strategical thinking. It is probable that a great deal of agricultural and economic development took place as a result of monastic activity -the founding of major religious houses often on marginal land probably brought about an expansion of the areas under cultivation. Work, particularly artistic activity, was given a new purpose by linking it to religious practice.

In the visual arts the Church provided new outlets because of its special needs. Liturgical vessels and other instruments, vestments, books, sculptures and a monumental architecture - all were required. Stone churches are attested in the missionary period by at least one place name but wooden churches seem to have been very much commoner and to have been built over a long period. Some of the surviving early church buildings are simple adaptations of building methods employed on secular sites. The small oratory of Gallarus, Co. Kerry, in form like an upturned boat made of dry-stone walling, is similar in shape to many of the chambers of contemporary souterrains - underground refuges and stores frequently associated with secular habitations. More sophisticated, rectangular, gabled structures survive. Often made of large, irregular but closely-jointed blocks of stone they preserve in detail skeuomorphs of features of log-built prototypes.

The earliest Christian carvings may well be slabs and pillars bearing simple incised crosses and simplified chi-ros, alphas and omegas. Sometimes associated with Ogham inscriptions a few may be as early as the 6th century A.D. Most are undated. Later, slabs with engraved inscriptions or bearing low relief crosses -sometimes the ringed 'Celtic' cross - appear. Large and elaborately decorated examples cannot with confidence be dated much before 700 A.D. and there is no convincing evidence for large-scale free standing sculptured crosses before the later 8th century.

Metalwork in the earlier part of the Christian period is not well documented. A series of bronze hanging bowls or lamps is known in Britain. Their 'escutcheons' -decorative plates from which the suspension hooks spring - frequently bear elaborate designs in the Ultimate La Tène style enamelled in red and later in red, blue and yellow. It has been argued in the past that these bowls, found mainly in 6th and 7th century pagan Saxon graves, were booty from the celtic lands of the west including Ireland. It is not necessary to assume this - workmanship in the La Tène tradition could well have been widely practised in England including areas under Saxon control. Early hanging bowls of this form are not known from Ireland but the style of Ultimate La Tène scrollwork is present on a small number of objects including a 'toilet implement', latchets (cloak fasteners), some penannular brooches and hand pins. Normally red champlevé enamel was used with the design seen as a thin reserve of bronze. The occasional substitution of silver for bronze in the making of ornaments together with the adoption of *millefiori* glass (platelets cut from bundles of fused glass rods which had been arranged in a decorative pattern) testify to the widening of the metalworker's repertoire at this period. *Millefiori* work was carried on at the site of Garranes, Co. Cork, in the later 6th century. A small group of imposing penannular brooches - of which that from Ballinderry Crannóg is the finest - have on their terminals broad fields of red champlevé enamel in which are floated plates of *millefiori*. The mouldings of the hoop of the Ballinderry brooch are so closely comparable with a moulding on a hanging bowl from the Sutton Hoo ship burial in England that the brooch - and the group as

◁ *Gilt-bronze crucifixion plaque, Cat. 47, p. 120*
◁◁ *Bronze figures of ecclesiastics, Cat. 46, p. 120 (left) and Cat. 84, p. 176 (right)*

St. Kevin's 'Kitchen' (church), 10th-12th centuries (?),▷
Glendalough, Co. Wicklow

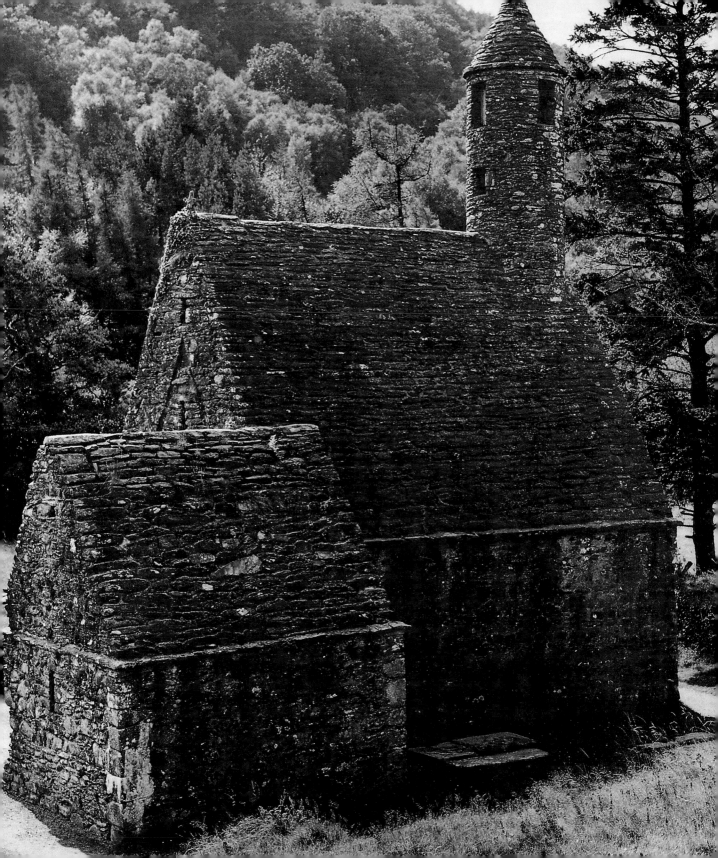

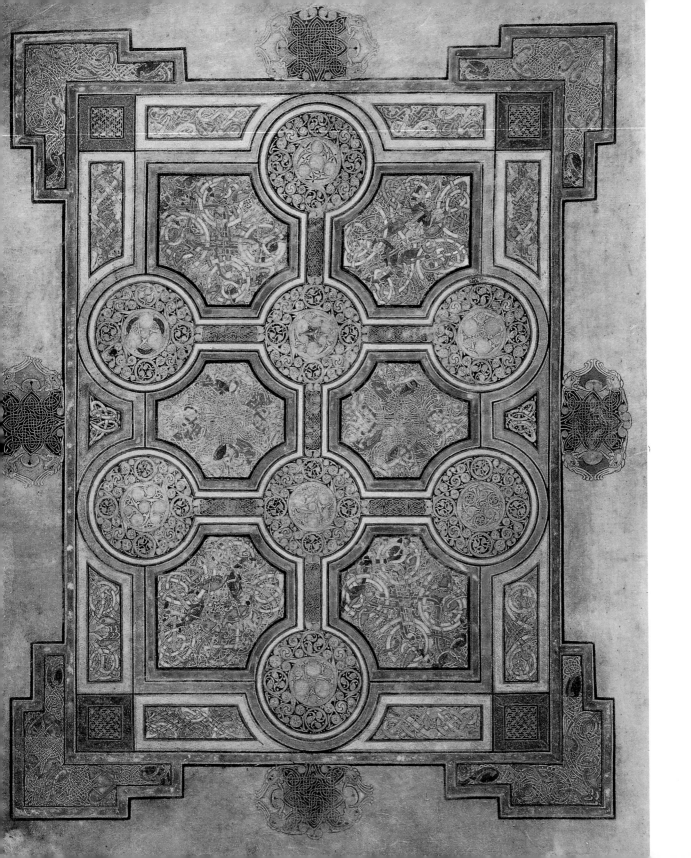

a whole - are probably earlier 7th century in date. The Ballinderry brooch appears to have been tinned and this, too, shows that Irish craftsmen were acquiring new skills. A very small number of early manuscripts survives. Writing - in the form of *ogham* script - had appeared in Ireland before Christianity. There can be little doubt that *ogham* - mainly used for memorial inscriptions and in form consisting of groups of notches usually cut along the edges of a stone - represents a native response to influences from Latin civilisation. It was a limited alphabet and was preserved by later monastic scholars in a spirit of antiquarianism rather than as a useful medium of expression. Liturgical writing must have been introduced with the earliest missionaries and the expanding Irish church would have required copies to fulfil the needs of new foundations. What these books looked like and what versions of scriptural text they repeated we can only guess at. By the mid-to-late 6th century, however, the earliest Irish manuscript, the 'Cathach' of St.Columba shows that a distinctive native style had emerged. The 'Cathach' is a fragmentary psaltar written in the Irish half uncial script. Enlarged initials occur and they are decorated with simple scrollwork and trumpet patterns of Ultimate La Tène type. The colours are mainly red and brown and red dots are often employed to emphasise initials. The simplicity of the decoration of the earliest manuscripts does not lend itself to detailed analysis of decorative style.

The foundation of a monastery by the Irish monk, Columba, on the western Scottish island of Iona in 563 A.D. was a critical event of the development of civilisation in Ireland. From Iona missions to the Picts and, later, Anglo-Saxons were organised. Close connections brought about by missionary activities in the early 7th century and by the presence in Irish monasteries of large numbers of Saxon students, lay and clerical, ensured that Ireland both contributed to and drew upon cultural developments in Britain especially in the kingdom of Northumbria. A great deal of controversy has taken place about the relationship of Ireland and Northumbria and exaggerated claims have been made on both sides for the provenance of important objects.

In 635 A.D. St. Aidan, under royal patronage, led a successful mission from Iona which completed the conversion of much of Northumbria. Important monasteries with a marked Celtic character were founded of which the most famous was undoubtedly Lindisfarne. There, traits characteristic of the Ultimate La Tène style

◁Book of Kells, carpet page with double-armed cross, fol. 33r

of decoration and tendencies in manuscript illumination and organisation already in evidence in Ireland were married to Anglo-Saxon traditions of jewellery and Germanic animal ornament to produce in northern England a new style of which the Book of Durrow is the first major representative to survive in Ireland.

The correspondences between manuscripts and metalwork are frequently so close that a history of style in Ireland in the later 7th and the 8th century cannot be considered without taking account of the developments in illumination and here, undoubtedly, Northumbria was a key area in the generation of new fashions in ornament. The picture is, however, biased by the fact that manuscripts of early date are well known in Britain while those preserved from Ireland tend in the main to be later (8th century) in date and so a detailed history of the formative period is difficult to trace.

If the continuity of manuscript illumination in Ireland is difficult to show, matters are entirely different with metalwork. A great number of objects of 8th and 9th century date survive to testify to a period of great artistic activity and inventiveness. It is clear that there was relatively little distinction between what were appropriate motifs for manuscripts and what were suitable for personal jewellery, liturgical vessels and reliquaries. The organisation of ornament in panels in the borders of manuscript pages often clearly mimics the layout of ornamental metalwork. In some paintings we can see obvious attempts to render the effect of the specialised techniques of the gold- and silversmith. The love of colour, so marked in manuscripts, is approached by the polychrome effect of the jewellery which was made possible by the adoption of a range of new techniques in the 7th century.

To the native repertoire of bronze-casting, engraving and colouring with red champlevé enamel were added by the 8th century, gold filigree, granulation, gilding, silvering, kerbschnitt, die-stamping of foils and a variety of new colours in glass and enamel. Glass was often employed to cast studs with inset, angular ornamental metal grilles in obvious imitation of cloisonné jewellery work of Saxon and Frankish type. The grilles are not, however, true cloisons containing semi-precious stone but rather thin strips of metal set into the cast surface of coloured enamel. The hallmark of this school of craftsmanship was, therefore, colour combined with a love of sumptuous all-over decoration and, as in the case of pseudo-cloisons, the stretching of local technology to imitate but not reproduce exactly effects borrowed from other traditions.

Much of the product of the 8th and 9th century

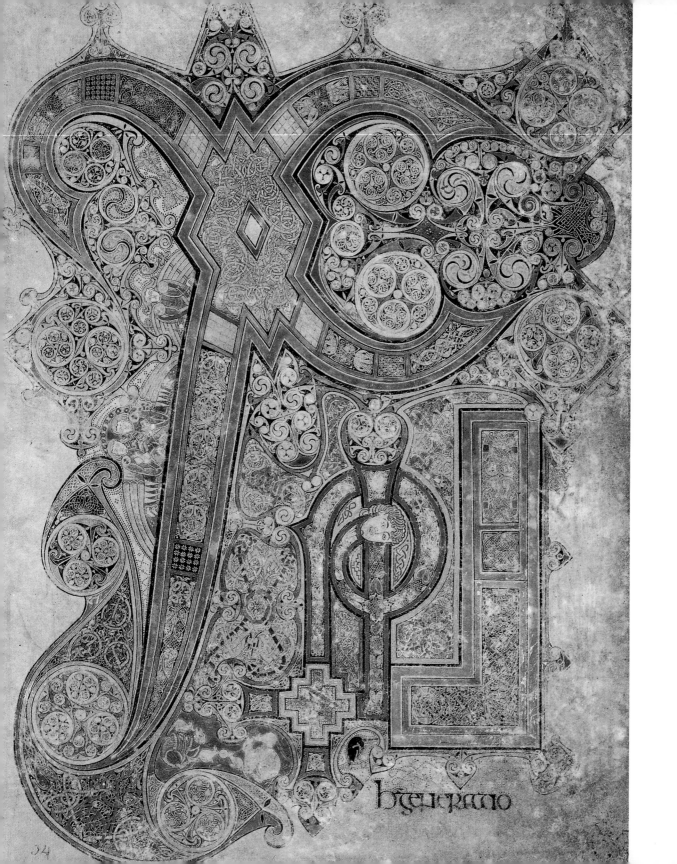

hgeneratio

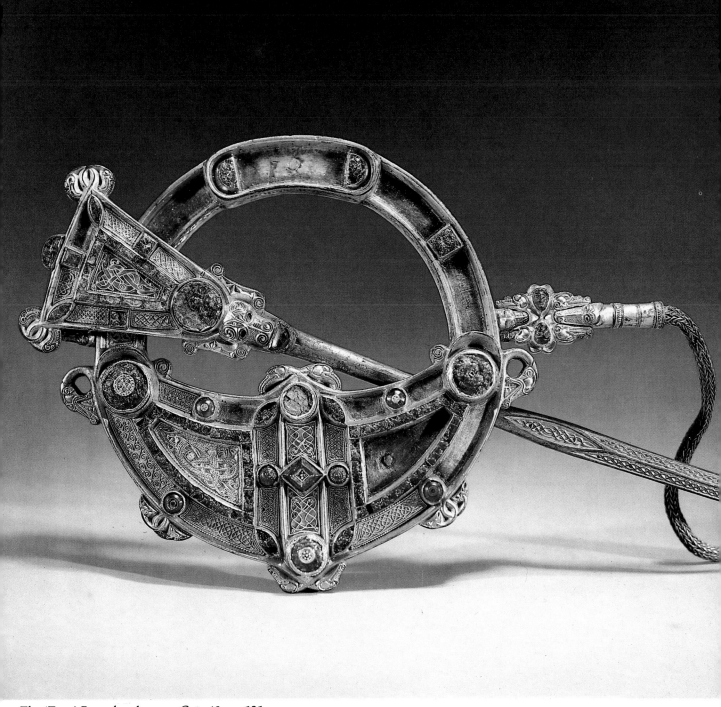

The 'Tara' Brooch, obverse, Cat. 48, p. 121

◁*Book of Kells, the Chi-Rho page of St. Matthew's Gospel, fol. 34r*

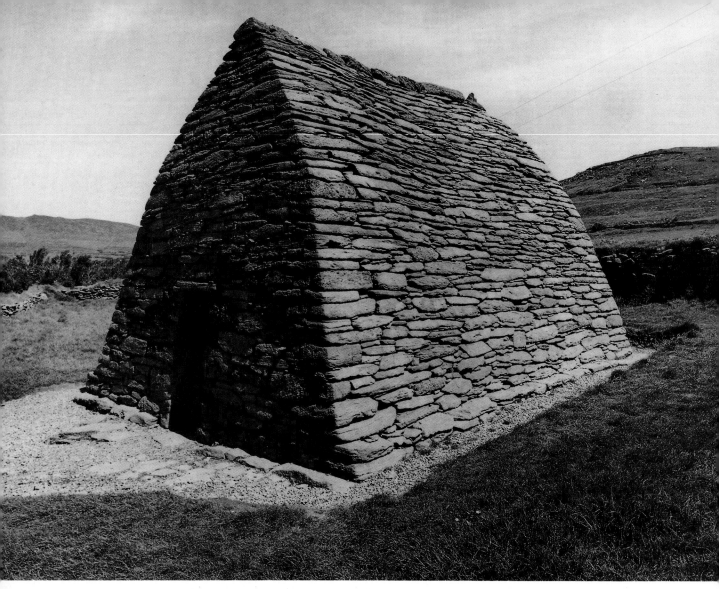

Gallarus Oratory, Dingle peninsula, Co. Kerry, between ca. 800 and 1200 A.D.

workshops is good competent craftsmanship but a high proportion of it is also of a refinement, subtlety and sheer virtuosity of technique that it has seldom been approached in quality in subsequent European history and that it makes nonsense of modern distinctions between "higher" and "decorative" arts.

Much of the metalwork was made in the service of the Church and there are strong literary hints that some craftsmen were clerics and that a great deal of this work may have been accomplished in monastic *ateliers*. Writing of St. Patrick in the 7th century, his biographer Tirechán refers to the missionary's companion, St.

Assicus, a bronzesmith whose works the author had seen at a number of churches. Patens and book covers were attributed to Assicus and indicate not only the existence of large metalwork objects in 7th century Ireland but also the wide distribution of work attributed to one man. Of rich personal ornaments, it can only be said that they were worn both by clerics and laymen of high status and may have been made in both monastic and secular workshops. The practice of the skills of fine metalworking are indicated on a number of lay sites of importance such as the royal crannóg of Lagore, Co. Meath.

What later 7th century Irish metalwork looked like we cannot be sure. The first personal ornament of which we have fairly reliable indications of date is the great ring brooch usually called the 'Tara' Brooch although actually found on the seashore near Bettystown, Co. Meath. It is "pseudo-penannular", that is, its ring is completely closed and greatly expanded as a field for ornament. The shape of the panels of the broad part of the ring imitate the form of the terminals of the penannular type from which they are in part derived. The 'Tara' Brooch is of cast silver-gilt. The panels of the front carry sheets of gold foil each bearing filigree work of great refinement. Animal patterns, simple scroll work and thin, stylised serpents are represented by a variety of beaded, twisted and plaited wires and gold ribbon. Amber and glass studs, some of them bearing filigree insets, decorate the settings. Projecting cast bird and animal heads embellish the ring. A chain of knitted silver wire ('trichinopoly' work) springs from an elaborate hinge on the side of the ring. The back bears cast ornament including animal designs, friezes of birds and elaborate compositions in "kerbschnitt" of Ultimate La Tène style - tightly-wound spirals, trisceles and trumpet scrolls. One panel in particular, calls for special comment. It lies between the two pseudo-terminals and consists of a pair of very slender beasts with hatched bodies. Their necks are crossed and their legs are interlocked, their bodies are fancifully contorted to give, at first sight, a figure of eight impression. They are executed in a manner known on a number of pieces of metalwork from outside Ireland, for example from 9th century Viking graves in Norway (perhaps loot from the west) and from the hoard concealed towards the end of the 8th or beginning of the 9th century at St. Ninian's Isle in Scotland. Their style and feeling, however, have led some authorities to compare them with motifs in the Lindisfarne Gospels and so to suggest an early 8th century date for the brooch. This is not certain by any means but it is a good working hypothesis.

At the time the 'Tara' Brooch was made, the Ultimate La Tène style was still vigorous. Although no longer prominently displayed, the silver panels of the pseudo-terminals on the back are amongst the finest expressions of it. Technically they are mervellous - a thin coating of silver was placed on an embossed copper sheet and was then polished away to reveal the underlying red metal in a series of carefully balanced counter rotating spirals

High Cross, Ahenny, Co. Tipperary, 8th century A.D.

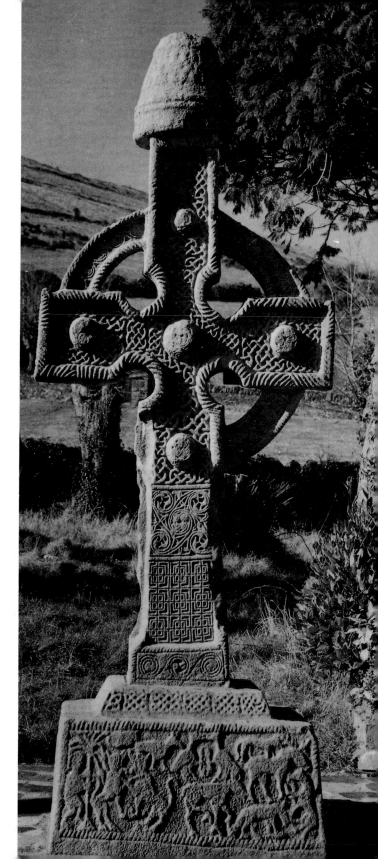

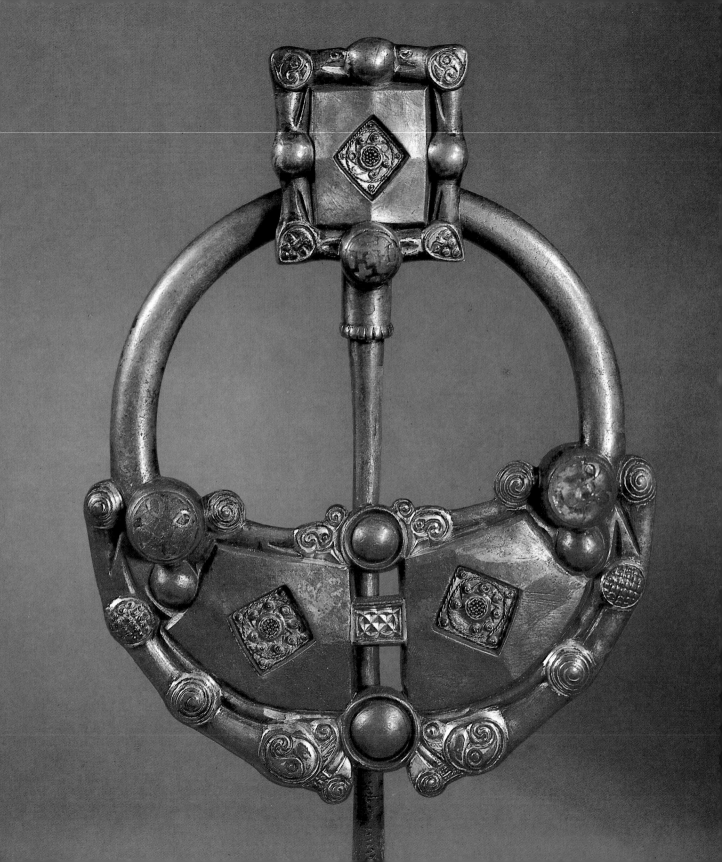

linked by complex scrollwork. A thin film of gold foil is pierced in a similar manner in a small panel on the ring. This brief account does not exhaust the technical and aesthetic variety of the 'Tara' Brooch but it does serve to indicate how closely the heavily decorated manuscript pages are matched in three dimensions in contemporary metalwork. All the ornament we have described is crowded onto a ring which is less than 9 cm in diameter. On that small brooch we can see not only traces of a range of artistic influences but also more tangible evidence for foreign contact - the amber used on the brooch must have been imported either from England or from the Baltic, the mercury used in the gilding was likewise an import and it is probable that the silver also came from overseas. The source of the gold in the filigree is unknown.

The 'Tara' Brooch stands at the head of a series of magnificent personal ornaments. The pseudo-penannular form was popular in Ireland in the 8th and 9th centuries. The 8th century version is represented by the large heavily decorated brooch from the Ardagh hoard and by the beautiful Cavan Brooch. In the 9th century the two smaller pseudo-penannulars from Ardagh, the Roscrea and Killamery brooches as well as others show a diminution in the amount of ornament. These later pseudo-penannulars are characterised by stylised animals along the margins of the rings, a fashion which also occurs occasionally on a form of 9th and 10th century massive silver penannular brooch. Filigree, too, became simple and appears somewhat unaccomplished. The use of coloured enamels seems to have been replaced in the 9th century by large amber studs and later by metal bosses.

In the 9th century the penannular form enjoyed a renewed fashion, this time in silver. The brooches, known as "bossed" after the ornamental metal bosses with which many are decorated, were generally made of hammered silver and engraved with animal patterns of mixed Anglo-Saxon and Irish influence. They were probably devised in Ireland to satisfy Viking taste for massive silver ornaments. Fragments of them cut up ("hacksilver"), have been found in coin-dated hoards of the early 10th century in both Britain and Ireland.

In the 9th century another silver penannular form - the 'thistle' brooch appeared. On these the rings terminate in large knobs often carefully scored to produce a pattern resembling the surface of the blackberry fruit ("brambling"). Their pinheads end in similar knobs often with flared projections which make them look very like the thistle flower. Frequently very large, normally of silver, they are widely distributed in Viking lands but their ultimate origins lie in the metalwork of 8th and 9th century Ireland. Evidence from hoards suggests that they were current as late as the mid-10th century. A thistle brooch was found in the Ardagh hoard and thus one find can be seen to have contained examples of brooch types current over a period of as much as two hundred years. Other cloak fastenings were in use throughout the period - small ring brooches of cast bronze with simple kerbschnitt interlace are known as well as a range of humbler pins. A variety of silver brooches with pendant heads and exceptionally long pins seems to represent an Irish development with slight Scandinavian influence. One form sometimes referred to as the "kite-brooch" survived in use until the 10th century as examples excavated from Dublin have demonstrated.

8th and 9th century sites mentioned in the text

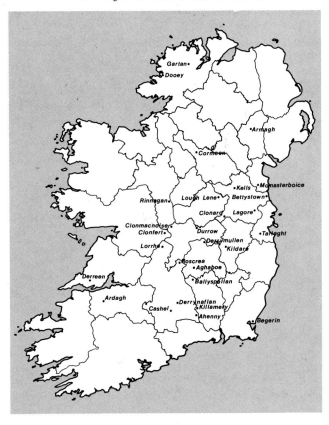

◁Pseudo-penannular brooch, Cat. 63, p. 145

The chronology of brooches, although somewhat controversial, is rather better understood than that of ecclesiastical metalwork. Religious objects of the period are common in Ireland and are quite obviously the product of well-found and patronised schools of craftsmanship. What may well be the earliest objects are of gilt-bronze, of which the Rinnagan Crucifixion Plaque is a good example. The figure of Christ dominates the scene; he is dressed in a long sleeved tunic. On either side of the head are two angels while a lance- and sponge-bearer flank the cross below. The soldiers wear Irish costume of cloak and tunic. The decoration includes interlace, curvilinear motifs and key-patterns of classical derivation. The object is thought to have formed part of the decoration of a book but it may have been a component of a much larger and more ambitious work such as an altar, shrine or cross.

The cults of the relics of native saints became fashionable early and a variety of shrines was made to house them.

Of these, the house-shaped form (better described as 'tomb' - or 'church' - shaped) copies in detail the appearance of early Irish oratories. They were insular versions of a reliquary type well-known throughout Europe. One of the most magnificent of objets d'art of 8th century Ireland is a shrine made to preserve the belt of an unknown saint. It was found almost forty years ago in a bog at Moylough, Co. Sligo. The reliquary closely imitates the shape of the belt and includes a large ornamental buckle. Decorated with animal heads, sophisticated Ultimate La Tène designs stamped on silver foil, interlocking "L"- and "T"-shaped panels of coloured enamel, glass studs and millefiori, it must have been the principal treasure of an important monastery. The bells of saints were also enshrined and the crest of such a reliquary dating to about 800 A.D. was formerly preserved at Killua Castle, Co. Westmeath. The 'Bell of the Will' or St. Patrick's Bell was early placed in a shrine at Armagh and was, along with the *Bacall Íosa* ('Staff of Jesus', that is, St. Patrick's crozier), one of the most important and respected relics of early Ireland.

A feature of most shrines is that they were made to be carried about and they are frequently equipped with loops for suspension straps. Early annals speak of them as being brought to the sites of important ecclesiastical and political meetings where their presence was used to solemnise agreements reached. The taking of reliquaries on circuit and visits to important shrines must have contributed greatly to the dissemination of metalworking styles throughout the island. Occasionally they are spoken of as being carried in flight before some threat, often the Vikings. Some were of course seized by Scandinavian pirates and fragments, undoubtedly from Irish reliquaries, have turned up in 9th century graves in Norway.

Liturgical vessels of Irish manufacture are rare. Three chalices, two patens and some other objects including a strainer and a possible censer (from Vinjum in Norway) are known. Some hanging bowls of late type with enamelled anthropomorphic escutcheons from Norwegian graves and some wooden pails complete the list.

Of all of these, the Ardagh silver chalice found with the silver brooches already described and a smaller bronze vessel is undoubtedly the finest expression of the art of the metalworker to survive from 8th century Ireland. If it lacks the profusion of ornament of the 'Tara' Brooch it makes up for it in the sheer excellence, subtlety and variety of ornament which is applied in a carefully balanced composition. For once, the artist has resisted the temptation to invade the great expanses of polished silver. The qualities of the metal are however emphasised by a fine inscription against a dotted background and very faint but beautifully drawn engraved designs below the handle escutcheons and decorative roundels. Glass, mica, malachite, crystal, gold filigree and granulation, stamped silver, impressed copper and gilding embellish the piece. With its pair of handles and decorative girdle and roundels, the Ardagh Chalice is an adaptation of a Byzantine form to Irish traditions of workmanship. In its decoration and design the vessel is as eclectic as the other major contemporary works and summarises the wide range of influences drawn upon by the artists of the Golden Age. Its decoration has often been compared to that of the Book of Kells and hence it has been ascribed to the 8th century, perhaps rather later than the 'Tara' Brooch.

One of the most interesting discoveries of recent years has been the fact that the Ardagh Chalice was not unique. A hoard of liturgical vessels found at the ancient monastery of Derrynaflan, Co. Tipperary, contained a 9th century chalice which in most major respects is so similar to the Ardagh vessel as to suggest that there was a strong traditional Irish design for large vessels used for administering consecrated wine to the faithful. The Derrynaflan hoard also contained a large silver paten decorated in a style close to that of the Ardagh Chalice. With these was a beautiful strainer-ladle which is best regarded as an Irish version of the sieves which have from time to time turned up in Byzantine and other hoards of church silver. Humbler liturgical vessels are represented by the bronze chalice from Ardagh and the simple copper paten of St. Tighernan of Errew, Co. Sligo, which was enshrined in the mediaeval period.

Short croziers made of bronze tubes lapped around wooden cores with joints covered by elaborate decorative knops appear to have been the characteristic symbol of bishops in Ireland from an early stage. Some were undoubtedly made to preserve the wooden staffs of saints but wooden cores were structurally necessary for supporting thin sheet-bronze. It is unjustified therefore to describe every example as a reliquary. The Irish type, if the evidence of the Aghaboe figure and certain sculptures is to be relied on, had emerged by the early 8th century and was to remain in vogue until the 12th when imported romanesque versions supplanted it. A few early fragments survive, of which the most ambitious and accomplished can be seen on the so-called 'Kells Crozier' in the British Museum. Repaired on a number of occasions the earliest work represents an Irish reflex of styles of animal ornament current in 9th century Britain and parts of the Carolingian Empire. It was clearly an ambitious work and it is interesting to note on it the restricted variety of techniques and ornaments and the virtual absence of curvilinear motifs which can be traced to the Ultimate La Tène tradition. After a history spanning about eleven hundred years, the 9th century saw the decline and virtual extinction of the La Tène style in metalwork.

The development of sculpture in stone paralleled in many respects the history of metalwork and the 8th century was to see the emergence of the tall, freestanding wheeled high cross of the type often referred to as 'celtic'. There is no clear agreement on the origins of the Irish high cross -it has been argued that the design was first elaborated in timber and was modelled on small metal-covered processional crosses. It has been suggested, as with manuscript illumination, that the monasteries of Columban foundation, especially Iona, played an important part in transmitting to Ireland ideas current in northern Britain. One widely accepted theory is that a series of crosses decorated almost entirely with abstract ornament copied from contemporary metalwork and found in the south midlands was the earliest. The finest examples are at Ahenny, Co. Tipperary. On these figures sculpture was confined to the base. Later, carved scriptural scenes become common on the shafts of the crosses, culminating in a magnificent series of crosses with a large number of illustrations derived from the Old and New Testaments and presented in a regular manner. The great period of stone carving was, however, during the 9th and 10th centuries when, it is clear, the Irish craftsmen were drawing heavily on Carolingian iconographical schemes.

The view has sometimes been put forward that the development of imposing crosses represented the response of the Irish craftsman to the threat posed by the Vikings. The artistic effort was diverted to the embellishment of great heavy crosses which, not being portable, would not have attracted the attentions of thieves. Metalworking and manuscript illumination, so the theory runs, went into a drastic decline. This simplistic view is not tenable any longer - the destructive effects of the Vikings have been grossly overrated, metalworking continued to achieve respectable standards throughout the 9th and 10th centuries. The development of large sculptures is evidence of confidence and patronage not of decline and destruction.

The evidence of borrowings from the Vikings is likewise unconvincing in the 9th and 10th centuries. A few minor decorative traits are, perhaps, attributable to their activity in Ireland - the so-called ring-chain ornaments of the 10th century and, perhaps, the general appearance of the animals on the unprovenanced silver 'kite-brooch' but little else. The traditional sources of inspiration continued to form the arts of metalworker and sculptor in the 9th and 10th centuries - the long and distinguished native school, the cognate traditions of Britain and also, perhaps, the styles of the Carolingian and Ottonian worlds in which numerous Irish clerics made their careers.

The 'Tara' Brooch, Cat. 48, detail of ornament on the reverse

45

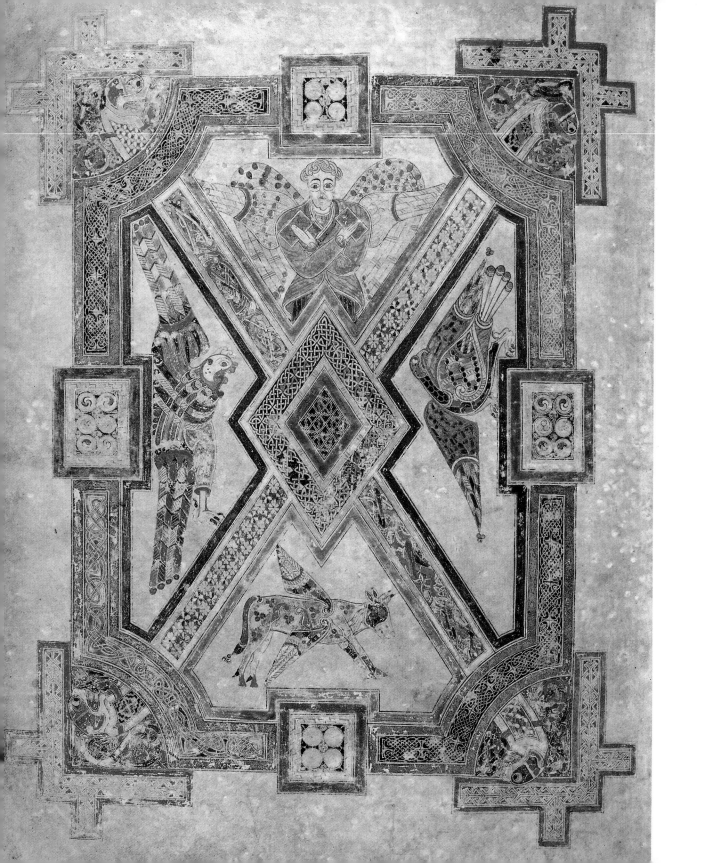

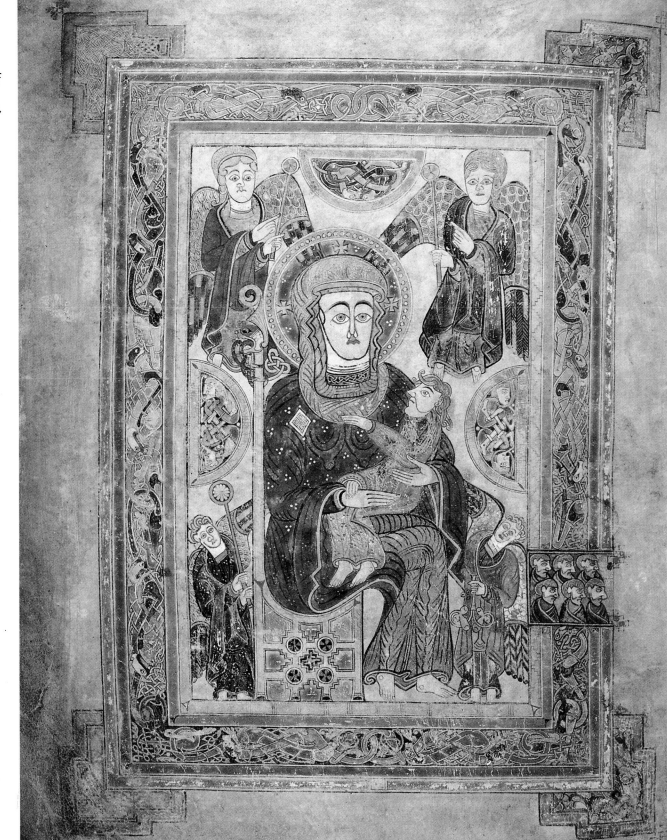

Irish Manuscripts in the Early Middle Ages

Bernard Meehan

In the period between the late seventh and early ninth centuries, manuscripts were produced in Ireland and places of Irish influence to an artistic standard surpassing that of the rest of Europe. The copying of manuscripts was an essential feature of the Christian and monastic culture which had come to Ireland from Roman Britain, in a process with which the fifth century Briton St. Patrick is especially associated. Gospel books in particular were required for study and liturgical purposes as well as for the missionary work by which Irish monks spread Christianity to Scotland, to Northumbria and to such foundations in Europe as St. Gall and Bobbio, where important surviving manuscripts were written. Christian teaching was communicated in the unifying language of Latin, increasingly through that translation of the Bible known as the Vulgate, which Pope Damasus commissioned from St. Jerome in the fourth century.

Missionaries and scholars naturally used books of a size they could carry easily. Such 'pocket' Gospels include the Book of Dimma and part of the Stowe Missal, written in a 'miniscule' script for reasons of economy, while the spacious and solemn letter forms of 'majuscule' were reserved for luxury productions to be used on the altar on major occasions. These manuscripts, of which the Book of Kells is the finest surviving example, were distinguished as masterpieces both of calligraphy and of painting. Their major decorative features were portraits of the evangelists Matthew, Mark, Luke and John; the evangelical symbols - in Jerome's version respectively the Man, the Lion, the Calf and the Eagle; the opening words of each Gospel; the canon tables or concordances of Gospel passages compiled in the fourth century by Eusebius of Caesarea, for which images of elaborate arches were constructed; and 'carpet' pages or pages solely of ornament unrelated to text, commonly involving the cross, a central element in the Christian tradition. The decorated pages glorified the Word of the Gospel, and in themselves, together with the copying of the text, served as acts of devotion.

A sense of devotion was undoubtedly required of the copyist or scribe, who in this period may often have been identical with the artist. For while he was honoured with a place in society appropriate to the sacred texts he transmitted, his occupation was one which the monastic rules properly defined as work, and his frustrations are recorded in marginal annotations. Poor results were blamed variously on defective materials, bad light, cold, ill health, loneliness, lack of practice or the need for haste. Exceptional haste was demanded of Dimma, a scribe in the monastery of Roscrea, Co. Tipperary, who according to legend had only one day to fulfil the requirement of the founder of the house St. Cronan (died 619) for a copy of the Gospels. With the aid of hagiographic convention, the sun failed to set for forty days, time enough for the scribe to complete his work. About two centuries later inscriptions in the eighth century Gospels known as the Book of Dimma were altered in an attempt to identify it as the volume copied by Dimma under these miraculous circumstances.

The Northumbrian historian Bede, writing in the eighth century, recorded that the noble English students who had come to Ireland for instruction in the previous century had been provided free with the necessary books, which suggests that the production of manuscripts took place on a large scale. This was especially the case in houses of wealth and power and stability, such as Armagh, which in the eighth century was consolidating claims to ecclesiastical supremacy over the whole country; or Iona, the small island off the west coast of Scotland which functioned as head of the large communion of houses founded by St. Columba (died 597) until after 806, when the community there moved to Kells, Co. Meath, as a result of Viking attacks.

That scribal activity was of the first importance to Columba and his house is clear from Adomnan's life of the founder, and the scriptorium of Iona is now generally thought to have been responsible for the most lavish of the surviving insular manuscripts, the Book of Kells. Considerable wealth was required for the creation of such a manuscript including vellum from a herd of about 150 calves, an especially large quantity since the Book of Kells, like another great insular codex the Lindisfarne Gospels, is constructed in such a way that the backbone of the animal runs across rather than down the spine of the book. Iona's control of the wealth of its tributary houses presumably enabled it to acquire vellum and pigments, most of which had to be imported, some from afar, and were thus expensive.

factus est tues filius meus dilectus me.
bene complacuit mihi.
Ipse ihs erat incipiens quasi an
norum triginta. ut putabatur filius

ioseph
VI puit heli
VI puit matha
VI puit leui
VI puit melchi
VI puit iannie
VI puit ioseph
VI puit mathat hie
VI puit amos
VI puit nauum
VI puit esli
VI puit nagge
VI puit enauu

Book of Kells, Genealogy of Christ, fol. 200r

The painters of Kells used reds from red lead and kermes, made from the pregnant body of a Mediterranean insect (*Kermococcus vermilio*); yellow from orpiment (yellow arsenic sulphide, which served as a substitute for gold), ox gall and yellow ochre; purples, mauves and maroons from a Mediterranean plant (*Crozophora tinctoria*); white from white lead; bright green from verdigris and an olive shade produced by mixing it with orpiment; a blue from either the oriental plant indigo or the north European plant woad, and most extravagantly several other shades of blue from lapis luzuli, a stone which ranked in the middle ages with gold in value. Lapis had to be brought via merchants of many nationalities from mines in the Badakshan district of Afghanistan in the foothills of the Himalayas.

The Viking raiders who disrupted manuscript production and monastic life in the ninth and tenth centuries were attracted however not by wealth of this kind but by precious metals, including those in which books were encased. Cassiodorus (ca. 485 - ca. 580) had encouraged the belief at his monastery in Calabria that a binding should match the richness of a book's contents. The binding stolen from the Book of Kells in 1007 no doubt came into this category. Traditionally, books had been stored in leather satchels on the walls of monastic cells. Satchels continued to be made late into the medieval period and presumably in abundance, though the satchel associated with the Book of Armagh is one of only two examples left in Ireland. To enshrine a book in a *cumdach* was however to serve a purpose other than mere utility such as this. The reverence surrounding the Book of Durrow arose from the belief that it had been written by St. Columba, and caused Flann Mac Maelsechnaill (died 916), king of Ireland, to place it in a shrine which was lost from Trinity College Library around 1690. His son Donnchadh had a shrine made for the Book of Armagh in 937 on the assumption that it was the work of St. Patrick. This *cumdach* is no longer extant, but those made for the Stowe Missal and the Book of Dimma survive.

The book took on the sacral properties of a relic of the saint with whom it was associated, and was said, in a hagiographical commonplace, to survive intact immersion in water. A hymnal in St. Columba's hand was claimed by Adomnan, for example, to have fallen one Christmas into a river and lain there in its satchel until washed up the next Easter, when the satchel was found to have decayed but the hymnal to be dry and unharmed. Immersion in water was not always accidental; in the seventeenth century, water in which the Book of Durrow was dipped to cure sick cattle caused great damage at the folds and staining which is still visible. Healing was a common motif; shavings taken from Irish manuscripts and steeped in water were believed by Bede to be effective against snakebite. At Iona books in Columba's hand were used not only to cure the sick but even on one occasion late in the seventh century as part of a ritual designed to end drought.

Here is a clear example of the adaptation of paganism to Christianity, which caused books among other objects to be used for primitive talismanic purposes. The psalter known as the *Cathach* (battler) was traditionally supposed to have been written by St. Columba - a belief actually within the bounds of palaeographical possibility - and as such was carried into battle by his kin the O'Donnells as a talisman of victory. The Book of Armagh was similarly used at battles including Down in 1177 when it was captured by the Anglo-Norman John de Courcy but later returned.

Elements of traditions predating Christianity are apparent also in the decoration of manuscripts. The practice of prefacing the Gospels with a cross is seen in the Coptic Glazier codex written around the year 500. In this device and in its use on book covers the cross was perhaps performing a primitive atropaic or protective function in addition to its celebration as a central element of Christian symbolism. A crucifixion scene appears in an Irish Gospel book at St. Gall, and one was planned for the Book of Kells but regrettably never executed. In the scene of his arrest in the Book of Kells, Christ dwarfs his captors, and his limbs are arranged as if on a cross. Reminders of the crucifixion are featured as minor decorative forms in many pages and in a full cross-carpet page in the Book of Durrow and Kells. Decoratively the opening of the narrative of Matthew's Gospel was given separate treatment with emphasis on the abbreviated Greek form of the name of Christ (Chi and Rho) at its first appearance. The Book of Durrow, the first surviving manuscript to elaborate the Chi, made explicit the association of its shape by the suprascript addition of a cross. In the Book of Kells the Chi occupies the whole height of the page. Amidst the profusion of decoration are symbolic reminders of the eucharistic body of Christ. The otter, the cats and mice, and the butterflies, perhaps representing the cosmological entirety of sea, earth and air respectively, are depicted in this page consuming fish, wafer and chrysalis, which all acted as eucharistic symbols. The fish, very common in the Book of Kells, was in itself one of the earliest christological symbols, and was employed as such in the Chi-Rho page of the Book of Armagh.

Book of Kells, Canon table, fol. 5r ▷

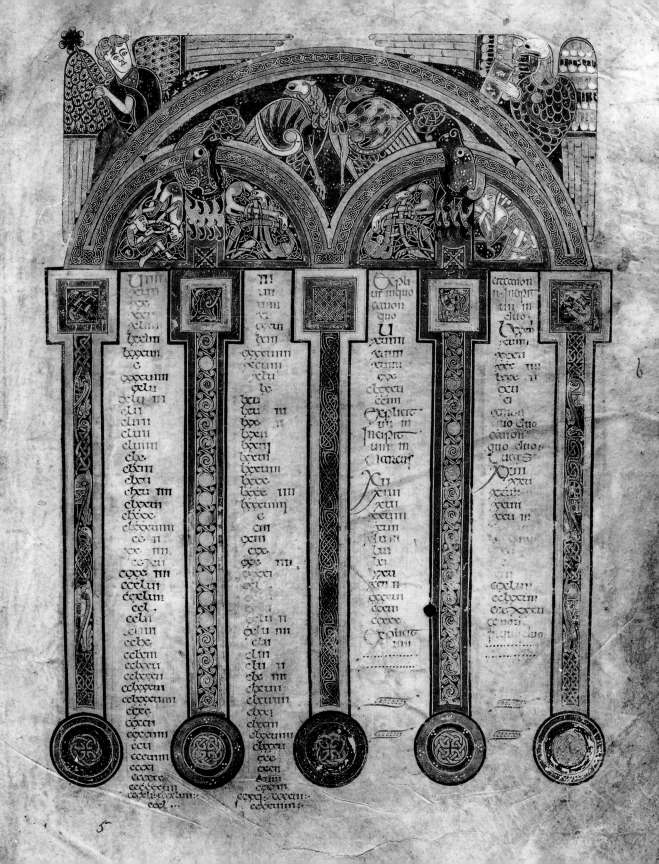

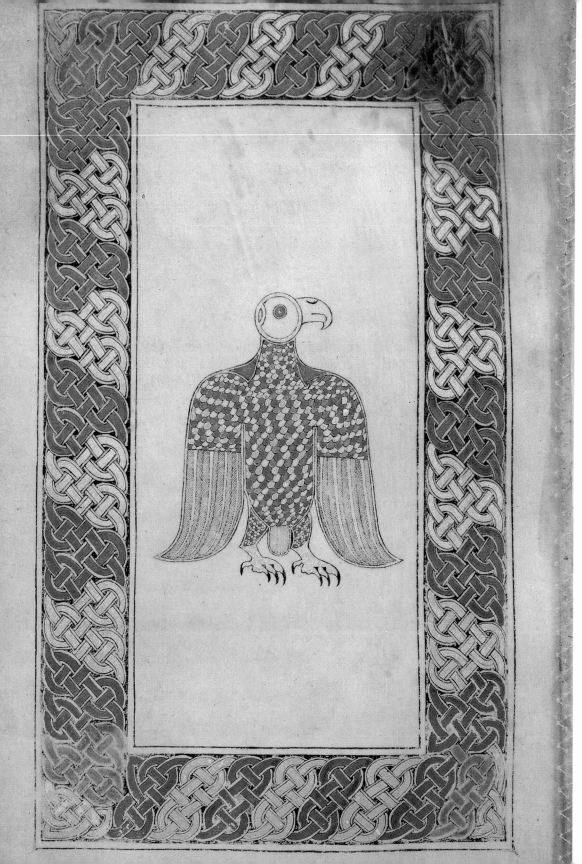

Book of
Durrow, Eagle
Evangelist's
symbol, fol. 84v,
see p. 116

Book of
Dimma, Eagle▷
Evangelist's
symbol, fol. 104v
see p. 132

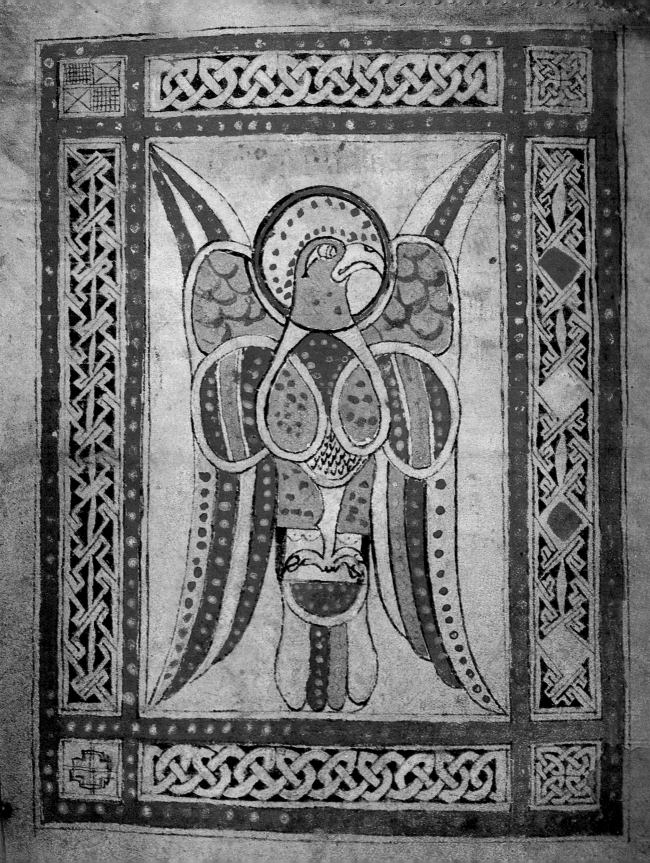

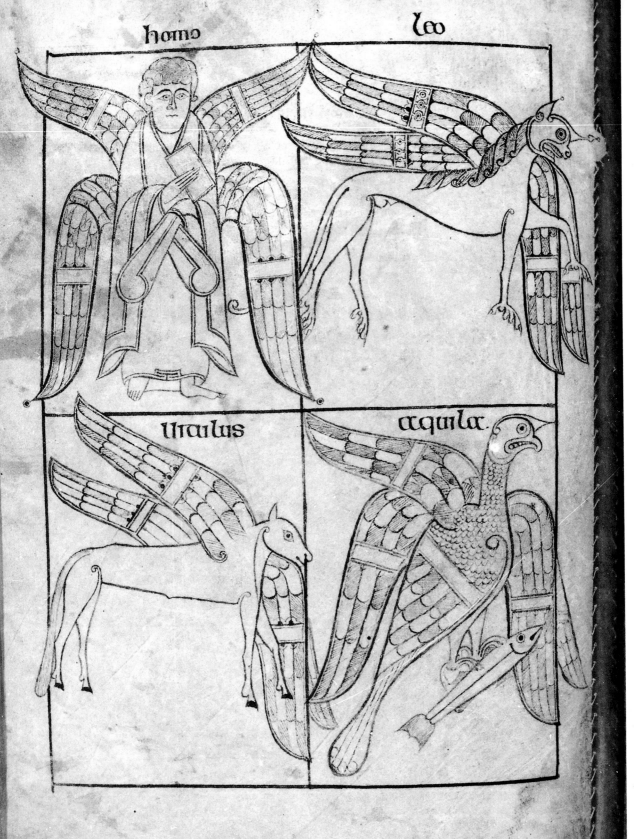

homo leo

uitulus aquila

Book of Armagh, Symbols of the Evangelists, fol. 32v, p. 137

The Chi-Rho page of Kells, which may have taken longer to complete than any other in insular art, is often regarded as the culmination in itself of the whole style. The origins of insular art are subject to continuing debate and controversy. 'Insular' is a deliberately neutral term coined to apply to manuscripts in the style produced not only in Ireland but also in Northumbria and houses in Europe like St. Gall, Bobbio and Echternach where celtic and Anglo-Saxon decorative influences mingled with each other and with iconographic models from the eastern Mediterranean. It is on stylistic grounds that most manuscripts are assigned approximate dates, but lack of comparative material means that attempts to place them in strict lines of descent cannot be definitive. The Book of Armagh is exceptional in the precision with which it may be dated. The Book of Durrow, while the earliest fully decorated insular gospel book extant, is clearly too sophisticated to have been the first produced. Kells, too, which in many ways appears to stand alone, may probably be explained only in terms of manuscripts no longer extant which may have been similar to it. References by Giraldus Cambrensis to a Gospel book he saw in Kildare should be read with this in mind. He has often been thought to have referred mistakenly to the Book of Kells in his description written ca. 1187, but given Kildare's standing as a scriptorium and centre of learning in the eighth century it is conceivable that a manuscript like this could have originated there:

> . . . for almost every page there are different designs, distinguished by varied colours . . . Fine craftsmanship is all about you, but you might not notice it. Look more keenly at it and you will penetrate the innermost secrets of art. You will make out intricacies, so delicate and subtle, so exact and compact, so full of knots and links, with colours so fresh and vivid, that you might say that all this was the work of an angel and not of a man.

How much of this style was original and how much borrowed or adapted from models now lost is open to debate, but it is possible to discern the first extant appearances of certain recurring decorative elements. The characteristic feature of the decoration of the sixth century Gospel book known as *Usserianus primus* (Trinity College Dublin MS 55) is the use of a series of red dots surrounding some of the initials. The device known as 'diminuendo', by which the letters of decorated opening words are formed in decreasing sizes, appears in the slightly later psalter, the *Cathach*. Interlace patterns developed from late classical models appear in the fragmentary Durham Gospels (Durham Dean and Chapter Library MS A. II. 10) of around the end of the seventh century, where they had a static form. In the Book of Durrow, interlace took on zoomorphic as well as abstract aspects, and all these techniques were confidently integrated with celtic spiral and trumpet patterns and with motifs transferred from jewellery. The influence of metalwork, including work done in the Sassanian empire, was predominant in insular art. In Durrow such influence is particularly to be observed in the remarkable connections between one of the carpet pages and objects found in the early seventh century royal burial at Sutton Hoo in east Anglia; and in the evangelical symbol of the Eagle, whose plumage resembles enamel inlays. Other influences observed in the decoration of Durrow include millefiori glass, to be seen in the tabard worn by the evangelical symbol of the Man, and Pictish stonework. Designs in the carpet pages of Durrow are set against backgrounds, sometimes of blank vellum. Insular art had not yet developed that ambiguity between subject and background soon to be characteristic of the style, evident in the Lindisfarne Gospels and the Book of Kells.

It is in the Book of Kells that the full development of the insular style is reached. Letter forms became animate, with an elastic capacity to expand and contract. The iconographic models used for Kells were clearly various, but appear to derive ultimately from Byzantine sources, probably through Italian, Greek or Coptic intermediaries. The human figures of Kells are depicted in frozen postures, with no sense of movement conveyed even in the scene of the arrest of Christ. The evangelists are portrayed sitting upright; ignoring the books and quills of their occupation they instead fix the reader with an unflinching, almost hypnotic gaze.

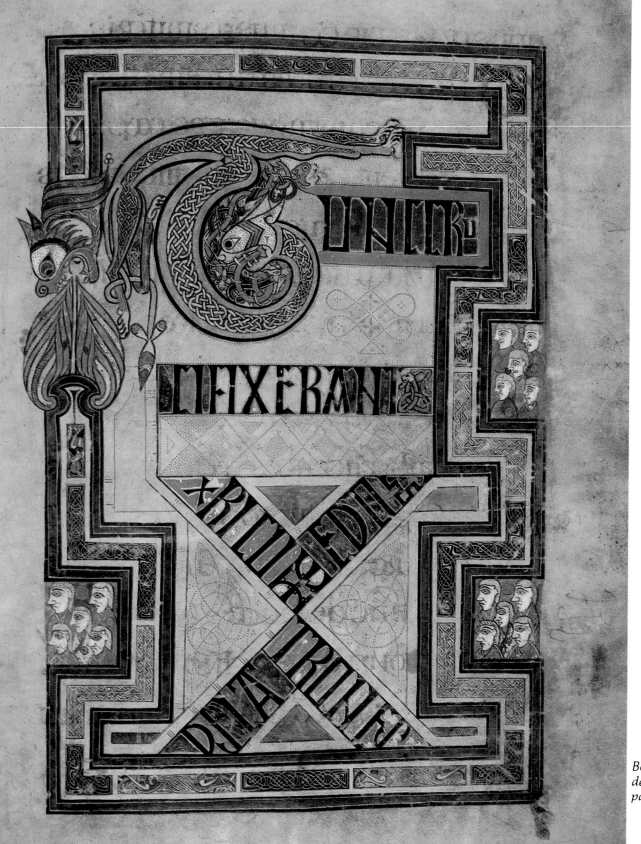

Book of Kells decorated text page, fol. 12

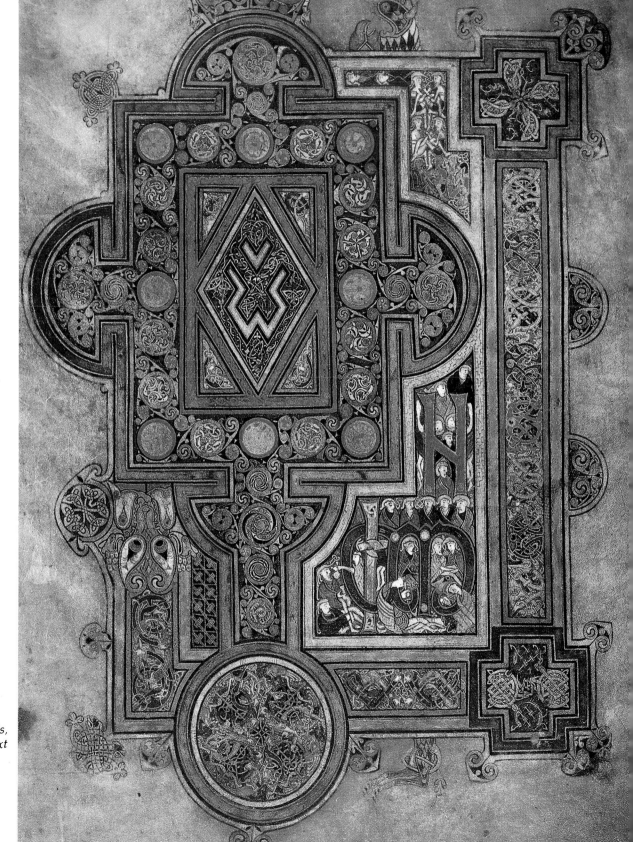

Book of Kells, decorated text page (Quoniam), fol. 188r

Viking and Romanesque Influences 1000 A.D. - 1169 A.D.

Raghnall O Floinn

In the 11th and 12th centuries Ireland began to develop towards a native feudal society, a trend which was however cut short by the Anglo-Norman invasion of 1169. The first Irish coinage was struck in Dublin in 995 by its Norse king, Sitric. The use of coinage and a system of weights and measures was later adopted, albeit on a limited scale, by the native Irish. Coastal towns founded by the Vikings at Dublin, Waterford and Limerick became centres of trade with Britain and the Continent. Contemporary historical records speak also of the presence of streets, quarters and markets at some of the larger inland monasteries but the nature of these 'monastic towns' has yet to be demonstrated by archaeological excavation.

Brian Ború, who fell at the battle of Clontarf in 1014, was the first provincial Irish king almost to succeed in stamping his authority over the whole island. For over a century and a half, others tried unsuccessfully to emulate his achievement. Although none succeeded, what did develop was a gradual centralisation of political power among a small number of provincial dynasties whose wealth and patronage manifested itself in sculpture, metalwork and manuscript painting. There is also evidence at this time for a centralisation of monastic teaching and one can for the first time see the development of centres of craftsmanship in the larger monasteries and coastal towns.

Little has remained above ground of the work of craftsmen based in the Viking towns. No pre-Norman sculpture survives from these centres in contrast to Dublin's political ally, York, perhaps because the arts in Ireland were essentially monastic and the monasteries failed to gain a foothold in the Viking towns.

Patronage of the arts is more publicly marked in the 11th and 12th centuries by the presence of inscriptions on metalwork and stone sculpture recording the names of secular and ecclesiastical patrons, providing - for the metalwork at least - a reliable chronological framework independent of art-historical criteria. Significantly, these inscriptions also regularly contain the names of the craftsmen who executed the work indicating the respected position they held in Irish society - a status which is unusual in European art at this time. Craftsmen seem to have specialised in one medium as the inscriptions clearly distinguish the gold- or silversmith (cerd) from the mason (saer).

There is some evidence that the skills of craftsmen were passed from father to son. Cúduilig Ua hInmainen and his sons made the shrine of St. Patrick's Bell (79b) c. 1100 and the father of Sitric (who decorated the book shrine known as the Cathach) is also recorded as a metal smith and both were based at Kells.

The name Sitric is of Norse origin and the side panels of the Cathach are decorated in the Scandinavian Ringerike style and have been compared to a trial piece found in Dublin (74a). Excavations in Dublin have revealed a wealth of workshop material in the form of trial pieces and crucibles. The quantity of the Dublin trial pieces -over 150 are known - indicate a craft centre of considerable size and demonstrates its importance in the transmission of Viking art styles. A highly skilled group of woodcarvers were also active in Dublin at this time (73).

Little is known about how such centres were organised. The design and decoration of objects such as croziers and bell-shrines are so different, one from the other, despite their numbers, that it is difficult to speak of schools of craftsmanship and design in the way that one can for, say, Mosan or Rhenish metalwork. The occurrence of different styles of animal interlace on the shrine of St. Lachtin's Arm (80) shows the lack of uniform design on a single object. The absence of any form of an iconographic scheme in Irish art of the period is a further hindrance. What we can see are relationships of motifs and techniques between works of art which perhaps suggests the existence of wandering craftsmen as well as the presence of centres of craft production.

These themes can be explored in metalwork. Most of the ornamental objects that survive are reliquaries. The cult of local saints, which was a feature of the Irish church from the earliest times, is manifested by the large number of reliquaries of objects associated with them, such as books, bells and croziers. Less common are relics of the saints' bodies although the arm reliquary of St. Lachtin is

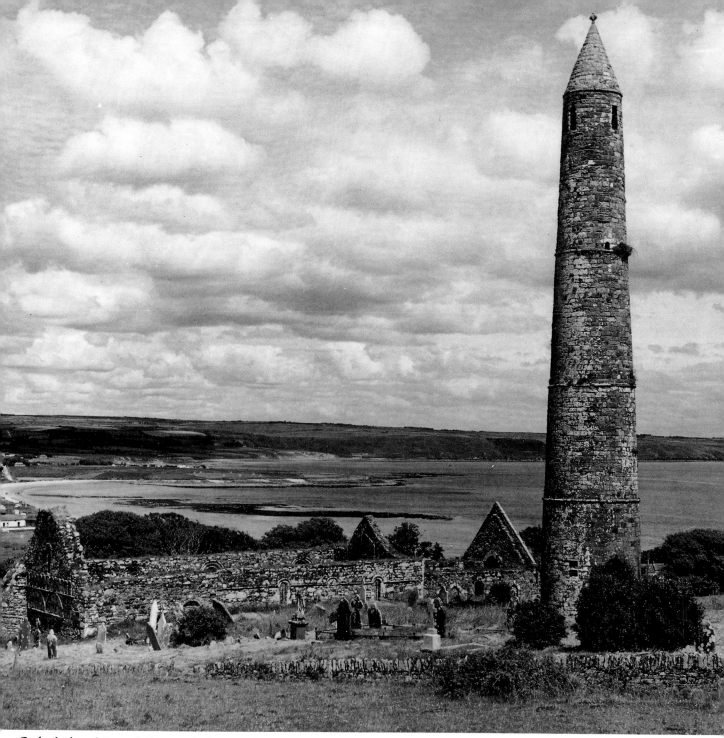

Cathedral and Round Tower, Ardmore, Co. Waterford, 12th century A.D.

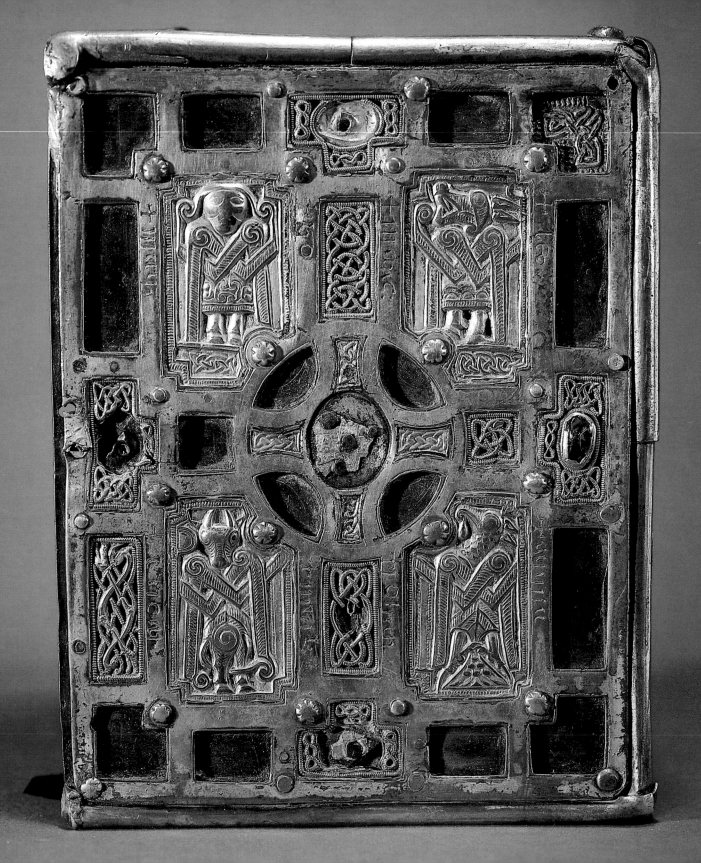

one of a number of such reliquaries known to have existed.

Elaborately decorated objects for secular use are even more rare and are confined to a few fragments of decorated drinking horns. The Kavanagh Charter Horn (89), now covered with mounts of late medieval date, may date from this period, but these horns may have also had a liturgical purpose. The fashion for elaborate brooches and pins came to an end in the 10th century although some highly decorated small ring-headed and stick pins were worn.

Irish book shrines were designed to enclose and protect manuscripts. Book covers are unknown. The books of Durrow and Armagh were enshrined in the 10th century but the earliest complete book shrine to have survived is the *Soiscél Molaise* (75) dated to the first quarter of the 11th century. The Evangelists' symbols on the front are derived from earlier analogues in manuscript painting such as the Book of Kells (54) and Book of Armagh (56). Evangelists' symbols are rare in contemporary Irish manuscripts. The interlaced animal ornament on the *Soiscél* is a development of earlier motifs also but certain traits such as the use of broken contours and the attitude of some of the animals may derive at second-hand from the 10th century Scandinavian Jellinge style. However, Viking styles did not have a major impact on Irish art until the mid-11th century. The pierced silver plaque on the back of the shrine is an element found again and again on metalwork of this period and was inspired by 10th century Ottonian ivories. A renewed interest in foliage as an ornamental device based on the classical vine scroll is seen on the shrine of the Stowe Missal (76) and on a trial piece from Dungarvan (71).

A native pre-Romanesque figure style in metalwork developed in the 11th century, perhaps centred on Clonmacnoise, and is best seen on the Shrine of the Stowe Missal (76) and on a crucifixion plaque from Clonmacnoise (78). It reached its peak on a sadly damaged *chasse* known as the *Breac Moedóic* which is decorated with plaques containing figures of saints and ecclesiastics in arcaded niches. This experiment was short-lived, however, and by the close of the century artists had reverted to the more familiar themes of animal interlace.

The Scandinavian Ringerike style, based on the combination of the motifs of a lion and snake 'in combat' and scrolls and lobed tendrils first appears in Irish art around the mid-11th century, probably transmitted *via*

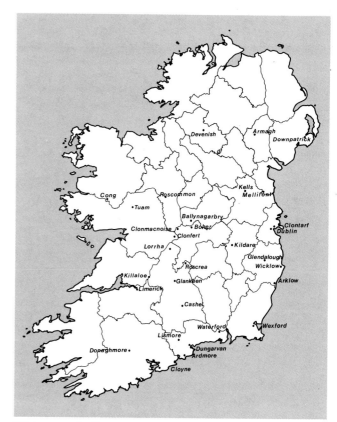

Viking and Romanesque periods, location of sites mentioned in the text

England. Some of the woodwork and trial-pieces from Dublin (73-74) probably stand closest to the original Viking style. In Ireland, the most favoured motifs in this style were animal heads with interlaced moustaches and manes and snakes with ribbon-like bodies of two or three line widths arranged in figure-of-eight patterns as on the crook of the Clonmacnoise Crozier (77). The style is also found on some 11th century Irish high crosses in the west. The Viking towns looked not towards the Irish monasteries as their models for church organisation but to England. Dublin's first bishop, Dunan, was consecrated by the Archbishop of Canterbury and later in the 11th century Limerick and Waterford also submitted to Canterbury, thus focussing England's (and Rome's) attentions on the Irish Church which had diverged through centuries of independence from the Continental model. The most glaring difference was the absence of a proper diocesan structure which led to a multiplicity of bishops and this external interest coupled

◁ Soiscél Molaise' Reliquary, Cat. 75, p. 161

61

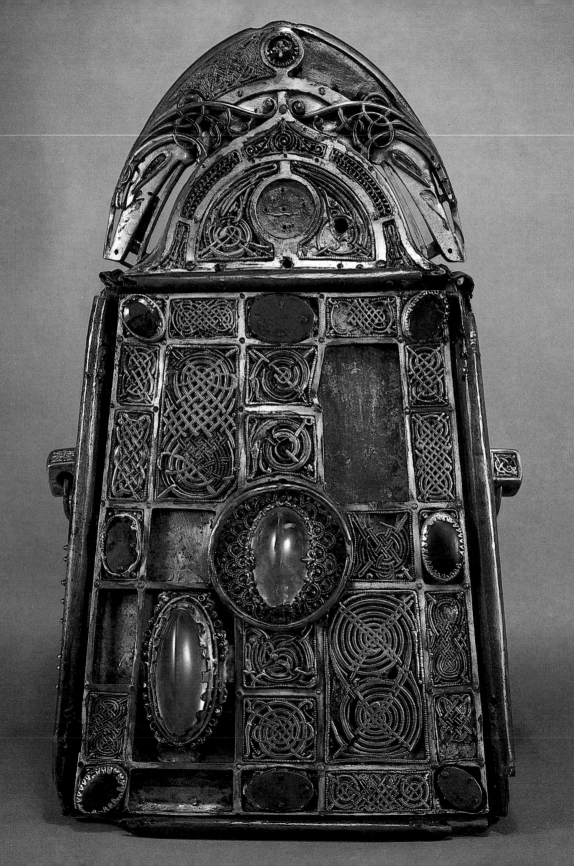

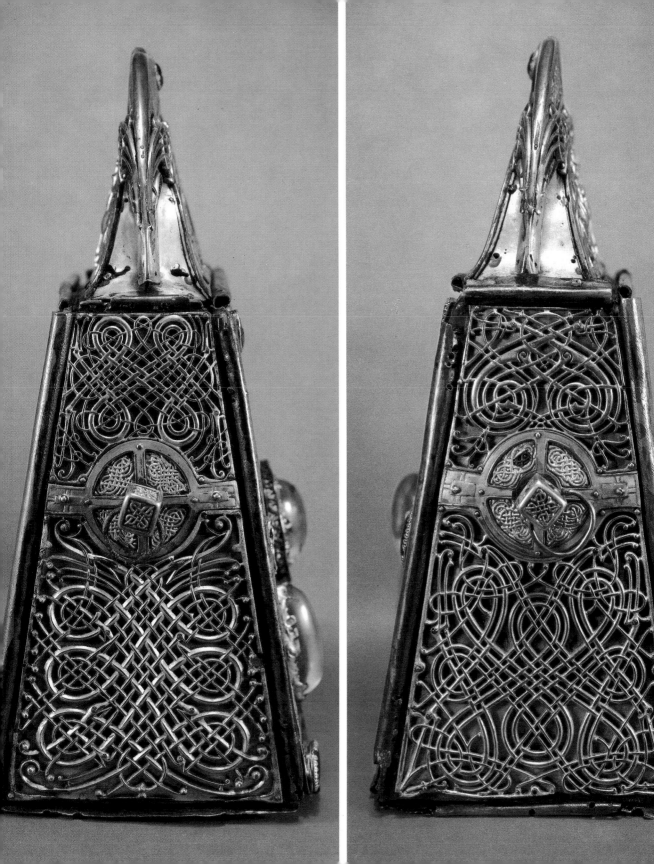

with a growing reform movement within the Irish Church led to a series of church synods which established diocesan centres in Ireland at the Council of Rathbreasail in 1111 and subsequently modified at Kells in 1152. During the period while these reforms were undertaken conflicts must have arisen between rival monasteries to establish claims to the proposed sees. This probably accounts for the large numbers of reliquaries made or repaired at this time. High crosses were once more erected and may have played a part in this inter-monastic rivalry. The elaborate iconographical schemes of the earlier crosses were abandoned, however, and many examples included the prominent figure of a bishop carrying in front of him his crozier as a symbol of his authority. Many of these later 11th and 12th century high crosses are found at the centres of the new ecclesiastical sees such as Cashel, Tuam and Glendalough.

It is perhaps no coincidence that croziers are the most common form of reliquary to have survived from this time. By tradition, they were held to contain the wooden staffs of the early saints. Croziers, along with bells, were regarded as the most intimate of the early saints' possessions. They had the power to work miracles, provide cures and curse enemies and were also used for collecting ecclesiastical revenue and for the administration of oaths. Relics were frequently brought to battle to ensure victory and the battle of Down in 1177 the relics of the North of Ireland were captured by the Norman baron John de Courcy. These included the croziers of Comgall, Argail, Eimhín and Mura, the bells of Patrick, Armagh and Tigearnach and the Book of Armagh.

The reform movement in the Irish Church under royal patronage occurred at a time when elements of the Scandinavian Urnes style were being adopted by Irish artisans. The Irish Urnes style is characterised by an animal interlace less tightly woven but more disciplined than that of the preceding Irish version of the Ringerike style and is based on quadrupeds with attenuated jaws through which thinner thread-like snakes with protruding eyes are woven. Animal heads with elaborately interlaced manes and moustaches occur universally on the terminals of crozier and bell shrine crests.

On many objects, the interlaced animals are composed of strips of silver set against a plain bronze background and are outlined with narrow inlays of niello. Other inlaying techniques became popular at this time including the use of zig-zag gold or silver wires in a niello paste and damascened borders of twisted silver and copper wires sometimes arranged in a herringbone pattern. In the case of the Shrine of St. Lachtin's arm (80), the bronze plates of the forearm are covered in a network of quadrupeds and snakes treated in the Urnes style inlaid in silver and niello so dense that it is difficult to pick out the individual animals. Cast panels of more naturalistic interlaced animals occur on this object which were originally covered in sheets of gold foil held on by 'stitching' - a technique used to greater effect on earlier metalwork of the 8th and 9th centuries to secure panels of gold filigree. The impressed silver panels on the palm of the hand which carry foliage scrolls are perhaps derived from the Romanesque manuscript painting of southern England or France.

The filigree panels on the arm reliquary consist of debased plant motifs and filigree work from this period in general is poor in comparison with earlier work. Filigree of a higher quality occurs on the crest of the Shrine of St. Patrick's Bell (79b) made between 1094 and 1105. The filigree panels of interlaced animals on the front of this shrine are of an unusual complexity being composed of layers of superimposed plain and serrated gold wires which throw the designs into high relief. The bell shrine is also covered with openwork plaques of gilt-silver decorated with sinuous beasts with long thin jaws whose bodies form a series of graceful loops, their eyes picked out with studs of blue glass.

Other objects show a revival of *millefiori* and enamelling techniques not traced on Irish metalwork since the early 9th century. The crest of the Lismore Crozier (81) is set with beads of blue glass inset with chequer patterns of *millefiori* in red and white. Champlevé enamelled plaques were added to the Clonmacnoise Crozier (77) of which only one, situated under the drop, survives. Beads of glass set in gold cloisons are found on the crest of the shrine of St. Patrick's Bell and on other objects, representing the first occurrence of this technique in Irish metalwork.

The enamelled plaques on the Clonmacnoise Crozier consist of palmette and other foliate designs inspired by Continental Romanesque models. More traditional geometric enamelled patterns are found on two of the

◁ *Shrine of St. Patrick's bell, Cat. 79b, p. 167 (sides)*
◁◁ *Front, Cat. 79b*

St. Manchan's Shrine, Boher, Co. Offaly, 12th century▷
A.D. (detail)

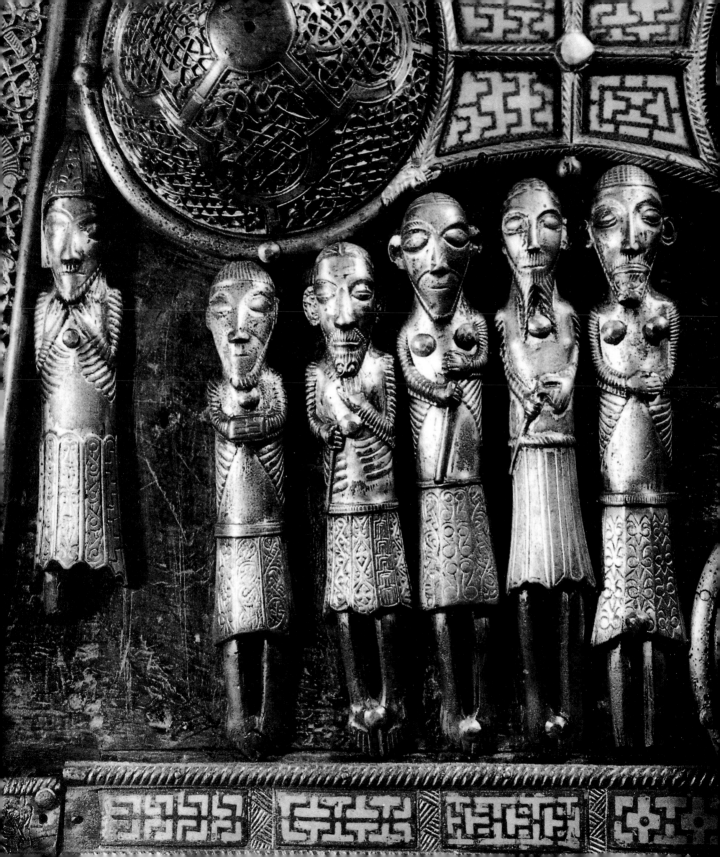

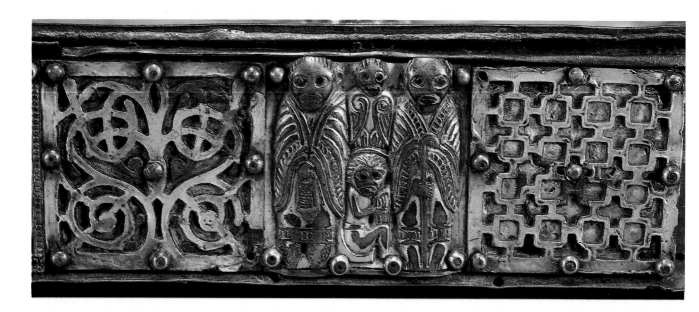

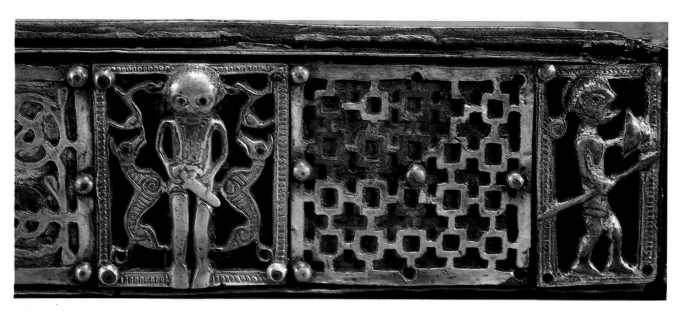

Shrine of the Stowe Missal, Cat. 76, details of the sides

Crozier of Clonmacnoise, Cat. 77, p. 165▷

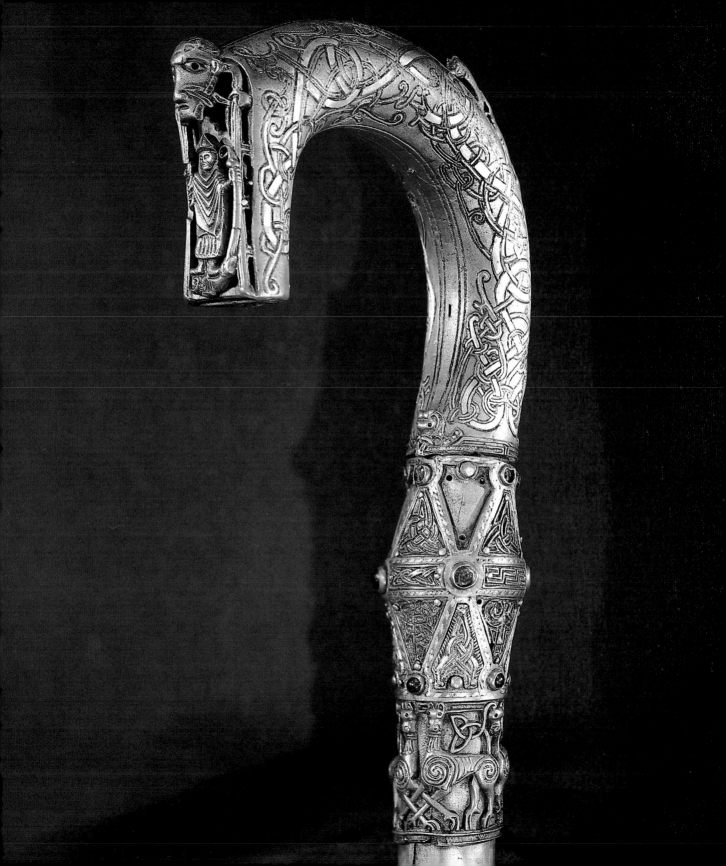

most elaborate shrines decorated in the Irish Urnes style, both made in the west of Ireland - the Cross of Cong and St. Manchan's Shrine. The Cross of Cong is a processional cross made in 1123 at the behest of Turlough O'Connor, King of Connaught - one of the most important political figures of the 12th century - to enshrine a portion of the True Cross (see page 8). Standing some 75cm. in height, it is composed of openwork gilt bronze plates fixed to a wooden core. A domed crystal set in the centre protected the relic and is surrounded by scrolls of silver wire set in niello and panels of filigree scrollwork. The curved outlines of the arms and shaft are accentuated by enamelled studs in yellow and red and the base of the cross is gripped by the jaws of an animal. The openwork plaques contain panels of ribbon-bodied quadrupeds locked in combat with wiry snakes. The individual animals are clearly distinguishable unlike the confused jumble of animals designed by a less competent hand on the back of the Shrine of the Book of Dimma (83). Openwork panels comparable to those on the Cross of Cong adorn the gabled reliquary of St. Manchan preserved at Boher Church, Co. Offaly, which is also covered with full-length human figures perhaps modelled on Romanesque crucifix figures. A related figure is included in the exhibition (84). These objects suggest that a school of competent metalworkers existed in the west of Ireland in the early 12th century. A small number of Romanesque bronze crucifix figures of late 12th century date are known but their simplicity and stylisation indicate an unwillingness for naturalistic representation on the part of the Irish artist.

Full-length human figures are otherwise absent from Irish metalwork of the 12th century apart from the occasional human head on the crests of croziers. On the lowermost knop of the Lismore Crozier (81), however, a panel of human figures with interlocked limbs is an archaic motif whose origins can be traced back to the Book of Kells (54) and to the high crosses of the 9th century. The meaning and symbolism of these figures, if such was ever intended, is not clear. Similar enigmatic figures, perhaps executed by the same artist, occur on a bronze cross from Cloyne, Co. Cork (82).

Manuscript illumination in the 11th and 12th centuries was, by comparison with metalwork, conservative and restrained. The absence of influences from contemporary school of painting such as those at Winchester and Canterbury in England is testimony to the independence and introspection of Irish scribes. Nevertheless, the period is marked by intense literary activity which included the compilation of secular texts - historical annals, genealogies, folklore and poetry. The Welshman,

Sulien, came to Ireland in 1054 to be trained as a scribe and illuminator. His son, Iewan, was responsible for the decoration of the Psalter of Ricemarsh in the Irish style - a manuscript which can be related to other Irish works of the later 11th century such as the Liber Hymnorum, a psalter decorated with initials formed of interlaced animals with foliage ornament based on the Ringerike style.

The decoration of these manuscripts is modest by the standards of earlier work. The translation of the Urnes style combat theme on 12th century manuscript work is much less effective and confident than on contemporary metalwork or sculpture. Figured scenes are lacking and only a few full page illuminations representing the symbols of the evangelists and rendered in an archaic style are known.

Figure sculpture is also notably absent on Irish Romanesque architecture. Prior to the 12th century, Irish church architecture was of the most rudimentary design consisting of a plain, rectangular oratory sometimes with chancel attached. It is generally agreed that Ireland's first Romanesque building was Cormac's Chapel at Cashel, the new metropolitan see for the southern half of the country, dedicated in 1134 and built under the patronage of Cormac Mac Carthaigh, King of Munster (who also commissioned the Shrine of St. Lachtin's Arm (80). It is built in the same modest style as earlier churches with the traditional steeply pitched stone roof. Two small square towers were built on either side of the nave, in contrast to the earlier fashion of building a free standing circular bell-tower to the west of the church. Despite its small size, it was designed on a grand scale with internal and external blank arcading, with chevron ornament, chancel arch of four orders and doorways with carved tympani. Inside, the walls and ceilings were covered with paintings of figured scenes and borders of foliate scrolls. Masons were brought from the West of England and from the Schottenkloster at Regensburg where a member of Cormac Mac Carthaigh's family was abbot.

Cormac's Chapel remains, however, the only truly Romanesque building in Ireland. Elements of the new style were used in other buildings, notably the elaborate doorways with inclined jambs after the fashion of the earlier lintelled doorways. Arches were decorated with rows of human and animal heads instead of the complex iconographical schemes of Continental churches and capitals were used as fields for Irish Urnes style animals and human heads with interlaced hair. Only at Kilteel, Co. Kildare, and at the Cathedral of Ardmore, Co. Waterford, do we find monumental figure sculpture on a grand scale. At the latter, an arcaded frieze with scenes

including Adam and Eve, the Adoration of the Magi and the Archangel Michael weighing the souls set in the west wall betrays western French influences.

The Ardmore arcade was erected towards the close of the 12th century at a time when the more austere architecture of the Continental orders such as the Cistercians was beginning to make its presence felt elsewhere in Ireland. The Cistercians were introduced to Ireland in 1142 by St. Malachy. Monks from Clairvaux established a foundation at Mellifont in Co. Louth and St. Bernard sent the architect Robert to help build the church there which was consecrated with great ceremony in 1157 and at which leaders of the reform movement both clerical and lay were present. Monasteries of regular plan - which contrasted with the irregular multiplicity of small churches on Irish monasteries - were built over much of Ireland in the succeeding decades and by the time of the Anglo-Norman invasion of 1169, 8 Cistercian and no fewer than 63 houses of the Augustinian canons were founded in Ireland.

Romanesque facade relief, Ardmore Cathedral, Co. Waterford, 12th century A.D.

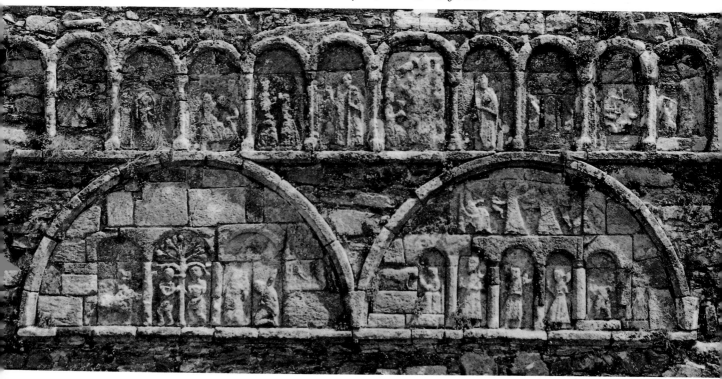

The Norman Conquest and the Later Middle Ages 1169 A.D. - c. 1500 A.D.

Raghnall Ó Floinn

In order to recover his position after losing his lands to his enemies, Dermot Mac Murrough, King of Leinster, sought help from the English king, Henry II. A party of Anglo-Norman knights from south Wales landed on the south-east coast in 1169 and within a year had established control over the province of Leinster and the principal towns of Dublin, Waterford and Wexford. Henry, alarmed at the possibility of his subjects gaining power outside his jurisdiction, arrived in Ireland in 1171 to check this potential threat. When he left the following year he had not only set up a central government on the lines of the Norman administration in England but had received the submission of the Irish bishops and many of the provincial Irish kings.

The Norman barons could now, with royal blessing, extend their possessions and by 1250 two-thirds of the island were under their control with only the north-west remaining in Irish hands. Their military control was strengthened by the building of earthen, and later stone, castles and the permanence of the colony - divided into lordships controlled by the principal barons involved in the invasion - was ensured by the arrival of immigrants from south western England and Wales to work on the land and in the towns. New towns were founded and manorial grants made to attract further settlers. By the end of the 13th century the Norman Lordship of Ireland with its towns and villages, castles and newly endowed abbeys had altered the face of the Irish landscape and the course of Irish art.

At the larger towns such as Dublin, Kilkenny and Waterford, cathedrals in the Gothic style were built in the decades after 1200 designed by masons brought over from the west of England. Modest by European standards, they employed all the elements of the Early English style. At the same time, churches in the Hiberno-Romanesque style continued to be built in the west until the mid-13th century. Nothing survives of 13th and early 14th century goldsmiths' work in Ireland although these new foundations must have been richly furnished. Annalistic references to the enshrining of relics are few in the 13th century - one of the exceptions being the discovery and enshrining of the relics of Patrick, Bridget and Columcille at Armagh in 1293.

By the early 14th century the Anglo-Norman colony was in decline and at the same time there was a resurgence of some of the native Irish chieftains who managed to regain some of their lost territories aided by Scots mercenery soldiers. Some of the established Norman families began to adopt Irish customs and laws and by the 15th century the English administration was effectively confined to a few counties around the capital, Dublin.

This change in the fortunes of the native Irish led to a new spirit of confidence and to a revival of claims to kingship. Ancient symbols of kingship such as the Kavanagh Charter Horn (89) - the only item of regalia to have survived in Ireland - assumed a new importance. The Shrine of the Stowe Missal (76) was refurbished between 1371 and 1381 by Phillip O'Kennedy who styled himself King of Ormond. It is decorated in provincial Gothic style with a jewelled cross composed of twisted silver wires inlaid with basse-taille translucent enamel. The engraved figures in the spandrels owe nothing to earlier Irish art but the lack of a coherent iconography is evident in the choice of subjects. The crucified Christ is shown in one quarter and the figure of the mourning St. John immediately to the right. There is no corresponding figure of the mourning Virgin but, instead, a Madonna and Child are shown in the panel below that of the crucifixion. The figure of a bishop in the fourth quarter may represent either St. Patrick or St. Thomas a' Beckett - one of the few foreign saints to gain a widespread following in Ireland.

The gilt silver plates added to the Domnach Airgid book-shrine (85) by the goldsmith John O'Barrdain in the mid-14th century represent some of the best work of the period. Although similarly confused in its iconographical layout, the panels of apostles and saints have an almost sculptural feeling unusual for the 14th century in Ireland.

During the depressed economic conditions of the 14th century little building was undertaken but in the succeeding century Irish architecture developed its own native style of Late Gothic. Although the forms of rib-vaulting and tracery were archaic by English standards the quality of stone carving was often accomplished.

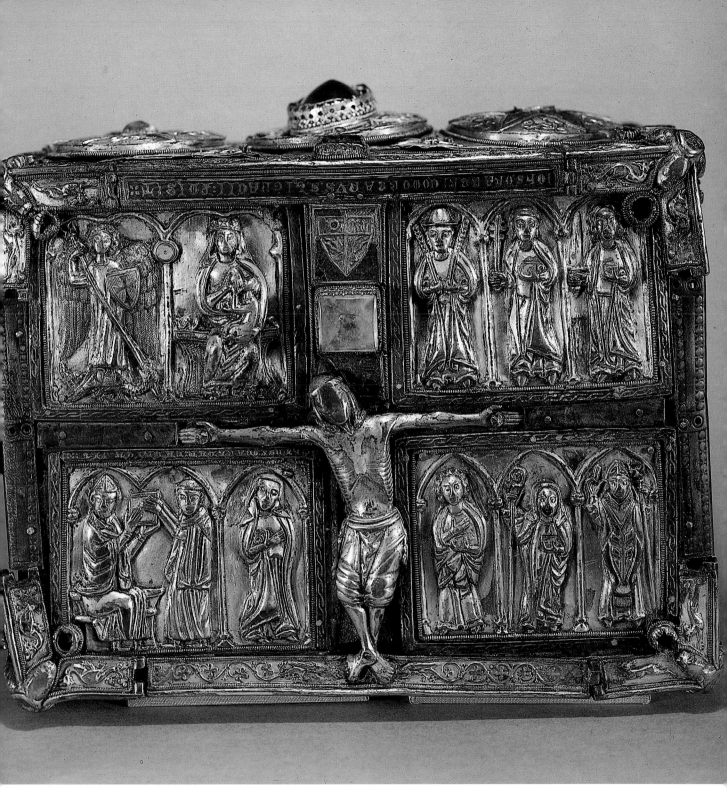

"Domnach Airgid" book shrine, Cat. 85, p. 176

Monastic architecture of the period, with its thick, battered walls and stepped battlements, presents a fortified appearance, reflecting the unsettled conditions of the time. The most accomplished work is to be found in Leinster centred on the Butler territory of Ormond. An accomplished school of tomb carvers under the direction of Rory O'Tunney and his sons existed around Kilkenny in the late 15th and 16th centuries. Figures of apostles and saints adorned the sides of these tomb chests replacing the weepers commonly found on similar tombs elsewhere in Northern Europe.

A distinctive element of Gaelic society in the later Middle Ages were the professional learned classes. Native society had changed little since pre-Norman times and in the absence of universities, education, law and poetry were hereditary professions. That artisans were regarded as part of this privileged class is shown by their frequent mention in the Irish annals. Matthew Ó Maelruanaigh, who died in 1479, is described as the chief artisan and eminent goldsmith of the Maguire family. Irish craftsmen also travelled to Scotland where members of the Ó Cuinn and Ó Brolcháin families contributed to the development of a unique school of carving centred on the monastery of Iona in the 15th century. Elements of this style are to be found on Irish work such as the leather satchel made for the Book of Armagh (86) and on a harp, whose closest analogues are to be found in Scotland (87).

The major influences on Irish Gothic art came, however, from England. A series of alabaster altar panels, produced at Nottingham and Bristol in the 15th century, have been shown to be the inspiration for the decoration of an elaborate tomb at Ennis Friary, Co. Clare. Imported English processional and altar crosses were also the models for the elaborate gilt silver processional cross from Ballymacasey, Co. Kerry (88). The figure of Christ compares well with the best of European Gothic work and the addition of small animals and interlace on the inscribed arms of the cross gives it that uniquely Irish flavour for incidental detail so common on contemporary architecture.

While craftsmen in metal and stone absorbed these new impulses to produce a provincial Gothic style, manuscript painting remained retrospective. Demands for new texts by secular patrons led to a conscious revival of the techniques and motifs of 12th century and earlier manuscript illumination. However, in the intervening centuries, the skills and artistry of the earlier schools had been lost. Decorated initials based on 11th and 12th century manuscripts abound on such compilations as the Book of Ballymote and the Yellow Book of Lecan. An interesting combination of manuscript and metalworking techniques occurs on the Cross of Clogher, a 15th century altar cross which contains openwork geometric panels on the back in the manner of earlier metalwork and around the central boss the words DEUS and AMEN formed from interlaced animals.

The iconoclasm which followed the Reformation in Ireland in the mid-16th century, combined with the wars of the 17th have left few remains of religious and secular art in metal, wood and painting and what does remain comes largely from Gaelic areas where a few objects were preserved by their secular custodians. The portable art of the Anglo-Norman colonists and their successors was almost entirely swept away and two 15th century inventories of the treasury of Christ Church Cathedral, Dublin, serve to illustrate what might have survived. Among the chief treasures are mentioned the celebrated speaking crucifix of Dublin, the *Baculum Iesu* or staff of Jesus - an elaborate crozier reputedly a gift to St. Patrick from Christ himself - and the marble altar of St. Patrick.

These relics were recorded by the Norman chronicler Giraldus Cambrensis in the 12th century. The inventories list other reliquaries including those of the Irish saints Laurence O'Toole, St. Brandon and the bones of St. Patrick and of St. Bridget and also portions of the True Cross, the Cross of Peter, the Chain of St. Peter, the Sepulchre of Our Lord and the Sandals of St. Sylvester. Sacred vestments are mentioned also, including portions of the vestments of St. Olaf of Norway and St. Herbert, Bishop of Cologne.

The reformation heralded a new era of English interest in Ireland and under successive Tudor monarchs the power of the Irish chieftains was broken by superior military force and a policy of planting settlers of English and Scots origin in the annexed territories. In their wake came a new taste for more austere work in the Renaissance style in which the native Irish were to play no part.

Jerpoint Abbey, Co. Kilkenny ▷

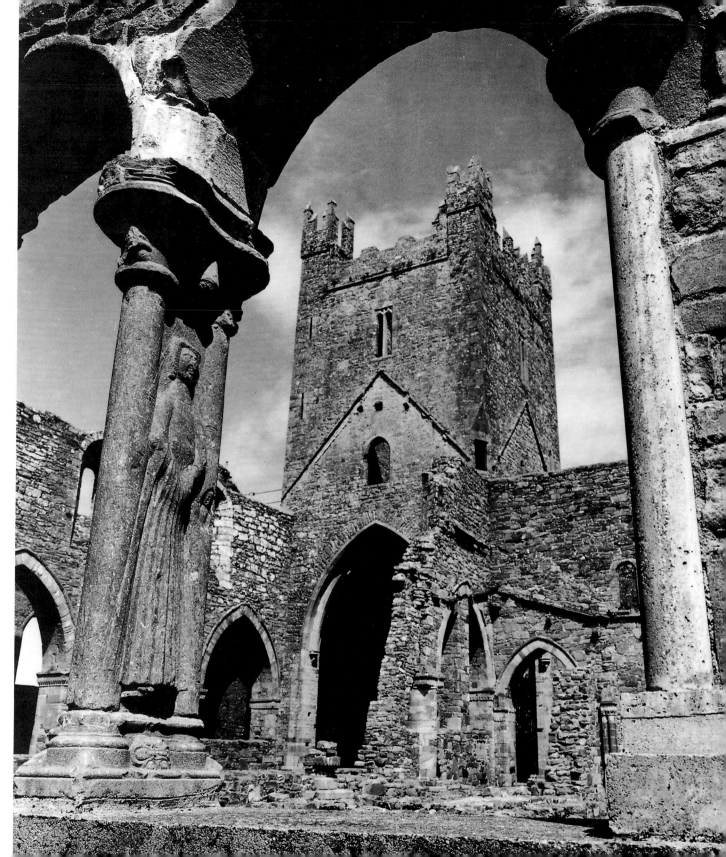

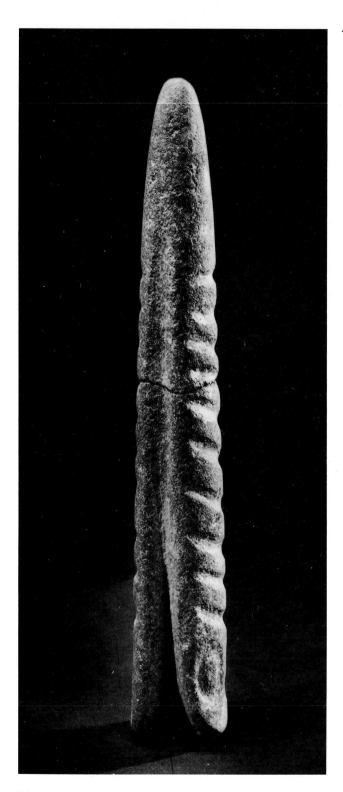

◁ 1　Carved Stone

Knowth, Co. Meath
ca. 3000-2000 B.C.
L. 25.5 cm; Max. W. at base 3.8 cm; W. at point 6 mm.
Refs: Eogan 1974a, 47 - Shee-Twohig 1981, 125-126.

Discovered during the 1970 season of excavations at the passage grave cemetery of Knowth in the Boyne Valley, Co. Meath. Found in a small depression outside the entrance to the great western tomb, under the main mound of the cemetery.
The object tapers gradually from the broader end which is semi-circular in cross-section to a rounded point. On one face it bears a series of transverse arched grooves, slightly slanted to give a helical effect. Close to its broad end, there is also a band of U-shaped motifs. The horizontal course of these decorative zones is interrupted by a deep groove which runs the full length of the opposite face of the object and tapers in width and depth towards the point. A similar object but made of antler or bone, has also been discovered at Knowth (Eogan, 1974a 47). Amongst the finds from passage graves at Tara and Lough Crew, Co. Meath, and Carrowmore, Co. Sligo, are examples of smaller bone pendants of this general shape. There are also distant comparisons with certain chalk idols from passage graves in Iberia (Leisner 1965, 150).
The purpose for which the object might have been used is unknown - it may have fulfilled some ritual function.
N.O'C.

2a　Stone Hammer

Monknewtown, Co. Meath
NMI: 1882:232
Date uncertain, Earlier Bronze Age?
L. 8 cm; Max. W. 4.65 cm; D. of perforation 1.9 cm; Wt. 242.65 g.

Found in a field near the passage grave of Dowth in the Boyne Valley, Co. Meath.
Stone hammer of pestle type, smooth and well polished all over, including the domed ends. The shaft hole is cylindrical and its interior is partly polished. It is made of porphyritic amphibolite, a stone which is not found *in situ* locally (Coghlan 1945, 237).
N.O'C.

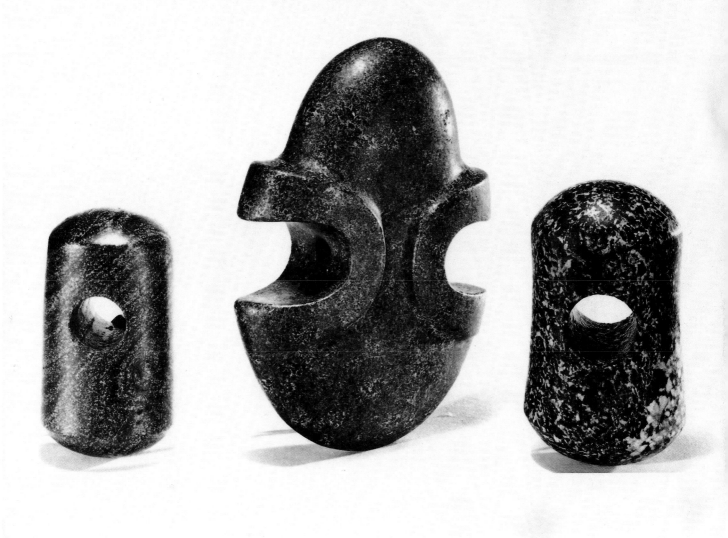

Cat. 2b, c, a

2b Stone Hammer

Unlocalised, Co. Fermanagh
NMI: 1901:44
Date uncertain, Earlier Bronze Age?
L. 7 cm; Max. W. 3.8 cm; D. of perforation 1.5 cm; Wt.
185.5 g.

Find circumstances unknown.
Stone pestle hammer, highly polished, with domed
hammer faces. The shaft hole is cylindrical, highly
polished internally and with sharp clean-cut edges at both

ends. It is made of gneiss which occurs in the west and
north-west of Ireland.
Perforated hammers of different kinds have a widespread
distribution throughout Europe. The tradition of
perforating stone for the production of tools can be
traced as far back as the mesolithic in northern Europe.
The pestle hammer is a particularly accomplished variety
showing a high degree of workmanship. It seems likely
that a bow drill may have been used in making the shaft-
hole with sand as an abrasive. It has also been observed
that some perforations may have been formed by pecking
with a pointed implement.

As is usual in the type, the hammers in this exhibition show no signs of wear - this might support an argument for ceremonial use. It has also been suggested that they may have been used in very fine gold and other metal working. In the case of sheet gold, a high surface polish is necessary on the hammer face in order to achieve a fine finish, as any damage to the tool, no matter how slight, would have been reproduced on the surface of the metal (Maryon 1938, 186).

Pestle hammers and others with cylindrical shaft holes are not well represented in Ireland. None of the Irish pestle hammers comes from a good datable context and most are either unlocalised or unassociated bog finds. However, the finding of examples in the vicinities of Lough Gur, Co. Limerick, and the Boyne Valley, Co. Meath, may be of some significance as both these areas have produced evidence of extensive activity in prehistoric times.

Because of this lack of independent dating evidence, the date of the Irish examples must remain uncertain. There have been some associated finds of pestle hammers outside of Ireland however, which suggest that an Earlier Bronze Age date is likely. N.O'C.

2c Stone Battle Axe-head

Clonmore, Co. Carlow
NMI: 1902:109.
1600-1300 B.C.
Max. L. 11.7 cm; Max. W. 8 cm; W. at central constriction 3.2 cm; Wt. 445.55 g.
Refs: 2a. Coghlan 1945, 237 - 2b. Coghlan 1945, 237-8 -2c. Frazer 1891, Ryan 1975, 135-6.

Discovered at Clonmore Castle, near Rathvilly, Co. Carlow. Stated to have been found under a large stone with a small bronze axe and the shank of a bronze pin (Frazer 1891, 215). Only the battle-axe head survives.

It has a splayed blade and a rounded butt, highly polished all over. There are two opposing concave facets, centrally placed on the narrow faces, each of which is outlined by a regular broad moulding. It is unlikely that this axe was ever intended for practical use - the shaft hole is so narrow that it is difficult to imagine that it could have been strongly hafted. A ceremonial function seems more probable. In addition to Clonmore, 'battle axes' have been found at a number of other sites most often in association with urn burials. At Tara, Co. Meath, for example, a 'battle axe' was associated with a collared urn, a food vessel and a bronze dagger (unpubl.,

ref. in Ryan 1975, 135). Cognate artifacts have also been found elsewhere in Europe N.O'C.

3a Food Vessel

Killinagh, Co. Cavan
NMI: W 13, WK 76
2000-1300 B.C.
H. 9.6 cm; External D. of rim 13.6 cm; D. of base 7 cm.

Richly decorated bowl food vessel, constricted at mid height. Found in 1822, lying in a stone cist according to Wilde (1857, 188).

As is usual with vessels of this type, it is decorated all over with the exception, however, of the base which is plain. There are, in all, five horizontal zones of decoration divided from each other by narrow bands of false relief wavy lines and by the medial constriction. The two broadest zones consist of vertical lines of comb impressions positioned immediately above and below the constriction. On the lower portion of the vessel there are two further bands, one of horizontal comb impressions, the other of vertical. These are bordered above and below by a narrow band of wavy lines executed in false relief. The rim bevel bears a similar but more elongated curved line of false relief work. Just below the rim there is a total of five narrow, alternating bands of comb impressions and wavy bands. The base is heavily carbonised. N.O'C.

3b Food Vessel

Dunamase, Co. Laois
NMI: WK 84
2000-1300 B.C.
H. 12 cm; External D. of rim 14.7 cm; D. of base 8 cm.

Bowl food vessel, of tripartite form. Found with an inhumation in a stone cist near the historic fortress of Dunamase. The finding of a second vessel at the same time was recorded but this has not survived.

The rim bevel is decorated with rows of comb ornament placed horizontally across its width. Just below the rim are three deeply-incised lines. Below this, there is a zone of slanting lines of comb impressions separated from the next zone of oppositely slanting comb impressions by a false relief wavy line. Below this is the first of two

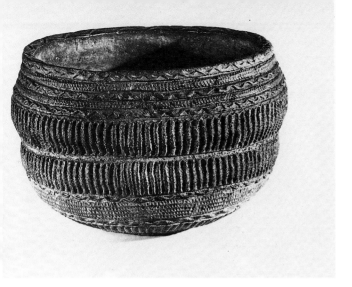

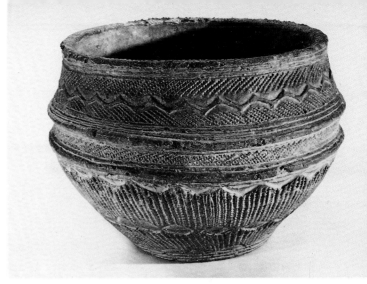

Cat. 3a

Cat. 3b

mouldings delimited above and below by incised lines. The groove between the two mouldings is also ornamented with slanting lines of comb ornament. The lower portion of the vessel is divided into two zones filled with vertically placed comb patterns larger than those used higher up. Above and below these zones there are bands of small lunate panels cut out of the clay. This serves to give a false relief effect to the intervening area. A series of three incised lines encircle the vessel just above the base. The underside of the base is decorated with six chevrons placed at intervals within an outer incised circle.

Bowl and vase food vessels occur frequently in Earlier Bronze Age burials in Ireland and Britain. Variants of the bowl type are somewhat commoner in Ireland. In its classic form, the bowl food vessel tends to be semi-globular in shape with comb-impressed and false relief ornament. The majority have been found in association with burial deposits, both inhumation and cremation and in cists and pits in roughly equal proportions. They have occurred both in isolated burials and in cemeteries -some, perhaps half of the cemeteries, being in mounds or cairns. The reuse of passage grave mounds by Bowl Food Vessel people has been noted at a number of sites, including the Mound of the Hostages at Tara and Cairn K, Carrowkeel, Co. Sligo (Ó Ríordáin 1968, 167). Excavation of unburnt remains has shown that these are usually placed on their sides in a crouched position with the bowl close to the skull. The origins of the bowl food vessel are generally considered to be closely connected with the beaker pottery tradition but some degree of influence was probably also derived from native pottery of the Neolithic. N.O'C.

3c Pygmy Cup

Knocknecoura, Bagenalstown, Co. Carlow
NMI: W 14, WK 72
2000-1300 B.C.
H. 5 cm; External D. of rim 9.35 cm; D. of base 1.25 cm.
Refs: 3a Wilde 1857, 188 - Lucas 1973, 30 and Fig. 9 - 3b Unpublished - 3c Wilde 1857, 179-180 - Lucas 1973, 31 and Fig. 8 - Kavanagh 1977, 80-1.

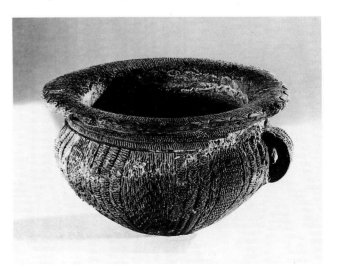

Cat. 3c

A miniature funerary vessel decorated with incised geometric ornament. It was discovered in 1847 during railway construction and said to have been contained originally within a larger vessel, now missing (Wakeman 1903, 148).

The cup has a widely everted rim and a rounded shoulder from which it tapers downwards to a narrow recessed base. It is decorated over the greater part of its outer surface with very finely-incised lines arranged in vertical panels. These panels taper towards the base in sympathy with the outline of the cup. It is the only example from Ireland which bears a handle.

The Bagenalstown pygmy cup is one of about seventy vessels of this type from Ireland. The cups appear to have been designed as accompanying vessels to the larger funerary pots of the period. All but one of the vessels, where burial circumstances are known, were associated with the rite of cremation. The exception is the example from Drung, Co. Donegal (Rynne 1963, 169-79).

The type is almost always associated with other funerary pottery and no example has ever been identified on a domestic site.

Although the pygmy cup is relatively common in both Ireland and Britain, its origins are likely to lie outside Western Europe (Rynne 1963, 175; Savory 1941, 37-48). This example is considered to have Portugese parallels (Kavanagh 1977, 81).

The distribution of the type is concentrated in the east of the country and the midlands. N.O'C.

4 Gold Lunula

Colour pl. p. 17

Ross, Co. Westmeath
NMI: 1896:15
ca. 1800 B.C.
Max. Lateral W. 20.0 cm; Max. W. of collar 6.3 cm; Wt. 40.2 g.
Refs: Armstrong 1920, 56 - Briard 1965, 71-74 - Mitchell 1977, 49 - Raftery 1980, 19 - Taylor 1968, 260-261 -Taylor 1970, 71 - Taylor 1980, 114.

This object was found while ploughing in the townland of Ross, near Lough Ree and was purchased from a Dublin jeweller in 1896.

There are over one hundred recorded finds of lunulae in Western Europe, eighty-one of which have been found in Ireland. Eight finds are recorded from France including the well known Kerivoa and Saint-Potan examples (Briard 1965, 71-74). Thought to have been worn around the neck or in the hair, they are amongst the earliest products in gold of the Irish Earlier Bronze Age. Recent studies (Taylor, 1970) have distinguished three classes of lunulae - the Classical type, which is regarded as superior in execution and design - symmetry in the layout of ornament being a predominant feature; the Unaccomplished type, which uses less metal and is less skilled in treatment and the Provincial type, which is a thicker, more rigid product and displays variations in the decorative motifs and their execution. All of the Provincial lunulae, with the exception of one from Co. Fermanagh, have been found outside Ireland. The decorative elements find their origin in the geometric motifs of the Earlier Bronze Age bronze axes and beaker pottery while the distinctive shape may be derived from other forms of necklace both in metal and stone.

The Ross lunula is of Classical type but because of the breakdown in the symmetrical arrangement of the motifs it falls short of the finest achievements in lunula production. The decoration on lunulae is normally confined to the horns and to the internal and external edges. On the Ross lunula the horns are decorated, with four groups of unequally spaced incised lines with 4 or 5 lines in each group. The outermost line in each group is bordered by a series of triangles some hatched and some plain. Between each two lines, further motifs are inserted which consist mostly of rows of unconnected Vs or of groups of lines varying from 5-8 placed at right angles to the lines which enclose them. These bands of motifs are bordered on both sides by three lines following the curvature of the object, each pair forming a V shape at the terminal. Two of these lines continue along the inner and outer edges of the lunula. On the inside of these two lines a further pair of lines have been incised. Each pair of lines is bordered on both sides by a series of unconnected Vs similar to those described above. The effect is to leave an area varying in width from 2.1 cm to 4.1 cm undecorated. The terminals consist of sub-rectangular expansions at right angles to the body of the lunula. The method of production has been considered by Taylor (1968, 260), who, on the basis of the evidence from the Kerivoa hoard, suggests that they were beaten from a thin bar of gold, the terminals having been produced first. The possibility that the basic shape was cut from a previously prepared sheet must also be noted. M.C.

5 Hoard of Three Gold Lunulae

Banemore, Co. Kerry
Reg. Nos: (a) R1755 (b) R1756 (c) R1757
ca. 1800 B.C.

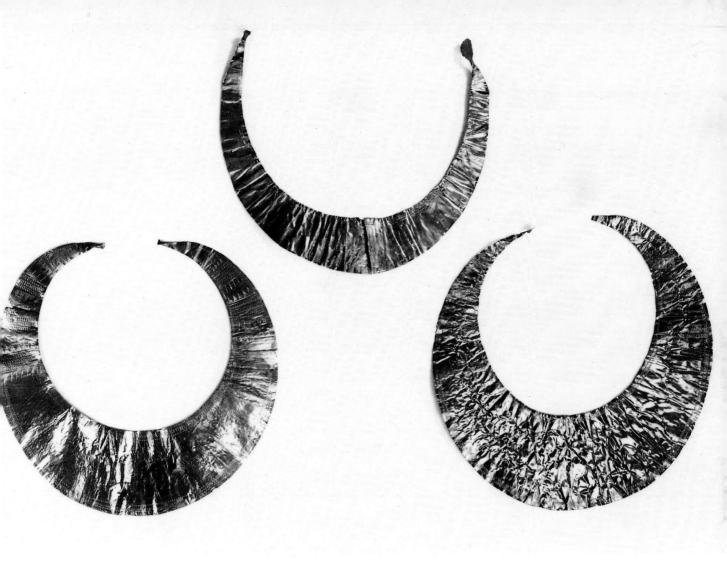

Max. lateral W. (a) 20.1 cm (b) 19.95 cm (c) 18.8 cm;
Max. W. of Collar (a) 6.64 cm (b) 5.83 cm (c) 3.9 cm; Wt.
(a) 46.6 g (b) 41.9 g (c) 30.06 g.
Refs: Coffey 1908-9, 257 - Armstrong 1920, 53-54 -Taylor
1970, 55 - Taylor 1980, 106 - Ryan and Cahill 1981, 22.

This hoard of three gold lunulae was found in a bog in
1864 and consists of two Classical examples (2a and b)
and one Unaccomplished example (2c). Each one has
suffered in antiquity - 2(a), from which one terminal is
missing, is severely crumpled in appearance; 2(b) is in
two parts and both terminals have been cut off; 2(c) is in
two parts; it has had a complete strip cut from its outer
edge and the terminals are damaged. Despite their present

appearance this hoard forms a group, a comparative
assessment of which shows how, with the use of the same
raw materials and the same basic repertoire of motifs, the
two Irish types of lunula are produced. The decoration
on the Unaccomplished lunula 2(c) is inexpertly and in
the same places, crudely executed. The layout of the
design is unbalanced and there are a number of very
obvious errors in the chosen motifs. Lunula 2(a)
conforms in proportions to the Classical type - the
maximum width is 6.64 cm which is within the limits of
the Classical group e.g. the Ross Lunula (No. 4) has a
maximum width of 6.13 cm and the Banemore lunula 2(b)
is 5.83 cm in maximum width. However, when the
decoration on 2(a) and 2(b) is compared in detail it is

clear that the craftsman who made 2(b) was far more experienced and skilled. There are fewer errors in the initial placement of the motifs e.g. the positioning and proportions of the pendant triangles is better and in the hatching of the triangles fewer slips of the graver are noticeable. M.C.

6 Pair of Gold Discs

Colour pls. pp. 16, 17

Tedavnet, Co. Monaghan
NMI: 1872: 34, 35
2000-1800 B.C.
Max. D. (a) 11.3 cm (b) 11.5 cm; Wt. (a) 22.5 g (b) 22.8 g.
Refs: Frazer 1899, 41 - Armstrong 1920, 84 - Mitchell 1977, 49 - Taylor 1979, 237-242 - Taylor 1980, 19, 20, 110 - Raftery 1980, 19.

About twenty examples of discs of this type are recorded from Ireland including six pairs. This pair was found in the roots of an old oak tree and purchased in 1872. There are no reliable recorded associations with objects of this type in Ireland.
The Tedavnet discs, like the others in the group, are made from sheet gold. The decoration, achieved by a combination of repoussé and punching can be divided into two areas. The circumferences of the discs are decorated by a band consisting of two outer continuous raised lines, each bordered by two rows of punched dots within which is a further pair of raised lines enclosing a running zig-zag. The central motif consists of a large cross-shaped device defined by raised lines and rows of punched dots. The cross is encircled by a narrow band made up of similar devices. Between each arm of the cross, positioned diagonally, is a right-angled motif composed of three rows of punched dots alternating with three raised lines.
Two perforations, placed centrally, suggest that these discs may have been attached to some form of organic material such as a textile or leather. M.C.

7 Pair of Gold Earrings

Castlerea, Co. Roscommon
NMI: W63, W64
ca. 1200 B.C.
Max. W. (a) 3.4 cm (b) 3.5 cm; Wt. (a) 19.1 g (b) 18.4 g.

Refs: Wilde 1862, 38, 43 - Armstrong 1920, 38, 87 - Hawkes 1961, 447, 450-453, 459, 473 - Hartmann 1970, 98, 199 - Mitchell 1978, 49 - Taylor 1980, 20, 111 - Raftery 1971, 19.

This pair of gold earrings has been produced by the technique known as flange-twisting. The flanges are made by hammering out the angles of a bar of rectangular section which is then twisted. The terminals are formed by the addition at either end of a biconical bead-like piece to which a shank of circular section has been joined. The shank tapers gradually to the end.
Hawkes (1961, 450-453) sees the development of this type of earring as a response to the strip-twisting technique of the Early Bronze Age in Mediterranean Europe which involved soldering together two angled strips of gold and then twisting them. On the other hand, Taylor (1980, 62) regards the invention of flange-twisting as of purely insular origin and cites chronological and technoligical reasons why this should be so. However, it must be pointed out that in Hartmann's analysis (1970), the metal of this pair of earrings falls into the 'Restgruppe' which is regarded by him as imported. M.C.

8 Gold Earring

No locality, Ireland
NMI: W66
ca. 1200 B.C.
Max. W. 2.4 cm; D. of central disc 1.64 cm; Wt. 14.15 g.
Refs: Wilde 1862, 38 - Armstrong 1920, 38, 87 - Hawkes 1961, 447 - Ó Ríordáin 1955, 168 - Ryan & Cahill 1981, 28.

This type of earring is extremely unusual in Ireland. In appearance it resembles an earring consisting of a centrally placed disc with biconical beads on either side which is known from Near Eastern Early Bronze Age contexts.
An examination of the earring shows that it is composed of up to nine individual components including the two outermost beads which incorporate the terminals, two inner beads on either side of the central disc with a semi-circular moulding between the disc and the bead. All the components have been soldered together. The outer edge of the disc and the adjoining beads have been unevenly milled.
Only one other similar earring is known from Ireland -from Macroom, Co. Cork - it consists of five solid beads on either side of a central disc. However it is much

smaller in size - the maximum width is only 1.6 cm. Biconical beads in sheet gold and stone are known from a number of places in Ireland including seven gold beads from Croghtenclough, Co. Kilkenny and a jet bead from a necklace found in the Mound of the Hostages at Tara, Co. Meath (Ó Ríordáin 1955, 168). M.C.

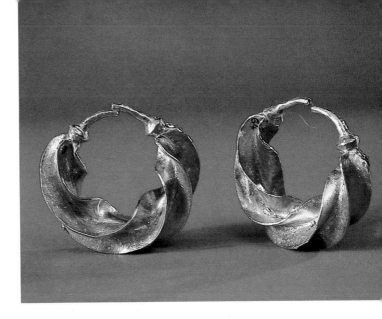

Cat. 7

9 Two Gold Torcs

Tara, Co. Meath
NMI: (a) W173 (b) W172
1200 B.C.
Max. D. (a) 37.3 cm (b) 43.0 cm; Wt. (a) 385.1 g (b) 852.0 g
Refs: Petrie 1832, 156, 157 - Petrie 1839, 181, 182 - Petrie 1841, 274-276 - Wilde 1862, 71-72 - Macalister 1917-1919, 225, 256 - Armstrong 1920, 20-22, 59 - Eogan 1967, 132, 133, 139, 164 - Mitchell 1977, 49 - Raftery 1980, 19 - Taylor 1980, 62, 109.

The exact find circumstances of these two very large gold torcs are not known. However, it is recorded they were found c. 1810 near the monument known as the Rath of the Synods at Tara, Co. Meath. They are of similar type but vary considerably in weight and diameter although the analysis of the gold in both shows them to be of the same composition.

Both torcs are of the four-flanged variety which means that they were produced from square or rectangular-sectioned bars of gold. The heavier torc was made from a larger bar of gold and consequently the flanges are wider. Both are closely and regularly twisted. The terminals, which are more elaborate than is usual for this type of torc, are attached separately to the twisted ends by soldering and are turned back to hook into one another. They consist of a bar of gold of circular cross-section which gradually increases in diameter from 0.85 cm to 1.2 cm over a distance of 9 cms. In the case of 9(b) one of the terminals has been expanded by the addition of a gold bar 21 cm long and 0.7 cm in diameter. It tapers gradually to 0.5 cm in diameter and is attached to a conical knob which has a moulding or collar of semi-circular section attached to its inner end. The terminals of 9(a) are very similar but the expansion rod has been coiled into a spiral which terminates in a similar fashion. These objects form part of a large group of neck, arm and presumably waist ornaments produced by twisting a bar

Cat. 8

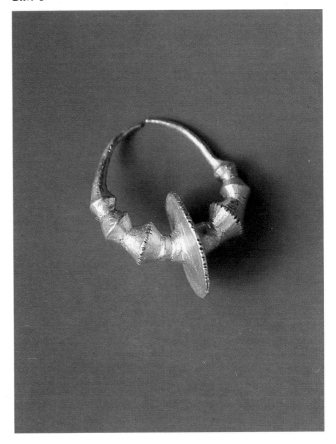

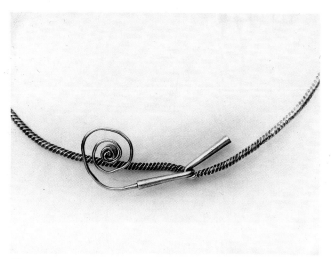

Cat. 9a

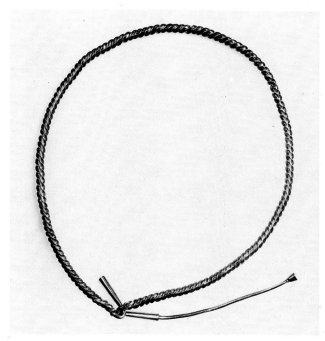

Cat. 9b

rectangular or triangular section is twisted and (2) flange-twisting whereby flanges are hammered out at the angles of the bar and then twisted. While discussion continues (see Cat. No. 7) concerning the precise sources for these influences it is clear that the Irish craftsmen of the period successfully modified the various techniques to produce an amazing variety of twisted ornaments.

M.C.

10 Two Gold Armlets
Colour pl. p. 84

Derrinboy, Co. Offaly
NMI: 1959: 693, 694
1200-1000 B.C.
Max. H. (a) 7.2 cm (b) 7.1 cm; Wt. (a) 69.89 g (b) 67.49 g.
Refs: Raftery 1961, 55-58 - Eogan 1964, 277-280 - Eogan 1981, 359-363 - Mitchell 1977, 50 - Raftery 1980, 20 - Taylor 1980, 20, 51, 53, 59, 110.

These armlets were among a hoard of gold objects which also included a gold necklet, formed by lapping gold wire over a leather thong, two gold tress rings and a piece of copper wire. The armlets are made of fairly heavy gold sheet, the edges of which were turned over to form a raised reinforced border. The sheet was folded into a cylinder, somewhat elliptical in plan, measuring 5.25 cm × 6.3 cm and 5.8 × 6.4 cm respectively.

The main feature of the decoration consists of six raised bands formed of short oval ridges alternating with five plain raised bands. This panel is bordered longitudinally by a V-sectioned ridge with turns at right angles at the narrow ends. A second similar ridge was raised between the last mentioned and the edge. Between these ridges are parallel rows of punched dots.

This style of decoration has been recently discussed in detail by Eogan (1981, 359-363) and has been termed the 'diadem-vessel' style - the broad ribbed bracelets such as these are regarded as the earliest examples of the style. Eogan (1981, 362) further regards the origin of such bracelets as southern British 'with a continental background' rather than a direct derivation from late Unetician sources as discussed by Taylor (1980, 53).

M.C.

of metal with or without flanges. Bar-twisted or cast (mock-torsion) bronze neck rings developed in central Europe under Eastern influence and spread to Britain and Ireland c. 1200 B.C. Two methods were used to produce the twist effect (1) bar-twisting whereby a bar of square,

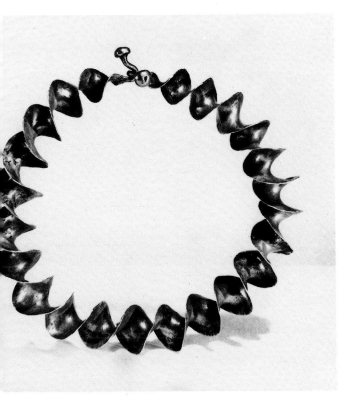

Cat. 11

entry (R2606), as from the neighbourhood of Belfast and was acquired through the same person. However, although it is possible that they were found together, there is no direct evidence for this.

About one hundred and twenty ribbon torcs are known from Britain and Ireland - the bulk of the discoveries coming from Scotland and the northern part of Ireland. Large numbers of ribbon torcs have been found together in hoards e.g. the Inishowen-Largatreany torcs and the Law Farm hoard which seems to have contained over thirty torcs (Coles, 1968). Their origin and date have been the subject of much recent discussion (Coles 1968; Eogan forthcoming; Taylor 1980) much of which has centred on the fact that up to 1978 the main associations of ribbon torcs were other ribbon torcs or material of Iron Age date (see Cat. Nos. 26, 27 and 28 below). Hartmann (1970) had also suggested an Iron Age date on the basis that the gold in the ribbon torcs and the gold in La Tène material in Ireland is derived from a Continental source.

However, the discovery of an untwisted three-flanged torc with a ribbon torc at Coolmanagh, Co. Carlow (Manning and Eogan 1979, 20-27) would seem to confirm that the initial manufacture of ribbon torcs and flanged torcs is more or less contemporary and centres on the late second or early first millenium B.C. M.C.

11 Gold Torc

From the neighbourhood of Belfast, Co. Antrim
NMI: R2607
ca. 1200 B.C.
Max. D. 11.3 cm; Wt. 42.2 g.
Refs: Coles 1968, 163-174 - Manning and Eogan 1979, 20-27 - Taylor 1980, 63-64 - Ryan & Cahill 1981, 26 - Eogan, forthcoming.

This type of torc was produced from an ingot of gold beaten out into a strip or ribbon c. 1 mm thick and subsequently twisted. The hammer marks are very noticeable. The original register entry describes the torc as being 'in two parts', however, there is evidence that it may have been broken in four parts and subsequently repaired. The ribbon narrows towards the terminals, becoming a bar of round cross-section. The ends are capped with small knobs. Another, very similar but larger, torc is described also, in the preceeding register

12 Gold Dress-Fastener

Colour pl. p. 20

Clones, Co. Monaghan
NMI: IA/L/1963:1
ca. 700 B.C.
Overall W. 21.2 cm; Max. D. of terminals 10.2 cm and 10.6 cm; Wt. 1,031.5 g.
Refs: Stubbs *et al* 1892, 173 - Hawkes & Clarke 1963, 220-235 - Eogan 1964, 302 - Powell 1973-74, 5 - Mitchell 1977, 50-51 - Raftery 1980, 20 - Taylor 1980, 66-68, 109.

This, the heaviest of all Irish gold dress fasteners, was found in 1820 and purchased by Trinity College. It is now on permanent loan to the National Museum of Ireland. The general shape of the object is similar to the majority of the dress fasteners of the same type but it excels in the quality of its decoration and in the quantity of gold used in its manufacture. It consists of a 'bow' or 'handle' with two terminals which expand evenly from the extremities

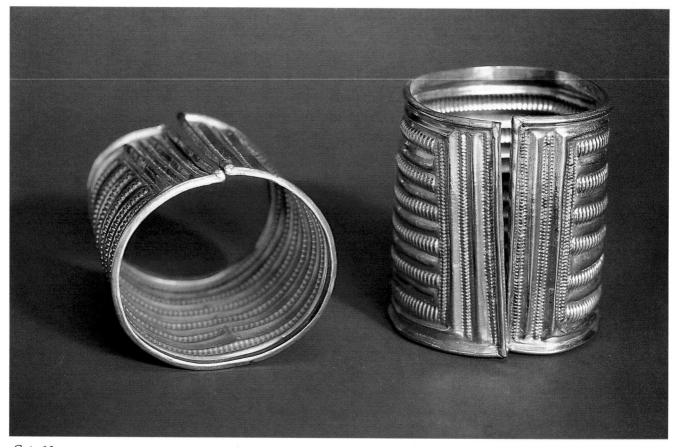

Cat. 10

of the bow and which are usually hollowed or dished. Dress fasteners were produced in a number of different ways including the casting of the whole object, the casting on or fusing (Cat. No. 18a) of the terminals to the bow or thirdly, the forming of the bow and terminals from a single sheet or bar of gold (Cat. No. 18c and 18d). The bows may be solid or hollow.

As in this and many other examples the edges of the terminals have been finished and strengthened by hammering up a slight flange. Immediately inside the edge internally and externally are two and three concentric raised lines respectively. A row of hatched triangles is incised against the innermost rib on the underside. The upper surface of the terminals is decorated by an all-over pattern which utilizes a single motif, consisting of a punched dot set in a series of concentric circles. The bow is plain except for an area

near the junction with the terminals which is decorated with rows of parallel and oblique lines bordered by a double zig-zag. The upper surface of the bow is decorated by three randomly-placed hatched triangles which in comparison to the other decoration are very inexpertly executed.

Although the subject of much discussion regarding their origin and development (Eogan 1964, 302, Hawkes and Clarke 1963, 220-235, Taylor 1980) these fibulae are generally regarded as an Irish adaptation of the well-known fibulae of northern Europe which functioned with the aid of a pin. The Irish examples may have been used to fasten a garment by means of a double button hole or by using opposed loops (see illustration, Hawkes 1963, 222). It is clear that, whatever their purpose, objects such as the Clones example were not subjected to everyday use.　　　　　　　　　　　　　　　　　　　　　M.C.

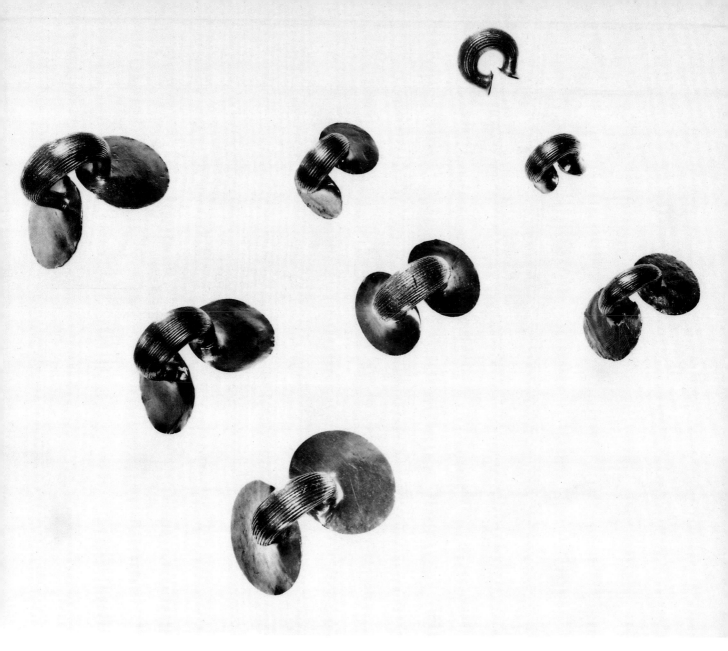

13 a-h A Group of Eight Gold Dress-Fasteners

No locality except 13(b) from Innismore Isle, Co. Fermanagh
NMI: (a) P823 (b) R1859 (c) R4044 (d) W125 (e) W126 (f) W128 (g) W130 (h) W131.
ca. 700 B.C.

Refs: Wilde 1862, 63, 65 - Armstrong 1920, 65-67 - Eogan 1972, 189-210 - Ryan & Cahill 1981, 33.

These small dress fasteners consist of an approximately semi-circular body to which two discs are attached. The method of manufacture is variable and may combine the casting of the body with the soldering on of the discs or the discs may be cast in one piece with the body to be expanded and finished by hammering. Some hollow

examples were made by forming the sheet gold round a tube and soldering along the inner edges. In all of them the outer curve of the body is decorated with a series of deeply incised parallel scores. These lines end somewhat short of the junction of the bow and the terminal disc, this area being decorated with a panel of cross-hatching delimited on each side by two or three incised lines. The terminals, other than 13 (a), are undecorated. 13(d) and 13(e) differ from the rest of the group in that the discs are unexpanded. They have been cast in one piece and it is possible that they are unfinished.

These objects are peculiar to the Irish Late Bronze Age and seem to represent the efforts of goldsmiths to produce a smaller, more efficient fastener than the earlier fibulae (see Cat. Nos. 12, 15) from which they must have developed. A number of them have been found in hoards of Late Bronze Age material including one undecorated example from the Gorteenreagh hoard which also included a gold collar and two gold hair-rings (see Cat. No. 22). M.C.

14 a-c A Group of Three Small Gold Penannular Rings

No locality
NMI: R4036, R4038, W137.
ca. 700 B.C.
Max. span of body (a) 1.83 cm (b) 1.28 cm (c) 1.25 cm;
Wt. (a) 9.1 g (b) 5.2 g (c) 4.0 g.
Refs: Armstrong 1920, 68 - Eogan 1972, 190, 208-209 -Taylor 1980, 68, 116, 117 - Ryan & Cahill 1981, 34.

These objects resemble the previous group (13 a-h) in many ways. However, they do not possess the terminal discs and there is no evidence to suggest that they ever did. The execution and placement of the decoration is similar also but it is more difficult to suggest a function. An attempt had been made to saw off part of the end of 14(a); 14(b) also appears to have been tampered with.

About fifteen similar rings are recorded from Ireland (Eogan 1972, 208-209) most of which have no provenance. While they have been regarded as unfinished dress fasteners it has also been suggested that they may have served as some form of currency or hair ornament.
 M.C.

Cat. 14

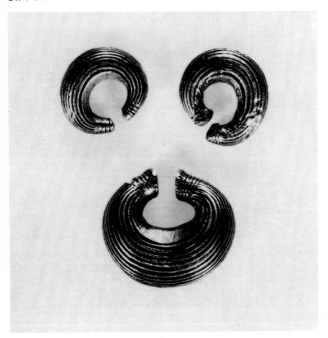

15 Gold Dress Fastener and Wooden Box

Killymoon Demesne, Co. Tyrone
NMI: 1967: 234, 239 a-b.
8th to 7th century B.C.

Dress fastener: Max. W. 9.6 cm; Max. D. of terminals 3.8 cm; Wt. 102.9 g - Box: L. 21.4 cm; W. 10.2 cm; H. 7.0 cm - Recess: L. 9.8 cm; W. 9.0 cm; Depth 5.5 cm - Lid: L. 19.5 cm; W. 6.8 cm; H. 3.55 cm.
Refs: Armstrong 1920, 33 - Raftery 1970a, 169-174 - Taylor 1980, 113.

This gold dress fastener was found in the accompanying wooden box in the early nineteenth century. The box, which is made of alder, is of very simple construction being carved from a single piece of wood. The box and lid are now somewhat warped and shrunken but it is still possible to see the tool marks and the recesses in the bottom of the box made to receive the terminals of the dress fastener.

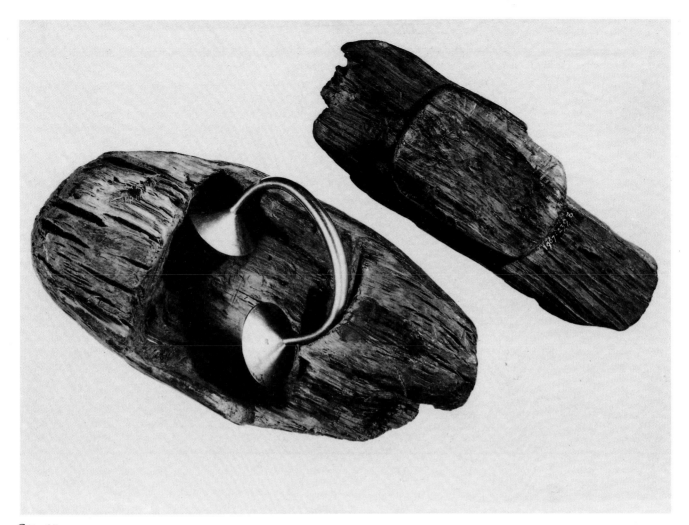

Cat. 15

The gold dress fastener was made from a solid bar of gold of circular cross-section. It is difficult to ascertain whether or not the terminals were attached separately or were made in one with the bow. The edges have been reinforced by the raising of a low flange. Although well finished some crease-like flaws are visible on the upper surfaces of the terminals. These are due to inadequate polishing. There are several recorded examples of gold objects found in rather crude wooden boxes including a lunula from Crossdoney, Co. Cavan and a gold dress fastener and three gold bracelets from Kilmoyley North, Co. Kerry. M.C.

16 Gold-Foil Covered Lead Bulla

Bog of Allen, Co. Kildare
NMI: W265
700 B.C.
L. 6.4 cm; W. 5.6 cm; H. 2.6 cm; Wt. 146.9 g.
Refs: Petrie 1832 b, 180 - Wilde 1862, 85-86 - Armstrong 1920, 43,92 - Armstrong 1922 a, 133-135 - Taylor 1980, 66, 115 - Ryan & Cahill 1981, 36.

This heart-shaped bulla consists of a lead core covered by a sheet of thin gold foil. The gold foil was impressed with

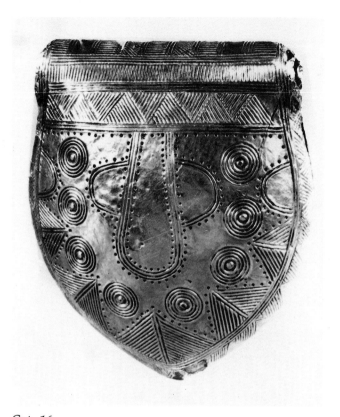

Cat. 16

Two forms of bulla are known from Ireland - the heart-shaped form of which five examples exist and the penannular ring type such as the examples from Killyleagh, Co. Down. Their purpose is unknown, nor it is known from what or where they developed as no prototypes exist. The core of the River Bann example (Armstrong 1920, 43, 92) was analysed in the late 19th century and was suggested to be blood, whether human or animal is not known.

M.C.

17 Two Gold Boxes

From near Mullingar, Co. Westmeath
NMI: 1884: 8, 9
ca. 700 B.C.
Max. D. (a) 5.8 cm (b) 5.6 cm; Wt. (a) 18.7 g (b) 15.95 g.
Refs: Armstrong 1920, 89 - Lucas 1973, 34 - Eogan 1981, 347-348 - Ryan & Cahill 1981, 35 - Ryan, forthcoming.

the design. The top of the bulla is provided with a transverse perforation by which it is possible to suspend the object.

The motifs consist for the most part of chevrons, triangles, U-shapes, concentric circles, cross-hatching, groups of vertical and horizontal lines and rows of dots. On one surface the juxtaposition of U-shaped motifs, outlined by dots gives the impression of an anthropomorphic representation. The main feature of the other surface is a large V-shaped area filled by rows of lines, hatched triangles alternating with plain bands. The top of the bulla is covered with bands of horizontal and vertical lines interspersed with plain areas and panels of cross-hatching, while the sides are covered with hatched triangles.

These two boxes are very similar in manufacture and design and differ only slightly in dimensions. In their original condition each box consisted of a cylinder of sheet gold closed at both ends by a tightly fitted decorated disc.

Both have suffered in antiquity - one box is now open at one end and one of the discs of the other has been torn. The cylindrical components measure 5.8 cm and 5.6 cm in diameter and 2.56 and 2.6 cm in height respectively. The strip of gold sheet was decorated by punching a continuous line from the back about 5.2 mm in from each edge. The two ends were sweated together and no trace of the join can be seen on the outer surface. An average of 2mm of the raw edge was then turned to the outside of the cylinder.

The decoration of the discs is identical and consists of a centrally placed conical boss set in series of ten concentric circles, bordered by an outer circle, the space between filled with radial lines. Nine conical bosses each at the centre of a series of seven concentric circles enclose the central motif. Outside these are two concentric lines accentuated at regular intervals by milling. The raw edge of the disc was turned in like a hem. This is fitted under the out-turned raw edge of the cylinder and pressed tightly against the side. In this way the assembly of the box is completed and it cannot be opened except by prising off one of the discs.

Three other similar boxes are known, one pair with an unknown provenance and one single find from Co. Kerry (Ryan forthcoming). Their purpose is unknown but they may have held some organic substance. The choice and placement of the decorative motifs is very similar to the discs which form the terminals of the collars such as that from Gleninsheen (Cat. No. 21). The production methods - the overlapping of the edges to form a bond is also paralleled in many of the collars. M.C.

Cat. 17

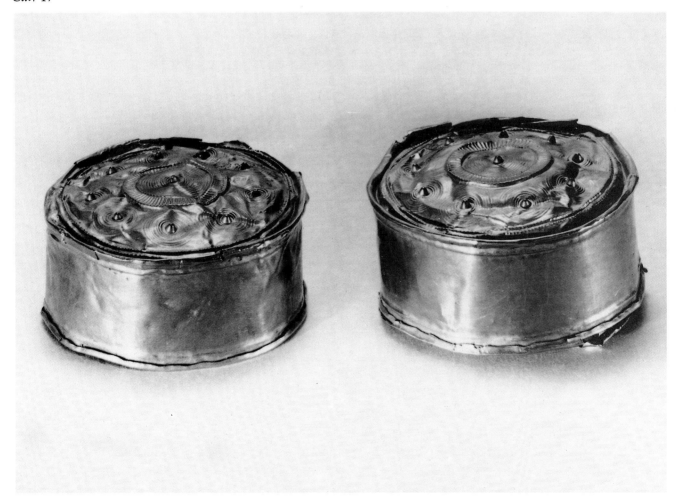

18 a-e A Hoard of Gold Ornaments

From a river in Co. Waterford, near New Ross
NMI: 1896: 1-5.
8th to 7th century B.C.
Max. W. (a) 9.5 cm (b) 15.1 cm (c) 8.0 cm (d) 6.8 cm (e)
8.1 cm; Wts. (a) 548 g (b) 148.3 g (c) 60.07 g (d) 64.1 g (e)
42 g.
Refs: Frazer and Johnson 1893-96, 776-783 - Armstrong
1920, 31, 70, 72 - Eogan 1964, 302, 304, 348 - Taylor
1980, 113 - Ryan and Cahill 1981, 30.

This hoard of five gold ornaments was found in 1895 in a
river. It consists of a fibula or dress-fastener (see Cat. No.
12, 15) and four penannular bracelets with inclined
hollow terminals. The group is of interest as it consists of
solid and hollow objects and illustrates how through the
use of different techniques, similar types could be
produced.
The fibula (18b) consists of a solid bar which gradually
thins out from the centre. The terminals appear to have
been sweated on in a partially prepared state and then
hammered out to required shape. The edges of the
terminals were folded back to form a reinforced
moulding. Inside this moulding are two raised lines which
must have been produced by chasing.
The bracelet (18e) has been made in exactly the same
way. The terminals vary in that the outer and inner
surfaces have been decorated with raised bands. The
third solid object is 18a. It is also the heaviest of the
group. The method of manufacture does not differ
greatly in that the terminals have been attached to the
ends of the bar by sweating. The edges of the terminals
have been strengthened by the addition of a strip of gold
which has been bent over to grip the upper and lower
surfaces of the terminal. Internally the rims of the
terminals are decorated with a panel of cross-hatching
executed after the fixing of the rims in place. The external
surface of the terminals is decorated with seven pendant
triangles bordered by a panel of cross-hatching on the
bow.
The two remaining bracelets (18c and 18d) are hollow
and were made from a single piece of sheet gold
hammered to the required shape, bent over to form the
bow and terminals and then sweated together. The seams
which were not sufficiently polished to obliterate them,
are continuous along the bow and terminals. The
terminals of one hollow bracelet are decorated internally
and externally with a band of five raised lines which,
from a slight descrepency in their alignment, indicates
that the sheet was decorated before being shaped.

Although the decorative elements of three of the objects
(18, a, d and c) are similar it seems unlikely that this
hoard represents a collection of personal jewellery in the
same way as the Gortreenregh hoard (see Cat. No. 22)
does. The large bracelet, if it is such, had obviously been
used over a considerable period of time as the decoration
on the bow and terminals is completely worn on the
upper and lower surfaces. It is difficult to suggest how
this wear was caused - if worn as a bracelet or used as a
dress fastener the wear would be expected to occur on
and in the inner and outer areas, respectively. The
remaining objects show little sign of wear and this may
indicate that some of the objects are slightly later in date.
M.C.

19 Gold Collar
Colour pl. p. 100

Mooghaun, Co. Clare
NMI: W26
8th - 7th century B.C.
Max. lateral W. 161 cm; Max. W. of collar 4.8 cm; Wt.
200 g
Refs: Wilde 1862, 33, 34, 41-42 - Armstrong 1917, 21-36 -
Armstrong 1920, 58 - Eogan 1964, 306, 335 - Raftery
1967, 68-71 - Lucas 1973, 39 - Raftery 1980, 20 - Taylor
1980, 100.

This type of collar is made from a heavy sheet of gold
which expands evenly from the terminals towards the
centre. It varies from 0.8 cm in width, just inside the
terminals to 4.8 cm at the centre, when flat. The ter-
minals are solid, flattened oval in plan and measure 1.15
\times 1.0 cm. The sheet was gradually bent inwards to form
a C-shaped cross-section. The area just inside the ter-
minals is decorated with a pattern of incised lines parallel
to the body of the collar and edged by two sets of lines
placed at right angles. The central part of the collar is
decorated on the inner edge only by seven hatched trian-
gles. The decoration is very worn and barely visible in
some places.
It is one of six similar collars found in 1854 during the
construction of a railway. They formed part of the largest
hoard of gold objects ever found in Europe. Although
only 26 original pieces survive, 13 in the National
Museum of Ireland and 13 in the British Museum, it has
been calculated that the hoard consisted of 150 individual
items, the majority of which consisted of penannular
bracelets with solid, evenly expanded terminals. The bulk

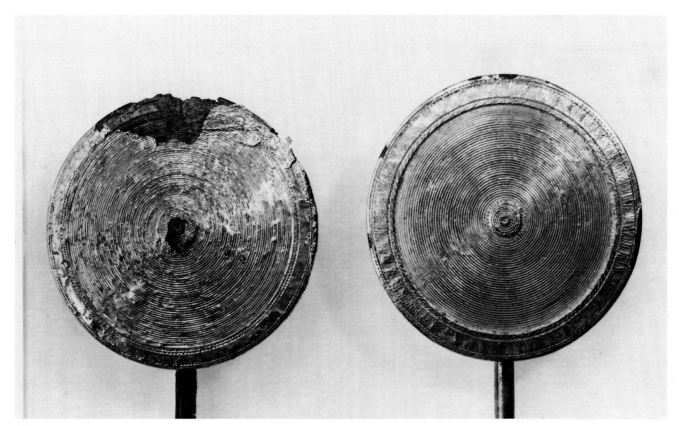

Cat. 20

of the hoard was melted down but some casts and drawings of the lost objects exist.

The six Mooghaun collars are the only examples of this type known from Ireland. The development of this form of collar can be seen as a further indication of the contacts between Ireland and northern Europe where gold collars of similar shape are known at this period.

<div align="right">M.C.</div>

20 Two Disc-Headed Pins

Ballytegan, Co. Laois
NMI: 1967: 2, 3
8th to 7th century B.C.
Max. L. (a) 19.2 cm (b) 19.8 cm; D. of discs (a) 5.9 cm. (b) 6.0 cm
Refs: Raftery 1970 b, 87, 94-96 - Eogan 1974 b, 87, 95-98 - Ryan & Cahill 1981, 39.

These two gold foil-covered disc-headed pins (also called sunflower pins) resemble one another very closely in both the details of their manufacture and decoration. They differ somewhat in overall length and there are some variations in the application of the decorative motifs.

The pin and head were produced separately; the pin being bent at right angles and fixed to the head. The disc head is convex in front and concave at the back and has a slightly raised edge. Along the circumferance of the disc is a narrow groove into which the gold foil has been fitted tightly.

The main decorative feature is a series of fine concentric grooves set about a central hollow. This is visible in 17(a) and it is reasonable to suggest that it also exists in 17(b). The pattern of grooves seems to have been cut into the surface of the bronze rather than cast. The gold foil was then pressed in the grooved surface. The circles continue to within 4 mm to 6 mm of the edge of the disc where in the case of 17(a) they are broken by a plain band 2 mm wide, bordered on both sides by a double row of circles

with a dot-like motif at regular intervals in the bottom of the groove. The decoration of this band is more complicated in the case of 17(b); the concentric circles are terminated by a circle with the integral dot motif. Outside this is a narrow band with lightly impressed oblique lines, another dotted circle followed by a band decorated with cross-hatching and a final double row of circles.

These pins form part of a large hoard of bronze objects found in a sand quarry in 1967. Included in the hoard were two pins - one a disc-headed pin with straight stem and the other, a sunflower pin with a large conical boss and geometric motifs. Sunflower pins have been divided into two types - Class I and Class II. The Ballytegan gold-foil covered pins belong to Class I which are characterized by a small central boss surrounded by incised concentric circles.

Clear parallels for these pins are known from northern Europe and from Denmark in particular where sixteen gold foil-covered examples are recorded (Raftery 1970 b, 96). Raftery is convinced that the Ballytegan examples were, in fact, imported into Ireland in the eighth century B.C. M.C.

21 Gold Collar

Colour pl. p. 96

Gleninsheen, Co. Clare
NMI: 1934: 85
ca. 700 B.C.
Max. lateral W. of collar 31.4 cm; Max. W. of collar 10.5 cm; D. of terminals 10.0 cm to 10.2 cm; Wt. 276 g.
Refs: Anon. 1934, 68 - Gleeson 1934, 138-139 - Raftery 1967, 70-71 - Powell 1973-4, 5, 8-10 - Ryan & Cahill 1981, 38.

This gold collar was found concealed in a rock fissure in 1932. No other objects were found with it.

It consists of a crescent of sheet gold to which two terminal discs are stitched using twisted gold wire. The collar is formed from a single sheet which expands from 7.4 cm to a maximum width of 10.5 cm at the centre. In order to reinforce and finish the raw edges a narrow strip was rolled over to the front giving an edge of semi-circular section. Immediately inside the edges is a single row of oval bosses punched from the back. The intervening space is filled by seven concentric raised bands which, like the collar itself, widen towards the centre. The area between each pair of raised bands is decorated by three rows of rope-moulding; two narrow cables on either side of a wider one. It is clear that this pattern of cables was achieved by working the gold from the front. A series of very small punched dots indicates the points from which the oblique strokes which create the cable effect were drawn.

The construction of the terminal discs is very simple. Two circular plates, one slightly larger than the other, are fitted together by overlapping the edge of the larger (back) plate and pressing the two plates together, thus giving a rather unfinished appearance to the front of the terminals.

Both discs are decorated in a similar way. The main feature of the front plates is a large conical boss set in a series of plain concentric circles, bordered by a circle of bosses and two concentric rows of rope-moulding. A band c. 2 cm wide is filled with eleven smaller conical bosses, also set in concentric circles. The perimeter of the disc is finished by a circle of bosses contained by a further two circles of rope-moulding. The decoration of the back plates is less complex consisting of alternate, concentric rows of rope moulding and bosses. It is interesting to note the differences in the execution of the design on the front and back discs. Some of the circles are incomplete and others are incorrectly aligned. Where the decoration is hidden by the collar the application of the cable pattern to the circles and the punching of the bosses has been disregarded completely.

The collar is attached to the terminals by inserting the edges into a slit in the back discs and tacking the two together with a fine twisted gold wire. Two rows of horizontal stitching are used. The area between the rows of stitching is interspersed with cable patterns producing the effect of a uniform panel of rope-moulding. The collar was secured further, at each side, by three more tacks at right angles to the stitching described above. These stitches have come away from the terminals.

The Gleninsheen collar represents one of the finest achievements of Irish Later Bronze Age goldsmiths. It is one of eight such collars still in existence although historical sources indicate the former existence of several more. A number of other items of gold work including two discs, may represent parts of other similar collars. Their distribution is very restricted, being confined mainly to Counties Clare, Limerick and Tipperary.

How and where this type of collar came into being has not been resolved as yet. Powell (1973-4, 8-10) cites Northern European triple- and multi-ribbed neck ornaments as possibilities but also suggests that the movement of ideas may have been in the opposite direction. Raftery's views (1967, 70-71) would appear to be in general accord with Powell but the weight of his opinion seems to favour an Irish origin for the type.
 M.C.

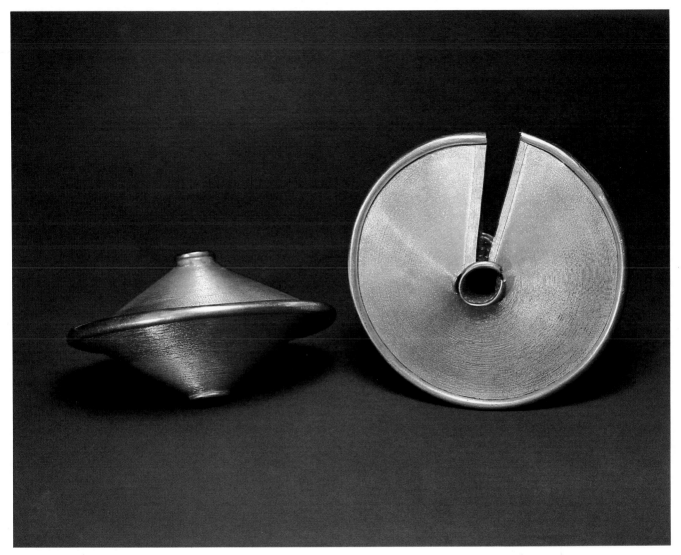

Cat. 22

22 Two Gold Lock Rings

Gorteenreagh, Co. Clare
NMI: 1948: 326, 327
8th to 7th century B.C.
Max H. (a) 5.25 cm (b) 5.10 cm; Max. D. (a) 9.81 cm (b) 9.98 cm; Wt. (a) 95.31 g (b) 95.25 g
Refs: Raftery 1967, 63-65 - Eogan 1968, 93-148 - Mitchell 1977, 52 - Raftery 1980, 21.

These two objects belong to a group of twenty or so similar objects most of which have been found in the area bounding the Shannon estuary. They form part of a hoard of gold objects, found in 1948 under a large stone, which contained a gold collar, two bracelets with expanded terminals and a small undecorated dress fastener similar to Nos. 13 a-h. The terminals of the gold collar had been forcibly removed and survive in a somewhat damaged condition.

The so-called lock rings are of a complex construction and consist of two truncated conical penannular face-plates fitted together to form a large bi-conical 'bead'. The face plates are held together by an outer binding strip of C-shaped cross-section. A hollow split tube of sheet gold is fitted through the centre of the bi-conical structure

and is held in place by overlapping the rim at the top and bottom. The face-plates themselves consist of concentric twisted gold wires individually soldered averaging 3 wires to 1 mm. The edges of the face plates are reinforced by a narrow band of soldered wires positioned at right angles to the cone. The hollow tube is decorated with five parallel pairs of lines consisting of small punched bosses. These bosses may help to keep the lock of hair securely in position.

These objects have been the subject of an exhaustive study (Eogan 1968), which has discussed their origins and development. While no prototypes have been recognised either in northern or mediterranean Europe, Eogan feels that they must have developed from an imported model and subsequently been introduced from Ireland to Britain and France. It is important to note that the vast bulk of the face-plates of Irish lock-rings are made of gold wire while this effect is achieved, in Britain and France, by incising sheet gold where side-plates are also used. This feature is unknown in Ireland.

The shield, which was found in a bog between Ballinamoona and Herbertstown, near Lough Gur, appears to have been beaten from a flat cake of bronze. The corrugated surface has been hammered from behind. It consists of a raised central boss surrounded by a basal rim. Outside this are six equally spaced concentric ridges separated by six rings of raised hemispherical bosses. The courrugation is not merely decorative. Such a surface would have been stronger and would have afforded greater protection from sword slashes. The rim is formed by the inturned edge of the shield. There is a handle on the back traversing the hollow of the boss. This is held in position by two rivets with hemispherical heads which fit neatly into the inner ring of bosses. There are two sling loops affixed in similar fashion, the rivets being placed in the middle ring of bosses. There are traces of fibrous material on the shield formerly interpreted as a leather lining but recent examination in the National Museum suggests that the object was wrapped in a textile when deposited.

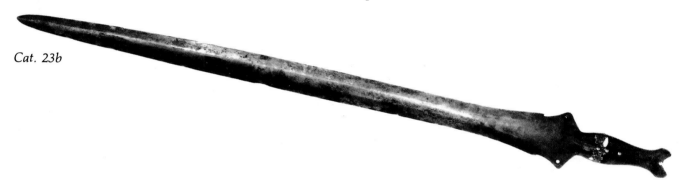

Cat. 23b

Lock rings are known from a number of other hoards of Late Bronze Age date which fix the type in the eighth century B.C. M.C.

23a Bronze shield
Colour pl. p. 97

Near Lough Gur, Co. Limerick
NMI: 1872: 15
ca. 700 B.C.
D. 71.3 cm; D. of boss 15.65 cm; Depth of boss 3.3 cm; Wt. 1611 g
Refs: Evans 1881, 352 - Coffey 1913, 75, fig. 68 - Smith 1918-19, 148-150 - Hodges 1956, 44 - Coles 1962, 167, 183, 188 pl. XXIX - Lucas 1973, 40, fig. 17 - Herity and Eogan 1977, 195-197 - Mitchell 1977, 52-53, pl. 12 - Raftery 1980, 21.

Of more than thirty bronze shields from Britain and Ireland over half are of similar type. Coles refers to them as "Yetholm" shields after a find place in Scotland. The objects have a continental origin.

The Lough Gur shield is the only one of Yetholm type found in Ireland compared with eighteen from Britain. The possibility that the object is an import must therefore be considered. E.P.K.

23b Bronze Sword

Killaloe, Co. Clare
NMI: 1934: 197
ca. 600 B.C.
L. 77.3 cm; W. of blade (middle) 3.28 cm; W. of butt 6.66 cm; Max. W. of tang 3.2 cm; T. of blade 0.68 cm; Wt. 788 g
Ref: Eogan 1965, 144.

This fine bronze sword was recovered from the River Shannon. There is an outswelling of the tang at the terminal and a notched indentation occurs at its extremity. A fragment of metal has broken off between the base of the concavity and the end rivet hole. The tang also swells out towards the butt. Three further rivet holes are present along the longitudinal axis towards the butt end of the tang. The latter, which has a slight thickening at the edge, has been repaired in antiquity either by brazing or by casting-on.

There are two rivet holes on the butt one of which contains a bronze rivet 12 mm in length. A bow-shaped line on the butt indicates the lower limit of the hilt plates. A ricasso is present.

The blade is long and has a flattish central thickening with the sides drawn out.

The object was cast in a clay mould. Tiny air-holes occur on its surface.

More than 600 bronze swords are known from Ireland. Eogan places the present example within his class 5. Swords of this type are derived from the central European Gündlingen swords which are associated with a mature phase of the Hallstatt Culture. E.P.K.

23c Leaf-shaped spearhead

Near Belturbet, Co. Cavan
NMI: 1912: 18
8th or 7th century B.C.
L. of blade 53.5 cm; Max. W. of blade 6.25 cm; Max. D. of socket 2.9 cm; Wt. 740.05 g
Refs: Unpublished; but discussion of the type may be found in the following publications:
Coffey 1893-96, 486-510 - Armstrong 1921-24, 142, fig. 6 - Evans 1933, 187-202 - Eogan 1964, 270 - Herity and Eogan 1977, 195.

This spearhead was found with a similar but smaller example, at a place called "the Ford", half a mile from Belturbet, Co. Cavan. The shaft socket runs the full length of the blade and tapers evenly towards the point. The wings of the blade are lanceolate. Two peg holes occur 1.6 cm below the wings. A damaged area adjoining one of these had been repaired in antiquity by casting on a new piece of metal. Portion of the original wooden shaft survives in the socket.

Plain leaf-shaped spearheads may have been in production in Ireland from as early as the 14th century B.C. They are commonly represented in finds from the Later Bronze Age and continued in use into the Iron Age when the manufacture of iron examples began. A spearhead of this type was found with bronze swords of a mature phase of the Later Bronze Age at Youghal, Co. Cork.

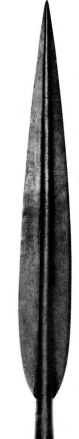

Cat. 23a

A date in the 8th or possibly the 7th century B.C. seems most likely for the large leaf-shaped spearheads. Certainly the technology necessary for casting large bronze objects was available to the Irish bronze smiths of the time as evidenced by the large-scale production of swords and horns. E.P.K.

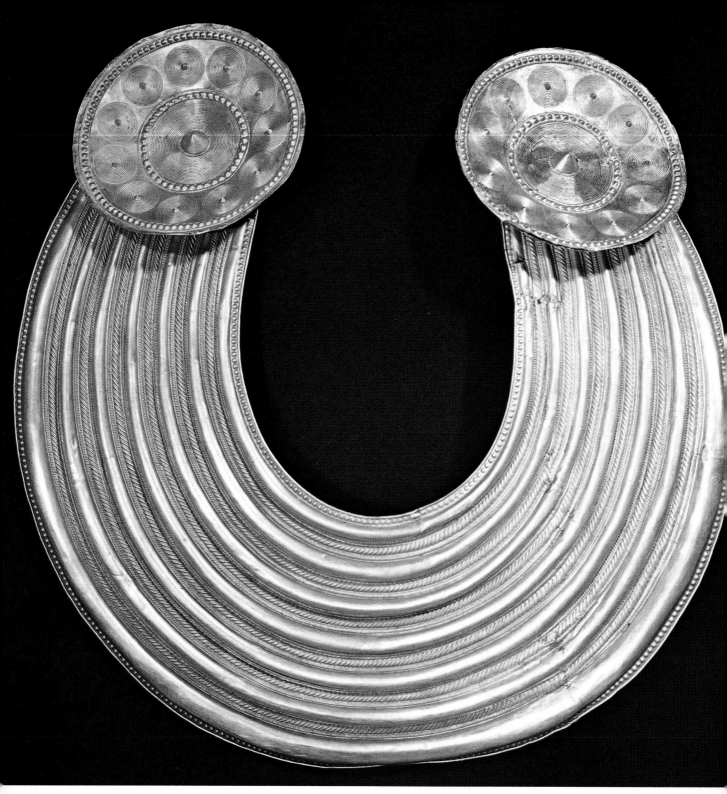

Gold collar, Gleninsheen, Co. Clare, Cat. 21, p. 92

Large bronze shield, Cat. 23a, p. 94 ▷

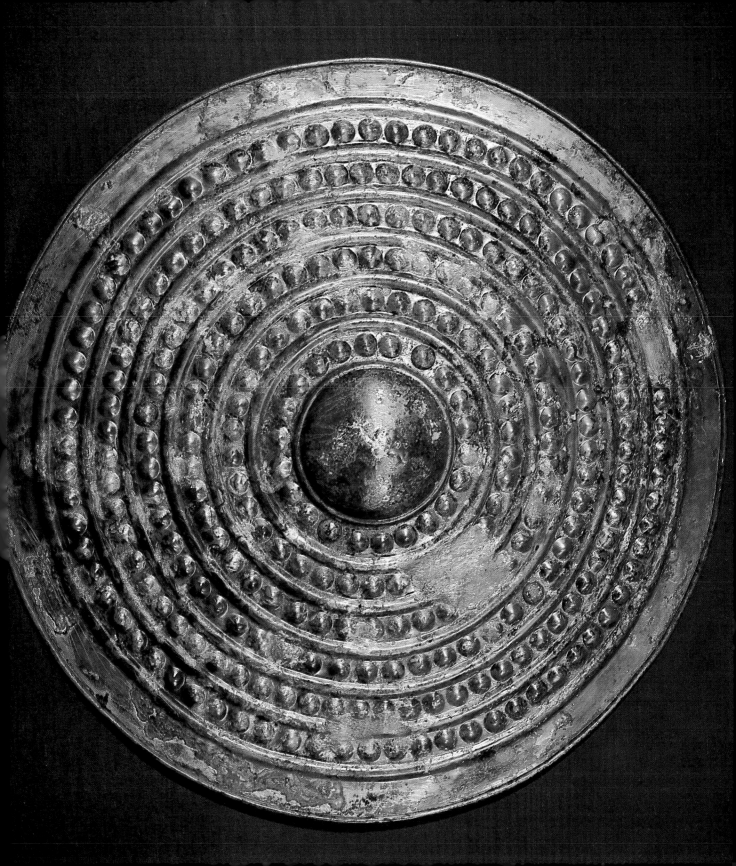

24 Bronze Cauldron

Castlederg, Co. Tyrone
NMI: 1933: 119
7th century B.C.
Max. D. 56 cm; D. of rim 46 cm; Internal Depth 40.2 cm;
D. of handles 12.2 cm; Wt. 6277 g
Refs: Leeds 1930, 34 - Hawkes and Smith 1957, 182 -
Lucas 1973, fig. 16 - Herity and Eogan 1977, 204 -
Mitchell 1977, 53, pl. 13 - Raftery 1980, 21.

The cauldron, which was found in a bog, is made of thin
sheets hammered from bronze ingots and riveted along
the seams. The base is rounded. The body of the vessel is
composed of three offset bands of metal. There are four
horizontal rows of conical rivets. The vertical rivets are
symmetrically placed in offset lines. A reinforcing metal
strip is placed behind them in those cases where their
position does not coincide with a seam. The profile is
markedly incurved at the shoulder and ends in an everted
rim. The latter is decorated with tiny circular holes
evenly positioned in four rows. The lip is rolled over a
reinforcing ring. Two large cast rings of octagonal cross-
section are attached to the rim. These are placed opposite
each other. They are held by two cast loops which are
brazed and riveted to the vessel. Two curved reinforcing
strips are attached internally below the handles.

About thirty-two bronze cauldrons of this period have
been found in Ireland. Hawkes and Smith place the
Castlederg cauldron within their class B.I. which includes
eighteen Irish cauldrons. The type is based on Greek and
oriental prototypes. The conical-headed rivet form
appears to be derived from central Europe. E.P.K.

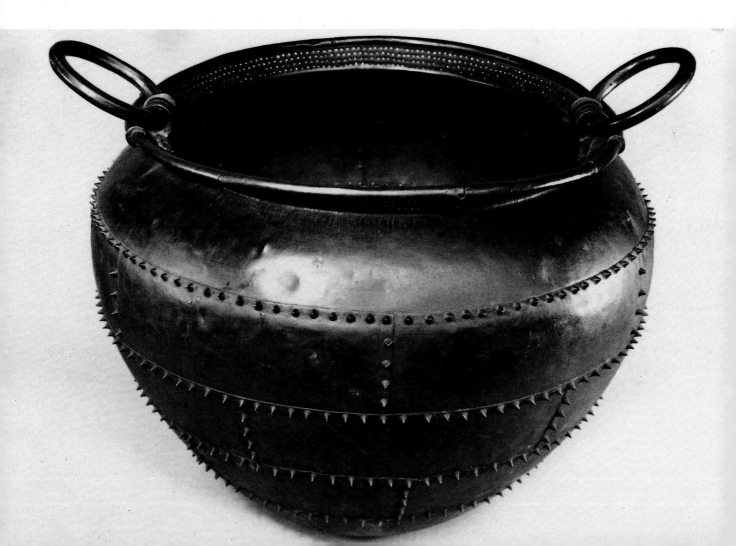

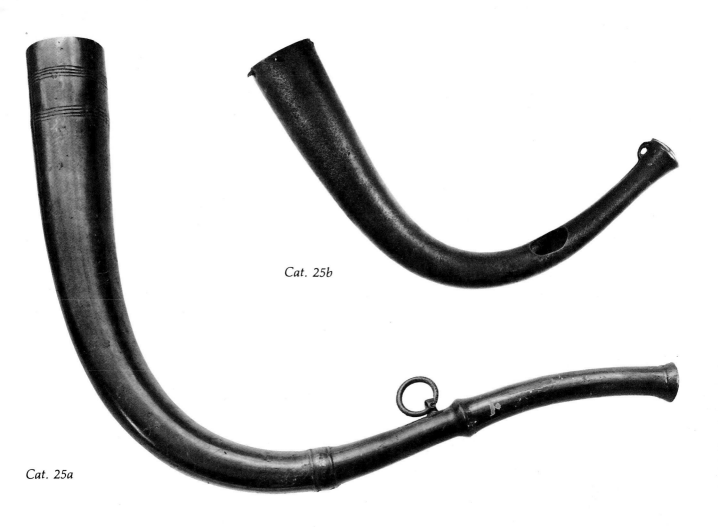

Cat. 25b

Cat. 25a

25a Bronze horn

Drumbest, Co. Antrim
NMI: 1893: 17
7th century B.C.
Full L. 89.5 cm; Max. D. 7 cm; Min. D. 2.65 cm; D. of mouth-piece 3.5 cm; D. of loop 4 cm; Wt. 2060 g
Refs: MacAdam 1860, pl. 1, 100 - Coles 1963, fig. 1, 330, 340-343, 353 - Megaw 1968, 347-8, fig. 77:4 - Holmes 1979, 169, 177-179.

The horn was found in a hoard containing three others in Drumabort Bog, Drumbest, Co. Antrim.
The main body of the object was cast in two separate pieces in clay moulds.

The larger consists of an evenly flared metal tube which curves at roughly right angles. Near the narrow end a loop containing a moveable ring has been cast-on. Approximately halfway between this and the bend there is a broad moulding flanked by two thin mouldings. At the bell end there are two zones of four concentric grooves which are unevenly cut into the surface of the metal.
A slightly curved cylinder c. 19 cm in length forms the second major component of the horn. It was cast-on at the narrow end of the larger tube and has a flared mouthpiece defined by a moulding.
Over the entire surface of the horn numerous chaplets (small flat pieces of metal which were used to hold the clay core in position during casting) are observable. The method of manufacture is dealt with in detail by Holmes.

The techniques involved show remarkable sophistication and are a culmination of a long period of development by Irish bronzesmiths.

The Irish Bronze Age horns form the largest single group in the trumpet-horn family of instruments from the Bronze Age. One hundred and twenty are recorded. This represents 55% of the total of Bronze Age instruments of this type recorded from Europe and the Middle East.

Coles groups the Irish horns into two classes. Class I horns are concentrated in the northeast of the country; Class II occurs in the southwest. There is an overlap of both classes in the midlands where both are found in the hoard from Dowris, Co. Offaly.

Irish horns may be end-blown (as in the present example) or side blown (no. 25b). These Irish side-blown instruments are unique in the archaeological record. The Drumbest hoard contained two end blown and two side blown instruments.

The musical potential of the Irish horns is discussed by Holmes who concludes that they were played in the manner of the Australian *didjeridu*. This mode of playing would allow for the laying down of a harmonic and rhythmic base for communal music-making.

E.P.K.

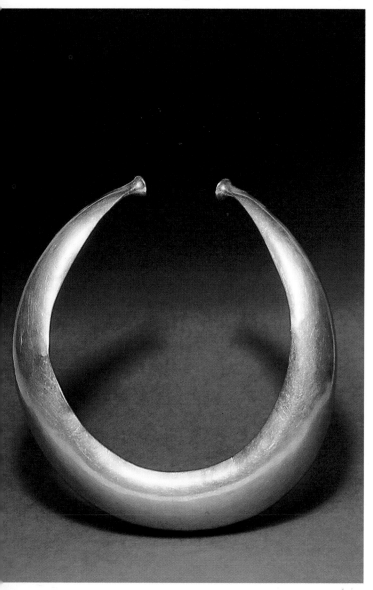

Gold collar, Mooghaun, Co. Clare, Cat. 19, p. 90

25b Bronze Horn

Drunkendult, Co. Antrim
NMI: 1930: 107
7th century B.C.
L. 58.5 cm; D. at mouth 6.5 cm; the blowing aperture is 13cm from the end and measures 4.3 cm × 2.2 cm; D. of end 2 cm; L. of loop 2 cm; Wt. 1007.7 g
Ref: Coles 1963, 353.

The object was found in a bog in association with portion of another horn. It was made in a two-piece clay mould the sides of which were not properly aligned during the casting process. As a result of this the decoration at the closed end is uneven. Chaplets are present in the surface. The horn consists of an evenly-flared bronze tube which also expands at the narrow end. It curves in the middle, both halves being set roughly at right angles. The blowing aperture which is on the side of the horn is oval. The closed end of the instrument is convex with a raised roundel. A small loop occurs immediately above this on the inside of the curve. There are six regularly spaced decorative spikes around the open end.
The horn is of Coles's Class I.

E.P.K.

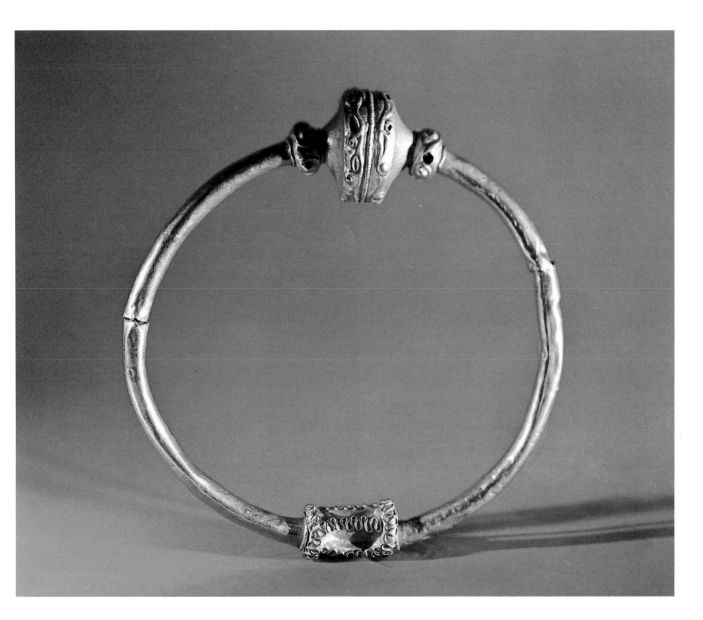

26 Gold Torc

Near Clonmacnoise, Co. Offaly
NMI: W290
3rd century B.C.
D. 14.7 cm; D. of buffer terminal 3.7 cm; L. of "box" feature 3 cm; Av. T. of "box" feature 1.45 cm; Wt. 102.96 g. (The metal contains about 19% silver, 2.5% copper, .018% tin and a tiny amount of platinum.)
Refs: Anon 1861, 3 - Wilde 1862, 47-49, figs. 575-577 - Gomme 1886, 34-35 - Evans 1897, 405, fig. 8, pl. 42 -

Armstrong 1920, 29, 65, No. 120, pl. XIII:98 - Maryon 1938, 210 - Megaw 1970, 114, No. 174 - Mitchell 1977, 85, pl. 14 - Raftery 1980, 22.

The earliest known published report states that the torc was found with No. 27 "in a bog near Clonmacnoise on the brink of the Shannon".
The ring is formed by two curved gold tubes made from rolled and bent strips. The seam, which is along the concave edge, is soldered and polished. The large fused "buffer" feature at the front is flanked on each side by

cone-shaped features. The former was made in two halves which were soldered together. The seam is concealed by a strip of serrated wire. The cone-shaped features were then attached, also by using solder, the seams being concealed by strips of twisted wire. These features bear repoussé decoration. The motif employed on the buffer is a continuous series of raised S-shapes which terminate in round bosses. On the flanking features spirals are employed, again terminating in raised circular bosses. The background is dotted to accentuate the repoussé designs. The end of one of the curved tubes of the ring is movable. It fitted into one of the side features in the front where it was secured by means of a pin which passed through both. The "box-like" feature at the rear allowed both halves of the torc to pivot, thus enabling the wearer to place the object in position. Its sides are depressed, being alternately eliptical and hourglass in shape. The meandering wire which is soldered to the frame is cleverly interlaced.
Both in decoration and form the torc is closely comparable with continental examples. It is likely to be an import from Gaul. E.P.K.

27 Twisted Gold Torc

Near Clonmacnoise, Co. Offaly
NMI: W291
3rd century B.C.
D. 14.2 cm; W. of twisted bar 0.7 cm; T. of bar 0.1 cm; L. of terminals approx. 2.15 cm; W. of terminals approx. 1.95 cm; Wt. 65.3 g. (The metal contains over 30% silver, 3.7% copper, .015% tin and .026% platinum.)
Refs: Anon 1861, 3 - Wilde 1862, 47-49, 73-74, fig. 603 - Gomme 1886, 34-35 - Armstrong 1920, 29, 62, No. 88 - Mitchell 1977, 85, pl. 15 - Raftery 1980, 22 - Eogan (forthcoming), 91, 123, No. 43.

This torc is said to have been found with No. 26. It is made from a twisted strip of metal. The ends are worked into round rods which end in expanded dished terminals. Hollow gold knobs are fitted into these. The latter were made in two halves soldered together.
Twisted gold ribbon torcs are known from La Tène Europe. An apparently later Irish La Tène example, that from Somerset, Co. Galway (No. 28) has very simple terminals. The type has been discussed earlier (see No. 11). E.P.K.

Cat. 27

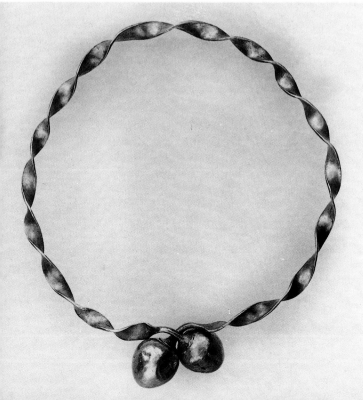

28a-c Hoard of Objects

Somerset, Co. Galway
NMI: 1958: 156, 157, 158
1st century A.D.
Refs: Raftery 1960, 1-5, pl. 1 - Henry 1965, 14-15, 71 (fig. 6c), 218, 220, pl. 5 - Ryan and Cahill 1981, 42 - Eogan (forthcoming), 87-117.

These objects, which consist of a decorated bronze "box" and a gold ribbon torc, were found in a hoard containing a number of other items. Some were of iron but these were unfortunately discarded by the finder. The other objects which survived are an enamelled bronze mount, an openwork bronze mount, a bronze fibula, a bronze cup handle, a 'cake' of bronze and a bronze ingot.

28a Decorated bronze "lid". D. 8.1 cm; Depth of "lid" 1.3 cm; Wt. 53.8 g
There is a raised central area bearing repoussé ornament in the La Tène style. A trumpet pattern coils around a small central boss and terminates in a lentoid boss. The area within the trumpet pattern bears a series of incised concentric circles - the spaces between alternate circles

being filled with equally-spaced punched dots. The remainder of the raised central area is similarly dotted. This technique recalls the work on the terminal of the Clonmacnoise torc (No. 26). A lightly incised triangle filled with irregular lines running roughly parallel to its sides occurs on the flat surface at the edge. This does not appear to be part of the original design. There is a thin moulding around the rim of the side which appears to have been accentuated by means of hammering the edge. This has produced a slight internal lip. Equally spaced along the moulding are three holes, one of which still retains portion of an iron rivet.

When found, the gold torc and the enamelled mount were placed within the lid which was in turn fitted with the base.

28b Bronze "base" of "box". D. 8.8 cm; Depth 1.4 cm; Wt. 44.6 g

This is broadly similar though slightly larger than the "lid". It also has a raised circular area, in this case undecorated. There is a slight lip on both sides of the rim resulting from hammering the edge.

The "box" formed by the two components may be an improvisation. The rivets on the decorated portion could serve no obvious function on the "box" as found. It may be that some intermediate section became detached in antiquity. A broadly similar "box", W15, is reported as having been found fitted together in precisely the manner of the Somerset "box". This "box", which differs from the Somerset "box" among other things in that there are also

Cat. 28a-c

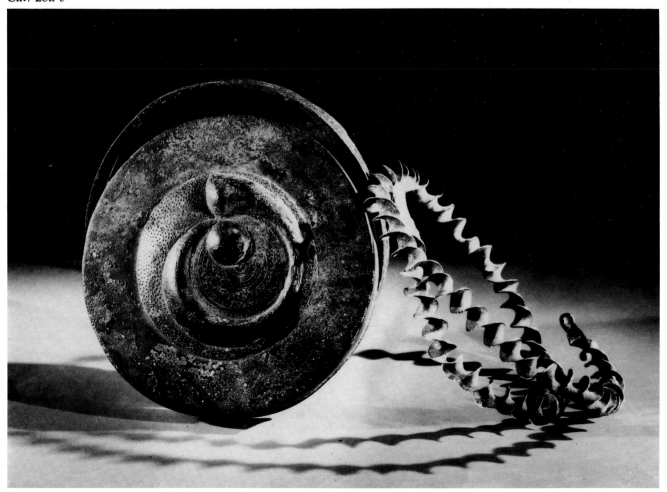

three rivet holes in its "base", was recovered from the bed of the river Shannon at Athlone (Wilde 1857, 640).

These "boxes", together with the Cornalaragh "box" (no. 32) form part of a small group of Irish Iron Age objects the function of which remains unclear.

28c Gold ribbon torc. W. 6mm; T. 0.5mm; L. c. 42 cm; Wt. 19 g

The object has been hammered from a gold ingot and finished with an open twist. The terminals, which have a rectangular cross section, thicken towards the ends which are slightly knobbed.

The terminals are approximately 1.7 cm. in length. They thicken from 0.5 mm to 5 mm at their extremities. The class has been discussed in relation to the torc from near Belfast (no. 11). E.P.K.

29 Bronze sword hilt

Colour pl. p.24

Ballyshannon Bay (or Harbour), Co. Donegal
NMI: S.A. 1926: 47
1st century B.C.
L. 13.4 cm; W. at base 7.08 cm; Wt. 238.5 g
Refs: Anon 1925, 137-8 - Jacobsthal 1944, 14, N. 4 - Clarke & Hawkes 1955, 198-227 - Mitchell 1977, 85-86, pl. 16 - Raftery 1980, 22.

The object was brought from the sea-bed in a fisherman's net about the year 1916. The blade, which is now missing, was about 15" (c. 37.5 cm) in length. It was triangular in shape and made of iron. The hilt is cast in the form of a human figure. In its original form the object was one of a number of swords with anthropoid hilts which Hawkes refers to as class G. The head and facial features are finely moulded but it has been referred to as being somewhat "barbarous", that is, it shows less Roman influence than other swords of the class. The hair is depicted by means of the typically Celtic technique of vertical ridging. A horizontal band runs across the forehead from ear to ear which may represent textile or curled hair. It has been claimed by Jacobsthal to represent a vestigial "leaf-crown", such as that which occurs on the figure depicted on the Celtic carved pillar at Pfalzfeld, Germany. The ears appear to have been largely cut away. The eyes are slanted. A raised triangular panel occurs on the front and the back below the neck. The grip is ridged by three short reel-shaped ring-mouldings. The surfaces of the latter are decorated by means of short etched lines which are irregularly distributed. Similar

decoration occurs on the handle of one of the flagons from Basse-Yutz, France.

The "arms" and "legs" terminate in large round knobs set off by mouldings. The object may be an import from Gaul. E.P.K.

30 Gold Collar

Colour pl. p. 25

Broighter, Co. Derry
NMI: 1903: 232
1st century B.C.
D. of collar 19.4 cm. Axial measurements of curved tubes: Max. 3.1 cm; Min. 2.5 cm. Terminals: D. 4.45 cm; W. 1.65 cm. Total Wt. 184.95 g. (The metal contains 23% silver, 4.8% copper, .05% tin, .01% nickel and .014% platinum).
Refs: Evans 1897, 399-405, figs. 5, 7, pl. XXII - Coffey 1902-4, 258 - Armstrong 1920, 24-29, pl. XIII - Leeds 1933, 132, fig. 35b - Henry 1936, 233 - Lloyd Praeger 1937, 63-67, pl. VI - Mahr 1937, 410 - Raftery 1937, 410 - Maryon 1938, 210-211 - Lloyd Praeger 1942, 29-32 - Jacobsthal 1944, 81 n.1, n.4, 99, n.3 - Raftery 1951, 198, fig. 234 - Fox 1958, 45, 48, 56 - Rynne 1961, 707 - Megaw 1970, 167 - Raftery 1971, 103 - Lucas 1973, 52, pl. 6 - McGregor 1976, 97, 111, 115, 185 - Mitchell 1977, 87-88, pl. 21 - Kilbride-Jones 1980 a, 23-27, 44, 52, 76-83, 131, fig. 5:1 - Raftery 1980, 23-24 - Warner 1982, 29-38.

The object is part of a hoard discovered during ploughing at the end of the last century. The other objects in the hoard, all of which were of gold, include a model boat together with its fittings, a gold bowl with rings for suspension, two chains and two twisted collars.

The collar is complete except for its rear moulding and the applied decoration from one of its buffer terminals. The ring consists of two semi-circular tubes which were formed from sheets of gold. These were rolled into a cylindrical form and the seams soldered. The tubes were packed with some material, possibly sand, and then bent into semi-circles. Relief decoration on the convex surfaces was achieved by chasing. The motifs were defined by incised lines and were brought into relief by depressing the background. The main technique was hammering and the surface was subsequently polished to remove hammer-marks. A graver and compass were also employed. The cross-section of each tube is oval, measuring least across the axis between the convex and concave surfaces. This is largely a result of the reworking of the decorated surface. The decoration consists of an intricate foliage design of complex symmetry. The main

framework of the decoration appears to be based on the classical lotus-bud motif. It comprises a series of interconnecting S-shaped scrolls incorporating extended trumpets defined by lentoid bosses. These terminate in leaf-shaped comma-motifs mounted with exaggerated snail shell-like roundels. The latter are separately made and attached by lugs which pass through the tubes and are folded over inside. Solder also appears to have been used to attach them. The area between the raised decoration is filled with concentric arcs of circles scratched on with a compass. This serves to emphasise the raised decoration.

The ends of the tubes adjoining the terminals each bear a single row of small punched-up pellets. These appear to be an attempt at disguising the heads of the rivets which secure the joint. Some of the rivets appear to be replacements. The other ends of the tubes are damaged. A number of rivet holes survive. These would have served to secure the tubes to some form of swivel feature, now missing, similar to that which occurs in the Clonmacnoise torc (no. 26).

The tubes are riveted to two short cylinders of equal breadth. These appear to penetrate through the buffer terminals which are soldered on. They terminate in a mortice and tenon arrangement which fastened the collar. The T-shaped tenon is surrounded by raised repoussé lines. The area between the terminals and the joinings with the curved tube is decorated, apparently in repoussé technique, with trumpets, lentoid and circular bosses. The circular bosses are dished. Every one bears an inscribed circle and a gold ball is soldered in the centre of each.

The buffer terminals which are made from beaten sheet gold are recessed on their circular face. There are two recessed channels on the upper sides of the terminals. Fitted into one of these is an openwork strip of three rows of conjoined repoussé bosses which convey the effect of granulation. The fact that the decoration on the ring of the torc is chased rather than repoussé results mainly from the technical difficulties involved in producing the object. Had the decoration been produced by repoussé prior to the folding and bending of the gold, it would have buckled and torn. The basic techniques of working relief decoration in gold from the front had long formed part of the repertoire of the Irish goldsmiths. This is evidenced by the work on the Gleninsheen collar (no. 20). The use of rows of pellets to disguise rivet heads on the Broighter collar also harks back to earlier days for it is reminiscent of the manner in which the rivet heads on the Lough Gur shield (no. 23a) were rendered inconspicuous by being placed in a row of repoussé bosses.

The decoration and workmanship shows that the object is of Irish manufacture. The type however, has its origin on the continent where a number of similar collars are known. The mortice and tenon fastening device is found on a number of continental collars, for example, on that from Fenouillet in France. E.P.K.

31 Bronze Trumpet
Colour pl. p. 28

Loughnashade, Co. Armagh
NMI: W8
1st century B.C.
L. along convex edge 186.5 cm; Max. D. 8 cm; Min. D. 2.6 cm; D. of boss 6.2 cm; W. of boss 2.7 cm; D. of decorated ring 19.3 cm; Wt. 1216.5 g
Refs: Browne 1800, 11-12 and pl. - Stuart 1819, 608 - Petrie 1833, 29 - MacAdam 1860, 103, pl. 2 - Wilde 1861, 625, 630-1, 634, figs. 527, 531 - Armstrong 1923, 22-23 - Megaw 1970, 147, No. 246 - Lucas 1973, 52, figs. 35, 37 - Herity and Eogan 1977, 242, 247 - Mitchell 1977, 88, pl. 22 - Kilbride-Jones 1980a, 44, 76, 126, fig. 13:3 - Raftery 1980, 24.

The trumpet as now constituted has four main components: two cylindrical tubes, a ridged ring or knob which is situated at the junction of the former two components and a decorated ring which is attached to the mouth of the trumpet.

The larger of the two tubes is curved and flared. It was manufactured from a thin sheet of bronze closed by a seam along the concave edge. The edges were carefully aligned. A thin strip extends along the seam internally. The outer seam was sealed by means of a ridged strip of bronze fastened by a series of well formed rivets. These were placed at regular distances and passed through the three plates of metal. The tube has been repaired in three places.

The second tube is of different construction. The edges overlap and are fastened with rivets. A metal strip, which originally appears to have run the full length of the seam externally, survives in two places. This was attached by widely-spaced rivets supplemented by solder. There is no internal strip. There is a very slight out-turning of the blowing aperture. The difference in construction of this tube leads one to the conclusion that it was not originally part of the instrument but a replacement. Four trumpets in all were found in the bog at Loughnashade. The present example alone is known to have survived. It is

possible that portions of different instruments became associated subsequent to their discovery. The knop is constructed from two pieces of hammered bronze. These are joined by folding along the central ridge. At the mouth of the trumpet there is a decorated bronze ring. The ornament, which is executed in repoussé, is based on the classical lotus-bud motif. The quadrants are mirror images of each other. The design is composed of long sinuous tendrils which terminate in spiral bosses in high relief. A number of elongated trumpet curves are incorporated into the design. The ring has a raised, rolled-over rim.

There is a short cylindrical tube attached to the ring which appears to be a later addition.

The earliest description of the find circumstances suggest that the objects were part of a votive deposit. The important Iron Age enclosure known as Emain Macha is close by.

A large undecorated Iron Age trumpet was found at Ardbrin, Co. Down and portion of another, bearing two bosses similar to that on the Loughnashade trumpet was found at Roscrea, Co. Tipperary. The statue of the dying Gaul from Pergamon, the original of which dates to the 3rd century B.C., depicts a similar large curved trumpet.

<div align="right">E.P.K.</div>

Cat. 31

32 Bronze openwork "box lid"

Colour pl. p.24

Cornalaragh, Co. Monaghan
NMI: (ex Shirley Collection; No. 33).
1st century A.D.
D. 7.4 cm; Depth 1.5 cm; Wt. 44.2 g
Refs: Anon 1852, 14 - Lucas 1973, 45, 51, fig. 33 -Mitchell 1977, 86-87, pl. 19 - Raftery 1980, 23.

This beautifully decorated "box lid" was found at a depth of 12 feet in a bog in 1844. There is a wide raised circular area of the upper surface. At the centre of this there is a smaller raised disc bearing an openwork La Tène design. A sinuous strap which narrows at each end spans the central space and divides the disc symmetrically. Two opposed spiral patterns emerge from the edge at right

angles to this. Each curls around and ends in a small knob linked to the rim by a reinforcing bar. The larger openwork disc is pierced with a lattice arrangement of lozenges with curved sides. The apertures regularly decrease in size inwards towards the centre of the disc. The side of the "box" has a moulding at top and bottom. There is a slight internal lip produced by hammering the edge. Three rivet-holes occur on the side near the lower edge.

Four rivets at the edge of the central design and four rivet-holes at the edge of the larger openwork disc indicate that a metal plate originally underlay the design. Two rivets which occur on the openwork mount from Somerset, Co. Galway, presumably had a similar function. It is possible that the two "mounts" from that hoard perform the same function as the central disc on the Cornalaragh "box" in composite "boxes" of similar type.

<div align="right">E.P.K.</div>

33 Bronze cup

Keshcarrigan, Co. Leitrim
NMI: W37
Early 1st century A.D.
Max. D. 15.3 cm; Depth 7.2 cm; Wt. 279 g
Refs: Wilde 1861, 534, fig. 413 - Henry 1936, 214 - Jope 1954b, 92-96 fig. 2:1 and pl. VIII - Megaw 1970, 160-161, No. 273 - Mitchell 1977, 87, No. 20 - Raftery 1980, 23.

The vessel was found in the stretch of water between Lough Scur and Lough Marrive. It was first beaten into shape and then finished by the exertion of pressure on the surface while the object was being spun into a wooden mould. There is a central chuck mark on the base.

The vessel, which may have been a drinking cup, turns in at the shoulder and has an everted rim. This is decorated with a zig-zag line in false relief produced by hammering. There is an incised line inside the rim and another above the shoulder.

The handle, which is cast, is in the form of a bird, probably a duck. The eye sockets, now empty, probably held enamel settings. It is soldered to the body of the vessel.

A bowl of similar manufacture was found in the River Bann, near Coleraine. A number are known from the south of England. The decorative theme of the handle of the Keshcarrigan vessel is typical of Irish La Tène art. A cup handle, which also terminates in a bird's head, was found with the hoard from Somerset, Co. Galway (No. 28). E.P.K.

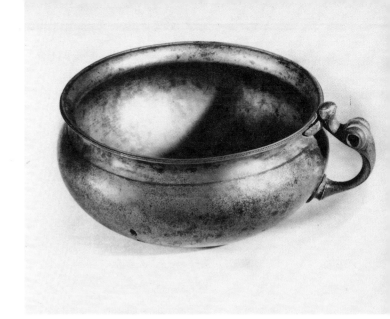

Cat. 33
Cat. 34

34 Bronze scabbard-plate

Toome, Co. Antrim
NMI: 1937: 3634
2nd century B.C.
L. 44.5 cm; Max. W. 4.6 cm; Wt. 56 g
Refs: Raftery 1951, 194, fig. 216a - Jope 1954a, 85-87 -Jope 1960, 79 - Rynne 1961, 707 - Megaw 1970, 148, No. 249 - Lowery, Savage and Wilkins 1971, 174, pl. XId - Mitchell 1977, 86, pl. 17.

The object is reported to have been found "near the river Bann at Toome, Co. Antrim".

Somewhat crudely made in thin bronze, there is a tapering narrow tongue 11 cm long at one end. At the extremity of this there are two rivet-holes, one above the other. The broad end is bow-shaped. It is perforated by three holes bearing rivets of bronze or copper. These are set equidistantly from the broad end.

One surface is decorated with a finely engraved design. The etched lines of this consist of tiny continuous chevrons. These are not consistently executed and in many cases they degenerate into ragged, irregular or even straight lines. The tool used to produce the design is known as a "walked scorper" and the method of use is dealt with by Lowery, Savage and Wilkins (1971). A single design of stylised foliage is repeated from top to bottom along the plate. Each successive design is a mirror image of the one above it. The basic form is a spiral which is mainly defined by two continuous lines. At the sides of the plate the spirals thicken into wide crescentic areas. These are divided longitudinally and are decorated with a herringbone pattern. Hatched lines are used to decorate the two adjoining lentoid areas which terminate the spiral. The main spirals run on to the plate from the edges. In each case a smaller hatched spiral occurs above the point of entry. Similarly, a small hatched spiral is attached below the crescentic areas.

The decorated surface originally faced outward. Subsequently the scabbard-plate was reversed and shortened. The reversal of its curve was effected by punching round depressions along the margins.

About 10 scabbard-plates engraved in La Tène style are known from northeastern Ireland. Though manufactured in Ireland, they have a continental origin. E.P.K.

Cat. 35

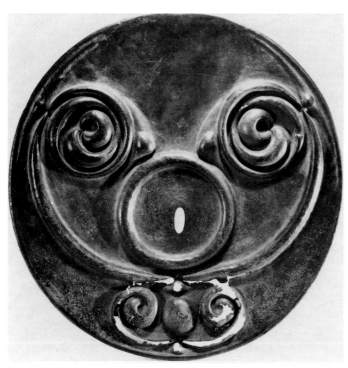

35 Bronze Disc

Monasterevin, Co. Kildare
NMI: W3
1st or 2nd century A.D.
D. 30.6 cm; Wt. 646 g
Refs: Wilde 1861, 639 - Raftery 1941, 28 - De Paor, M. & L., 1958, 247, pl. 1 - Mitchell 1977, 88, pl. 23 - Kilbride-Jones 1980a, 80, 82, 126 - Raftery 1980, 24.

This object, which is of a type unique to Ireland, was found in association with a similar though more fragmentary disc.

It appears to have been beaten from a cake of bronze and then decorated in repoussé technique. The latter consists of an asymmetrically placed ring within a palmette-derived or pelta design. This is surmounted by a similar smaller design which encloses a circular boss. The decoration incorporates trumpet patterns, spirals and C-shaped motifs. Within the ring there is a slot with rounded ends. The decoration is in high relief and has been beaten up from behind. The surface, which is slightly dished, has also been hammered. Hammer marks are clearly evident within the ring. This may have been intentional as a means of setting off the relief decoration. The rim has been rolled over from the front.

Seven of these discs are known to exist. Their function is unknown and has been the subject of widespread speculation. One possibility is that they were decorative mounts suspended from the sides of chariots, a suggestion reinforced by the fact that the discs occur in pairs. The similarity in the layout of the design on the Monasterevin disc and the roundels on the Attymon Y-shaped pieces (no. 38) may not therefore be entirely fortuitous. E.P.K.

36 Bronze object known as the "Petrie Crown"

Colour pl. p.29

Find place unknown.
NMI: P869, 870
2nd century A.D.
Max. L. of base plates 7.5 cm; Max. W. 4.1 cm; D. of roundels 5.1 cm; Max. L. of horn 10.7 cm; Max. W. of horn 2.7 cm; Wt. 78.4 g
Refs: Stokes 1883, 473-480, pl. XXII - Stokes 1892-96, 290, pl. XIX - Stokes 1932, 44-46 - Henry 1940, 41-42, 48, 191, pl. 13a - Raftery 1941, 26-28, 95, pl. 1:10 - Jope and Wilson 1957a, footnotes 128-131 - Jope and Wilson 1957b, 97, 99, 100 - O'Kelly 1961, 1-12, pl. I-IV - Henry

1965, 67, 71, 207, pl. 11 - Megaw 1970, 159 - Mitchell 1977, 89, pl. 24 - Kilbride-Jones 1980a, 75-76, 122, 212, fig. 35:1 - Raftery 1980, 24-5.

This object acquired the name "Petrie Crown" after the 19th century antiquarian George Petrie in whose collection it had been. It consists of a number of individual components joined together in various ways. There are two adjoining plates to each of which is attached a large dished roundel. A cone is attached to the back of one of these. A patch of solder indicates that the other roundel also bore a cone.

The base plates, which are of thin cast bronze, are flat and parallel sided. Three-sided openwork voids create the impression that they are composed of running semi-circles. There are repoussé mouldings along the top and bottom edges outside of which are rows of small perforations. These may have allowed the object be sewn to a cloth or leather head-dress. The plates are attached to each other by two rivetted metal strips, one of which is broken.

The two concave roundels are attached to the plates by means of fittings formed of rolled tubes of sheet metal flanged at each end. These are attached to the plates by rivets, and the roundels by means of soldering. They are not centered on the fittings and the point of attachment in each case is fronted by a boss.

The horn is made from a thin cast-bronze plate which was rolled into a cone, the broad end of which is curved. The proposal by one authority that the relief decoration was produced by shaving away the background metal is mistaken. The seam was sealed by rivetting to an underlying metal strip. In places the rivet heads are tooled so as not to interfere with the decoration. Otherwise they are flush with the surface. The cone is riveted to a further piece of metal which in turn is attached by means of a metal pin to a flanged fitting soldered to the back of the roundel. The horn has a rilled edge at the pointed end, which is open. There are two small opposed rivet-holes near the edge which suggest the former existence of some form of setting.

The decoration employed on the object is in low relief. The designs are based on the palmette and lotus-bud motifs. They consist of elongated spidery trumpet-patterns and lentoid bosses. The designs terminate in stylised birds' heads which differ in treatment on the horn, the roundels and the plates. The lentoid bosses and the eyes of the birds on the plates are achieved by repoussé. The designs on the plates are similar. The roundels differ from each other. That on the right bears a circle within which there is an equal armed cross. There is a perforation at the centre of this. The birds eyes on the roundels, on the horn, and the centre of the right hand roundel boss are also perforated. The boss on the left roundel carries a setting, possibly of red enamel and the perforations referred to must originally have borne similar small studs. The birds' heads, most particularly those on the horn, are remarkably similar to decoration which occurs on British 'Dragonesque' brooches of the early 2nd century A.D. and these may have served as one source of inspiration.

The ornament can be compared closely with that on three bronze horns from Cork and a bronze disc from Loughan Island in the River Bann. These objects testify to the metalsmiths' ability in the casting of thin, decorated bronzes. (See Jope and Wilson 1957a, footnotes 128-131 for other examples). The horn on the Petrie crown was cast flat and then rolled into the desired shape because this method of manufacture is considerably simpler than casting in the round, an alternative which would have necessitated extraordinary accuracy in the positioning of a core. E.P.K.

37 Decorated Stone

Mullaghmast, Co. Kildare
NMI: unregistered
Possibly 6th century A.D.
H. circa 1 m; Max. W. 37.5 cm

Cat. 36

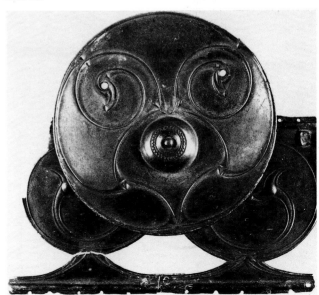

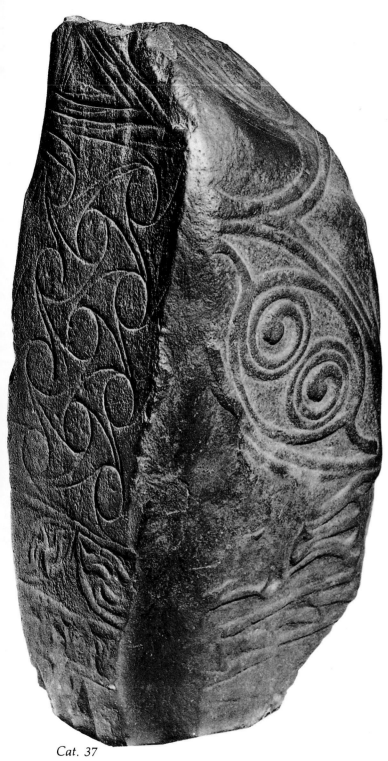

Cat. 37

Refs: Coffey 1902-4, 263-266, fig. 7, pl. 22 - Armstrong 1923, 30-31, pl. VI - Macalister 1935, 178-179, fig. 28 - Macalister 1949, 232.

The stone which is schist, came to light when a castle was demolished during the last century. It has been damaged in a number of places. The decoration is both incised and in relief. The top bears a triscele within a circle. This is framed by three trumpet motifs. A further trumpet links the base of the circle with one of the side panels. Here there is a pointed oval containing two spirals with clubbed terminals, the whole being set within a further pointed oval. This is similar to the design on the bronze enamelled latchet (no.39). Below this are two highly stylised animal heads comparable with those which occur on the terminals of the penannular brooch (no. 44). A band of zig-zag decoration, which originally may have run around the entire stone, is carved beneath the zoomorphic design and below this there are the remains of an incised saltire.

The adjoining surface to the right bears an inscribed decoration within an oval panel, framed in relief. The decoration is highly geometrical and based on interlocking peltae or palmette-derivatives. The surface is damaged. A small portion of relief decoration remains at the top of the incised panel and a fragment of the zig-zag band below is discernable.

The next side is badly effaced. The decoration, which is in relief, appears to have been set within a rectangular panel. The only surviving motif is a large spiral which has a clubbed terminal.

The remaining side has four zones of decoration the largest of which is incised, the rest being in relief. At the top is a series of triangles set one within the other. The large panel below this is once more decorated with interlocking peltae or palmette-derivatives. The panel below this contains two pointed ovals each of which bears a pair of leaf-comma motifs. The zig-zag panel at the bottom is almost completely effaced.

The practice of erecting standing stones goes back to the neolithic period in Ireland. During the hundred years before and after the birth of Christ standing stones decorated in La Tène style were erected at Turoe, Co. Galway, Killycluggin, Co. Cavan and Castlestrange, Co. Roscommon. These were directly inspired by continental prototypes. A number of undecorated Irish standing stones may also date to this period. The designs employed on the Mullaghmast stone show that it is considerably later in date than the decorated stones above referred to. Its decoration can be closely paralleled on metalwork of the fifth and sixth centuries A.D. It does undoubtedly hark back to the earlier stones - for example

the zig-zag band at the base is reminiscent of the decoration at the base of the Turoe stone. With the possible exception of the animal heads, which may have a Scottish origin, all the decoration is a late form of the La Tène style.

The Mullaghmast stone has an important transitional position, as it links the pre-christian sculptural tradition with that which evolved by way of cross-inscribed pillars and decorated slabs to culminate in the great high-crosses of the Christian era. E.P.K.

38 a-d Attymon hoard
Colour pl. p.114

Co. Galway
a, b: Two bronze bridle bits. NMI: 1891: 9, 9a
c, d: Two bronze Y-shaped pieces. NMI: 1891: 10, 10a
Possibly 3rd century A.D.
L. (a) 31.8 cm (b) Central link missing (c) 34.8 cm (d) 35.0 cm; Max. W. (a) 8.35 cm (b) 8.35 cm (c) 17 cm (d) 16.8 cm; Wts. (a) 389.28 g (b) 292.92 g (c) 289.43 g (d) 300.62 g
Refs: Armstrong 1923, 24, pl. III - Raftery 1937, 410-411 - Raftery 1951, fig. 229 - Henry 1965, 11, pl. 4 - Haworth 1971, 38-40, 44, 45, figs. 8-9 - Greene 1972, 59-78, fig. 16 - Duignan 1976, 207 - Mitchell 1977, 90, pl. 26 - Raftery 1980, 25.

The hoard was found in a peat bog about 1½ miles from Attymon Railway Station, Co. Galway.
The snaffle bits, which are of cast bronze, show considerable wear. The pattern of wear is identical on both. The central link of (a) appears originally to have been cast in a figure of eight form. The ends appear to have worn away through friction with the side links and were replaced with rivets. The rivets are dissimilar in appearance and in workmanship and one of them appears to be a later replacement. The side links are curved. They splay towards the outer end. The inner end is cast in the form of a bird's head. The rest of the convex upper surface is decorated with a raised palmette design. The splayed ends of the side links project beyond the side rings for a distance of about 2.5 cm. Stop studs are present at each side of the ring pivots. They are extensively worn. Formerly they contained a setting, probably of enamel. The side rings have a pointed oval cross-section. The Attymon bits have been placed late in the series of Irish La Tène bridle bits.

All three extremities are decorated on each of the two cast bronze Y-shaped piece. Semi-hemispherical knobs occur on the shanks. These bear raised decoration consisting of three running spirals triangularily juxtaposed, and centered on a triscele. The design is basically similar to that employed on a bronze disc from the River Bann, at Loughan Island, Co. Derry. The latter has decoration which is closely comparable to that on the Petrie Crown (No. 36). The base of each is surrounded by a low moulding where it joins the shank. There are faint grooves on the shanks 1.2 cm below this and the intervening areas are decorated with lightly incised irregular lines. The forks flatten towards the ends and expand into roundels. These are defined in each case by a raised line which almost forms a complete circle. It extends as two parallel lines for a short distance along the fork where it ends in a pelta. The roundels bear a central perforation 8 mm in diameter. They are decorated with raised off-centered ovals which have crescentic swellings along the sides nearest the extremities of the forks. They each bear a single raised pelta. The layout of the design on the roundels is broadly similar to that on the Monasterevin disc (No. 35).
One hundred and thirty five Early Iron Age bridle bits and about ninety Y-shaped pieces are known or recorded in Ireland. The bits are a distinctively Irish type while the Y-shaped pieces are unique to Ireland. In at least eight cases bits have been found with Y-shaped pieces. Both occur in pairs so it seems reasonable to assume that they were used to harness horses in paired draught. References to chariots are frequent in early Irish literature and representations of chariot-like vehicles occur on Irish high crosses. The function of the Y-shaped pieces is unclear. They are most generally regarded as having been used as pendants which were suspended from the horse's head or as leading pieces. E.P.K.

39 Bronze Enamelled 'Latchet' Brooch

Find place unknown
NMI: W492
Date uncertain: 5th-7th century A.D.
W. of disc-shaped plate 5.7 × 5.9 cm; Wt. 39.8 g
Refs: Wilde 1861, 566-567 - Smith 1917-18, 127-29 - Henry 1965, 68-69, 115, 207 - Mitchell 1977, 90 - Kilbride-Jones 1980a, 211-213 - Raftery 1980, 25.

Made of cast bronze, this object consists of a circular flat plate from the edge of which springs a sinuous S-shaped

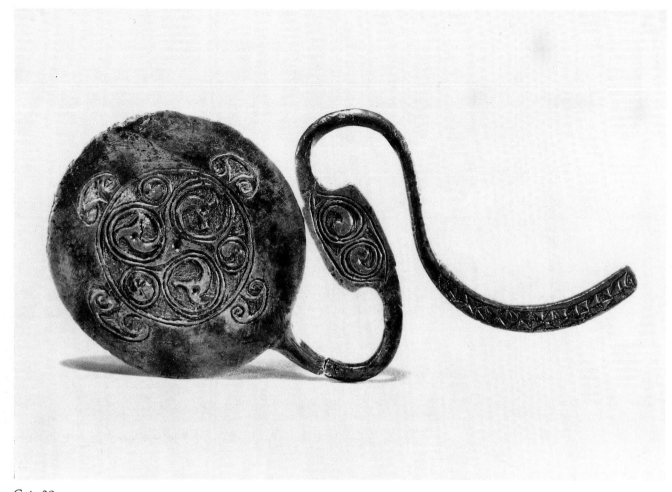

Cat. 39

tail. The disc, a flattened expansion of the tail and its end bear champlevé enamel decoration. Originally red, the enamel is now almost wholly gone. The design was fairly crudely executed the principal motif is a roundel containing a reserved triscele with bird-headed ends to the arms with tightly-wound spirals and counter-rotating lobed scrolls extending from them. The circle containing this has four equally spaced but uneven peltae projecting from it. The expansion of the arm bears a pair of reserved opposed tightly-wound spirals terminating in comma-shaped lobes in a lentoid frame. The end of the arm is slightly expanded and has a series of assymetrical cross-forms made up of contiguous wedge-shapes also as a reserve in an enamelled background. Close inspection shows that the cutaway surface has been roughened or 'keyed' for the reception of enamel. Irregularities in

workmanship can also be clearly detected. The style of decoration links the 'latchet' with a number of other objects (Nos. 40 and 44 for example) decorated with Ultimate La Tène motifs in reserve in a field of champlevé red enamel. The 'latchet' is however difficult to date but is generally regarded as being contemporary with similarly-decorated hanging bowls in 6th and early 7th century Saxon graves in England.

Objects of this rare type are regarded as having been garment fastenings - the tail was presumably inserted through slots in the cloth. There is evidence to suggest that they were worn in pairs and that their fastening properties were occasionally enhanced by the addition of thick spiral wire coils to the tail in the manner of those on the penannular brooch from Ballinderry Crannóg (No. 54). M.R.

40 Bronze Enamelled Toilet Implement

Stonyford, Co. Kilkenny
NMI: 1881: 526a
5th/6th century A.D.
L. 8.4 cm; L. of head 3.5 cm; Max. W. 188 cm; Wt. 14.3 g
Refs: Ó Ríordáin 1947, 63 - Bateson 1973, 73 - Martin 1976, 459-560.

Made of cast-bronze decorated with a complex triscele with suggestions of bird-head motifs at the ends of the scrolls and simple herring bone devices reserved in a field of red champlevé enamel. The object takes the form of a short handle with mouldings expanding into a broad flattened comma-shaped hook. The handle is equipped with a ring and loop for suspension. It has been compared with late Roman and other continental toothpicks but while similar in shape, it was probably too thick to have functioned as such. While its purpose is unknown, there is little doubt that the form of the handle follows a pattern familiar in small military accoutrements of the late Roman world.

Technically and stylistically it is closely allied to the 'latchet' (No. 39) and the penannular brooch (No. 44). Examples of the form have been found in contexts as late as the later 8th or early 9th centuries. M.R.

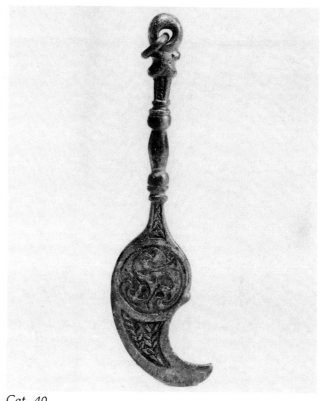

Cat. 40

Cat. 41

41 Enamelled Bronze "Hand Pin"

Find place unknown
NMI: P634
6th or 7th century A.D.
L. of pin 17 cm; L. of decorated portion 1.8 cm; D. of semi-circular plate 1.65 cm; Wt. 33 g
Refs: Ball and Stokes 1892, 291-2 - Stokes 1932, 63 - Henry 1936, 221, 222 - Raftery 1941, 93 - Kilbride-Jones 1980a, 213.

It is made up of two elements - a long pin with a right-angled projection at the top terminating in a circular plate fitted at the back with a free-riding loop and with a long tube projecting at the front. The tube bears an incised herringbone design. Attached to this is a thick, semi-circular plate to which are fastened two further similar

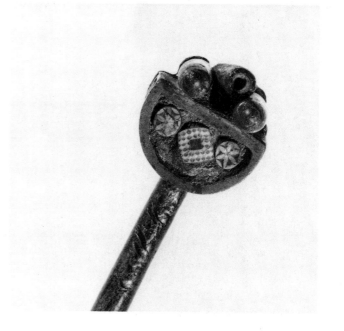

113

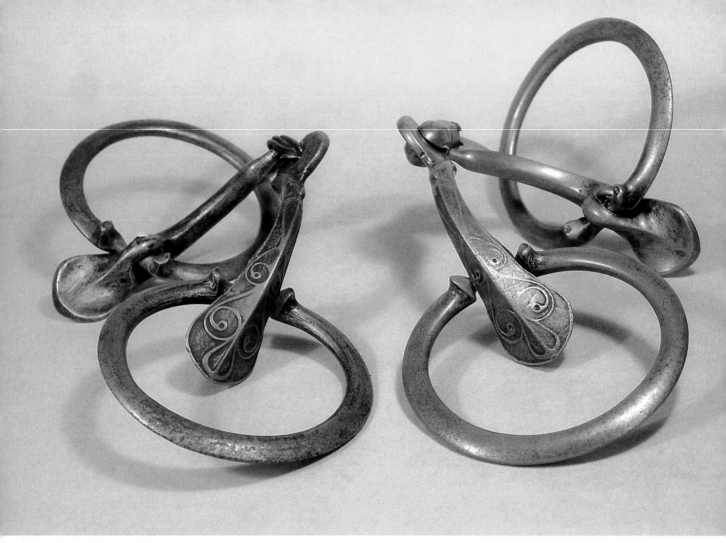

Cat. 38a-c, p. 111

tubes. The sunken front of the semi-circular plate was originally filled with enamel but most of this is now missing. Two fine, small roundels of blue and white *millefiori* glass in a marigold pattern, flanking a quadrangular platelet of yellow and red, also of *millefiori*, survive on the front. The side of the plate is also sunken and in it are quadrangular bronze panels most of which still carry small *millefiori* medallions in blue, white and red glass. They, too, were intended to have been seen against a background of red enamel but, here also, it has disappeared.

Called "Hand" pins because of their resemblance to a human hand held up with the fingers bent at 90° to the face of the palm (some have five projecting tubes), they were presumably used as decorative cloak fasteners. Their ultimate origins seem to lie in pins of the prehistoric Iron Age and their early development can be particularly well traced in southern Scotland in the early centuries A.D. The type appears to have been fashionable in Ireland in the poorly understood period from the 4th to the early 7th centuries A.D. Precise stylistic dating of individual hand pins is to a large extent speculative.

M.R.

42 Stone Pillar

Aglish, Co. Kerry
NMI: W1
5th-6th century A.D.
Max. L. 93 cm; Max. W. 26 cm; W. at top 22 cm; W. at base 18 cm
Refs: Wilde 1857, 136 - MacAlister 1945, 137-8.

Stone pillar bearing an ogham inscription, together with a Maltese cross, spear and swastikas which were almost certainly inscribed at a later date. It is made of grey-wacke which is a form of sandstone. The pillar was presented to the Royal Irish Academy by a nineteenth century antiquarian, Richard Hitchcock, who brought it there for safekeeping. A second and much smaller fragment of an *ogham* stone is still *in situ* in Aglish graveyard on the Dingle peninsula in Co. Kerry.

The *ogham* script is the earliest form of writing known in Ireland. It is a system of linear symbols cut on either side of, or across, a stem line and is based on the Roman alphabet. The key is recorded in a manuscript known as the Book of Ballymote compiled circa 1300 A.D. *Ogham* inscriptions on stone are by far the commonest and over three hundred of these survive. They are particularly well represented in the south of Ireland - over eighty *ogham* stones are known from Co. Kerry alone. The example from Aglish is interesting in that it bears two separate inscriptions differing from one another in date. An *ogham* inscription is the earlier of the two and it is cut along the two long sides of the stone. It is usual for the inscription to be placed so that it is read up one angle, across the top and down the other angle of the stone. In this example however, as it now stands, with the cross at the top, the *ogham* inscription is upside down. This immediately suggests that the cross was added at a later stage by someone who did not understand the *ogham* or who disregarded it. Furthermore, the object is incomplete as there is a gap in the middle of the inscription where the original uppermost portion of the stone has been broken off. It reads: . . . MAQI MAQ (I . . .) GGODIKA.

This is probably a commemorative inscription. The majority of *ogham* stones are inscribed only with personal names and the genealogical details of those concerned. However, it has also been suggested that as these inscriptions are normally in the genitive case, it is possible that the stones may have been boundary markers, delimiting the property "of X the son of Y the son of X".

The secondary inscription on the Aglish stone consists of a Maltese Cross in a circle, carved on the original base of

R
Z
NG
G
M
N
S
F
L
B
Q
C
T
D
H
I
E
U
O
A

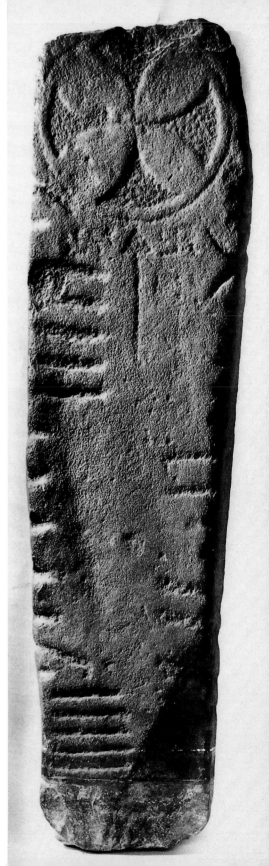

the pillar. Below the cross, there are two swastikas with a spear or arrow between them, pointing towards the cross. The spear might be taken to be a symbol of that which pierced the side of Christ on the cross, while the swastika is a symbol of the resurrection.

There are over twenty other examples of *ogham* stones in the Kerry area having later cross inscriptions. It has been suggested that these may have been added in order to Christianise the monuments. While this is a possibility in some cases, *ogham* stones as a whole should not be regarded as a purely pre-Christian phenomenon in Ireland. In fact the majority have been dated on linguistic evidence, to about the 6th century A.D., well within the Christian era. At Church Island, Co. Kerry, there is an instance of an *ogham* inscription superimposed on an earlier Christian cross. It seems likely that the *ogham* script has its origins in pre-Christian times - early examples do occur - but may have become more widespread within Christian times. While inscriptions on stone are by far the commonest, there are also some examples of *ogham* writing on metalwork. A hanging bowl from Kilgulbin East, Co. Kerry, bears an inscription on its rim and suspension loop. There is also evidence for much later use of the script on the back of a ninth-tenth century, silver, bossed penannular brooch from Ballyspellan, Co. Kilkenny (no. 66). We cannot be certain for how long the script continued in general use but it seems likely that at least some knowledge of it survived down to medieval times. *Ogham* stones are also known in parts of England, Scotland and Wales where their presence is almost certainly due to Irish influence. N.O'C.

43 Book of Durrow

Colour pls. pp. 52 and 119

Trinity College Dublin MS 57
Written ca. 675, in majuscule script
245 × 745 mm. 248 folios.
Rebinding by Roger Powell in 1954.
Ref: Alexander 1978, 32.

The Book of Durrow contains the four Gospels in latin; Euseblan canon tables; Jerome's letter to Pope Damasus about his translation; prefaces; summaries; and glossaries of Hebrew names.

The manuscript has traditionally been seen as originating in Durrow, the monastery founded by St. Columba in Co. Offaly in 553, but some scholars have argued for an origin in Northumbria or Iona. The Gospels text is close

to the Vulgate yet distinct from texts known to have circulated in Northumbria. An inscription at the end of the manuscript, ascribing its production to St. Columba, perhaps dates from the early ninth century and suggests location at that time in a Columban foundation. In the middle ages it was known at Durrow as the Gospel book of Columba. It remained at Durrow up to the dissolution of the monastery in the sixteenth century, and thereafter in local hands until passing to Henry Jones, who became bishop of the diocese in 1661, and presented it to Trinity College Dublin.

Durrow is decorated with framed evangelical symbols, carpet pages and the illumination of the opening words of the Gospels. The carpet page which now prefaces St. Jerome's letter may be misplaced, perhaps having been made for Matthew's Gospel, which now lacks such an introduction. In Durrow the evangelical symbols follow a pre-Vulgate order in which St. Mark is represented by the Eagle and St. John by the Lion. B.M.

44 Enamelled Bronze Zoomorphic Penannular Brooch

Find place unknown
NMI: X1675
6th or 7th centuries A.D.
L. of pin 16.8 cm; D. of ring 8.55 cm; Max. W. of terminals 2 cm; Wt. 63.6 g
Refs: Coffey 1909, 20-23 - Kilbride-Jones 1935, 37, 416, 417, 455 - Henry 1965, 68 - Kilbride-Jones 1980b, 108, 109 - Ryan and Cahill 1981, 44.

Of cast bronze and hammered, the terminals - or expanded areas at the ends of the ring - take the form of stylised animal heads with the snout towards the ring. On each terminal was a sunken field of champlevé red enamel - traces of which are still visible - with a thin reserve of bronze showing through in a complex series of interlocking 'peltae' or C-shaped scrolls forming an involved but elegant design in the Ultimate La Tène tradition. The ring is ribbed and the pinhead also. The long, skewer-like pin is mostly plain but, where it crosses the ring, there are two groups of grooved lines. An identical brooch is in the collections of the Ulster Museum and is stated to have been found in the River Shannon, near Athlone.

This, the earliest example of its kind in the exhibition, belongs to a great family of cloak fasteners fashionable in Ireland from about the 2nd century A.D. until the 10th

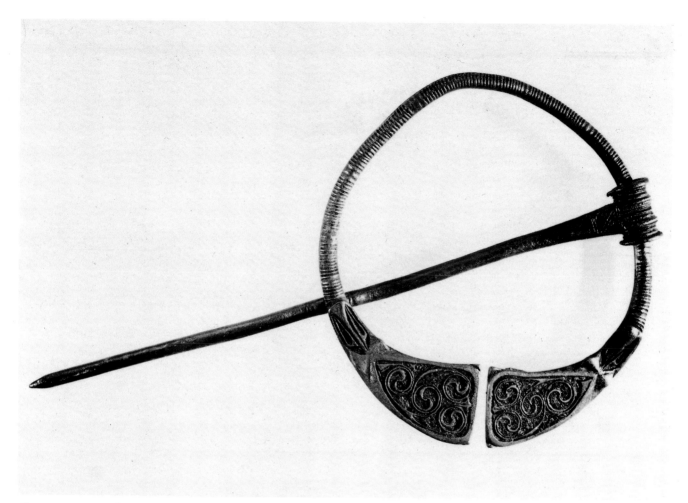

Cat. 44

century. They are called penannular because their rings are incomplete and they were fastened by piercing the fabric of the cloak with the pin and rotating part of the ring underneath it. The drag of the cloth held the pin against the body of the brooch. It appears to have been normal - and sensible - to wear the brooch with the pin pointing upwards towards the shoulder. Many surviving pins are worn and bent through constant use.

The earliest Irish examples appear to have been borrowed through contact with peripheral areas of Roman Britain and, perhaps, southern Scotland as early as the 2nd century A.D. These were simple brooches, the terminals of which took the form of stylised animal heads hence the term 'zoomorphic'. The broad terminals in time came to assume great importance as fields for displaying lavish ornament often of La Tène - derived scrollwork. Enamel came increasingly to be applied and by the 7th century the brooches had become very elaborate.

Partly replaced by 'pseudo-penannular' brooches as high fashion in the 8th century, the penannular brooch enjoyed a renewed vogue in modified form in the later 9th and 10th centuries.

M.R.

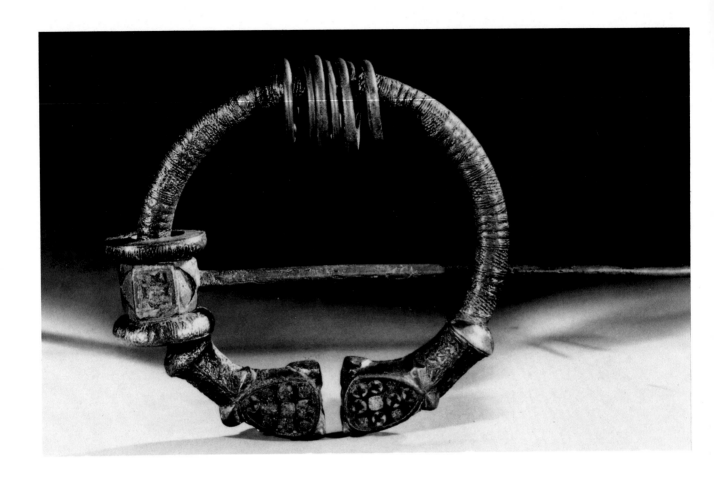

45 Enamelled Bronze Zoomorphic Penannular Brooch

Ballinderry Crannóg No. 2, Co. Offaly
NMI: E6: 422
7th century A.D.
L. of pin 18.3 cm; Max. W. of ring 8.6 cm; T. of ring 7.5 mm; Wt. 188 g
Refs: Kilbride-Jones 1935-37, 443-444 - Hencken 1941, 34-38 - Kilbride-Jones 1980b, 120 & fig. 40, 122 - Ryan and Cahill 1981, 48.

Made of cast bronze with apparently, hollow terminals. One of the most elaborate of zoomorphic penannular brooches, it belongs to a small group which have on each terminal and on the pinhead, sunken fields of red champlevé enamel with inlaid platelets of *millefiori* glass. The reverse of each terminal of this brooch is decorated with engraved, compass-drawn marigold and partial marigold designs on an applied plate. The sides of the terminals bear incised herringbone motifs and traces of tinning now missing elsewhere on the brooch. The ring is decorated with alternating bands of lines, hatchings and herringbones. The pin is rounded and tapered; the pinhead consists of a barrel-shaped element to which are soldered two decorated side-rings. The reverse of the pinhead has a sunken oval panel. On the ring there is a pair of bronze wire coils: each has one sharp and one blunt end and may have been used in combination as an additional fastening device to pass through the cloth of the garment and to hold the pin in place.

The ribbing of the ring of the brooch is closely comparable with the decoration of a moulding on an enamelled hanging bowl from the Saxon ship burial of Sutton Hoo, England, suggesting that this brooch belongs to the earlier 7th century. The use of millefiori platelets, floated in a field of red enamel is also closely matched on the Sutton Hoo bowls. M.R.

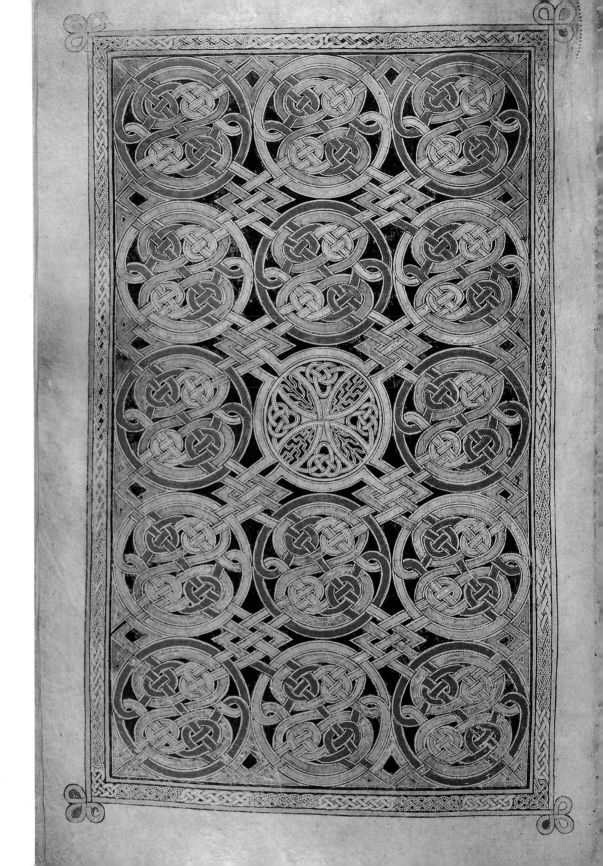

*Book of
Durrow, Carpet
page, fol. 85v,
Cat. 43, p. 116*

46 Bronze Figure of an Ecclesiastic

Colour pl. p.32 left.

Aghaboe, Co. Laois
NMI: R2945
Date uncertain: 7th or 8th century A.D.
L. 12.9 cm; Max. W. 4.78 cm; W. 137 g
Refs: Crawford 1923, 87 - Raftery 1941, 145, 154 - Henry 1965, 94, 100[n], 114 - Lucas 1973, 58 - Mitchell 1977, 92 - Raftery 1980, 34, 35.

Made of cast, formerly gilt, bronze in high relief the figure is stiffly modelled. The body shown as wearing a long tunic, is almost cylindrical; the limbs are simply rendered and the head is somewhat disproportionately large with the ears especially emphasised. The figure holds in one hand a book and in the other a short staff (perhaps a crozier) with a curved walkingstick-like handle. Around the brows there is an ornamental head band now very worn. Kerbshnitt decoration in the Ultimate La Tène style forms the background for the head. Interlace decorates the background on the left-hand and fret patterns the right-hand sides. The body of the garment was covered with interlace. The object is pierced for attachment - probably to a shrine - in a manner which disregards the presence of the ornament. This casual disturbance of carefully-wrought decoration is a strange but regular feature of much 8th and 9th century Irish metalwork.

Representations of the full human figure are fairly rare in metalwork of 7th and 8th century Ireland. The crucifixion plaque (No. 47), the escutcheons of a small number of late hanging bowls in Norwegian Viking graves, on a brooch from Togherstown, Co. Westmeath and some filigree on the newly discovered Derrynaflan paten are the only examples. Where they occur, they are generally rendered in as stylised and greatly simplified a manner as the Aghaboe figure, clearly signalling the resistance of the craftsmen to a representational style. The human head, however, was widely used in metalwork (Nos. 48, 51a, 55, 64). The influence of manuscript illumination probably helped to make human representation more common. The Aghaboe figure cannot be precisely dated but certain elements relate it to the style of the 8th century. M.R.

47 Openwork Gilt Bronze Crucifixion Plaque

Colour pl. p.33

NMI: R554
Probably 8th century A.D.
L. 21.1 cm; W. 13.9 cm; Wt. 184.35 g
Refs: Gougaud 1920, 131 - Crawford 1923, 157 - Raftery 1941, 105-106 - Henry 1965, 114 - Lucas 1973, 58, 117, 119, 170 - Mitchell 1977, 91-92 - Raftery 1980, 34 - Harbison forthcoming.

Made of hammered gilt bronze with engraved and chased ornament, the plaque may be one of the earliest surviving representations of the crucifixion in Ireland. The figure of Christ is greatly enlarged in relation to those of the flanking soldiers and angels. He is shown wearing a long-sleeved tunic with decorated cuffs, hem and vertical bands on the skirt. Christ's breast is covered by an Ultimate La Tène style repoussé composition of interlocking peltae and tightly-wound spirals apparently a skeuomorph as false nailheads are depicted on it. The arms and upper part of the shaft of the cross are shown - their concavity and clearly indicated edge mouldings suggest that they were modelled on a developed sculptural form. The soldiers and angels are shown with their bodies in profile and their heads full face. The right hand soldier's (Longinus) cloak and tunic have a running border of Ultimate La Tène scrolls. The cloak bears faint incised lines. The left hand figure (Stephaton) has an ornamental hem on his tunic and broad decorative stripes on his cloak on which a hood may be indicated. The angels bear interlace, fret and Ultimate La Tène devices and their feathers are indicated by a herringbone hachuring. They hold short swords in their hands.

Thought to have been the decoration for a book-cover, the plaque could just as readily have been applied to a large composite shrine, cross or altar. Often considered to be one of the earliest examples of the style of the Golden Age it has been ascribed to the later 7th century. However in its perfection of many techniques of 8th century Irish work particularly 'kerbschnitt' and in its elaboration of the representation of a figured scene, it seems to belong more firmly to a developed than to a preliminary phase. This form of representing the crucifixion remained traditional in Ireland and areas of Irish influence in Scotland and the Isle of Man for many centuries (see No. 78). M.R.

48 Silver-gilt Pseudo-penannular Brooch (The 'Tara Brooch')

Colour pls. front cover and p.39

Bettystown, Co. Meath
NMI: R4015
8th century
D. of ring 8.7 cm; Max. W. of the terminal plate 4.55 cm; L. of pin 32 cm; Wt. 224.36 g
Refs: Coffey 1909, 8, 25-27, 39, 71 - Smith 1913-14, 228, 231-233, 248 - Stokes 1932, 57-65 - Raftery 1941, 126 - Wheeler 1949-52, 155-158 - Henry 1965, 108-110, 111, 116 - Lucas 1973, 64, 65, 85-93, 141, 143 - Whitfield 1974, 120-142 - Whitfield 1976, 5-30 - Mitchell 1977, 137-138 - Raftery 1980, 35-36.

Made of cast silver-gilt with gold filigree, amber and polychrome glass ornaments, the variety and sumptuousness of the decoration clearly rivals that of the more elaborate manuscripts. The brooch consists of an elaborate ring divided on the front into numerous panels by cast mouldings. The ring swivels freely in a loop of complex construction on the back of the pinhead. All the surfaces of the brooch, including the inner and outer edges, carry ornament.

The decoration may be divided into two types. On the front animal and plain interlace in gold filigree, together with cast beast - and bird - heads - in some cases with complete, attenuated bodies - projecting from the margins of the ring and pin-head predominate. Settings are almost all filled with amber cut and polished into various forms. Glass occurs but it is much less prominent. A knitted silver wire ('trichinopoly' work) chain, perhaps for a guardpin or brooch, is attached to one side. Its animal-headed tag bites a hinged tab decorated with four beast-heads in profile, which in turn pivots in the mouth of a head projecting from the side of the ring. On the tab are two tiny cast-glass human heads. Cast and gilded kerbschnitt ornament occurs on the shank of the pin and at the narrower end of the pin-head. The filigree of the panels of the front is especially fine. The motifs - animals, stylised snakes and simple scrollwork - are executed with great delicacy, vigour and skill on gold foil in a variety of gold wires of different thicknesses. The wires have been treated in many different ways - some are beaded, others plaited, others are simply twisted. In some cases a motif is built up from a combination of these as for example the large animal design in the surviving (left-hand) principal panel on the front. The beautifully-sketched beast in the main panel of the pinhead is constructed of parallel ribbons of gold set on edge and capped with beaded wire. The filigree panels are secured by means of 'stitching'. Small insets of filigree and granules of gold are placed in the principal glass - and amber - filled settings of the front and cover the means by which these are held in place.

The ornament of the reverse including the pin-head contains no filigree and is about equally divided between motifs in the Ultimate La Tène style, bird and beast panels and some interlaced knotwork. Amber occurs in settings on the back but in two of the principal ones, complex inlaid red-and-blue glass studs occur. The ornament of the back is mainly executed in cast imitation kerbschnitt but the two large silver panels with elaborate and extremely delicate Ultimate La Tène designs are most unusual technically. The design was produced by polishing away a thin film of silver which had been applied to a copper plate on which the design had first been lightly embossed: the ornament was then revealed in the red colour of the underlying metal. A panel, similar technically, occurs on the ring where a gold film has been pierced to reveal the design. Kerbschnitt ornaments occur on both the inner and outer edge of the ring.

There is a sound practical reason for confining the filigree to the front of the brooch. If it were not, the wires would be snagged by the fibres of the cloth of the garment on which it was worn and damage would occur. Nevertheless, it would seem that there is a marked difference in emphasis between the obverse and reverse and it may be that less fashionable elements were confined to the back to make way for motifs, techniques and materials enjoying contemporary favour.

The dating of the brooch is somewhat controversial. It has been argued that the entwined beast and bird friezes of the back are related in style to the decoration of the Book of Lindisfarne and so the brooch might belong to the earlier 8th century. The animal ornaments of the back of the ring and pinhead belong undoubtedly to a small and distinctive group of ornamental metalwork objects which is represented by finds in 9th century Norwegian graves, from the St. Ninian's Isle hoard and from Steeple Bumpstead in England. The characteristic contorted animal of this style is regularly associated with Ultimate La Tène motifs and relief-casting of considerable excellence. A generalised 8th century date for the 'Tara' Brooch is probably indicated because its ornaments are so clearly amongst the finest work of the Golden Age but reference to a precise bracket within that period would be questionable.

The 'Tara' Brooch is a ring brooch: that is, it has no gap between the terminals through which the pin may be passed to allow it to lock - hence the need for subsidiary fastenings implied by the chain and loops. It is therefore a

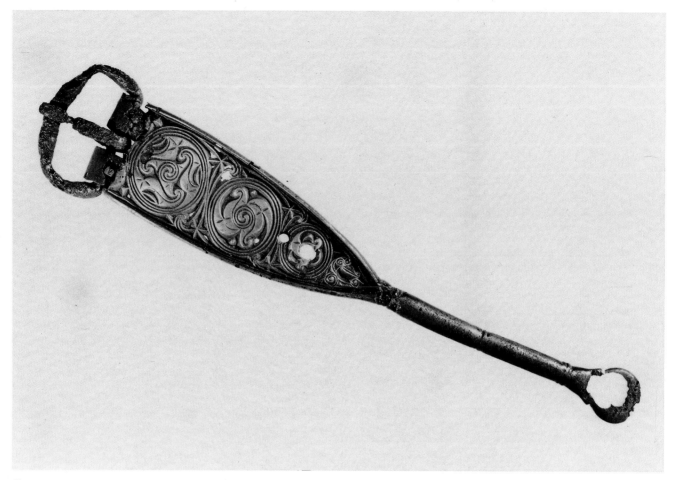

Cat. 49

pseudo-penannular, so called because the design and layout of the panels is quite clearly developed from the penannular form such as Nos. 44 and 45. The ring is greatly expanded as a field for decoration and has in effect become a pendant like those of some contemporary but humbler pins. Pseudo-penannular brooches enjoyed great popularity among the well-to-do in 8th and 9th century Ireland (Nos. 51c, d, e, 54, 61, 62) and most of the finest examples are made of silver unlike the earlier bronze penannular forms.

Penannular brooches remained more popular in Scotland during this phase and many of them show decorative developments parallel with those of the Irish pseudo-penannulars. M.R.

49 Bronze Belt-buckle

Formerly Gilt. Found in the excavation of the royal crannóg of Lagore, Co. Meath
NMI: E14:213
8th century A.D.
L.15.8 cm; Max.W. of decorated plate 2.4 cm; Wt. 37.15 g
Refs: Hencken 1950-51, 66 - Henry 1965, 13, 103, 140 - Lucas 1973, 139 - Ryan and Cahill 1981, 50.

The decoration consists of three tightly-wound, connected Ultimate La Tène style kerbschnitt spirals of decreasing size to conform to the tapering of the body-plate. The centre of each spiral is occupied by triscele

figures of varying complexity - that in the largest having dependent lobes creating a counter-rotating effect. At the narrowest point of the decorated panel, a dog-like animal with back-turned head is placed. It is a mature Irish version of an animal motif of the type originally borrowed into the repertoire in the 7th century A.D.

The composition combines a strong element of the flavour of the style of the 6th-7th century (objects 39, 40, 43) modified by the adoption of the kerbschnitt technique. There can be little doubt that this magnificent buckle was made for a person of importance — Lagore was a royal crannóg. Often compared with late Roman examples, it is in fact much less close to them than a series of small 8th and 9th century kerbschnitt and enamelled buckles from other Irish sites which were probably inspired by widely distributed Germanic versions. M.R.

50 Antler Trial Piece

Dooey, Co. Donegal
NMI: E33: 1385
7th-9th century A.D.
L. 12 cm; Max. W. 4.4 cm
Refs: Ó Ríordáin and Rynne 1961, 64 - Henry 1965, 93 and pl. - O'Meadhra 1979, 8, 23, 36.

Discovered in 1959 in the course of excavations at a sandhills settlement site on the Donegal coast. This site has produced a wide range of artifacts dating to the early historic period, many of which are associated with metal working.

The trial piece which is made of antler, bears a series of panels with ornamentation executed in the kerbschnitt technique. It has been cut at both ends and now shows some signs of wear. The motifs represented on the piece include triple spirals, multiple lozenges and hexafoils, most of which are incorporated into rectangular panels. Various dates in the first millennium A.D. have been put forward for the piece. It has been suggested that some of the motifs can be paralleled on Roman metalwork of the first few centuries A.D. (Kilbride-Jones 1980b, 210). However, the use of the kerbschnitt technique and the panelled arrangement of the decoration would imply a date not earlier than the 7th century A.D. Furthermore, patterns such as these appear to have had a long life on Irish metalwork - triple spirals are to be found on the back of the Tara brooch (no. 48) and marigolds occur occasionally on penannular brooches (no. 45). Trial pieces are not known to have occurred in pre-Christian

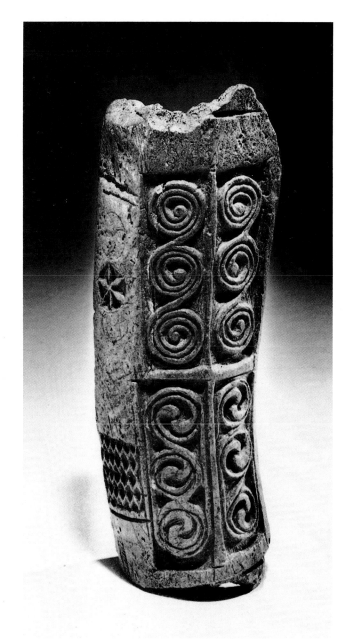

Cat. 50

contexts - this would also make an earlier date seem unlikely.

About 160 trial pieces are known from Ireland, occurring mainly at sites of the early historic period and Viking Dublin. They have also been found in Britain. Interpretations of their function vary considerably. The

term 'trial piece' has its origins in the belief that they may have been preliminary sketches - craftsmen may have used them in experimenting with designs prior to executing them in precious metal. It is also possible that they could have been used in the training of apprentices. Clay moulds for use in casting might also have been prepared from them. It has also been suggestd that metal foil may have been impressed directly upon them to reproduce patterns.

Because it is difficult to be certain of their use it has been suggested that the term trial piece should be dropped and replaced by the term 'motif piece'. (O'Meadhra 1979, 8).

N.O'C.

51 a-f The Ardagh Hoard

Co. Limerick
NMI: 1874: 99-104
Deposited in the 10th century A.D.?

This magnificent hoard consisting of a silver and a bronze chalice, three silver pseudo-penannular and one 'thistle' brooch was found in September 1868 by a youth digging potatoes within a ringfort called Reerasta Rath near Ardagh, Co. Limerick. The objects were buried at a depth of just under 1 m and partly protected by an upright stone. One of the few hoards of metalwork containing liturgical vessels, the dates of manufacture of the objects range from the 8th to, perhaps, the 10th centuries A.D. This has been taken to suggest that the hoard was concealed during a period of Viking activity probably in the 10th century.

51a The Ardagh Silver Chalice

Colour pls. frontispiece and pp. 126 and 127

NMI: 1874:99
8th century
H. 17.8 cm; D. at rim 23.1 cm
Refs: Dunraven 1867-74, 433-454 - Coffey 1909, 37-39 - Braun 1932, 59, 149 - Gogan 1932 - Stokes 1932, 65-72 - Raftery 1941, 142-143 - Elbern 1963, 68 - Elbern 1965 - Henry 1965, 106-115 - Lucas 1973, 97-105 - Organ 1973, 238-271 - Mitchell 1977, 138 - Raftery 1980, 36 - Ryan 1983 - Ryan forthcoming b.

This chalice, perhaps the finest Irish work in metal from the first millennium A.D. is a native rendering of a form well known from Byzantine silver hoards of the 6th century. While it is inspired by eastern mediterranean prototypes, it is wholly an Irish product adapting local traditons of bowl design and decoration to the production of a liturgical vessel. The chalice is of ministerial type *(calix ministerialis)* used for dispensing eucharistic wine to the faithful. It was restored twice since discovery - once in the 19th century when it was cleaned by the jeweller Johnson and again by the British Museum Laboratory in 1961 when a great deal was learned about its structure. The bowl and large sub-conical foot are made of beaten lathe-polished silver and the handles are cast in the same metal. The cylindrical stem and seating rings of the bowl and foot are made of cast gilt bronze. A gilded bronze moulding has been applied to the rim of the bowl. The components of the vessel are held together by a square-sectioned split-pin, the head of which can be seen in the bottom of the bowl. Where the split-pin reaches the surface of the underside of the foot there is a large setting with a conical polished crystal in a magnificent cast-bronze ring with filigree and kerbschnitt ornaments.

The handles spring from two ornamental escutcheons decorated with filigree and glass and rivetted in place. In general, the silver of the bowl is left undecorated but a magnificent applied girdle of gold filigree panels and glass studs encircles the bowl just below the rim and there are two applied roundels on the body each divided into a cruciform pattern and embellished with gold filigree and glass studs. An inscription recording in latin the names of eleven original apostles and St. Paul (ten of them in the possessive case and two, Tatheus and Simon, in the nominative), can be seen on the surface of the silver under the bowl girdle. The letters, in style close to capitals in the Book of Lindisfarne, are seen as a plain reserve against a stippled background. Lightly engraved borders outline the handles, escutcheons, roundels and the upper edge of the stem where it meets the bowl. Beneath the handles and the escutcheons these expand into animal or human headed motifs. Many of the glass polychrome studs have inset angular metal grilles which are in effect attempts to render the appearance of cloisonné garnet work of Saxon and Frankish jewellery. The placing of patterned silver foils under the studs of some of the settings of the foot is also evidence of a debt to those traditions. The principal studs of the handle escutcheons are bordered by compartmented channels which bore thin amber decorations fastened in position with a glue mixed with malachite which shows as green in

most cases. This was doubtless a goldsmith's preparation for delicate soldering pressed into service for an unusual purpose. Some of the blue glass studs on the underside of the foot have 'C' scrolls of beaded wire set into them. Sheets of mica were employed as a backing for some openwork panels on the foot.

The filigree is of great interest - much of it is executed on stamped foil which has had its background cut away. Beaded and twisted wires and gold granules are used and bird, beast and plain interlace are present together with simple scroll work and stylised snakes. The grade and type of wire is skillfully varied by the goldsmith to achieve in the tiny panels an effect of depth and to give vitality to the motifs.

The kerbschnitt ornaments, both of the stem and the underside of the foot are cast and the Ultimate La Tène style is well represented together with animal patterns interlace and key motifs. Openwork gilt-copper plates with fret patterns on the upper face of the flange of the foot, and on the underside, woven wire mesh and impressed copper plates complete the inventory of the ornament.

The chalice is a compendium of the skills of the metalworker in use in Ireland at that time. The excellence of the filigree is matched only on the 'Tara' Brooch (No. 48) and on the recently discovered Derrynaflan paten. The art of glassworking was still of a high standard but we can see in the use of crystal, amber and mica the tentative beginnings of experimentation with semi-precious stone as ornament. The ornaments link it closely with the style of the Book of Kells (No. 53) and the 'Tara' Brooch. It would be unwise to be too dogmatic about its date - it clearly belongs to a mature phase of the development of style perhaps the later part of the 8th century, It is not, however, a unique object. A chalice closely similar in design but 9th century in date has recently been found in the ancient monastic site of Derrynaflan, Co. Tipperary. M.R.

51b Bronze Chalice

NMI: 1874:99
Probably 8th century
H. (present) 11.8 cm; Max. D. of rim 13.8 cm; Depth of bowl, 6.74 cm.
Refs: Coffey 1909, 37, 39 - Gogan 1932, 18, 56 - Elbern 1963, 68 - Elbern 1965 - Raftery 1941, 142 - Ryan 1983 - Ryan forthcoming.

Damaged at the time of discovery, it is a plain beaten, lathe-polished bronze cup with a flared rim and pro-

Cat. 51b

nounced groove below it. The cup originally stood on a short tubular stem with a slightly out-turned rim. This was cut through by the finder and only the mouth portion survives. It was remounted on a wooden dowel during the 19th century - replaced in 1977 with perspex - so the evidence for more precise calculation of the original proportions of the chalice has been destroyed.

Often regarded as a celebrant's chalice (a *calix minor* or *calix sanctus*) the form of the bowl closely matches that of the large silver chalice in shape and technique of manufacture and the two from Ardagh, together with the recently-found Derrynaflan chalice, clearly demonstrate the existence of a strong native tradition of design of liturgical vessels. The use of bronze or copper for chalices is attested elsewhere in Europe at this time and is known to have been considered the metal of the nails of the crucifixion in one Irish tradition and therefore an entirely appropriate material for such a sacred purpose. It, too, is a rendering of a Byzantine style of chalice in a local idiom of bowl-making. M.R.

51c Silver-gilt Pseudo-penannular brooch

NMI: 1874:104
8th or 9th century
D. of ring 13.1 cm; Max. W. of terminal 7.58 cm; L. of pin 33.55 cm; Wt. 500.54 g
Refs: Dunraven 1867-1874, 452-454 - Coffey 1909, 37, 40-41 - Raftery 1941, 142 - Lucas 1973, 94 - Mitchell 1977, 141.

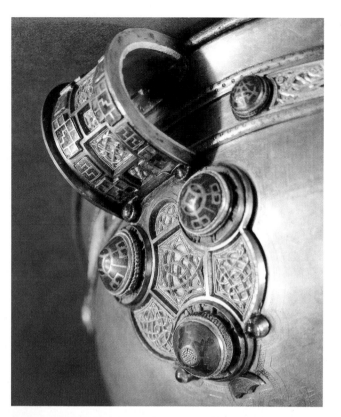

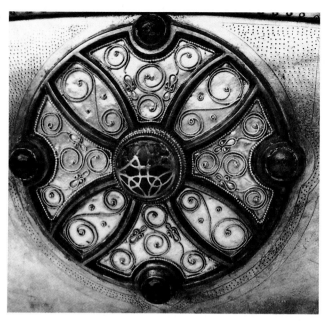

The silver chalice from the Ardagh hoard, Cat. 51a, p. 124

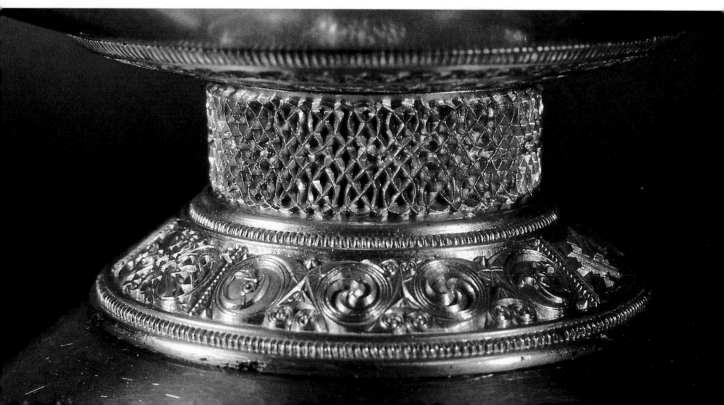

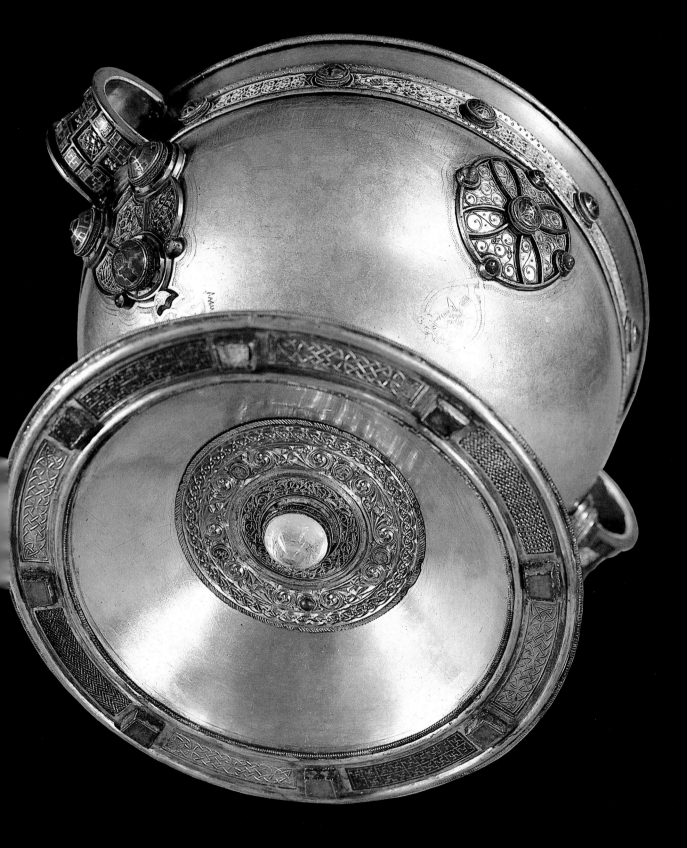

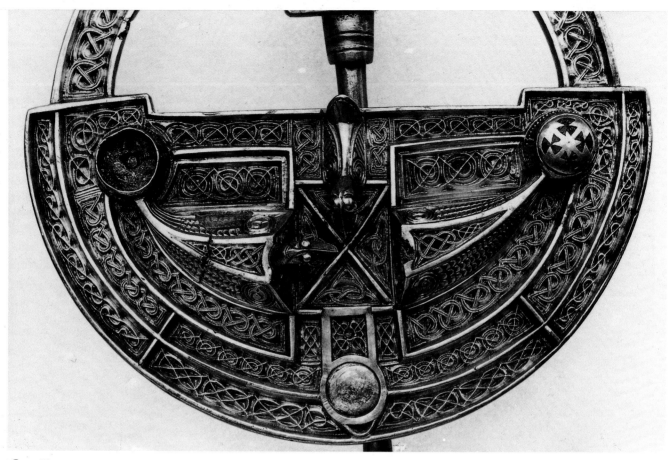

Cat. 51c

A large example of the familiar Irish type, the ring is completely closed and the terminals are merged into a broad semi-circular plate covered with narrow panels of kerbschnitt interlace, some of it in double-contoured lines. The hoop of the ring is divided into panels also kerbschnitt-decorated. Three birds in high relief decorate the plate. Two of them have their wing feathers indicated by a pattern of scales and panels of interlace on their backs. One of them has a portion of the metal on one side torn away to reveal a carved bone form underneath, the head of the other is missing. The third bird is smaller and less heavily decorated. Its tail is clearly modelled. The pinhead is trapezoidal with triangular projections on three sides. Its decoration echoes that of the plate and it contains an empty triangular and round setting perhaps for a bird figure. The shank of the pin bears a narrow panel of cast kerbschnitt decoration along an expanded portion of its length.

Round settings occur on the pinhead and ring in the customary positions but only one stud survives. It is silver, hemispherical and embellished with four angular glass inlays. It is clearly a clumsy attempt to render the appearance of the elaborate grilled or inlaid polychrome studs on objects such as the Ardagh silver chalice.

On the reverse, an incised line borders the edge of the brooch. Two panels, answering the position and general shape of the larger birds on the front, carry a gilt-bronze kerbschnitt beast motif on a thin plate which evidently covers fillings of hollows in the plate at that point. A similar feature occurs on several other Irish brooches. These beasts are related in style to examples on some 8th and 9th Carolingian metal objects of insular influence.

The absence of filigree, the relative lack of accomplishment of the surviving stud, the animal panels on the reverse might all suggest a date after the finest period of golden age metal-working. The appearance of

the prominent bird ornaments recalls the use of bird heads on the terminals of a number of elaborate Scottish penannulars - a type also represented in Ireland - and on the crook of the Irish 'crozier' from Ekerö, Sweden, and might require a reassessment of this brooch's dating. It belongs at earliest to the later 8th century and could conceivably be 9th century in date. M.R.

51d Silver-gilt Pseudo-penannular Brooch

NMI: 1874:101
9th century A.D.
L. of pin 25.55 cm; D. of ring 9.2 cm; Max. W. of terminals 4.60 cm; Wt. 160.09 g
Refs: Coffey 1909, 40-41 - Gogan 1932, 56, 57 - Raftery 1941, 142 - Graham-Campbell 1972, 115, 116 - Mitchell 1977, 197.

Cat. 51c

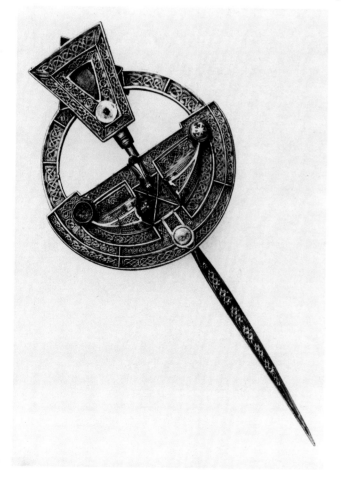

Cat. 51d ▷

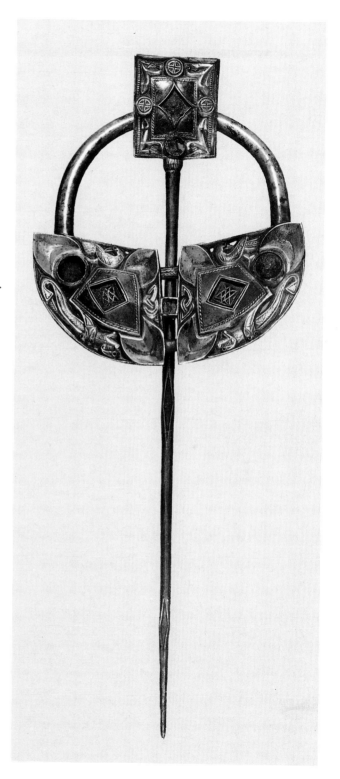

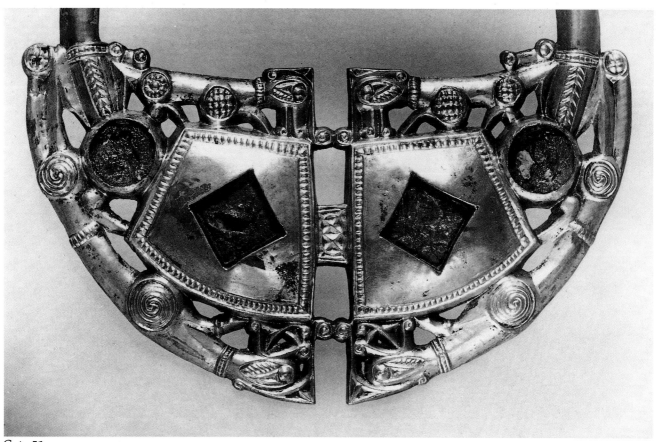

Cat. 51e

The hoop is plain and 'D'-shaped in cross-section. The pseudo-terminals take the form of two almost quarter-circular plates with a high, plain rim connected by three tabs. In each angle is a hollow, leaf-like moulding. The central area is raised and on it is a quadrangular depression containing a simple coarse filigree interlacement on an openwork sheet of foil. Between the lobes are cast ornaments, a simple, double-contoured knot, a bird with head turned back and, along the curved side, a hippocamp-like beast partly overlaid by the body of another. The latter have glass eyes, the birds have empty eye-sockets. On one terminal is a round amber stud and on the other an empty setting for another. With the exception of the raised areas, the terminals are gilded.

The pinhead is square with a raised inner panel, also square. The background is divided into four roughly L-shaped frames by three gilt roundels with a chiselled cross-pattern on each and a round amber stud at the point where the pin joins the head. In each of these panels

is a squatting, long-snouted beast each with a tiny glass eye and each with its foreleg raised in front of its face. On the raised area is a sunken panel for filigree: its sides are arcs. In it are the remains of a paste backing material used to adjust the depth of the filigree panel to the artist's satisfaction. The reverse of the brooch has two sunken areas corresponding to the raised parts of the front. One of these has a decorative capping composed of two silver plates with a gilded cross pattern. The other sunken panel has lost its covering and can be seen to be filled with lead. The loop for the pin bears a crudely incised basketry device. Its shank has two lozenge-shaped panels on one of which there is faintly incised knot.

This brooch shows characteristics which are repeated on a number of 9th century pseudo-pennanulars - the plain, half-round hoop, the square pinhead, the quadrangular sunken panels for filigree, the use of amber in preference to glass but, most particularly, the increasing emphasis on large animal motifs along the margins of the terminals.

M.R.

130

51e Silver-gilt, Pseudo-penannular Brooch

NMI: 1874:102
9th century A.D.
L. of pin 26.4 cm; D. of ring 9.72 cm; W. of terminals 5.7 cm; Wt. 227.74 g
Refs: Coffey 1909, 40-41 - Gogan 1932, 56, 57 - Raftery 1941, 142 - Mitchell 1977, 178, 179.

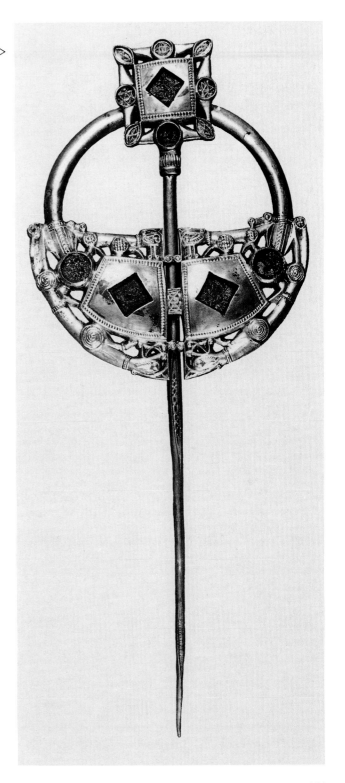

Similar in many respects to 51d, this pseudo-penannular brooch lacks the filigree-panels in the terminals and pinhead. The marginal animals are represented in openwork - they are elongated beasts with tubular bodies. Those on the outer margin are shown with open jaws, tongue and fangs and their crests or 'lappets' are extended to form decorative scrolls in the gap between the pseudo-terminals. Their joints are emphasised by spiral relief bosses. The beasts of the inner margin have closed jaws and their crests are used in the same manner. Their joints are marked by brambled bosses which are clearly intended to substitute for the enamelled studs with gold granules of 8th century work.

The pinhead is square with a raised central area in which there is a sunken panel. It is surrounded by lobed forms in openwork connected by oval and round bosses with simple kerbschnitt ornament on them. Round settings on the terminals and pinheads have been described as containing traces of red enamel. They do not: they are filled with a paste made of a whitish base with black particles in suspension in it. It is similar to the backing in the filigree plates and that behind the thin amber stud on the pinhead of 51d. These settings may therefore have contained thin amber sheets, glued in place in the manner of those on the studs of the handle-escutcheon of the silver chalice. The shank of the pin has two sunken pointed-oval panels with simple kerbschnitt on the front and a plain sunken panel on the back. On the back of the pseudo terminals are two slightly convex silver plates divided by cruciform gilt rope mouldings originating in circles.

It has been argued that the brambled bosses are an important component in the development of 9th century brooch styles and may have contributed to the appearance of the 'thistle' brooch. The absence of enamels and glass are also noteworthy features.

M.R.

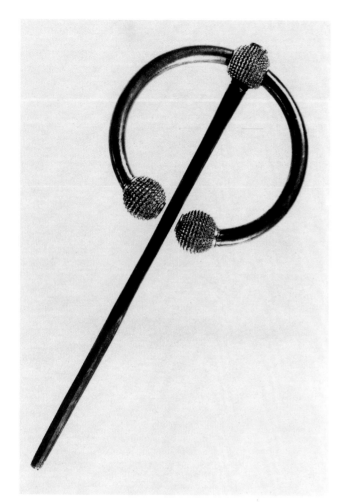

Cat. 51f

part is triangular in section. A male-female joint unites the shank with the pinhead.

This is a simple, elegant thistle brooch (see no. 68), examples of which have been found in hoards of the 10th century and the type may have been current in the later 9th also. This brooch is the most recent object from the Ardagh hoard and is often regarded as indicating the general period at which the objects were cached.

M.R.

51f Silver-gilt 'Thistle' Brooch

NMI: 1874:103
Later 9th or 10th century
L. of pin 17.9 cm; D. of hoop 7.65 cm; Av. D. of terminals 1.56 cm; Wt. 136.4 g
Refs: Coffey 1909, 40-41 - Gogan 1932, 56, 57 - Raftery 1941, 142 - Shetelig 1948, 76-78 - Graham-Campbell 1972, 123-124 - Mitchell 1977, 179, 180.

A plain round-sectioned silver penannular hoop terminates in two spherical, gilt brambled knobs. The pinhead is of similar form, the pin being initially round, flattens and widens towards the blunt point, its lower

52 Book of Dimma
Colour pl. p.53

Trinity College Dublin MS 59
Written late 8th century, in minuscule script
175 × 142 mm, 74 fols.
Rebinding by Roger Powell in 1957.
Ref: Alexander 1978, 69.

The Book of Dimma contains the four Gospels in a version which is basically the old latin translation revised extensively from the Vulgate, along with the late tenth or early eleventh century addition of a service for visitation of the sick. The same hand may have been responsible for the altering of inscriptions which attempted to attribute the copying of the manuscript to the scribe Dimma. At this time the manuscript was probably at the monastery of Roscrea, Co. Tipperary. The unaltered part of one inscription, however, indicates that it was written for Dianchride, a name occurring in the genealogy of the Ui Chorcrain who had a branch in north Tipperary and whose members are known to have been abbots of many major houses from the eleventh century on. The provenance of the manuscript is obscure until the nineteenth century, when its appearance is recorded in Nenagh, Co. Tipperary. In 1836 Sir William Betham, Ulster King of Arms, sold it to Trinity College Dublin. On a decorative level Dimma is not of the highest quality, but indicates useful comparison with other, more developed manuscripts. The first three Gospels are prefaced by seated portraits of the evangelists which appear to derive ultimately from the same model as the symbol of Matthew in the Echternach Gospels (Paris, Bibliothèque Nationale lat 9389). A different, more talented artist produced the Eagle of John and the opening of his Gospel, in a style reminiscent of the same theme in the Stowe Missal and the Book of Mulling.

B.M.

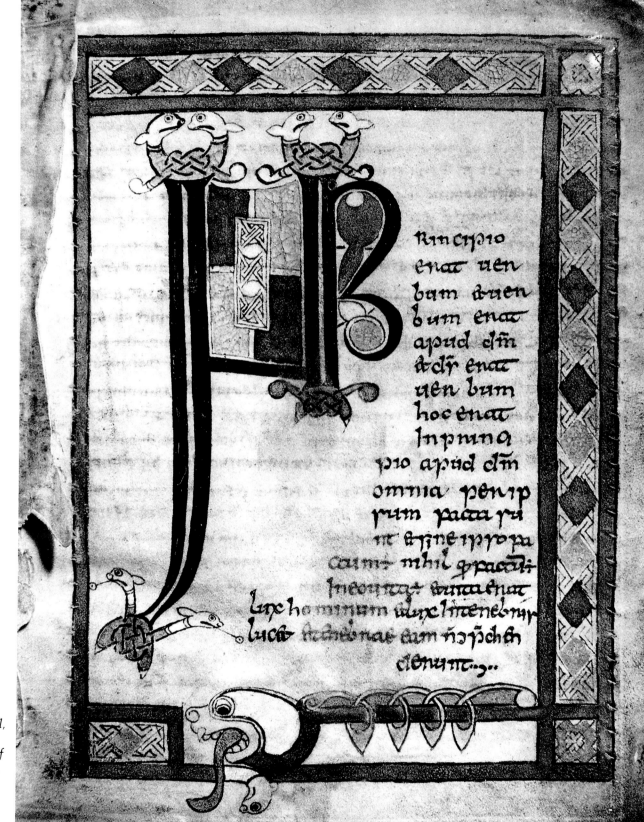

Rincipio
enat uen
bum &uen
bum enat
apud dm
& dr enat
uen bum
hoc enat
Inprinci
pio apud dm
omnia penip
rum pacta ri
nc &sine ipo ip
cam nihil qpacdis
Incouitat uitta enat
licx hominum uitxe litenebnis
lucis &tenebnas eum non comphend
denunt...

Stowe Missal,
Prologue to
the Gospel of
St. John, fol.
Ir, Cat. 53

53 Stowe Missal

Royal Irish Academy, Dublin. MS D iv 2.
Written ca. 800, in cursive minuscule and angular majuscule script.
15 cm × 12 cm. 67 folios.
Refs: O'Connor 1818-19, 45-51 - Todd 1856 - Stokes 1881 - McCarthy 1885 - Bernard 1893 - Warner 1906, 1915 - Lindsay 1913 - Gwynn 1916 - O'Rahilly 1926-28 - Kenny 1929, 693-699 - Mulchrone and Fitzpatrick 1943, 3431 - MacNiocaill 1961 - Ryan 1961 - Gwynn and Gleeson 1962, 49-52, 67, 212 - Henry 1965, 43, 161-162, 199-202, 205, pl. 112 - Byrne 1967 -Lowe 1972, Nos. 267-268 - Mitchell 1977, 139 -Alexander 1978, 68-70 - Ní Chatháin 1980.

The *Stowe Missal* is a Latin Mass-book of the early Irish Church. It may have been written in Tallaght, County Dublin, as the abbot of the priory, St. Máel Ruain, who died in 792 A.D., is commemorated in the Mass. According to the first inscription on the *cumdach* or casket (See No. 76), it was in Lorrha, County Tipperary, ca. 1050, and it could also have been written there. The *Missal* was named *Stowe* because in the 19th century it was part of a collection of manuscripts in the library of the Duke of Buckingham at Stowe House, Buckinghamshire, England. It was purchased by the British Government and deposited in the Royal Irish Academy, Dublin, in 1883 together with the other Irish MSS. from the Stowe collection.
The *Missal* consists of two separate manuscripts which were bound together for no evident reason other than that leaves were of the same size. It is bound in boards of oak covered with uncoloured vellum and around the three outer edges are strips of kid skins 2 cm wide stained with red.
The first manuscript (11 folios) contains excerpts from the Gospel according to St. John. It was written in a cursive minuscule script by a scribe who signed himself in *ogham* writing *Sonid* (f11r). In common with the 'pocket' Gospel books and books of devotion of the 9th century, the opening page of the Gospel (f1r) has a large ornamental initial and a group of initials coloured in red, yellow and purple enclosed in an ornamental border of geometrical pattern with a beast's head. The miniature of St. John the Evangelist is coloured in pink and yellow and the figure is similar to the short draped figure of the standing Evangelists of the *St. Gall Gospels*, with an eagle hovering with expanded wings over his head.
The *Missal* proper (56 folios) is in the second manuscript and it contains the Ordinary and Canon of the Mass, the order of Baptism and the order of Visitation of the Sick, of Extreme Unction and of Communion. The series of antiphons and alleluias are similar to the series for the Communion for the Sick in the *Book of Dimma*. At the end (ff 65-67) there is an Irish tract on the Mass, three Irish spells against injury to the eye, thorns, and disease of the urine, and some liturgical rubrics. The five original scribes of the *Missal* wrote in an angular majuscule script. A more cursive hand was used by a scribe signing himself *Móel Caích* (f 37) who revised it. The initial P of the opening prayer, *Peccavimus Domine*, in the Ordinary of the Mass is decorated and set in a border coloured in yellow and pink and, except for playful drawings of initial letters, the rest of the manuscript is not decorated.

B.D.

54 Book of Kells

Colour pls. pp. 7, 10-11, 36, 38, 46-47, 49, 56-57, 141.

Trinity College Dublin MS 58
Written ca. 800, in majuscule script
330 × 250 mm, 340 folios
Rebinding by Roger Powell in 4 volumes in 1953
Ref: Alexander 1978, 75-76.

The Book of Kells contains the four Gospels in a latin text based on the Vulgate intermixed with readings from the old latin translation; the Gospels are preceded by prefaces, summaries of the narrative and Eusebian canon tables. In the twelfth century, charters in Irish relating to the monastery at Kells were copied into hitherto blank pages.
The earliest mention of the manuscript occurs in 1007, when the Annals of Ulster record its theft from the church at Kells, Co. Meath (about forty miles north-west of Dublin) and subsequent recovery 'under a sod'. Scholars have disagreed on the date of the manuscript and on whether Kells was its place of origin; Northumbria and Pictish eastern Scotland have been among suggested alternatives. There has arisen in recent years, however, some consensus that it was produced by the scriptorium of Iona. When Vikings attacked the island in 806 and killed sixty-eight of the community the bulk of the house moved to Kells and had settled there by 814. That the manuscript is incomplete has been attributed not only to the loss of leaves in 1007 but also to the exigencies of the flight from Iona. Such a dramatic explanation may not be necessary given that its production probably occupied a

complete scriptorium over many years. Despite the dissolution of the Columban monastery of Kells in the twelfth century reform of the Irish church, the manuscript remained *in situ*, the former monastery now functioning as the parish church under the control of the bishop of Meath. It was venerated in the middle ages as the Great Gospel Book of Columba. When the quartering of Cromwellian cavalry in the half-ruined church threatened its safety, the manuscript was sent to Dublin for safe-keeping in 1654 by the governor of the town. Henry Jones presented it to Trinity College Dublin after becoming bishop of Meath in 1661.

The Book of Kells is distinguished in several ways from other insular Gospel books. On every page but two it displays an endlessly inventive range of minor decorated initials and marginal drolleries, some of which refer obliquely to passages in the text. To its already wide range of colours it adds the technique (shared only with the Lichfield Gospels, an eight-century manuscript probably of Welsh origin) of covering one pigment with the thin, translucent wash of another. In addition to iron-gall ink (made from sulphate of iron and oak apples combined with gum and water), Kells uses a black carbon ink made from soot or lamp black. The three main artists have been distinguished by the late Françoise Henry as the 'illustrator' (responsible for the Virgin and Child, the Arrest of Christ and the Temptation), the 'portraitist' and the 'goldsmith', so called because his work on the opening pages of the Gospels recalls metalwork in its fineness of detail, substituting yellow orpiment for gold.

It was probably planned that each Gospel should be prefaced with a page of evangelical symbols, a portrait and an elaboration of the opening letters. The Gospel of Luke now lacks a symbols page and a portrait and Mark has no portrait. If painted on single leaves like other major decorations, these pages might easily have become detached. B.M.

55 Silver Gilt Pseudo-penannular Brooch

No locality, Co. Cavan (the 'Queen's Brooch')
NMI: W43
Later 8th-9th century A.D.
D. of ring 11.4 cm; Max. W. of terminals 4.56 cm; L. of pin 18.9 cm; Wt. 245.55 gr.
Refs: Coffey 1909, 28 - Smith 1914, 231 - Armstrong 1915-16, 298 - Raftery 1941, 130-131 - Henry 1965, 111 - Lucas 1973, 94, 96 - Micthell 1977, 141, 142.

Made of cast silver-gilt the brooch displays many of the characteristics of the developed Irish pseudo-penannular form. The decoration of the pseudo-terminals is closely matched by that of the pin-head. The gap in the ring of the ancestral penannular form is strongly indicated by the organisation of the decorative panels but it is 'bridged' by three decorative tags, the outer two carrying cast relief human face-masks and the inner one, a fine inter-lacement. Except for three roundels with simple motifs in beaded wire and gold granules - one on each terminal and one on the pin-head - filigree and other applied gold ornament is eschewed. Instead, lavish kerbschnitt decoration occurs on almost all the surfaces of the front. In the centre of each pseudo-terminal is a subtriangular form composed of three relief, fleshy crescentic lobes disposed around an ornamental, flat-topped boss. The crescents are separated from each other by beautifully modelled animal heads biting inwards. The sides of the lobes carry kerbschnitt interlacements. The background on each terminal is decorated with animal motifs - each beast is shown as having a hatched or billeted ribbon-shaped body, a back-turned head and long snout grasping its own trunk.

The ring of the brooch is divided into two main parts on each end of which are animal heads. There is one on the pseudo-terminal on each side facing the hoop and continuing its line to the central lobes. At the other end of each section is a similar head facing towards the terminal. The principal decoration of hoop segments are long parallel strips of inter-twining, double-contour lines. In the middle of the hoop is a rectangular panel with a lozenge shaped sunken area, originally perhaps for filigree now missing. In the triangular areas around it are simple knotwork devices.

The pin-head reproduces the lobed decoration of the terminals and there are two small panels of kerbschnitt interlacing on the shank of the pin.

The brooch is somewhat difficult to date accurately. The long-snouted animals with back-turned heads seem to

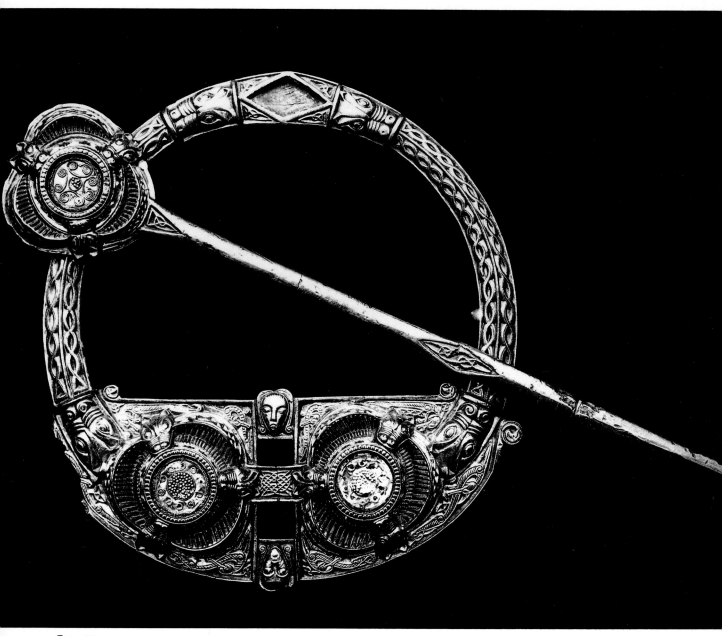

Cat. 55

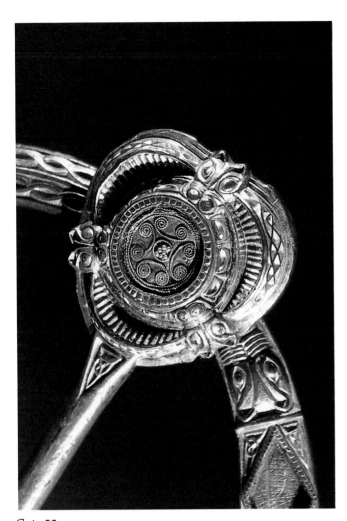

Cat. 55

56 Book of Armagh

pl. p. 54

Trinity College Dublin MS 52
Written 807, in minuscule script
195 × 145 mm, 217 folios
Rebound in two volumes by Roger Powell in 1957.
Ref: Alexander 1978, 77.

The Book of Armagh is the only surviving early Irish manuscript containing a complete New Testament, with a Gospels text regarded as the type of the Irish text. Included with it are canon tables, prefaces and interpretations of hebrew names. It also contains St. Patrick's confession, two seventh-century accounts of his life and the life of St. Martin of Tours by Sulpicius Severus.

The manuscript can, most unusually, be precisely located in place and time. An inscription records that it was made by the scribe Ferdomnach for Torbach, who was abbot of Armagh in 807. Besides Ferdomnach there was at least one other, contemporary scribe. A hereditary keeper (maor) guarded the manuscript in the middle ages. Late in the seventeenth century it passed from the last of this line, Florence MacMoyre, into the possession of the Brownlow family of Lurgan. It was bought for the Library of Trinity College Dublin by Lord John George Beresford, archbishop of Armagh and chancellor of the university.

As part of the insignia of the bishop, the manuscript was used in the middle ages to endorse Armagh's claims to ecclesiastical supremacy, a purpose served by the association of the patrician texts with the New Testament. In 1004 it was used to record king Brian Boru's confirmation of Armagh's privileges.

There is little use of colour in the decoration. The drawings of the evangelical symbols bear a strong stylistic similarity to work in the Book of Kells. The symbols are depicted with wings, which, in the case of the Eagle and the Calf, feature insets of the other evangelists. The Eagle is on a smaller scale than the other symbols and its positioning at the foot of the page suggests an afterthought. B.M.

anticipate developments of the Irish animal style of the 9th century. The relative paucity and simplicity of the filigree and the complete absence of glass might with caution be taken to suggest that the high point of craftsmanship had passed by the time the Cavan brooch was made. However, factors such as individual taste and different workshop traditions make that line of reasoning somewhat unreliable. There can be little doubt that the Cavan brooch is a fine and imposing object. It may be dated to the 8th or early in the 9th century. M.R.

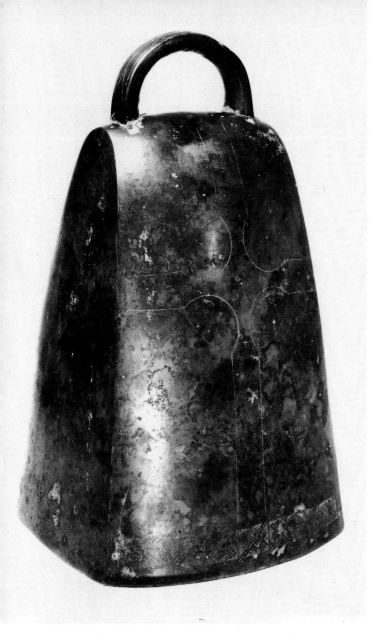

Cat. 57

57 Bronze Ecclesiastical Hand Bell

Castle Island, Lough Lene, Co. Westmeath
NMI: 1881:535
9th century A.D.?
H. 33.9 cm; Max. L. of mouth 19.4 cm; Max. W. of
mouth 14.5 cm; Radius of handle 5 cm; Wt. 5.981 Kg.
Ref: Bourke 1980.

Made of bronze cast in one piece, the bell is quadrangular in section with convex sides. The handle is a semi-circular loop, inverted D-shaped in cross-section. Internally the bell is fitted with a smaller loop for a tongue or clapper. The outer surface is smoothly finished, the interior is somewhat rough. A faint incised line follows the long sides of both main faces. On each, there is a lightly incised, elegantly proportioned wheeled or "celtic" cross standing on a border of fretwork. The cross-head is constructed by means of compass work. The sides of the bell are emphasised by a fine line. Along the lower edge of each is a band of angular interlacements organised about lozenge shapes with a pointed oval in the centre of each. The handle bears a simple incised lobed design.

The handbell was the predominant type in the early Irish church, two varieties being found: viz. those made of folded sheets of iron coated in bronze (see St. Patrick's bell, No. 78b) and those, such as the Lough Lene bell, made of cast-bronze. It has recently been pointed out that the bronze examples are the largest surviving castings from their period and must have been objects of considerable importance to the communities which owned them. The enshrinement of bells as important relics is well attested in early Ireland. The bells, being simple in design, are difficult to date closely. A 9th century date has been proposed for the present example.

M.R.

58 Wooden Bucket with Bronze Mounts

Derrymullen, Co. Laois
NMI: 1979:6
8th - early 9th century
H. 17.0 cm; D. at rim 20.0 cm
Refs: Unpublished.

Found in 1978 in a peat bog at a depth of 1.5 m. The bucket is turned from a single piece of yew wood, strengthened at rim and base with bronze binding strips. The body is bound with three bronze bands nailed to the wood, the upper pair decorated with pierced designs of lozenges, zig-zags and simple interlace. Bronze strips with incised lozenges against a hatched ground, which occur on the middle band, are ancient repairs. There are traces of an engraved geometric pattern on the lowermost band. The curved handle has an oval central portion, ornamented with a single strand of interlace against a dotted background and appears to be gripped at each end by a stylized snake-head. These animal heads are seen

again at either end of the handle. A pair of rectangular escutcheons with stylised animal heads secure the handle to the bucket. Both have a central amber stud surrounded by oval petal shapes decorated with kerbschnitt hatching. The loop of one escutcheon was repaired in antiquity.

This is a fine example of a group of some 30 complete or fragmentary insular buckets with decorative bronze mounts. Twenty have been found in Ireland, the remainder in Viking graves in Norway and Sweden in graves dated to the 9th and 10th centuries. In Ireland, vessels of this type have been found on settlement sites and as stray finds in rivers or bogs. One such find from a bog at Derreen, Co. Clare, included two buckets and a plain bronze hanging bowl. While these buckets were used for secular purposes, their small size indicates a specialised use for liquids in small quantities - perhaps for wine or other alcoholic beverages. Vessels of similar size, of ivory and bronze were used as containers for holy water for liturgical use in contemporary Europe and some of the Irish examples may have been used for the service of the Mass.

Engraved ornament on sheet bronze, often of poor quality and sometimes executed in openwork, is characteristic of Irish metal-work of the late 8th - early 9th centuries. Another example of this technique, executed against a hatched background, can be seen on the side-plates of the Domnach Airgid Book Shrine (no. 85). R. Ó F.

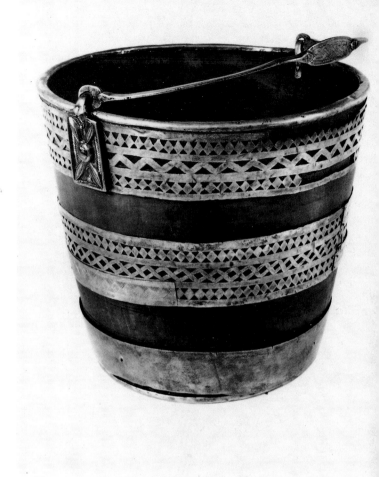

Cat. 58

59 Fragment of a Gilt and Silvered Cast-bronze Shrine

Find place unknown
NMI: 1920:37
9th century A.D.
Max. L. 13.1 cm; Max. W. 5.5 cm; Wt. 285.9 g.
Refs: Armstrong 1921, 48-51 - Crawford 1923, 163 -Mahr 1941, 56 - Raftery 1941, 99, 121-122, 131 - Henry 1965, 114-5, 254.

Generally presumed to have been the crest of a bell-shrine - that is the part of the reliquary designed to accommodate the handle, it is heavily gilt and in places silvered, on one face and silvered on the other. The object is 'D'-shaped in outline, the two main faces being semi-circular and the side being a broad, plain groove between ridges. On each side, tags bear large, cast tubular lugs. On the gilded face there is an enigmatic composition partly in openwork. Its main element consists of a stylised human figure flanked by long necked beasts

which appear to be whispering into his ears. On either side of the man is a roundel divided by a cross into panels of kerbschnitt knotwork. In the centre of each cross is a low, round amber stud, each rivetted in place, The man appears to be wearing a hood or cowl indicated by a sharp lozenge-shaped ridge about the face. His ears however protrude through it. His body is divided by a moulding into two panels each in turn divided vertically with plain incised triangles showing against a hatched background. His arms are short, the hands are simply indicated. The arms spring awkwardly from the shoulder. The foreparts only of the beasts are shown. Their legs are bent up towards their faces; their necks and cheeks are hatched, their joints are indicated by spirals.

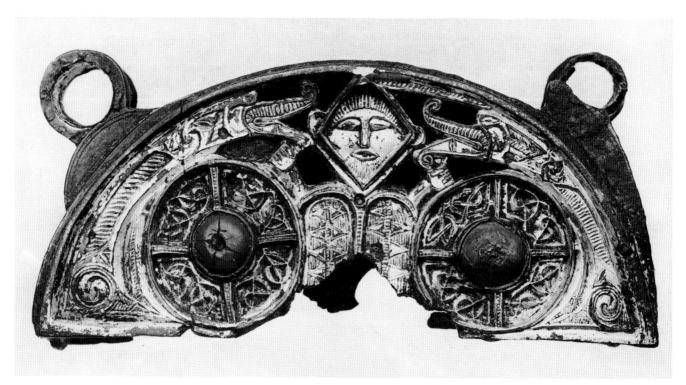

Cat. 59

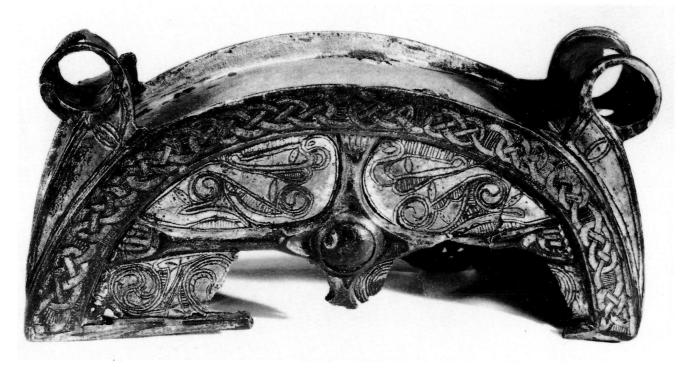

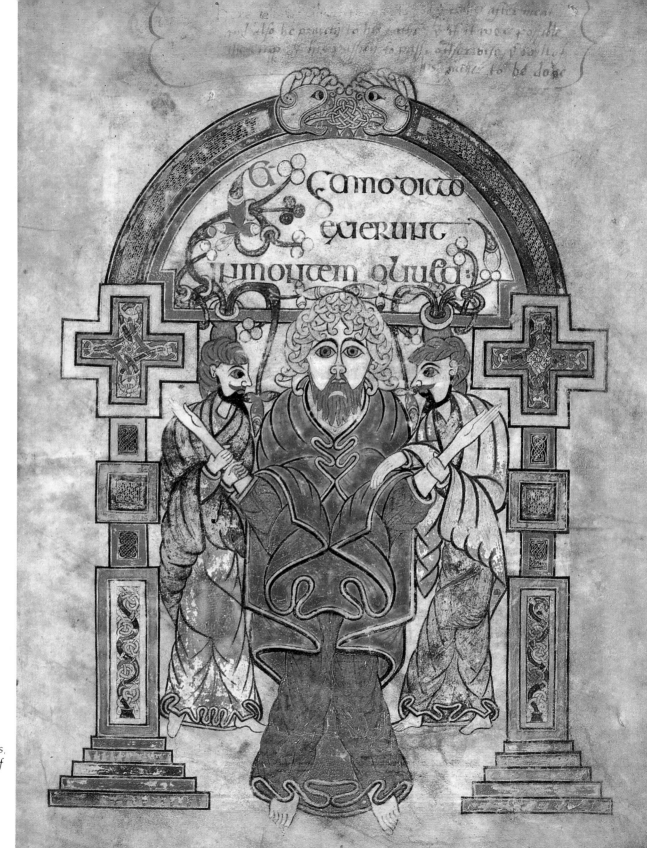

Book of Kells,
the Arrest of
Christ, fol.
114r

Trumpet-scrolls occur on their lower jaws and at the joint-spirals.

The reverse is differently decorated. The edge of the plate is marked by a broad, flat moulding in low relief with broad single-strand interlace seen as a plain reserve against a hatched background. The inner part of the plate is recessed and is divided into four panels by a cross of unusual design. It is in relief and formed of four human arms palms upwards with the fingers towards the edge of the panel. The ends of the arms towards the centre are markedly cusped and in the middle of the crossing is a round amber stud in a plain setting. The upper two background panels formed by the arms contain incised animals with back-turned heads, long snouts and forelegs bent back under their bellies. Their joints are indicated by tightly-wound spirals. Lentoids form trumpet scrolls on their noses, trunks and legs. The lower panels are now very badly damaged but sufficient survives of that on the left to show an elaborate composition of tightly-wound spirals, trumpet devices and trisceles in the Ultimate La Tène style seen against a hatched background.

Three of the tags bearing the lugs are half crescents, one is semicircular. All are silvered on their outer aspects, all have incised borders, the longer examples having, additionally, engraved lentoids.

The crest was attached by means of internal rivetted tags to the rest of the object. A surviving fragment of a bronze plate attached inside may have been a backing for the openwork.

While it is by no means certain what the object was originally it is likely to have formed part of a shrine and of these, a bell reliquary is the most likely. The ornament is accomplished but not the finest of its time. The attitude of the beasts shown on it, the use of amber, the absence of enamels and glass, the double-contoured kerbschnitt knotwork of one of the roundels all might suggest a date after the high point of 8th century accomplishment, perhaps in the earlier part of the 9th century. M.R.

◁ 60 Cross Slab

Begerin, Co. Wexford
NMI: 1877:112
ca. 10th century A.D.
H. 77 cm; Max. W. of cross head 32.5 cm; Av. W. of Shaft 20.5 cm.
Ref: Crawford 1913, 330.

Found in a graveyard on the deserted island of Begerin in Wexford harbour.

Disc headed cross slab made of shale. On one face there is a wheeled cross in low relief which is covered with interlaced ornamentation. The other face of the slab is plain, as is the area between the arms of the cross. There is a small circular feature at the centre, also in relief. A second smaller slab bearing a Latin cross is also known from Begerin (Crawford 1913, 330).

Grave slabs were quite common in Ireland in early historic times, especially at monastic sites in the midlands, such as Clonmacnoise and Seir Kieran. These slabs are nearly always recumbent and bear commemorative inscriptions in most cases. The Begerin example is erect and bears interlace pattern of a type rare in Ireland. The slab is more easily paralleled elsewhere. Some of the Manx, Scottish and Welsh crosses have features which bear comparison to it. The Bradden wheel cross on the Isle of Man for instance, is particularly close (Kermode 1907, 140 and pl.).

These crosses appear to have been influenced by Norse tradition - the ribbon interlace patterns are very much a feature of Scandinavian art. The Begerin slab was originally sited within a few miles of the Viking town of Wexford. N.O'C.

61 Bone Trial Piece ▷

Lagore, Co. Meath
NMI: W 29
ca. 8th-9th century A.D.
L. 22.2 cm; Max. W. 7.1 cm.
Refs: Wilde 1861, 344-8 - Wood-Martin 1886, 139 - Hencken 1950-51, 182-3 - MacDermot 1955, 86, 95-96 - Henry 1965, 93, 224 - Mitchell 1977, 140-141 - O'Meadhra 1979, 8, 24, 88-91.

An old find from the crannóg of Lagore, excavated in the 1930's by a team from Harvard University. It was found at the site by the nineteenth century antiquarian W. F. Wakeman.

The piece consists of a highly polished long ox bone, broken at one end. It is decorated with intricate interlace patterns and animal ornament of a type current in the late eighth to early ninth centuries. Most of the carving is concentrated on one face of the object - the surface of the opposite face has flaked away considerably and only very slight signs of working remain. Some of the ornament has been executed in the kerbschnitt technique, as for example the two convoluted animals with hatched bodies and portions of the abstract interlace work.

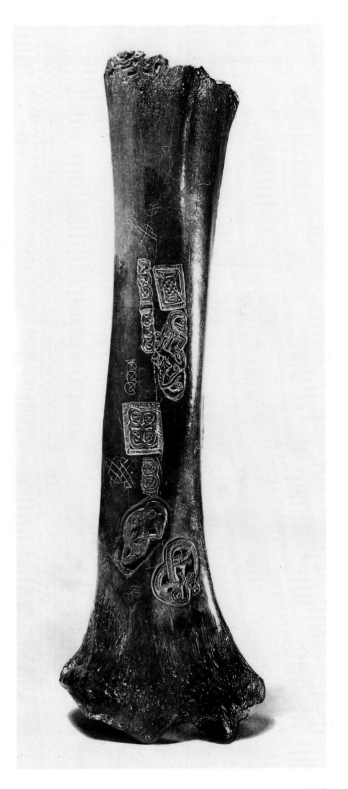

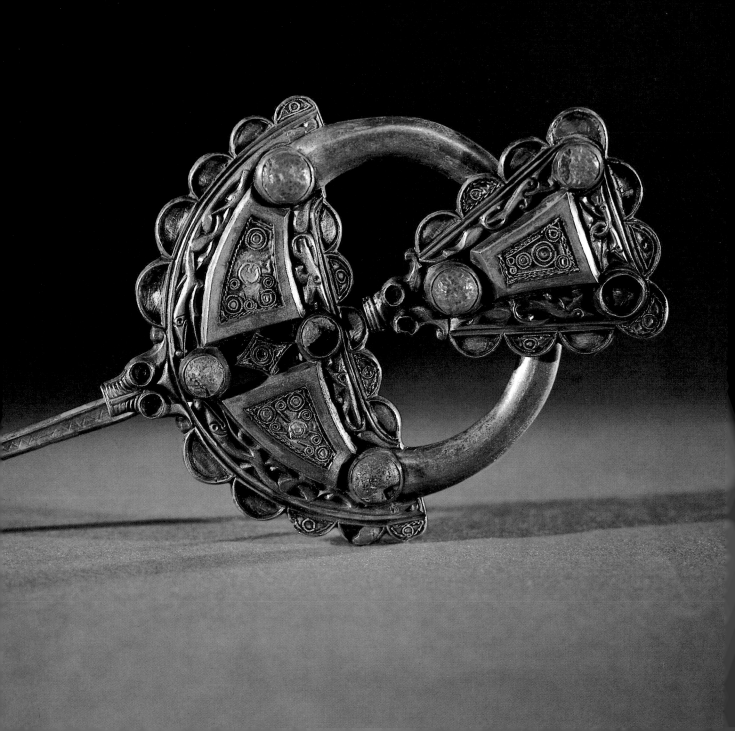

Simple incised ornament also occurs on the piece. Four trial pieces were found at Lagore during the 19th century and a further ten were discovered in the course of scientific excavation (Hencken 1950, 173, 181-3). One in particular (E14:531) is closely comparable to that on display. It bears no zoomorphic ornament but it does have similar complex interlaced patterns within hatched frames. The predominant decorative elements represented on this piece - the interlace, animals with curled jaws, spiral hip joints and hatched bodies - can all be paralleled on the metalwork of the period. The 'Tara' Brooch (No. 48), the silver-gilt pseudo-penannular brooch from Ardagh (No. 51e) and a penannular brooch from Kilmainham, Co. Dublin, all have comparable features. Some of the Irish metalwork in Viking graves in Norway is also decorated in a similar manner (Petersen 1940, 15-79). N.O'C.

◁ **62 Silver Pseudo-penannular Brooch**

Roscrea, Co. Tipperary
NMI: P737
9th century A.D.
D. of ring (including frill) 8.62 cm; Max. W. of terminals 5.22 cm; L. of pin 17.9 cm; Wt. 122.85 g.
Refs: Smith 1913-14, 233 - Mahr 1941, 70, 72 - Raftery 1941, 127 - Henry 1965, 112-113 - Graham-Campbell 1972, 115-117 - Lucas 1973, 93-94 - Mitchell 1977, 177 - Ryan 1982.

Made of cast silver with gold filigree and amber ornaments together with engraved motifs, it has all the structural and other characteristics of the traditional Irish design. The principal decorative features are the frills of projecting semicircular settings along the ring and pinhead used alternately for amber and coarse filigree ornament; the strange, stylised tube-like animals along the margins of the pinhead and pseudo-terminals and the crude filigree decorations of the raised panels of the ring and head of the pin. Typologically, it can be argued that the frills represent a development of small projecting panels on other 8th and 9th century brooches. The animal patterns are comparable in some respects to beasts on the margins of other 9th century pseudo-penannulars. The complete replacement of glass ornaments by amber is noteworthy and appears to be a general characteristic of 9th century work. On the reverse, are two engraved animal heads one on each side where the ring and terminals meet. They are probably related to similar engraved beast heads on some bossed silver penannulars (Nos. 65 and 66) of the later 9th and 10th century.

The workmanship of the filigree is of interest. It is undoubtedly coarse and attempts to achieve in a simpler way effects copied from more sophisticated work. For example, instead of employing granules of gold surrounded by collars of beaded wire as on earlier work, the smith raised small bosses on the surface of the backing foil to stimulate its appearance - this can clearly be seen on the right-hand pseudo-terminal panel. On the filigree of the pin-head, the craftsman attempts to approximate the effect of plaiting by laying twisted strips of gold side by side. It is probable that the Roscrea brooch belongs to the mid or later 9th century. M.R.

63 Silver Pseudo-penannular Brooch, partly gilt
Colour pl. p. 42

Killamery, Co. Kilkenny
NMI: R165
9th century A.D.
L. of pin 31.3 cm; D. of ring 11.4 cm; W. of terminals 6.3 cm; Wt. 485 g.
Refs: Anon. 1858-1859, 242-250 - Coffey 1909, 27 - Smith 1913-1914, 240 - Mahr 1941, 73 - Raftery 1941, 142, 147 - Henry 1965, 112 - Lucas 1973, 96, 143 - Graham-Campbell 1972, 115-7, 120.

Made of cast-silver, the brooch has most of the characteristics familiar on 9th century versions of the type (see 51d, 51e, 62). The gap between the pseudo-terminals is bridged by two plain studs and a tag with kerbschnitt ornament. Animals with tubular bodies decorate the inner and outer margins of the pseudo-terminals, their joints are indicated by spiral and 'brambled' bosses. The square pinhead has a pair of similar stylised beasts forming its edge. Their rumps and shoulder joints are indicated by pointed ovals with ambiguously represented designs in them, which can be interpreted as either human face masks or animal snouts. Sunken lozenge-shaped panels in the pseudo-terminals and pinhead carry filigree ornaments on sheets of gold foil. They are simple whirligig devices consisting of a central repoussé nest containing gold granules within a ring of twisted wire from which radiate lines terminating in cones of twisted wires each capped by a granule of gold. The whole design is framed in a border of twisted wire. Slight variations in the panels exist. That on the left hand pseudo-terminal has a matt appearance which may have resulted from the partial flooding of the wires and foil with solder during manufacture. The foil - like that of

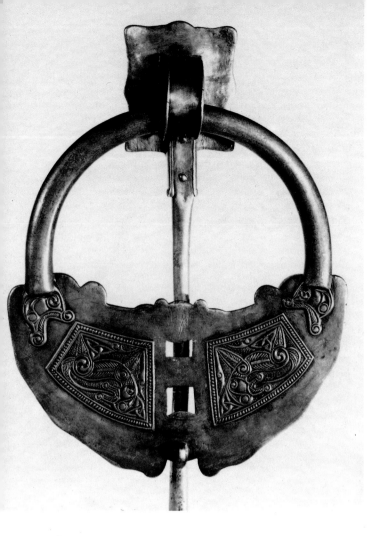

Cat. 63

plate meet. Two magnificent panels each with a deeply engraved squatting dog-like beast are the chief ornaments. They have back-turned heads and are shown biting their own tails. The foreleg of each is raised up in front of the face, the ears are indicated by triquetra knots while a further knot occurs between the hind leg and the belly. The body and limbs are heavily hatched and joints are indicated by spirals. The border is billeted in imitation of rope moulding. At the centre of the outer edge there is a loop for a thong. On the surface of the silver, near the inner margin is a faint scratched inscription which has been read as *Or ar Chiarmac* (Pray for Cormac) but is not clearly so legible. It may have been the name of a former owner of the brooch. M.R.

64 Small Bronze Ring Brooch

Cormeen, Co. Cavan
NMI: W346
9th century A.D.
L. of pin 16.5 cm; Max. D. of ring 3.7 cm.
Refs: Wilde 1857, 565, 566 - Coffey 1909, 34 - Armstrong 1922 b, 76 - Ryan and Cahill 1981, 53.

Made of cast bronze it consists of two elements - a decorative ring which hinges freely in a loop on a bronze pin. The pin projects above the ring and terminates in a human face mask shown with long hair, curled at the ends. The ring is decorated with cast imitation kerbschnit interlacing. Four D-shaped lobes and two sinuous panels project from the edges of the ring in a manner reminiscent of features of some late 8th or 9th century pseudo-penannular brooches. Two hemispherical amber studs survive and there is an oval setting for a third. A loop projects from the lower edge of the ring at a point diametrically opposite the pinhead. Like the more elaborate version on No. 65 it may have been used for a thong or chain which may have been tied around a gathering of cloak material skewered by the pin. Alternatively but less likely, it may have been attached to a smaller or matching pin.

Small brooches with pendant, decorative heads appear to have become very fashionable in the 9th century. They may be regarded as the humbler equivalents of the great pseudo-penannulars. Two divergent developments seem to have taken place, a series with elaborate decorated heads - of which the 'kite' brooches (Nos. 69, 70) are the most prominent - and a range of commoner, smaller pins with small closed ring heads. Frequently decorated, these

the filigree on the 'Tara' Brooch (No. 48) - is secured by 'stitching'. The hoop is oval in section and where it joins the terminal plate on each side, is a round glass stud in a raised setting with a four-lobed inlaid silver knot.

The pin shows evidence of much wear and damage - it has been repaired a number of times. It is secured in a half socket projecting from the pinhead and narrows slightly for the upper third of its length before expanding to accommodate a thin, lozenge-shaped slit on each face, below which it again tapers gradually to a blunt point. Incised ornament, now much worn, occurs along its outer aspect.

On the reverse are two animal heads with open jaws in low relief: one on each side where the hoop and terminal

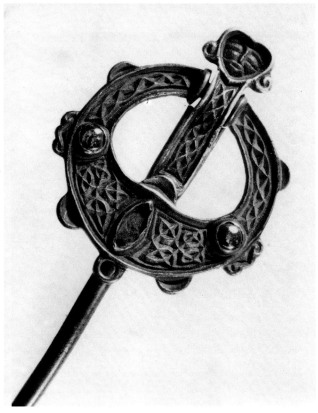

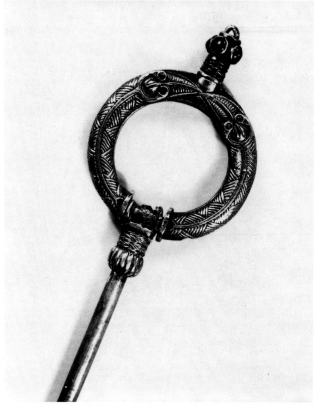

Cat. 64

Cat. 65

represent a grafting of characteristics appropriate to pseudo-penannular brooches on to the tradition of small, rather crude, ringed pins known from sites as early as the 6th-7th centuries.

Like the pseudo-penannular brooches they were not locking devices, the pendant acted as a field for the display of ornament and both types seem sometimes to have been worn in conjunction with thongs or cords.

<div align="right">M.R.</div>

65 Small Ring Brooch

Find place unknown
NMI: 27.W.28
9th or 10th century A.D.
L. of pin 12.3 cm; D. of ring 3.7 cm; Max. T. of ring 5 mm; Wt. 35.1 g.
Refs: Armstrong 1914-16, 296 - Armstrong 1922 b, 80-81 - Ryan and Cahill 1981, 54.

Related to pendant brooches, it is an especially fine example of a ring-pin, a type of dress fastener which, although originating earlier, became dominant in the later Viking period in Ireland and which was widely known throughout the Viking lands. The ring is round in section with, on its upper surface, decoration cast in the form of two serpent-like beasts with pointed snouts touching. Their bodies are hatched with a basketry motif infilling and their eyes appear to have been of glass. Opposite the beast-heads, the ring is markedly narrowed and provided with two guard-mouldings to accomodate the pin-head. A complex swivel with a pendant loop projects from the edge of the ring at a point diametrically opposite the pinhead. It is decorated with two cords of plaited wire and four hemispherical amber studs. The pin is rounded and tapers to a sharp point - it fits into an elaborately decorated, socketed head. This latter consists of a barrel-shaped fitting to accommodate the ring, a band of plaited wire and a melon-shaped moulding. This use of wire binding relates this object technically to the bossed silver penannular brooches such as No. 66. M.R.

<div align="right">147</div>

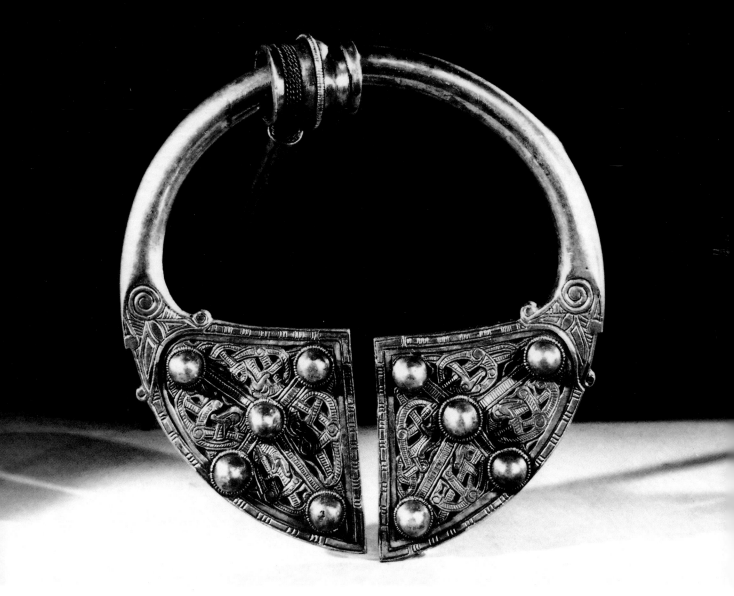

Cat. 66

66 Silver Bossed Penannular Brooch

Ballyspellan, Co. Kilkenny
NMI: R89
Later 9th or earlier 10th century
L. of pin 25.2 cm; W. across terminals 12.1 cm; W. of
terminals 5.4 cm; Wt. 196.2 g.
Refs: Salin 1904, 333 - Coffey 1909, 29 - Armstrong
1915a, 248 - Mahr 1941, 73 - Raftery 1941, 147, 148 -
Wilson 1958, 96 - Johansen 1973, 74, 78, 82, 83, 86-89,
93, 94, 96, 99, 102, 114, 119 - Graham-Campbell 1975,
36.

Made of hammered silver. The sunken area of each
terminal has set into it a complex, openwork panel of
four animal designs separated by grooved bands which
connect four domed bosses. Each boss is set in a ring of
ribbed wire and is rivetted to the body of the brooch,
thus holding the openwork decoration in place. A deeply
incised animal head, shown biting the terminal, ends the

148

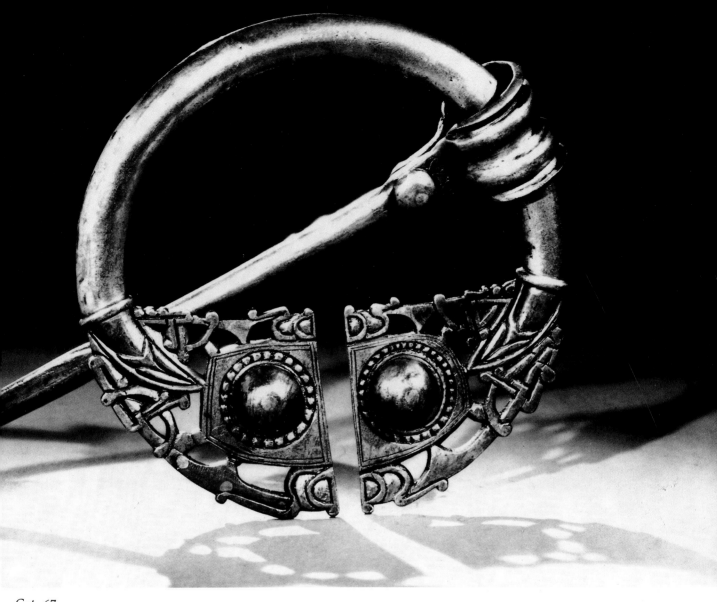

Cat. 67

ring on each side. The upper half of the pin is round, the lower half quadrangular in section. The pin is fitted into a projecting socket in the pin-head. The latter is barrel-shaped and folded from a ridged sheet of silver. It is bound by a beaded wire loop, the ends of which are secured by a tight binding of twisted wire around the pin socket. One side of the pin-head has a further binding of five turns of the same wire - another such may have existed on the other side. The back of the brooch is plain but scratched on its surface are four names in Irish in *ogham* writing:

CNAEMSECH CELLACH
MINODOR MUAD
MAELMAIRE
MAELUADAIG MAELMAIRE

It has been suggested that they were the names of former owners of the brooch.

Decorated in a mixture of Irish and Anglo-Saxon traditions, this is one of the finest examples of a late penannular brooch. The type, characterised by the

bosses, was current in various versions in Ireland and northern Britain in the late 9th century A.D. In Ireland they seem to represent the final stage of the manufacture of elaborately decorated penannular brooches. The Ballyspellan brooch does not, however, indicate a true return to the *locking* penannular form because its pin cannot pass through the gap between the terminals. The lavish use of silver in their production is due to the relative abundance of that metal as a result of Viking commerce and fragments of these brooches have been found in early 10th century silver hoards.　　　　M.R.

67　　Silver Bossed Penannular Brooch

Find place unknown
NMI: 13. W. 32
Late 9th or 10th century A.D.
L. of pin 16.7 cm; D. of ring 8.7 cm; Max. W. of terminals 3.5 cm; T. of ring 3 mm; Wt. 104.6 g.
Refs: Salin 1904, 334 - Smith 1913-14, 249 - Armstrong 1915a, 296 - Mahr 1941, 73 - Raftery 1941, 147-148 -Wilson 1958 - Johansen 1973, 84, 86-90, 93, 94, 96, 97, 105, 121 - Graham-Campbell 1975, 47 - Ryan and Cahill 1981, 48.
Of hammered silver it is related to the type represented by No. 66, but only two bosses decorate the terminals front and back. A sunken beaded band surrounds each boss on the foot, incised circles outline those on the back. The terminals are decorated along their margins with flat, openwork animal designs. The upper part of the pin is round, the lower is flat, quadrangular in section and lightly stippled. The pin-head is formed from a broad, ridged expansion of the pin, folded over the ring and rivetted to form a loop. Two lightly incised scrolls occur just above the rivet on each face.
Openwork animals on the margins of terminals are a characteristic also of some pseudo-penannular brooches (see No. 51e). The dating evidence for this feature is the fact that fragments of ornaments of that kind have been found among the hacksilver of coin - dated early 10th century hoards.　　　　M.R.

68　　Silver 'Thistle' Brooch

Find place unknown
NMI: W38
Late 9th/Early 10th century A.D.
L. of pin 25.9 cm; D. of ring 10 cm; Wt. 229 g.
Refs: Armstrong 1914-16, 297 - Graham-Campbell 1972, 123-124 - Ryan and Cahill 1981, 59.

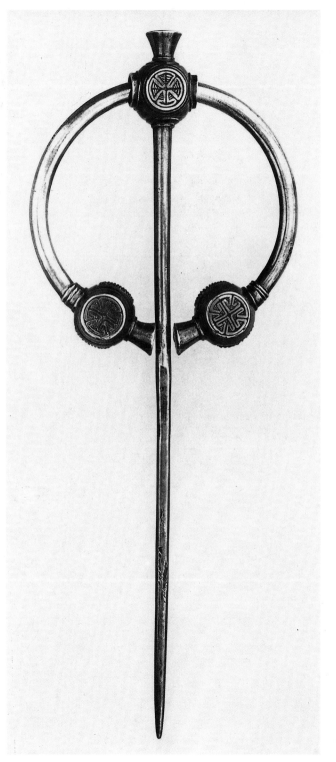

Cat. 68

A penannular brooch of a type which was popular in Ireland and parts of Britain and the Viking lands in the 9th and 10th centuries. They are normally referred to as 'thistle' brooches because of the resemblance of their terminals, sometimes with flared extensions, to thistle flowers.

It is of cast silver. The ring ends in two ball-shaped terminals, flat on one face with a key-pattern in false relief. The other face of each terminal is rounded and neatly brambled. The pin is fitted with a ball-shaped head which, with a vertical flared expansion, echoes the design of the terminals. The top of the pin-head bears a marigold design. The upper third of the shank of the pin is round in section, the lower part is square.

Fragments of thistle brooches such as Nos. 68 and 51f have been found in early 10th century hoards and there is evidence that the type continued in use until the mid-century. Thus the life of this variety probably spanned the later 9th to mid 10th century. Often they are thought of as a late revival of fashion for penannular brooches but this is only partly true because many Irish thistle brooches have gaps in the rings which are insufficiently wide to allow the pin to pass through. The 'thistle' brooch may well have developed from the brambled bosses of 9th century pseudo-penannulars (51, 63). The disappearance of the type seems to mark the end in Ireland of a long tradition of large and lavish cloak fastenings.

<div align="right">M.R.</div>

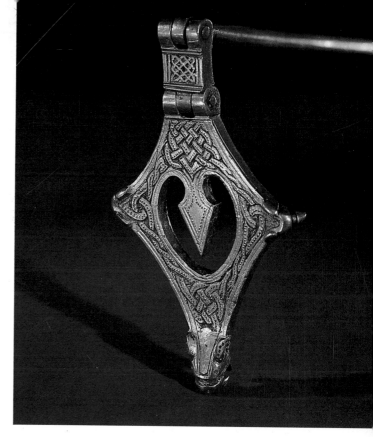

Cat. 69

69 Silver 'Kite-Shaped' Brooch

Co. Kilkenny
NMI: 1874:73
10th century A.D.
L. of pin 51.3 cm; Max. W. of pin 5.8 mm; W. of head 5.73 cm; Wt. 295 g.
Refs: Coffey 1909, 32 - Raftery 1941, 162 and Pls. 21, 1 and 40, 1 - Mitchell 1977, 180.

Said to have been found along with another silver brooch of similar type (Mahr 1932a, pl. 40, 1).

Made of cast and beaten silver, this brooch consists of a silver pendant attached by means of a hinged tab to a long pin. The pendant is roughly lozenge-shaped with concave sides and animal heads at three of the angles. Two of these are very simply indicated but the third which projects from the point of the pendant is much more elaborate in its modelling. It has open jaws and prominent fangs and in feeling probably owes much to contemporary Viking styles. The pendant is pierced by a roughly heart-shaped opening into which an arrow-shaped tongue projects. On the upper surface and on that of the tab an interlaced design is fairly neatly engraved. That on the pendant is carefully disposed to fit the shape allotted to it and the lines are emphasised by dotting. Dotting is also used on the arrow-shaped tongue while plain lightly-incised lines form borders on the sides and on the upper and lower surfaces. The underside of the pendant is equipped with a small fastening ring.

The upper third of the pin is round in section, the lower two-thirds octagonal. The three outward facing facets of the pin carry pairs of longitudinally-running incised wavy lines. All facets have incised lines along their borders.

Kite brooches are known only from Ireland and are relatively rare - only six silver examples are known - with pins ranging in length from 10 cm to 52 cm.

They seem to derive in part from the tradition of pseudo-penannular brooches where the head had ceased to serve as a lock and had become largely a field for the display of

ornament. The pins of these brooches would have been worn on the shoulder, the pin pointing upwards, the ring at the head serving to secure the pendant to the cloth. Similar massive display pins occur on some of the thistle brooches (No. 68) and are indicative of the increasing use of silver as a currency medium in the 9th and 10th centuries as evidenced by the large number of silver hoards known from Ireland at this time (Graham-Campbell 1976).

The kite brooches are difficult to date precisely although the surviving examples do show some Viking influence and small bronze examples have been found in 10th century contexts in the Dublin excavations. The heart-shaped aperture on this brooch is a feature found on two others of the type and it occurs also on the wooden harness bow fragment from Ballynagarbry, Co. Westmeath (No. 72). A tenth century dating would seem appropriate for this object. R. Ó F./M.R.

70 Silver 'Kite-Shaped' Brooch
Colour pl. p. 155

Find place unknown
NMI: 4.W.27
Late 9th/10th century A.D.
L. of pin 17.35 cm; L. of head 6.1 cm; Max. W. of pendant 2.3 cm; Wt. 49.85 g.
Refs: Armstrong 1914-16, 295 - Raftery 1941, 74 and Pl. 21, 2 - de Paor 1958, 104 - Henry 1967, 130-31 and Pl. 60 - Ryan and Cahill 1981, 61.

A double hinged tab separates the decorative almond-shaped pendant from the pin. The pendant, which terminates in a cast animal head grasping a wire ring with its jaws, is divided into five decorative panels about a setting for a stud of glass or stone, now missing. Four of the panels retain their filigree ornaments of animal motifs executed in gold filigree on foil, the panels being secured by stitching. The filigree is raised to a level flush with the edge of the panels by a backing of a grey paste. The bodies of the backward-looking animals are executed in twisted and beaded gold wire filled with gold granulation in partial imitation of contemporary Viking jewellery. The lowermost panel depicts an animal head shown full face. The ears and eye sockets of the animals were originally set with glass or stone. The central tab of the hinge also carries a small panel of gold filigree. The upper half of the pin is circular, the lower, rectangular and decorated with a running spiral on one face and a step pattern on the other.

An almost identical brooch (now lost) was found in the 19th century at the monastic site of Clonmacnoise. The filigree is sunken into panels and secured by stitching in the Irish fashion, not boldly on the surface as in many contemporary Scandinavian objects. The use of granulated bodies and the filigree animal head shown in plan shows similarities with Scandinavian box- and animal-headed brooches. Stylistically, therefore, the object is Irish with exotic overtones.

The shape of the pendant has been compared to some rare 9th century enamelled objects in England such as the 'Alfred Jewel' - an elaborate object of uncertain function. R. Ó F./M.R.

71 Bone Trial Piece
Colour pl. p. 155

Dungarvan, Co. Waterford
NMI: 1947:237
Late 10th, early 11th centuries
L. 10.65 cm; Max. W. 219 cm.
Refs: MacDermott 1955, 86 and Pl. - Henry 1967, 132 and Pls. - de Paor 1977, 149 - Mitchell 1977, 180-81 - O'Meadhra 1979, 24, 68-69.

This piece was discovered at Shandon quarry near Dungarvan in 1917. No further details are known. A wide range of other objects dating to different periods has been discovered in the area around this quarry.

The piece consists of a fragment of a long sheep bone which has been cut to give four flat surfaces suitable for carving. There are no signs of deliberate polishing of the bone. The main patterns are confined to two faces - they consist of a series of designs typical of the period which include animal patterns, interlace and knotwork.

There is a strong Viking influence represented on the piece. The occurrence of animals with head lappets and ribbon like bodies is very much a feature of the Jellinge Style. The *fleur de lis* motif, seen here between the bodies of two animals, occurs quite frequently on metalwork of the Viking period. It is paralleled for example on a trial piece discovered in the excavations at York (Graham-Campbell 1981, 47). Some of the ornament also bears comparison with certain panels on the Soiscél Molaise (No. 75) which can be dated on historical grounds to the first half of the eleventh century. The treatment of the animal motifs has also been compared with that on the Kells crozier (MacDermott 1955, 86). N.O'C.

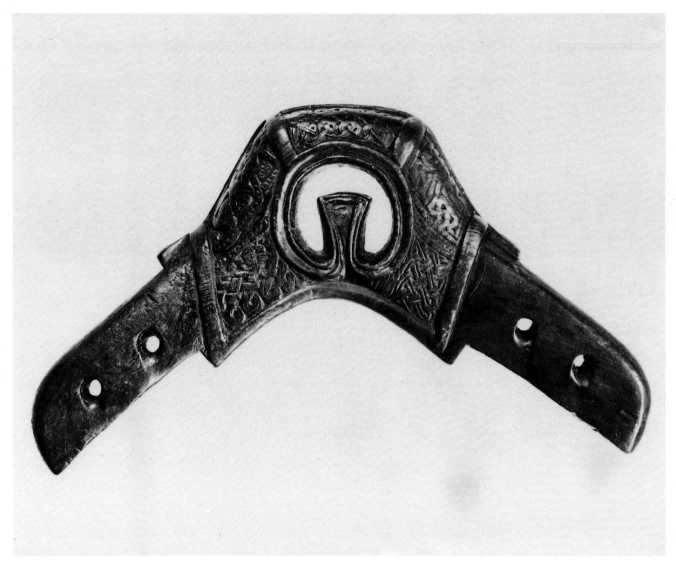

Cat. 72

72 Wooden Crest of Harness Bow

NMI: 1916:3
10th century A.D.
L. 18.3 cm; W. at centre 6.2 cm.
Refs: Anon 1879-82, 344-346 - Mahr 1932b, 40 - Mahr 1939, 19.

This harness bow, in the form of an inverted V with central heart-shaped aperture, was found in the bed of a drained lake.

The two main faces are divided into five geometrically-shaped fields defined by raised mouldings. Four of these contain poorly executed interlace patterns, the ribbons being either double or treble contoured or decorated with a row of dots. An irregular fret pattern fills the remaining panel. The crest of the object terminates in raised triangular panels containing triquetra knots.

The two side projections are rebated with flat lower surfaces. Each is pierced by a pair of lateral perforations which show signs of wear along their lower edges. The upper faces of these projections are carved with

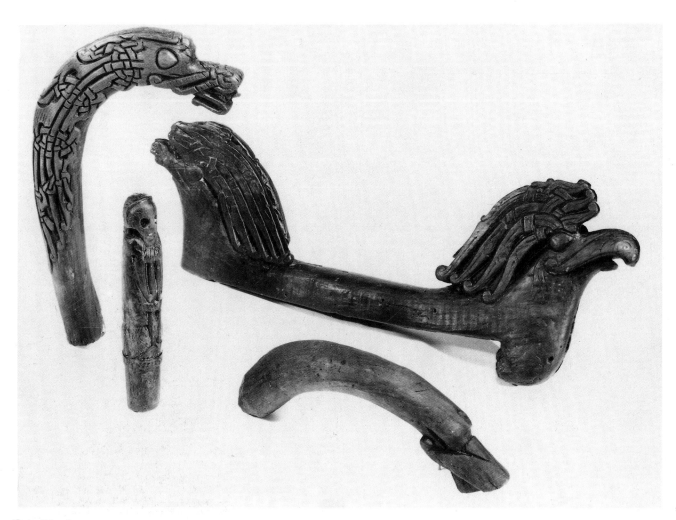

Cat. 73a-d

trapezoidal panels of fretwork and dotted interlace.

The perforated and rebated side projections indicate that the object formed part of something much larger. It is therefore more likely to be the crest of a harness bow (attached to the back of a horse and through which the reins passed) rather than a saddle pommel. Such harness bows are well-known in Scandinavia during the 9th and 10th centuries, usually decorated with metal mounts (Müller-Wille 1974). An almost identical object, although undecorated, was found in a 10th century context at Christ Church Place, Dublin, while portion of a harness bow decorated with metal studs in triangular fields of interlace was found at York (Roesdahl *et al* 1981, 123).

The fretwork patterns on the bow occur on wooden objects and trial pieces of the 10th and 11th centuries from the Dublin excavations while the dotted interlace and heart-shaped aperture occurs on the silver brooch from Co. Kilkenny (No. 69). R. Ó F.

73a-d Wooden Objects from Fishamble Street, Dublin

Refs: Wallace 1979, 143 - Fuglesang 1980, 77-78 - Wallace 1982, 129-142.

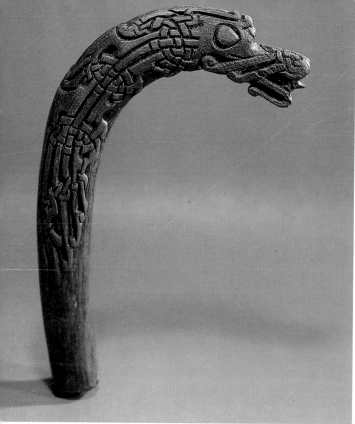

Cat. 73a

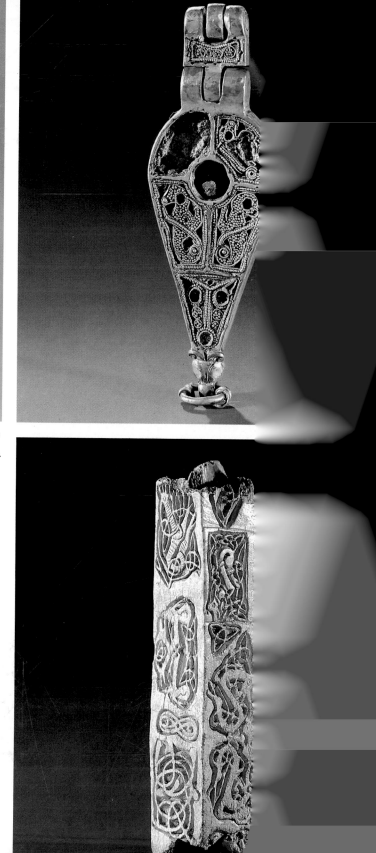

Cat. 70 ▽
Cat. 71 ▷

A number of finely carved wooden objects generally decorated in the Irish version of the Scandinavian Ringerike style have been unearthed in the course of the archaeological excavations in Dublin. The Fishamble Street sites produced so many artifacts carved or scored in this distinctive style that they must have been made in local workshops. These objects include crooked finials of which two are included here (73a and b), small hollow cylinders, a bucket-stave, a stylus handle, a dog-and-ball figurine, weavers' swords, a yarn-winder, a small house-shaped shrine, a knife handle and included here, a distinctive mount of unknown function with a pair of cocks' heads deeply carved in the Ringerike style (73c).

The excavations also yielded carved wooden finials (parts of ships' stems?) in possibly earlier and more recognisably Scandinavian design. These are unlikely to have been produced locally. A wood figurine included in this exhibition probably represents a local product of Irish rather than Scandinavian inspiration (73d).

The products of the Hiberno-Scandinavian Ringerike style are conventionally dated to the last decades of the 11th century. The derived rather than pure Scandinavian composition of this design has given rise to the suggestion that this art style was introduced to Ireland from England rather than directly from Scandinavia. The archaeological evidence from the excavations attests to close trading contacts between Dublin and Saxo-Norman England in the 11th century and to decreasing links with Scandinavia (Wallace 1982, 129). Fuglesang (1980, 77-78) has suggested that the origins of the Ringerike style in Ireland may be connected to the settlement of Saxo-Norse exiles from London in Dublin after their defeat at Hastings in A.D. 1066. The evidence from Fishamble Street points to the establishment here of this style at possibly an even earlier date (Wallace 1979, 143). The widespread adoption and relative popularity of this style in Dublin makes it possible that many ecclesiastical reliquaries of metal were produced to order in the town which had become the *de facto* capital of Ireland by the mid 11th century. P.F.W.

73a Carved Wooden Finial *Pl. p. 154*

Fishamble Street II, Dublin
NMI: E172:5587
Mid to late 11th century
Max. L. 17.1 cm; D. at undecorated end 2 cm; Max. T. 2.6 cm.
Ref: Wallace 1981.

Wooden object, curved in outline, round in section. One end is plain. The crook end is decorated with a stylized animal head and the straight end is transversely cut. A tongue protrudes from the centre of the snout.
The ornament is arranged in two fields. These comprise a pair of deeply carved panels, one on either side of the crook. The panels are separated from one another by a channel of two grooves on the upper surface and a plain field on the underside. The ornament on the sides consists of four interlaced tendrils highlighted with scored ladder patterns. The tendrils have three double-strand knots. A different interpretation of this pattern occurs on each side. The carving on one of the sides extends nearer the plain end than does the other. The eyes are pear-shaped and point forward towards the snout, the ornament on which consists of a pair of interlaced fronds.
The function of this object is not known. It may originally have formed the crook of a walking-stick as in the case of similarly-shaped objects carved in much the same style from Lund, Sweden (Martensson 1968; Graham-Campbell 1980). It is one of three such objects found in Dublin, one of which from Fishamble Street, is included below; the other is from a nineteenth century street-cutting near Christchurch (Bøe 1940, 67).
 P.F.W.

73b Carved Wooden Finial
Pl. p. 154

Fishamble Street III, Dublin
NMI: E190:4073
Later 11th century
Max. L. 13.1 cm; Max. D. 2.4 cm; Min. D. 1.6 cm.

Hitherto unpublished wooden object curved in outline, oval to round in section, the roundness being broken by a smoothly-shaved band on the inner or under surface. One end is decorated with a boldly carved animal's head, the other end is rather crudely cut to form a blunt point. The object decreases in diameter from this undecorated end. The carved head is simple and stylized and resembles that of a dog with a flat-ended snout. An expanded frond on either side sweeps back from the top of the snout to below the jowl, crossing the mouth. The eyes and forehead are represented by simple bulging protrusions.
This object may be unfinished. It resembles very closely the artifact from near Christchurch Cathedral described as handle-shaped (Bøe 1940, 67, 68). It is almost identical in size but the head is more detailed.
The function of this object is not known. The object here may be a simpler (and cheaper?) version of the larger more ornamented crooked object described above at 73a.
 P.F.W.

73c Carved Wooden Mount
Pl. p. 154

Fishamble Street, Dublin
NMI: E172:4309
Second half of 11th century
L. 26.6 cm; Max. T. of basal bar 2.8 cm; Max. H. 9.9 cm.
Refs: Graham-Campbell 1980, 131-2 - Wallace 1979, 143.

Carved from a single piece of wood, the object consists of a short wooden bar terminating in two carved cock's-heads.

Each of the cock's combs is divided into two distinct faces by the cutting of a deep longitudinal channel. This division of the fields of ornament recalls that of the crooked finial described above (73a). The connecting bar is D-sectioned and roughly finished and is perforated with (ancient?) insect-borings. One of the plates is poorly preserved. The cock's beak of one of the terminals is broken. The object now has rather a warped appearance. A broken projection underneath one end of the bar may originally have attached the object to a flat metal, leather or textile surface. The function of the object is not known.

The cock's-head terminals face outward at either end, each of the combs being deeply carved in densely interlaced tendril clusters in the local version of Ringerike style (Graham-Campbell 1980, 131). Each of the tendrils is divided by a lightly scored median groove. The eyes are pear-shaped with forward-facing points. The beaks consist of a raised frond on either side. This also bears lightly incised motifs in the same style. A pair of lightly scored fronds on either side of the head represent the wattles. The combs or manes are typical of animals in this style in Ireland, where the use of pairs of outward-looking animal-heads as terminals was common on metalwork shrines in the late Viking period (Graham-Campbell 1980, 131-2). P.F.W.

73d Carved Figurine

Fishamble Street II, Dublin
NMI: E172:2081
Second half of 11th century
H. 10 cm; Max. D. 1.9 cm.
Ref: Wallace 1979.

Figurine carved from a single round-sectioned rod. A plain area at the lower end, 2.2 cm high, shows a progressive decrease in diameter suggesting that it might have been used as a stopper. This is separated from the decoration by a 0.5 cm high raised band with a line of poorly executed lozenges or blobs. The figurine depicts a seated person of indeterminate sex. The feet are out-turned and the elbows are placed on the knees with the hands extended straight upwards to support a pointed chin or beard. The head has a high forehead and a squared nose with deep eye-sockets which may have contained glass, enamel or metal eyes. The mouth is an

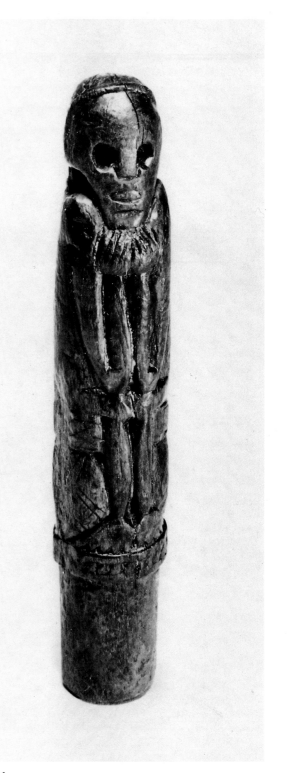

Cat. 73d

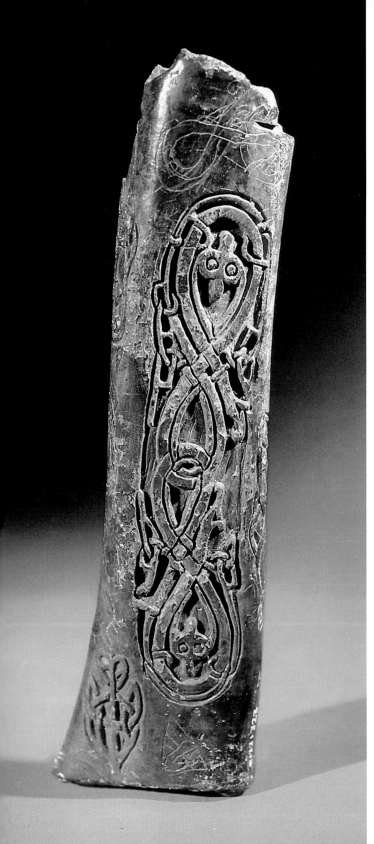

incised bow. The ears are represented by simple spirals on a raised head-band which separates the forehead from the hair or head-covering. The latter consists of parallel horizontal grooves on either side of a vertical parting. The head and shoulders are separated at the neck by a band with a line of conjoined lozenges. Below this is a long triangular interlace pattern which ends in a triquetra knot near the horizontal band which represents the seat. The interlace may represent plaited hair or could be part of a garment. The seat on which the figure sits is flat and circular. It appears to rest on oval-sectioned, cushion-like objects decorated with lightly-incised crossed diagonal bands. The edge of the seat is decorated with a lightly incised band of interlace.

The function of this object is not known. The base seems as though intended to have fitted into something. It could have been a stopper, as in the case of the somewhat similar but earlier object from Spong Hill, Norfolk, England (Hills 1980). Alternatively it may have been a gaming piece for a pegboard. The deep eye-sockets, the bow-shaped mouth, and the spirals on the head-band recall details on the probably contemporary side panels of the Stowe Missal Shrine (see No. 76), where a panel with a group of ecclesiastics has a angel in which the wings terminate in spirals reminiscent of the "ears" of the figurine described here. P.F.W.

◁ **74a-c Bone and Stone Trial Pieces**

Dublin
NMI: (a) E71:708 (b) E122:323 (c) E122:8760
Late 11th - early 12th centuries A.D.
(a) L. 11.4 cm; Max. W. 4.2 cm; Max. T. 2.5 cm
(b) L. 15.5 cm; Max. W. 4.5 cm; Max. T. 2.3 cm
(c) L. 11.5 cm; Max. W. 9.0 cm; Max. T. 0.8 cm
Refs: (a) Ó Ríordáin 1971, 75-76, Pl. VIII - National Museum of Ireland 1973, 288-29 - O'Meadhra 1979, 44-46 - Fuglesang 1980, 195-196 - Graham-Campbell 1980, 136
(b) Ó Ríordáin 1976, 136 and Pl. 3 - O'Meadhra 1979, 39-40
(c) Ó Ríordáin 1976, 136 and Pl. 2 - O'Meadhra 1979, 40-42 - Graham-Campbell 1980, 137.

These three trial pieces were found during archaeological excavations in Dublin city.
(a) Found in a 12th/13th century context at High Street, Dublin.

Shrine of the Stowe Missal, Cat. 76, p. 163 ▷

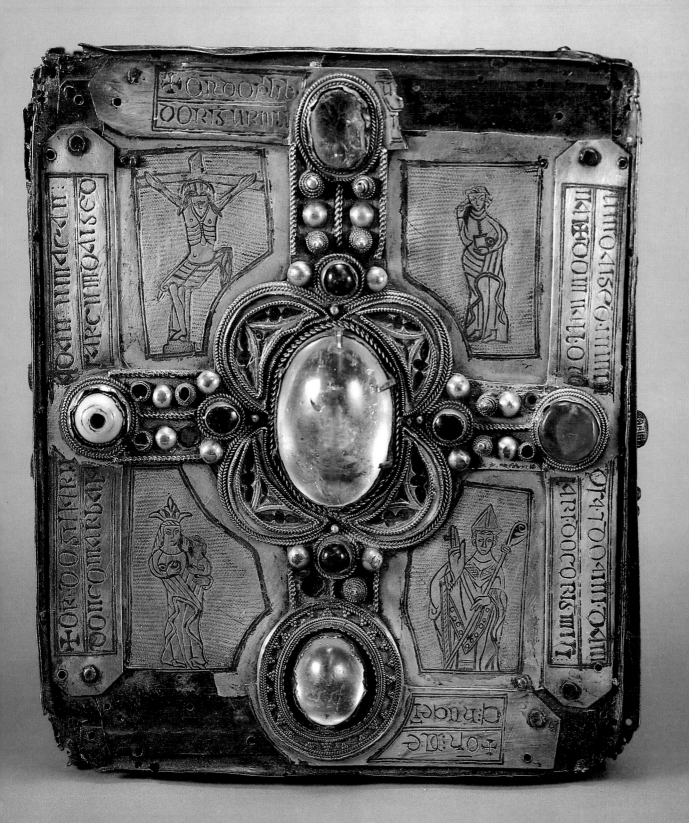

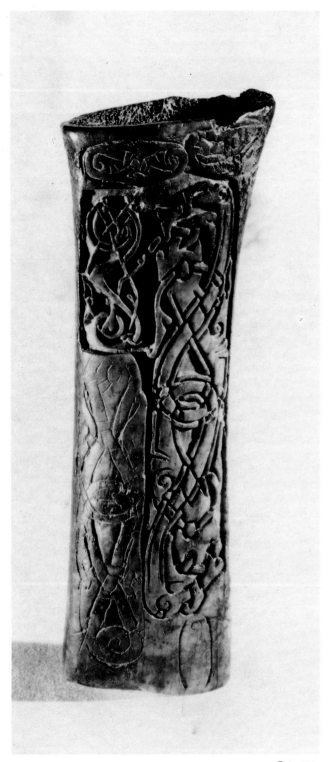

Polished long bone fragment, cut at both ends. On one face is a symmetrical design of interlaced snakes set in a sunken field. Their bodies are composed of parallel broad and thin ribbons arranged in pear-shaped loops intertwined with tendrils. A lightly sketched leaf pattern occurs on this face also.

A similar panel of interlaced animals occurs on the opposite face. Here, the design in unfinished and bodies of the animals are composed of a broad band flanked by thin ribbons. Below this is a single animal with coiled neck and hind quarters. The other panels on this face consist of figure-of-eight leaf patterns with spiralled ends. (b) Found in an 11th century context at Christ Church Place, Dublin.

Polished long bone fragment with 13 separately carved designs, roughly cut at both ends. Some designs are set in sunken fields, others lightly sketched. The main face contains a pair of interlaced snakes - arranged like those on trial piece (a). The animal heads point towards the centre and are shown with curled jaws and prominent upper fangs. The bodies of each animal narrow towards the tail and are looped back on each other forming closed double loops. Stylised plant motifs occur inside the arched hindquarters. A symmetrical interlaced plant motif occurs on this face also. On the reverse is a plant motif arranged symmetrically around a vertical stem. Thinner ribbons run parallel to and are interlaced with the main bands. Adjacent to this panel is a quatrefoil with heart-shaped leaves. Figure-of-eight plant motifs occur along the narrow sides.

The symmetrical arrangement of the animal and plant motifs on these two objects is very similar, although found on two separate sites. The ragged outlines and tight knots of interlace are characteristic of the Irish Ringerike style seen in metalwork on the crook of Clonmacnoise crozier (77). The axial symmetry is more disciplined than on comparable Scandinavian objects decorated in this style, such as the weather vane from Kallunge in Sweden (Wilson and Klindt-Jensen 1980, fig. 58). Parallels for the symmetrical arrangement are to be seen on objects from the south of England (compare Fuglesang, 1980, Pl. 27 A and Pl. 61 E). The geometric layout of the animal ornament on (a) has been compared to panels on the side of the Cathach book shrine, dated by its inscription to between 1062 and 1098 (Henry 1970, 88).

(c) Found in an 11th century context at Christ Church Place, Dublin.

Sub-rectangular shale tablet, damaged at one corner. The main face has an incised border inside which are 22 geometric panels of animal and interlace patterns. The

Cat. 74a

animals all share the same characteristics - curled upper and lower lip, pointed oval eye, pigtails or head lappets, spiral hip joints and sometimes spiralled hindquarters. There are also some panels of angular knotwork. On the back are some finished panels including a fine backward-looking animal, a quatrefoil and two panels of closely woven interlace. Other faintly sketched designs include a coiled and lobed tendril.

The animals on this piece are of a native Irish type which can be traced back at least to the early 9th century (compare 63). Similar animals are found on contemporary metalwork, such as the Soiscél Molaise (75) and on a group of illuminated manuscripts of 10th-11th date (Alexander 1978, Fig. 326-351).

A date in late 11th century would be appropriate for this piece in view of the Ringerike-style tendril on the reverse.

<div align="right">R.Ó F.</div>

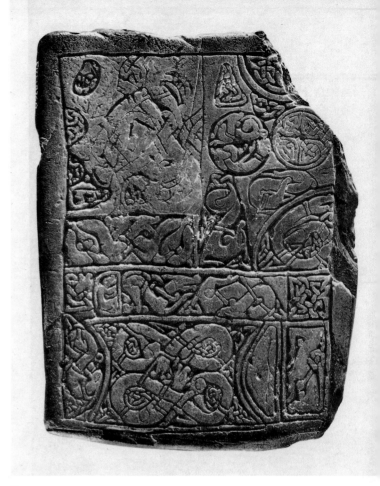

Cat. 74c

75 Bronze and Silver Shrine - 'Soiscél Molaise'

Colour pl. p. 60

Devenish, Co. Fermanagh
NMI: R.4006
Later 8th or 9th century; 1st quarter of the 11th century; 15th century A.D.
H. 14.75 cm; W. 11.70 cm; T. 8.45 cm
Refs: Stokes 1871, 144-50 - Petrie 1878, 89-91 - Crawford 1923, 154 - Raftery 1941, 119-121 and Pls. 57-58 - Henry 1967, 120-122 and Pls. 58-59 - Mitchell 1977, 182-183.

This shrine is traditionally known as the 'Soiscél Molaise' - the Gospels of St. Molaise - a sixth century Irish saint who founded an island monastery at Devenish, Co. Fermanagh. It was purchased from the O'Meehan family, the hereditary custodians of the shrine.

The earlier portion of the shrine consists of a bronze box, now held together by split tubular binding strips of silver, and a pair of hinged bronze mounts (one of which is a later copy in sheet bronze). The original hinge terminates in an animal head and contains two triangular fields of geometric cells filled with red enamel. It has been suggested that the original shrine may have taken the form of a gabled house- or tomb-shaped reliquary which would have been provided with hinges for the attachment of a strap or chain.

The shrine was later covered with a series of openwork frames of gilt silver rivetted to the bronze with silver rivets and set with panels of gold filigree and gilt silver.

One side of the shrine is now missing. The opposite face carries an inscription in Irish which reads:
OR DO (CENN) FAILUD DO CHOMARBA MOLASI LASUN (DERNAD) IN CUTACHSA DO . . .
A prayer for Cennfailad, successor of Molaise who caused this shrine (to be made) for . . .
+ 7 DO GILLUBAÍTHÍN CHERD DO RIGNI . . .
+ and for Giolla Baithin, goldsmith, who made (it) . . .
Cennfailad became abbot of Devenish in the year 1001 A.D. and died in 1025 A.D.

The principal face is laid out in the form of a ringed cross with rectangular terminals. The arms and terminals carry panels of interlaced beaded gold wires, the terminals originally being set with cabochons of red stone - only one of which survives. A circular jewel was set at the centre of the cross, but only the backing of gold foil survives. The arms of the cross within the circle contain

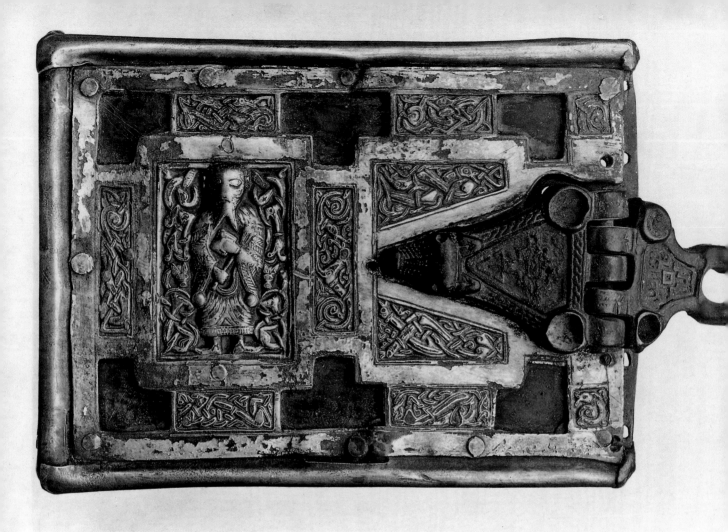

Cat. 75

panels of interlace in gilt silver. A panel along the left hand border contains a pair of interlaced animals who share a common tail- and head-lappet.

The four quarters contain representations of the four evangelists - the name of each and his symbol occur in Latin along the margins. The wings are shown as angular hatched ribbons with spiralled shoulder joints. The figures of the man (Matthew) and the lion (Mark) are clothed in knee-length garments, the former ornamented with interlocking pelta motifs. The ox (Luke) is shown with spiralled hip and curling tail. The figure of the eagle (John) is most elaborate - a small tear-shaped drop (perhaps representing blood) hangs from the curved beak, the breast is carved with scales to represent feathers

and the figure is provided with large talons and fan-shaped tail.

The side immediately below the main face contains a representation of an ecclesiastic in full-length tunic and cloak. He holds a book in his left hand and a flail or asperge in his right. He is flanked by a pair of animals with spiralled hind-quarters. Similar figured panels were probably attached to the other narrow sides. The remaining panels contain pairs of interlocked animals with spiralled hind-quarters and curled jaws. Similar panels occur on the other two sides. The inscribed face (on the right) was covered in the later Middle Ages with thin gilt silver plates of which fragments only survive. The back is covered with a silver plate pierced with

crosses and geometric openings revealing a sheet of gilt bronze engraved with curvilinear and knotwork patterns. The rim of the silver plate is engraved with circles and there are oval devices at the corners containing human heads and an interlaced pattern known as a ring-chain. The latter is characteristic of the Viking period Borre Style, elements of which were absorbed into Irish art in the 10th and 11th centuries.

This is the earliest surviving Irish book shrine of which eight examples are known. The covers for the Book of Durrow (43), Book of Armagh (56) and Book of Kells (54), known to have been in existence in the 9th and 10th centuries, unfortunately no longer survive. Book shrines seem to occur only rarely outside Ireland. In contemporary Europe, manuscripts were provided with elaborate bindings and covers.

Usually, book shrines consist of a wooden box with sliding lid (see No. 85) to which decorative metal plates

have been attached. It would appear from the construction of these outer covers, held together with split tubular binding strips, that the manuscripts were not meant to be readily accessible.

Three periods of workmanship can therefore be distinguished: in the late 8th or early 9th century the shrine was perhaps a portable **châsse**. It was converted into a book shrine in the early 11th century and partly re-embellished in the 15th. R.Ó F.

76 Shrine of the Stowe Missal

Colour pl. p. 159

Lorrha, Co. Tipperary
NMI: 1883:614a
Mid-11th and late 14th centuries A.D.
H. 18.7 cm; W. 15.8 cm; T. 5.6 cm
Refs: Petrie 1878, 93-97 - Crawford 1923, 153-154 - O'Rahilly 1926-28 - Raftery 1941, 154-155 and Pls. 65-67 - Mitchell 1977, 174-185.

The shrine, containing a small pocket-size manuscript (53) was discovered about the year 1735, sealed up in the walls of Lackeen Castle, 2 km from the monastic site of Lorrha, Co. Tipperary.

The core of the shrine consists of a box made of two blocks of wood with four smaller pieces forming the sides (two of which are modern replacements). This was covered with plain bronze plates originally fastened together with split tubular bindings. The detached 'lid' and narrow sides contain the earliest ornament. The lid is composed of lengths of bronze covered with silver. The broad raised edge and central cross are fastened by bronze nails. Square recesses containing sheets of bronze stamped with quadrilobes are set at the corners. Similar semicircular panels containing single-strand interlace occur at the terminals of the cross.

In the spaces between the arms threre are sheets of silver-covered bronze pierced with rows of squares or triangles. The lengthy Irish inscription around the edge reads:
BENDACHT DE AR CECH ANMAIN AS A HARILLIUTH
The blessing of God on every soul according to its deserts
+ OCUS DO MACCRAITH HU DONDCHADA DO RIG CASSSIL
And for Mac Craith Ua Donnchadh, King of Cashel
ÓR DO DONCHAD MACC BRIAIN DO RIG HEREND
A prayer for Donnchadh Mac Briain, the king of Ireland

Cat. 75

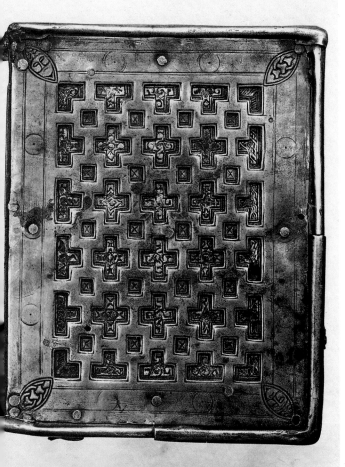

163

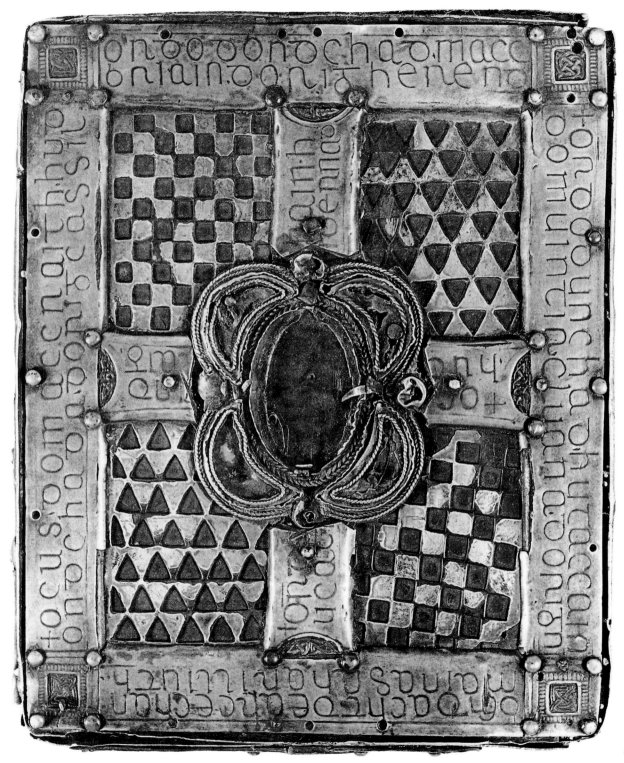

Cat. 76

+ ÓR DO DUNDCHAD HU TACCAIN DO MUINTER CLUANA DORIGNI
A prayer for Donnchadh Ua Taccain of the Community of Cluain who made (the shrine)

Donnchadh Mac Briain, son of the famous Brian Boru, was a claimant to the title of King of Ireland from about the year 1042, and died in 1064. Mac Craith Ua Donnchadh, king of Cashel, died in 1052. This portion, and the sides of the shrine can thus be dated between 1042 and 1052. The inscriptions on the central cross were cut away, probably in the 14th century, to accommodate a four lobed silver mount set with an oval stone, now missing. The lobes were set with bronze plates in the shape of gothic tracery against a leather backing.

The sides are adorned with a series of gilt bronze mounts and openwork plaques of bronze sheathed in silver backed with sheets of gold foil. A circular medallion depicting an angel with outstretched wings is set centrally along each narrow side. The wings are inset with blue glass beads containing spirals of silver wire. Each is clothed in a pleated loincloth and a rectangular stud of red glass is set on the breast, apparently shown as if suspended from the neck. Beasts with spiralled hip joints and blue glass insets with zig-zag and figure-of-eight silver wires grip the heads of the angels with their jaws. The long sides contain two of, originally three, gilt bronze plaques.

At the centre of one side is a bearded figure holding a sword flanked by pairs of dog-like animals. Uniquely, this plaque is backed by a sheet of leather embossed with a fret pattern. At one end of the same side is a bearded, long-haired, warrior clad in short trews. He carries a small shield with prominent boss and a short spear. This plaque is backed by a sheet of vellum. The opposite side contains a plaque centrally placed, depicting a pair of ecclesiastics flanking a seated figure playing a lyre above which is set an angel. The ecclesiastics are clothed in long tunics and cloaks. That on the left carries a hand bell with projecting clapper (see No. 79) and is shown wearing shoes. The other is shown barefoot holding a short crozier or staff before him. The other plaque on this face shows a stag being attacked by a pair of hounds (one of which appears to be on a leash) and a spear is shown directed at the stag's neck.

The spiralled tendril motifs on the openwork plaques is directly comparable to that on the trial piece from Dungarvan (71).

The other main face of the shrine is of 14th century date. Its centre is occupied by a jewelled cross of gilt silver set with rock crystals, studs of blue and red glass and an ivory bead (the latter perhaps modern). The lobes around

the central crystal contain Gothic tracery and translucent *basse taille* red and blue enamel. Plates of gilt silver depicting and crucifixion, the mourning St. John, the Virgin and child and a bishop are set in the four quarters. The edges are covered with plates of gilt silver with inscriptions in Irish:

+ OR DO PILIB DO RIG URMU(MAND) . . .
A prayer for Pilib, king of Ormond . . .
. . (C)UMDAIGED IN MINDSA 7 DO AINI DO MNAI
. . *(who) covered this shrine and for Aine his wife*
+ DOMNALL O TOLARI DO CORIG MISI
Domhnall Ua Tolari arranged me
+ OR DO GILLA RUDAN U MACAN DON COMARBA LASAR CUMDAIGED
A prayer for Giolla Ruadhan Ua Macain the successor by whom this was enshrined.

Pilib Ua Cennetig became king of Ormond in 1371 and he and his wife, Aine, both died in 1381. Giolla Ruadhan was the abbot of the Augustinian priory of Lorrha. Portion of an inscription in Lombardic characters along the bottom edge has not been satisfactorily deciphered. In both inscriptions, the name of the craftsman is given. The goldsmith who made the earlier portion, Donnchadh Ua Taccain of Cluain may have been from Clonmacnoise as there is a striking similarity in the treatment of the figures on this shrine and those on the plaque from Clonmacnoise (78). The simplicity of the earlier portion contrasts with the cumbersome provincial Gothic figures and ornaments on the later editions. R.Ó F.

77 The Clonmacnoise Crozier
Colour pl. p. 67

Clonmacnoise, Co. Offaly
NMI: R.2988
Late 11th century; 15th century A.D.
L. 97.1 cm
Refs: Armstrong 1914-16, 306 - Crawford 1923, 169 - Raftery 1941, 159 and Pl. 87.1, 88 - Mitchell 1977, 185-186.

No details of the early history of this piece are known except that it was traditionally associated with the abbots of the monastery of Clonmacnoise, Co. Offaly. A similarly ornamented fragment of a crozier was found at Clonmacnoise in the last century.

This crozier consists of two tubular lengths of sheet bronze lapped around a wooden staff and secured by three biconical knops, surmounted by a curved crook.

The hollow crook is cast in one piece. Both faces are covered with snake-like animals with ribbon-shaped bodies arranged in figure-of-eight patterns inlaid with strips of silver outlined with niello. These animals, with their tightly-woven knots and curled upper jaws are executed in the Irish Ringerike style, current in the late 11th century. The regular disposition of these animals and the absence of tendril ornament, seem to suggest influences from the succeeding Urnes style.

A pair of animal heads at the base of the crook have interlaced moustaches inlaid with niello and set with pellets and zig-zags of silver. The openwork crest, set in a slot along the top of the crook, is in the form of a procession of dog-like animals each gripping the hindquarters of the one before.

The rectangular drop is surmounted by a bearded human head, the hair falling to either side framing a figure of a mitred bishop, shown in the act of slaying a monster with his crozier. This figure is in the Gothic style and can be dated to the 15th century. The base of the drop is set with a D-shaped panel with a spiralled plant motif in yellow, blue and red enamel.

The upper and lower knops are set with geometric panels of cast ornament. These are outlined by studs of blue glass and a pleasing cable pattern consisting of inlaid strips of silver and red copper hammered into a groove. The plaques are decorated with interlace and palmette designs, and were alternately gilded or keyed for enamel (all of which is now missing).

Below the upper knop is a cast openwork ring with four erect cat-like animals, the eyes set with blue glass beads. Their tails, which end in further animal heads, and their spiralled joints, were inlaid with silver.

The central knop has a smooth surface inlaid with a loose interlace pattern in silver and niello. The seam of the bronze tubing would have originally been concealed by a vertical strip, now missing, which may have carried an inscription. The crozier ends in a pointed ferrule with a cast ring.

Wooden croziers or staffs are the most common of all the enshrined objects of the early Irish Church - over 40 complete and fragmentary examples are recorded (Crawford 1923, 163-173).

The relatively short walking stick with curved crook, used throughout Europe in the early middle ages continued to be used in Ireland until the later middle ages. The majority of Irish examples seem, however, to have been covered or refurbished in the 11th and 12th centuries.

The use of silver and niello inlays against a plain surface is characteristic of a small group of objects from the south Irish midlands dated to the late 11th and early 12th centuries. These include the two croziers from Clonmacnoise and a bell shrine from Glankeen, Co. Tipperary, now in the British Museum (Henry 1970, Pl. K) which also contains inlaid cable patterns of silver and red copper.

The regular figure-of-eight layout of the animal ornament on the crook is an Irish adaption of the Scandinavian Ringerike style. This design can also be seen on trial pieces from Dublin (74a, b). The plant motifs which decorate the knops also occur on contemporary stone sculpture. The origins of these motifs outside Ireland are controversial (Henry 1970, 198-200). R.Ó F.

78 Bronze Crucifixion Plaque
Colour pl. p. 175

Clonmacnoise, Co. Offaly
NMI: 1935:506
Late 11th - Early 12th centuries A.D.
L. 8.38 cm; W. 7.26 cm
Refs: Mac Dermott 1954 - Henry 1967, 123 and Pl. 8 - Mitchell 1977, 181 - Harbison 1980, 26-28 - Raftery 1980, 43.

This bronze plaque, said to have been found at Clonmacnoise, was cast, perhaps using a wax model. The figures stand out in low relief from the surrounding frame.

The figure of Christ is shown with outstretched arms and feet turned outwards. The long-sleeved garment is divided into eight panels containing half-palmette designs. The borders of the garment are milled as are the cuffs - a band above the hem is left plain. Angels are perched on Christ's arms and are shown with hatched wings, coiled at the shoulders.

Beneath Christ's right arm stands the sponge bearer Stephaton holding a cup on a long pole to Christ's lips. His hair falls in curls to the neck and he is clad in a suit of mail with slits in the hem at either side. The effect of mail is achieved by hatched bands. On the other side is shown Longinus, the spear bearer. He is shown fully frontal holding a spear to Christ's side wearing a mail shirt slit at the middle. Between these flanking figures and Christ are placed the crosses of the two thieves.

The border is stamped with a design of lozenges set in rectangular panels. Six large perforations at each corner and on the sides are the original means of attachment. Smaller rivet-holes occur along the upper and lower edges.

This plaque is one of six known from Ireland and may have formed part of a shrine or functioned as a pax - an object used in the Mass symbolic of the Kiss of Peace. The eyes of the figures would have been set with glass beads and the treatment of the figures is similar to those on the sides of the Stowe Missal Shrine (76). The palmette is characteristic of late 11th and 12th century Irish art and it has recently been suggested that some of these plaques were manufactured at Clonmacnoise (Harbison 1980).

R.Ó F.

79a-b Iron Bell of St. Patrick (a) and its Shrine (b)

Colour pls. pp. 62 and 192

Armagh, Co. Armagh
NMI: (a) R.4010, (b) R.4011
(a) 6th-8th century? (b) ca. 1100 A.D.
(a) H. 19.3 cm; W. at mouth 13.2 cm; T. at mouth 10.2 cm (b) H. 26.7 cm; at base 15.5 cm; T. at base 10.5 cm
Refs: Stuart 1819, vii-ix - Reeves 1850 - Petrie 1868, 109-112 - Ellacombe 1872, 353-359 - Reeves 1886 - Raftery 1941, 156 and pls. 78-80 - Henry 1970, 94-97 and pls. 22-24.

The bronze-coated iron bell is reputed to be that of St. Patrick himself and is recorded frequently in the Irish annals as one of the chief relics of Ireland.
It is made of two sheets of iron, the larger bent over to form the crown of the bell. The smaller sheet completes the body of the bell and is secured along its upper margin by three flat round-headed rivets. Similar rivets secure the sides of the bell.
The handle is of oval cross-section, the ends passing through the crown and overlapping on the inside to support the clapper. Two short lengths of iron mask the junction of handle and crown. The bell was then dipped in bronze.
The clapper is circular in cross-section with a heavy knob at its lower end. It is secured to the suspension loop by an S-shaped brass link which is modern. The clapper may be modern also.
Bronze-coated iron bells, of which 41 are known from Ireland (Bourke 1980), are also known from Scotland and Wales. Many have been found buried in graves. St. Patrick's bell is unique in that it is made of two sheets rather than the more usual single sheet of metal.
These bells are impossible to date, although most would appear to be earlier than the 9th century A.D.

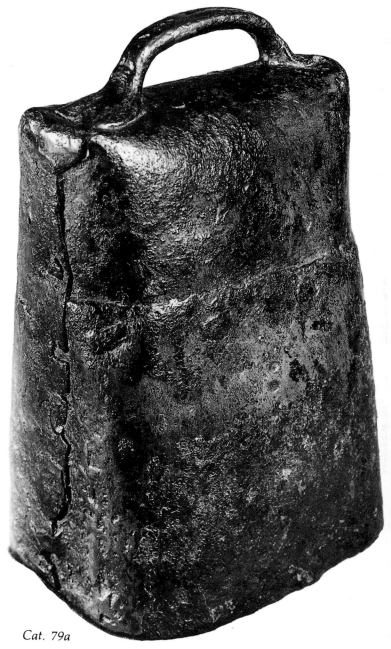

Cat. 79a

A lengthy inscription along the margins of the back plate of the shrine in Irish reads (from top left):
OR DO DOMHNALL U LACHLAIND LASIN DERNAD IN CLOCSA:
A prayer for Domhnall Ua Lochlainn who caused this bell to be made

167

OCUS DO DOMHNALL CHOMARBA PHATRAIC
ICON DERNAD:
*and for Domhnall, the successor of Patrick, with whom it
was made*
OCUS DOD CHATHALAN U MAELCHALLAND DO
MAER IN CHLUIC:
and for Cathalan Ua Maelchallain, the keeper of the bell
OCUS DO CHONDULIG U INMAINEN CONA
MACCAIB RO CUMTAIG:
*and for Condulig Ua hInmainen and his sons who
covered it.*

Domhnall Ua Lochlainn was king of Ireland from
1094-1121. Domhnall Mac Amhalgadha was bishop of
Armagh between 1091 and 1105. The shrine was thus
made in the ten years centering on the year 1100.

The keeper of the bell was entrusted with its safety and
preservation and, in fact, the bell and shrine remained in
possession of the Ua Maelchallain (Mulholland) family
until the late 18th century. The inclusion of a prayer to
the craftsman Cudulig and his sons points to the fact that
metalworkers, like other professional groups, often
inherited their trade from their fathers.

The shrine is composed of a curved crest and a tapering
body made of bronze plates held together with split
tubular bindings. A sliding plate of bronze is fitted to the
base to enable the bell to be easily removed.

The front is covered with a gilt silver frame which
originally held 30 gold filigree panels in place. These are
arranged in the form of a ringed cross, the centre now
occupied by a late medieval cabochon of rock crystal in a
gilt-silver filigreed frame.

The gold filigree panels around the edge contain pairs of
interlaced animals in regular figure-of-eight shapes. The
panels on the arms of the cross contain single animals
with spiralled bodies. Two of the four quarters contain
further filigree animals.

The filigree is of a most complex nature consisting of
beaded bronze wire which is overlain with pairs of plain
wires and then a second layer of beaded wire - this time of
gold - is laid over this again. The filigree is set on sheets of
gold foil and bordered by beaded gold wires. Oval
settings with studs of coloured stone at the centres of the
sides obscure further filigree panels. A large hog-backed
crystal is set in the lower left quadrant.

The backplate of silver is pierced with a series of
interlocking crosses against a bronze background, the
inscription incised along its margins.

The sides are adorned with pairs of cast openwork panels
separated by a ringed cross with panels of animal
interlace set between the arms. Cubes of silver, laterally
pierced for suspension, are attached to the centres of the
crosses. The openwork panels on the sides contain
interlocking animals arranged in graceful curves laid out
in a regular manner. These animals have long, drawn-out
jaws and almond-shaped eyes inset with blue glass. Thin
snake-like beasts with bulging eyes are woven through
these on the right-hand panel.

The crest terminates in a pair of animal heads with
interlaced moustaches and manes and large, pointed eyes
of blue glass. An empty circular setting on the front is
flanked by filigree panels of interlaced animals similar to
those on the main face. Around these are floral patterns,
including half palmettes, executed in beaded gold wire
placed on a ribbon set on edge. Above this is a blue glass
bead inset with cloisons of red and white glass.

The back of the crest is dominated by a semicircular
panel representing a pair of confronted birds with long
tails and strap-like wings. Cast silver panels with
interlaced figure-of-eight snakes are set above these,
flanking a medallion containing an animal with spiralled
body.

Although employing a wide range of tehniques, the
filigree work is of poor quality and the regularly-disposed
interlaced animal ornament lacks the vitality and range
of the animals on other contemporary objects such as the
Lismore crozier (81). The workmanship of the openwork
panels, however, is of a remarkably high quality. The
openwork panel on the upper right hand side shows a
good example of the so-called Urnes style 'combat theme'
in which one or more large beasts are interlaced with
small ribbon-like snakes. The latter are generally shown
in Irish metalwork, sculpture and manuscript
illumination with bulging eyes seen in plan. This seems to
be a feature of the English, rather than Scandinavian
Urnes style. The animals' heads with interlaced manes
and moustaches are an Irish elaboration of an Urnes style
motif.

The suspension rings indicate that this bell shrine, like
many others, was meant to be carried. Indeed, portion of
a chain was still attached to the object in the 19th
century. R.Ó F.

Donaghmore, Co. Cork
NMI: 1884:690
1st quarter of the 12th century A.D.
H. 39.0 cm; D. of base 7.0 cm
Refs: Anon. 1839 - Todd 1850-1853 - Petrie 1878, 104-5 -
Coffey 1909, 53-54 - Crawford 1923, 90 - Raftery 1941,
161 and pl. 99 - Henry 1970, 103-6 and pls. 38-40 -
Mitchell 1977, 214.

This reliquary is first mentioned in the mid 17th century
when it was in the possession of the O'Healy family who
held it as symbol of their tenure of lands around Donagh-
more, Co. Cork (Brady 1864, 19). A monastery was said
to have been founded there in the 6th century by St.
Lachtin.
The shrine has a wooden core covered with cast and
engraved bronze plates in the shape of a forearm with the
fingers bent over the palm.
The hand is cast in one piece and contains engraved
geometric panels of zoomorphic interlace and plant
motifs originally inlaid with silver. These alternate with
panels of gold and gilt silver wire, now much worn. The
fingernails are sheathed in silver and a triangular gilt
silver plaque with spiralled foliate ornament is seen in the
palm. A similar plaque with scroll ornament is set
beneath the finger tips. Panels of cast zoomorphic
interlace encircle the wrist. These panels were originally
covered in thin sheets of gold foil held in place by
stitching. The forearm consists of eight trapezoidal plates
fastened by vertical strips and by an openwork bronze
collar - originally gilt - depicting a frieze of four beasts in
the Irish Urnes style through which thin bodied snakes
are threaded. The plates are covered with a dense
network of interlaced ribbon-like animals with curled
jaws inlaid with silver and niello. The vertical strips carry
a worn inscription which reads:
(O)R DO MAELSECHNAILL U CELLACHAI DO
ARDRIG . . .
A prayer for Maelsechnaill Ua Cellachain, high king . . .
(D)O CHORMAC MC MEIC CARTHAIGHI DO
RIGDANU MUMAND . . .
*for Cormac son of Mac Carthaig the heir to the kingship
of Munster . . .*
OR DO TADC MC MEIC C(A)RTHAIGI DO RIG . . .
A prayer for Tadhg son of Mac Carthaig, king . . .
(O)R DO DIARMAIT MC MEIC DENISC DO
COMARBA . . .
A prayer for Diarmait son of Mac Denisc, successor of . .
Maelsechnaill Ua Cellacháin, described in the Annals as

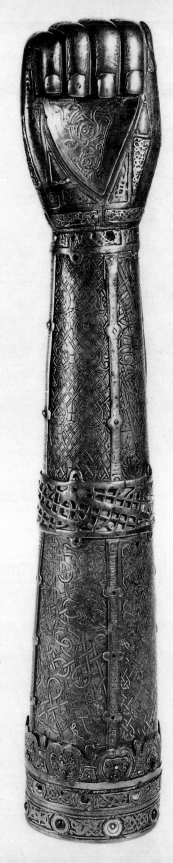

the king of southern Ireland, died in 1121. Tadg Mac Carthaig became king of Cashel and Munster after 1118 and was succeeded by his brother Cormac in 1124. The shrine can therefore be dated to the years 1118-1121. Of the ecclesiastic Diarmait Mac Denisc, nothing is known.

The base of the forearm is decorated with heart-shaped frames set with gilt silver filigree and two bands of zoomorphic interlace panels, originally covered in gold foil, separated by blue glass beads.

The base of the shrine (now detached) is set with gilt silver filigree panels. A similar band of filigree surrounds the central aperture flanked by ribbed panels originally covered in gold foil. The central aperture contained a circular setting of glass or enamel surrounded by millefiori platelets with cruciform patterns (now missing).

Similar arm reliquaries are known from contemporary Europe. An arm reliquary of St. Patrick, of late medieval workmanship is preserved at Armagh; a silver arm reliquary of the Irish St. Ruadhán was preserved at Lorrha, Co. Tipperary and an arm reliquary of St. Ciarán was preserved at Clonmacnoise until the 18th century (Huband Smith 1854).

The poor quality of the filigree work on this object contrasts with the more elaborate interlace patterns of the side plates. The use of stitching to attach gold foil, seen on this object, reappears in Irish metalwork in the late 11th century (see also No. 90). However, in contrast to the 8th and 9th centuries, where it is used to attach panels of gold filigree with foil backings, it is here used merely to attach gold foil coverings to the cast bronze panels of interlace on the wrist and base. It appears that this use of gold foil may have been a substitute for gilding. The animal ornament, particularly that on the plates attached to the forearm, is derived from the Scandinavian Urnes style. Some of the interlaced panels of snakes with single protruding eyes have no parallels in contemporary metalwork but are closely related to animals used in decorated capitals on some early 12th century manuscripts of Leinster provenance (Henry and Marsh-Micheli 1962, Pl. XIV a). Around the base, however, are single animals, some seen in plan, which also occur on the Shrine of St. Senan's Bell (90) and which have a respectable pedigree in Irish art.

The plant motifs on the palm, in contrast, are totally new and may derive from southern English or French Romanesque manuscripts, probably introduced in the wake of church reforms (Henry and Marsh-Micheli 1962, Pl. XXIV a). R.Ó F.

81 The Lismore Crozier
Colour pl. p. 183

Lismore, Co. Waterford
NMI: L.1949:1
ca. 1100 A.D.
L. 116 cm
Refs: O'Neill 1863, 39-45 - Petrie 1878, 118 - Crawford 1923, 172 - Raftery 1941, 159-160 and pls. 93-94 - Henry 1970, 97-99 and pls. 125-126.

In its construction, this crozier resembles that from Clonmacnoise (77) and encloses a wooden staff. It was found in 1814 in a wooden box in a blocked-up doorway at Lismore Castle, Co. Waterford along with a 15th century manuscript (O'Curry 1861, 196).

The crook is cast in one piece and is hollow except for a small box-shaped bronze reliquary introduced through the side of the drop. The setting for the front of the drop is missing. It is bordered by panels of zoomorphic interlace originally covered in gold foil. These are separated by rectangular plaques of blue and white *millefiori* glass arranged in chequer patterns.

Each side of the crook is divided into sunken panels, now empty, bordered by billeted mouldings and beads of blue glass with red and white *millefiori* insets.

The crest consists of three animals with open-fanged jaws. The front animal holds an empty setting, perhaps for a human head. The crest terminates in an animal head with interlaced moustache and mane, which is hollow and which contained a small reliquary.

A ropework moulding, covered in gold foil, runs along the inner curve of the crook, and ends in a human head to either side of which is an inscription:

OR DO NIAL MC MEICC AEDUCAIN LASAN (D)ERNAD IN GRESA

A prayer for Nial Mac Meic Aeducain who caused this (crozier) to be made

+ OR DO NECTAI CERD DO RIGNE I GRESA

A prayer for Neachtain the craftsman who made the work

Niall Mac Meic Aeducain became bishop of Lismore in 1090 and died in 1113. The object may perhaps be dated to the end of his life as Lismore was confirmed as a diocese at the Synod of Rathbreasail in the year 1111 A.D.

The upper knop is designed in a similar manner to the crook. It has a scalloped lower edge and is set with blue and green glass beads with inset geometric *millefiori* designs in white and red.

Cast bronze strips, with decorated borders of niello inlaid with silver wires, cover the seams of the bronze tubing. The central knop is set with bronze plaques with interlaced animals in the Irish Urnes style. These animals are characterized by their attenuated jaws, elongated almond-shaped eyes and head lappets or pigtails.

The elongated lower knop is cast in one piece with the ferrule. Its scalloped upper edge consists of four human heads whose long hair is inlaid with silver wires. It is set with panels similar to those on the central knop surrounded by silver and niello inlays. Four cruciform panels contain human figures. One pair contains four interlocking human bodies, another shows a kilted figure, while the fourth represents a figure carrying a book or satchel suspended from the neck. These figures stand so close to those on the Cloyne cross (82) that the two objects must have been produced in the same workshop if not by the same craftsman.

The ferrule is hexagonal in form. On five of the six faces horned human figures are shown flanked by quadrupeds seen in plan, their limbs are covered in silver foil. The human figures were originally covered in gold foil. The sixth panel contains a pair of interlaced animals.

Below this are six further panels of interlace and the ferrule proper consisting of a three-pillared structure above which is set a freely moving ring.

This object shows perhaps the most successful blend of Irish and Scandinavian art styles of the period around 1100 A.D. Pairs of confronted animals alternate with snake-like beasts whose spiralled bodies are derived from the English version of the Urnes style, best seen on a stone trial piece from Killaloe, Co. Clare (Graham-Campbell 1980, 137). The treatment of the animal ornament contrasts with the more ragged interlace on the contemporary Shrine of St. Senan's Bell (90).

The use of gold foil, stitched in place, and the revival of the technique of *millefiori* glass bears witness to the revival of the metalworker's skill under wealthy patrons in the later 11th and 12th centuries.

The significance of the human figures, especially the horned figures at the base of the crozier, is unknown. The figure carrying a book or satchel may perhaps represent a local saint. Figures carrying similar objects occur on the sides of the Shrine of the Stowe Missal (76). R.Ó F.

Cat. 81

82 Bronze Cross ▷

Cloyne, Co. Cork
NMI: 1885:371
Early 12th century A.D.
L. 12.4 cm; W. 11.8 cm
Refs: Anon. 1870-73, 457 - Caulfield 1882, fig. opposite p.4 - Crawford 1923, 156 - Raftery 1941, 162 and Pl. 106.6 - Raftery 1959, 113.

The object was found in the chapter house of the cathedral at Cloyne, an early monastic site founded by St. Colman.

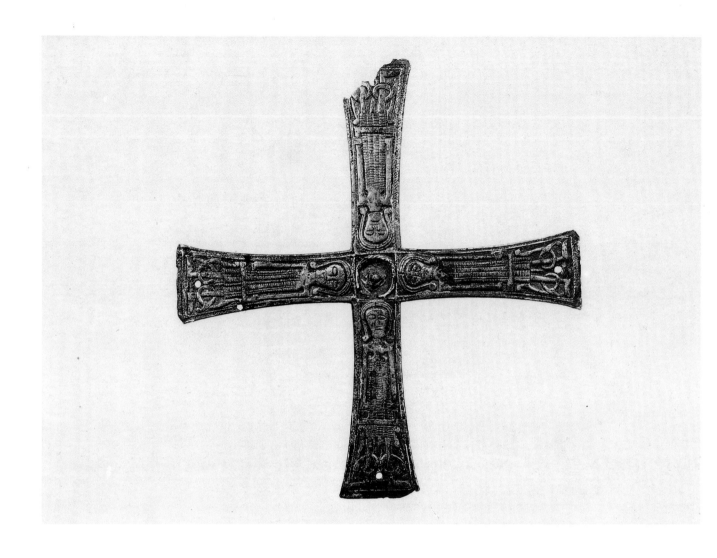

The Cross, which is slightly taller than it is wide, has concave-sided arms which expand towards the terminals. The edges are keyed for a niello inlay, most of which is now missing. Each arm contains a full human figure clothed in a kilt-like garment the treatment of which varies slightly from one figure to the next. The hair is parted at the centre and falls in curls to the shoulders. The disproportionately long arms of each figure are bent at the elbow. One arm is held behind the back and grips the other at the elbow.

An Urnes-style snake with almond-shaped eye curls around each leg. The edges of the panels are stitched or keyed to take sheets of gold foil, fragments of which can still be seen. A square frame at the crossing of the arms is set with a circular stud-setting of twisted silver wire. The ends of the arms are pierced, presumably for attachment to a larger object.

The treatment of the human figures is identical to those on the lowest knop of the Lismore crozier (81). The cross possibly formed the centre piece to a book shrine - its shape and proportions are very close to the cross on the shrine of the Book of Dimma (83). R.Ó F.

83 Shrine of the Book of Dimma

Colour pl. p. 174

Roscrea, Co. Tipperary
T.C.D.
12th century; late 14th century; 15th century
L. 19.0 cm; W. 16.1 cm; T. 4.4 cm
Refs: Monck-Mason 1818-19 - Petrie 1878, 100-102 -
Raftery 1941, 163 and pls. 101-102 - Mitchell 1977, 216 -
Ó Floinn 1982.

The shrine and the manuscript which it contained (52)
were preserved at Roscrea, Co. Tipperary, until the early
19th century when they passed, through several hands,
into the Library of Trinity College Dublin.

The shrine consists of a series of bronze plates, held
together with split tubular bindings forming a rectangular
box just big enough to hold the manuscript. One of the
short narrow sides is missing.

The front carries marginal strips of gilt silver which carry
a Lombardic inscription which reads:
TATHEVS O KEARBVILL REI DE ELV MEIPSVM
DEAVRAVIT:
Tadhg Ua Cearbaill, king of Éile had me gilt:
DIMINVS DOMNALDVS O CVANAIN CONVERBIVS
MEIMSVM RESTAVRAVIT:
*the Lord Domhnall Ua Cuanáin, coarb, was the last to
restore me:*
TOMAS CEARD DACHORIG IN MINDSA +
Tomás the goldsmith fashioned this shrine.
Tadhg Ua Cearbaill may be identified with a king of Éile,
a territory in north Munster, who ruled between 1380
and 1407. He was noted as a patron of the arts. The
ecclesiastic Domnall was a member of the Ua Cuanáin
family who were the hereditary successors or coarbs
(Latin: converbius) of St. Crónán, founder of the
monastery of Roscrea. A date in the last quarter of the
14th century for the refurbishment of the shrine is
probable.

Of contemporary date is the equal armed cross with
knotwork interlace and the openwork geometric pierced
silver plaques which cover this face. A crucifixion scene
with the Virgin and St. John - the cross with an IHS
monogram in Gothic lettering - was added in the 15th
century. Gothic script is not found in Ireland before
about 1400 A.D. Also added at this time were glass beads
in beaded-silver collets which adorn the cross and
marginal strips.

The back contains four openwork silver panels of
interlaced animals which constitute the earliest datable
portions of the shrine. These are executed in the Irish

Urnes style of the 12th century. The plaques at top left
and lower right contain no fewer than twelve animals
including snakes and birds while there are eight animals
on the remaining plaques. These animals are laid out in
graceful figure-of-eight patterns with hatched,
herringbone or rock-traced bodies.

The thin, flat silver plate on the right-hand narrow side of
the shrine is ornamented with similar snakes set against a
cross-hatched background and is probably of 12th
century date.

Damaged silver plates occur on the other two sides.
These contain *repoussé* panels of lions rampant in
quatrefoils and also unicorns and griffins in rectangular
frames. These two plates belong to the 14th or 15th
century remodelling of the shrine.

A plain silver cross and marginal strips carrying an
inscription in English were added to the back of the shrine
in the 19th century.

This shrine shows evidence of at least three periods of
remodelling during the middle ages. The openwork silver
plates on the back belong to the style of a group of
objects which include the processional Cross of Cong and
the Shrine of St. Manchan dating from the first half of the
12th century. The arrangement of the animals on this
shrine is cluttered, however, making it very difficult to
distinguish the individual animals.

The openwork geometric plaques on the front are,
perhaps 14th century replacements of earlier mountings.
Similar pierced plaques occur on the shrine of St.
Patrick's Bell (79b) and the shrine of the Stowe Missal
(76).

The presence of the shrine at Roscrea in the early 19th
century and the presence of the Ua Cuanáin family name
on the 14th century inscription (a family who were
associated with the monastery of Roscrea since the early
12th century) suggest that the shrine was originally made
for that monastery.

The refurbishing in the later 14th or 15th centuries at the
behest of Tadhg Ua Cearbhaill can be associated with the
latter's struggle with neighbouring Anglo-Irish and
English lords for control of the lands around Roscrea.

The reported discovery of this shrine and its manuscripts
in 1786 in a cave on the Devil's Bit mountain some miles
from Roscrea is spurious (see Ó Floinn 1982).

R.Ó F.

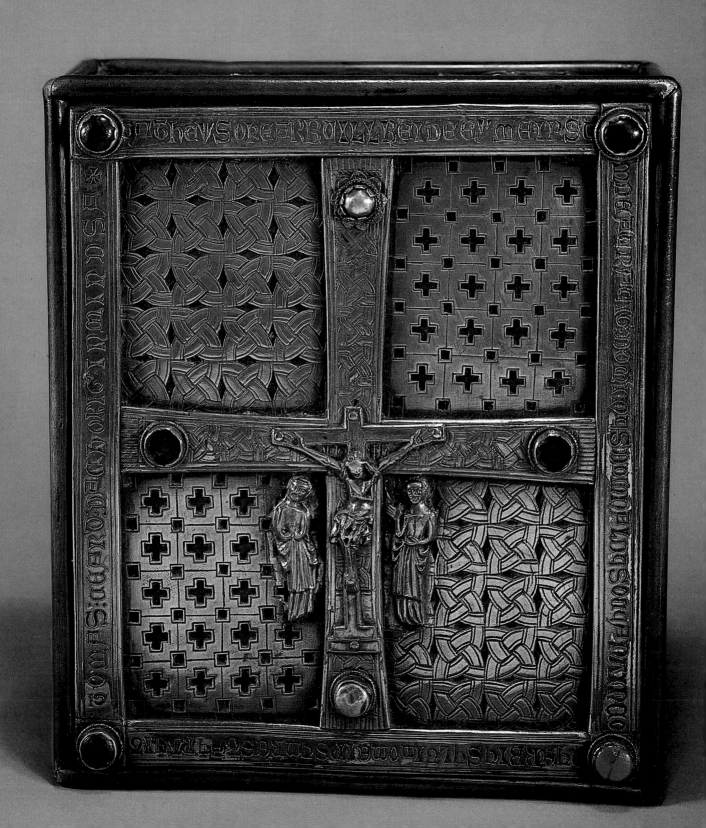

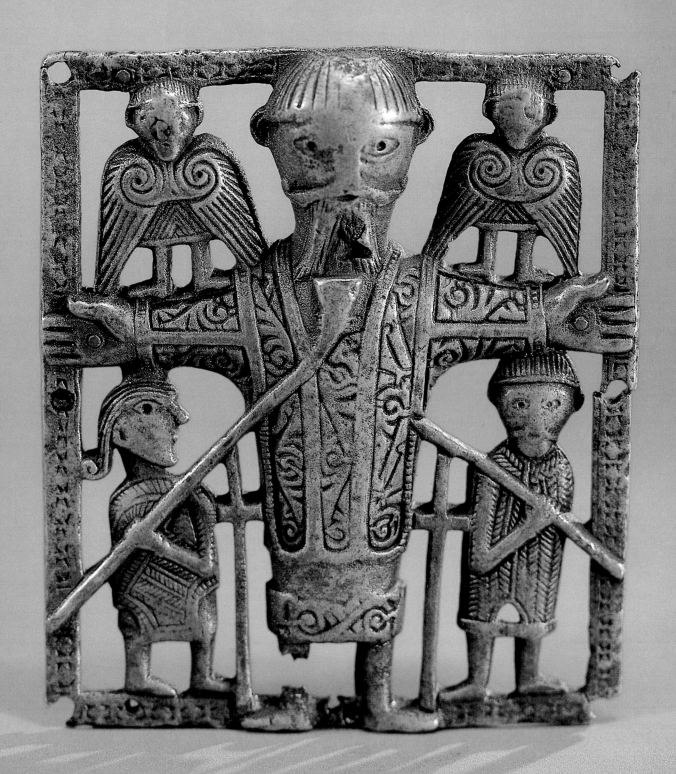

84 Gilt Bronze Figure of an Ecclesiastic

Colour pl. p. 32, right

Find place unknown
NMI: R.2940
12th century A.D.
H. 19.0 cm; Max. W. 3.2 cm
Refs: Graves 1874, 147-148 - Crawford 1923, 87 - Kendrick and Senior 1937, Pl. 29,4 - Raftery 1941, 162 and Pl. 106,1 - Mitchell 1977, 215.

This cast and gilt bronze representation of a bishop is one of a number of detached figures similar to those mounted on the gabled shrine of St. Manchan, preserved at Boher, Co. Offaly, which was originally set with about 50 such figures arranged in two rows on either face (Kendrick and Senior 1937).

The figure represents a bishop with a pointed mitre wearing a long-sleeved tunic decorated with interlocked hatched triangles. Over this is worn a high-necked cloak which appears to be fastened at the breast by a pair of disc brooches with cruciform designs, the centres of which are pierced for rivets for attachment to a backing. A third rivet hole, with a rivet still in place, occurs between the feet of the figure. The cloak is decorated with linked scrolls and a symmetrical plant motif and is provided with orphreys which fall down the front, between the arms.

The crozier, which has a semicircular spiralled crook, is held in both arms and the ferrule rests between the feet of the figure who wears a pair of shoes with central tongues similar to leather shoes of the period which survive from Ireland.

Representation of bishops in full ecclesiastical vestments first appear in Irish art in the late 11th - early 12th century. Many are shown in prominent positions on the contemporary high crosses and perhaps reflect the organisational reforms being carried out in the Irish Church which culminated in the Synod of Kells in 1152 which finally established the diocesan structure of medieval Ireland. A very similar figure to this one, representing an ecclesiastic with pleated garment and similar shoes, is in the collection of the British Museum (Henry 1970, Pl. 47). This figure was said to have been found on the site of the Augustinian monastery of St. John in Dublin. These two figures, although the products

of the same workshop which produced those on St. Machan's shrine, belong perhaps, to a different shrine. The elongated bodies, bulging ovoid eyes, pointed chin and fringed sleeves are features common to both groups. The treatment of the figures is Irish and the patterns of the dress are those found on contemporary Irish sculpture. The use of cast individual figures, not linked to a decorative background - compare the Aghaboe figure (46) and the Stowe Missal (76) - is a new departure but it is difficult to find convincing models on the continent which may have influenced this development. Henry (1970, 113) has detected Spanish influences while others would prefer a Northern European inspiration, perhaps in the Danish gold altar frontals (Kendrick and Senior 1937, 115).

R.Ó F.

85 Domnach Airgid Shrine

Colour pl. pp. 71 and 179

NMI: R.2834
Late 8th/early 9th century; mid 14th century; 15th century A.D.
L. 23.0 cm; W. 16.7 cm; T. 9.8 cm
Refs: Petrie 1839 - Armstrong and Lawlor 1917-1919 - Raftery 1941, 115-119 and Pls. 115-118 - Mitchell 1977, 216-217.

The name *Domnach Airgid* - 'silver church or shrine' - is derived from a shrine of the same name given by St. Patrick to St. Mac Cairthainn of Clones, Co. Monaghan, an event related in an early life of St. Patrick.

The reliquary was acquired in the mid-19th century from its hereditary keepers, the Maguires, formerly lords of Fermanagh. It appears to have been preserved in the neighbourhood of Enniskillen, Co. Fermanagh for many centuries.

When opened, the shrine was found to contain fragments of the gospels of 8th or early 9th century date. The shrine was not, however, made to contain this manuscript which had been folded over to fit into the reliquary. The depth of the shrine would suggest that it was not a book shrine but rather a container for relics.

The shrine consists of a box of yew to which decorated metal plates have subsequently been added. The box is carved from the solid and is provided with a sliding lid. Thin plates of tinned bronze were added to the box. These can be seen on the narrow sides and similar plates are concealed by later mounts along the long sides. These

◁ *Bronze crucifixion plaque, Cat. 78, p. 166*
◁◁ *Shrine of the Book of Dimma, Cat. 83, p. 173*

plates are ornamented with crudely engraved broad ribbon interlace surrounded by a border of fretwork and is executed against a hatched ground. This covering may be dated to around 800 A.D. when engraving of this kind was common on Irish metalwork (compare 58). The interlace has been compared in the past to that on the 7th century Book of Durrow (43) but the fret pattern on the shrine's plates does not appear in Irish art until almost a century later.

The main face of the shrine and the long sides were covered with cast and engraved silver gilt plaques with figured scenes. Two Lombardic inscriptions date this phase or ornament (both have been replaced upside down):

IOHS: O KARBRI: COMORBANVS: S: TIGNACI: PMISIT

+ IOHANES: O BARDAN: FABRICAVIT + +

The first refers to John O'Carbry 'successor of St. Tighearnach' who was abbot of the Augustinian monastery at Clones, Co. Monaghan, and who died in 1353. John O'Barrdain, the goldsmith, appears to have been a member of one of the many Irish families who followed the learned professions as hereditary occupations. Some members of the O'Barrdain family were distinguished harpers, others skilled metalworkers. Another John O'Barrdain is recorded as a metalworker in the town of Drogheda in the mid-15th century.

The front is divided into four rectangular plaques bordered by strips of silver inlaid with niello. The upper register contains, on the left, St. Michael the Archangel slaying the dragon and the Virgin and Child. To the right are the apostles James, Peter and Paul.

A worn figure of the crucified Christ is flanked by the mourning Virgin and St. John the Evangelist. The other figures are less easily identified. To the left is shown a monk handing a book to a seated bishop. This has been interpreted as St. Patrick handing the *Domhnach Airgid* to St. Mac Cairthinn. The figures of an abbess and an archbishop to the right may perhaps represent the Irish Saints Bridget and Columcille. All the figures are contained in arched niches.

Above the figure of Christ is set a triangular shield in red and blue enamel containing the implements of the Passion. Below is a square crystal and an enamelled bird in flight.

The sides are bound with hinged gilt silver strips of L-shaped cross-section. The corner pieces consist of three plates joined at right angles decorated with human or animal heads. Hounds, hares and wyverns with floreated tails occupy the borders along with panels of two-strand interlace - a rare occurrence on Irish late medieval

metalwork. Small settings for studs are placed at the four corners.

Three square plaques are set along the lower edge. These are not in their original positions and may have originally adorned the back.

The first shows St. John the Baptist carrying an enamelled disc bearing the Lamb of God and a scroll inscribed ECCE AGNUS DEI along with Salome holding aloft the head of the Baptist on a charger (platter). St. Catherine of Alexandria is shown carrying the wheel of her martyrdom flanked by a monk and an acolyte carrying a censer. The third represents Christ in majesty accompanied by censer bearers.

The top is covered by a plate set with three low bosses ornamented with crystals surrounded by six pointed stars. The central boss is ornamented with interlaced knots and pairs of birds pecking at a central cross. The stars to either side contain translucent blue enamel in the *basse taille* technique, the spaces between are occupied by lions and griffins.

Horsemen in full armour with short swords and wearing broad-rimmed kettle hats (*chapels-de-fer*) are shown between the bosses. The riders are clothed in long quilted garments (*aketons*) buckled at the waist with mail *pisanes* protecting the neck and shoulders. A square crystal is fixed to the lower edge of this face.

The back of the shrine was remodelled in the 15th century in bronze. Many of the binding strips were replaced and a gilt bronze cross bearing the names of the three Magi - Caspar, Melchior and Balthazar - in Gothic script was added.

This shrine is unparelleled in Irish metalwork in the variety of its figured scenes and the quality of the gilt-silver panels. It is the first datable piece of Irish Gothic metalwork. Although provincial by European standards, the craftsman was aware of current European techniques such as *basse taille* or translucent enamelling, also found on the shrine of the Stowe Missal (76).

The representation of apostles and saints finds its closest parallel on Irish figure sculpture of nearly a century later where similar figures are used as weepers on tomb surrounds (Hunt 1974, 105ff). The inclusion of the foreign Saints Catherine and Michael is indicative of their popularity in Ireland throughout the Middle Ages.

There is no reason to believe that the upper plate is not contemporary with the 14th century remodelling of the shrine and that the riders, with their *chapels-de-fer* and *pisanes* do not represent contemporary Irish armour.

R.Ó F.

Cat. 86

86 Leather Satchel for the Book of Armagh

T.C.D.
15th century A.D.
L. 32.0 cm; W. 27.0 cm; T. 5.7 cm
Refs: Petrie 1845, 327-331 - Abbott 1892, 164-165 -
Buckley 1915, 300-301 - Raftery 1941, 155-156 and Pls.
84, 85 - Waterer 1968, 79-81 - Mitchell 1977, 217-218.

Although now associated with the Book of Armagh (56),
this satchel was designed originally to carry a much
larger object.

It is made of a single piece of black-stained cattle-hide,
the sides folded inwards and sewn to the base and front
with leather thongs. It is provided with a generous flap
which covers two-thirds of the main face. A leather
carrying-strap was stitched to the sides. There are four
pairs of holes, equally spaced along the bottom of the
flap which correspond with similar perforations on the
main face. These were evidently the original means of
securing the satchel.
At some later stage a brass lock was added. Four oblong
slots sheathed in metal were made in the flap and through
these brass loops projected, probably to hold a sliding
bar, which was then locked in position.

The elaborate ornament was moulded, perhaps on a wooden former, in the *cuir bouilli* technique. On the flap, two side panels of angular interlace frame a cross of loosely woven interlace with roundels occupying the spaces between. An identical design occurs underneath the flap. Below, four roundels contain knotwork and single animals.

The back is framed with panels of interlace and an unusual geometric scroll design. Like the front, alternate animal and knotwork designs are contained within roundels. An unusual feature, also found on the harp of Brian Ború (87) is the intertwining of roundels where they meet. Animals are shown singly or interlocked in twos or threes. The roundel at lower left contains a debased Gothic inscription which, it has been suggested may represent the word *Amen* flanked by the letters *alpha* and *omega* (Mitchell 1977, 218). The spaces between the roundels are occupied by triquetra knots, interlocking links and lunettes.

The narrow sides of the satchel contain further panels of angular interlace and there is a pattern of s-scrolls enclosing triple spirals on the base.

Leather satchels are frequently mentioned in the literature as containers for books and relics. Two other leather satchels of this type survive, both also of later medieval date. During the later medieval period however, satchels appear to have been also used for non-ecclesiastical purposes. A tomb of an Irish layman dated to the 14th century, shows a figure (perhaps a poet or pilgrim) with his staff and satchel slung over one shoulder (Hunt 1974, Pl. 52).

The tightly woven angular interlace, arranged in oblong panels or roundels, is a characteristic feature of Irish art of the so-called Gaelic revival of the 15th-17th centuries when, under native Irish patronage, artists attempted to reproduce many of the motifs used on earlier, pre-Norman objects. The principles of intricate interlace were lost, however, and were replaced by crude knot and plaitwork patterns. The interlocking links and triquetra knots are common incidental devices on Irish late medieval sculpture and were sometimes employed as mason's marks. R.Ó F.

"Domnach Airgid" Shrine, narrow side, Cat. 85, p. 176

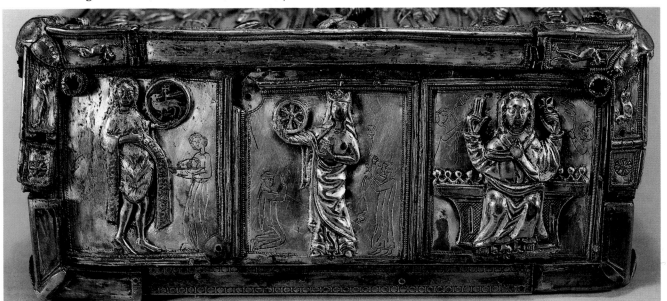

87 Wooden Harp - 'The Brian Boru' Harp

Colour pl. p. 193

T.C.D.
15th or 16th century A.D.
H. 86.0 cm
Refs: Vallancey 1786, 32-37 - O'Curry 1873, 263, 266-278 - Day 1890-91 - Abbott 1892, 171-173 - Armstrong 1904, 55-63 - Mitchell 1977, 218-219 - Rimmer 1977, 32-35.

Several conflicting accounts of the early history of this harp are known. The association of the harp with Brian Ború, high king of Ireland, who died in 1014 A.D. is no longer tenable. A silver badge perhaps of 16th or 17th century date depicting the arms of the O'Neill family, was formerly attached to the forepillar.

The harp is triangular in shape, consisting of a soundbox, a forepillar and a curved neck. The soundbox is composed of a hollow box of willow with a later plank of oak at the back. It narrows from the base to the shoulder which has been repaired. The upper surface is divided in two by a raised rib which expands into semicircular arches at the top. The rib carries 29 perforations protected by decorative metal 'shoes' through which the brass strings pass.

The top and sides of the soundbox are ornamented with circles linked by diagonal bands. Much of this ornament is restored but appears to have originally been drawn with a hot iron. The four sound-holes on the upper surface may originally have been sheathed in metal.

The curved neck was originally ornamented with a pattern drawn with a hot iron but carved geometric designs were added at a later date including an IHS monogram in Gothic script. A silver mount with settings for two oval crystals and a series of silver bosses are later additions - perhaps of the 16th century. A pair of curved brass strips are set into the sides of the neck and hold the tuning pegs in place.

The forepillar is covered with engraved ornament and may perhaps be of a later date than the rest of the harp. It is T-shaped in section ornamented with a two headed slug-like reptile which is a hallmark of the medieval Irish and Scottish harp. Roundels with pairs of animals in combat occur at the upper and lower ends of the sides. Between these is a continuous plant scroll with three-lobed leaves arranged spirally in each curve.

Panels of tightly woven interlace occur on the front, the borders of which are intertwined as on the roundels of the Armagh book satchel (86).

The centre of the pillar is ornamented with roundels from which three-lobed leaves spring. The central portion of this design was subsequently cut away, possibly to accommodate a metal mount.

This harp would originally have had 30 strings (one is obscured by the restoration of the forepillar). It is remarkably similar in shape and size to a harp in Edinburgh, Scotland known as Queen Mary's Harp. Ireland, particularly the north of the country, and western Scotland were part of the same cultural province in the later Middle Ages. Scottish merceneries fought in the armies of Irish chieftains and many Irish craftsmen, including stone masons worked in Scotland (Steer and Bannerman 1977, 106-107). The attribution of the harp to Brian Ború may derive from an early 13th century Irish poem which tells of a visit to Scotland to regain a harp of the O'Brien family.

The Irish and Scottish medieval harp with its forepillar of T-shaped section is first represented in the 11th century on a gabled shrine known as the *Breac Moedoic* (Henry 1970, Pl. 31). Earlier instruments represented in sculpture and metalwork (see No. 76) are of quadrangular shape and are not true harps but lyres. The medieval Irish harp had metal strings which were plucked with long finger-nails. It was held on the left shoulder, signs of wear being concentrated where the left hand reaches across the sound box to cover the upper register of notes, the right playing the bass.

Harpists, like poets were held in high regard in native Irish society. One Irish harpist even had a tomb erected in his memory, at Jerpoint Abbey, Co. Kilkenny, where he is shown alongside his wife, with a small harp by his side (Hunt 1974, Pl. 181). This tomb can be dated to the early 16th century. Another tomb in Scotland of around 1500 A.D. shows a harp with geometric ornament on the soundbox very similar to that on the Brian Ború harp (Steer and Bannerman 1977).

The ornament of the forepillar is very similar to a style of west Scottish stone carving centred on Iona (Steer and Bannerman 1977, 13ff). The plant scrolls and vines with interwined stems on the forepillar are especially close. It is not possible to say for certain whether the harp is of Irish or Scottish workmanship. R.Ó F.

88 Gilt Silver Processional Cross

Colour pl. p. 182

Ballymacasey, Co. Kerry
NMI: 1889:4
Last quarter of the 15th century A.D.
H. 67.2 cm; W. 51.2 cm; D. of socket 4.5 cm
Refs: Hewson 1879-82 - Buckley 1937 - Mitchell 1977, 219-220.

This processional cross was found in 1871 in fragments while ploughing reclaimed bogland. The main elements of the cross were subsequently soldered together with a white metal and many fragments are missing.
It consists of four main elements: a cross with a figure of the crucified Christ, a collar, a knop and a socket. The limbs of the cross are divided into three panels by soldered mouldings of gilt twisted silver wire. Quatrefoils at the ends of the arms were filled with openwork winged symbols of the Evangelists, each provided with a scroll which is uninscribed. To the left is the lion of St. Mark, at the top the eagle of St. John and to the right the calf of St. Luke. The symbol of St. Matthew - the winged angel - should be set at the foot of the cross but is now missing, giving the cross a rather squat appearance. The central quatrefoil may have held a crossed nimbus. Sprays of acanthus-like plant forms, portions of which are missing, ornament the sides of the arms.
The cast hollow figure of Christ was rivetted to the cross. He is shown clad in a loin-cloth with a crown resembling twisted rope. The detailing of the ribs and the hair is especially fine.
A small empty space containing a rivet on the upper limb probably held a *titulus*. A Gothic inscription covers the upper limbs of the cross and small figures of a pelican, a fox, a rabbit, a bird and a simple knotwork pattern occur between the words. The inscription reads:
CORNELIUS FILIUS JOHANNIS Y CONCHYR SUE NACONIS CAPITANUS
Cornelius son of John O'Connor, head of his sept

ET AVLINA FILIA MILITIS ME FIERI FECERUT
and Eibhlín, daughter of the knight, caused me to be made
PER MANU UILLIALMI CORNELI M° XXI°CCCCC ANNO DI
at the hands of William O'Connor, A.D. 1479.
John O'Connor, who founded the nearby Franciscan friary of Lislaghtin ca. 1470, died in 1478. His son Cornelius (or Connor) perhaps commissioned this processional cross as a gift to the friary in memory of his father.
The cross is soldered to an octagonal collar bearing figures of cowled (Franciscan?) monks holding small crosses. All are cast from the same mould. Above this is an openwork crest containing angels and foliate ornament.
Below this is a twisted knop set with eight lozenge shaped collets containing sheets of silver engraved with rosettes and other floral ornament outlined with niello. The knop is set on a socket decorated with vertical serrated ribs.
Crosses with floreated outlines containing symbols of the evangelists are a very common type throughout 15th century Europe. The inscription on this cross proves that it is of Irish workmanship. The quality of workmanship of the figure of Christ is exceptionally high and represents one of the high points of Irish Gothic metalwork. Similar crosses of less ambitious design are known from Ireland but date, perhaps, to the early 16th century (Armstrong 1915 b).
The inclusion within the inscription of small animals such as the fox or the pelican is typical of Irish art of the period and similar incidental animals are a feature of Irish friary architecture of the 15th and 16th centuries.
Few pieces of medieval Irish altar or church furniture have survived. Apart from this cross, a gilt silver chalice and paten, dated by an inscription to 1494 survives in the National Museum of Ireland (Buckley 1939, 14-18) and a mitre and crozier made for Bishop Connor O'Dea of Limerick in 1418 is preserved in Limerick (Hunt 1952).

R.Ó F.

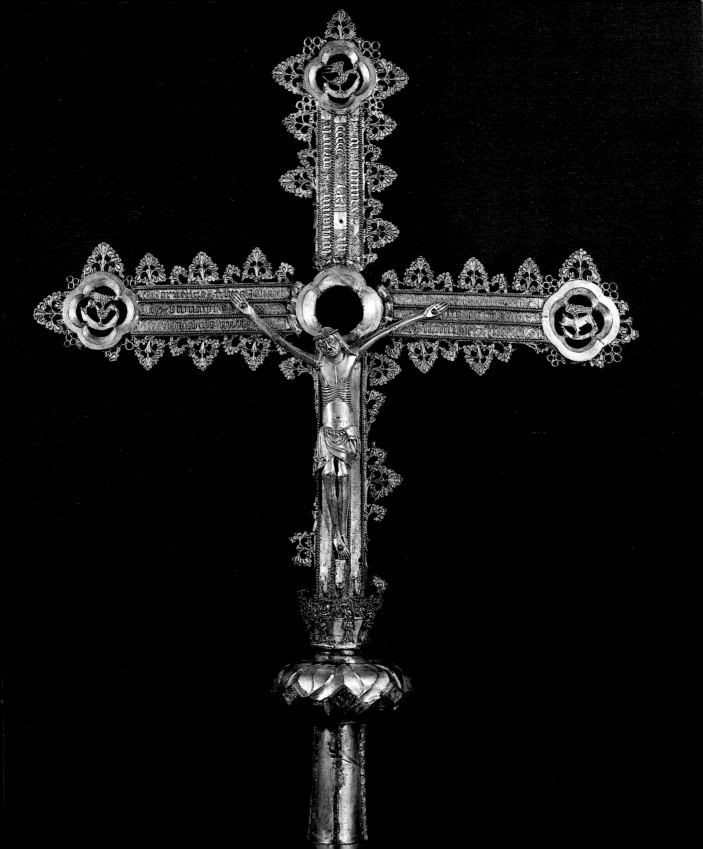

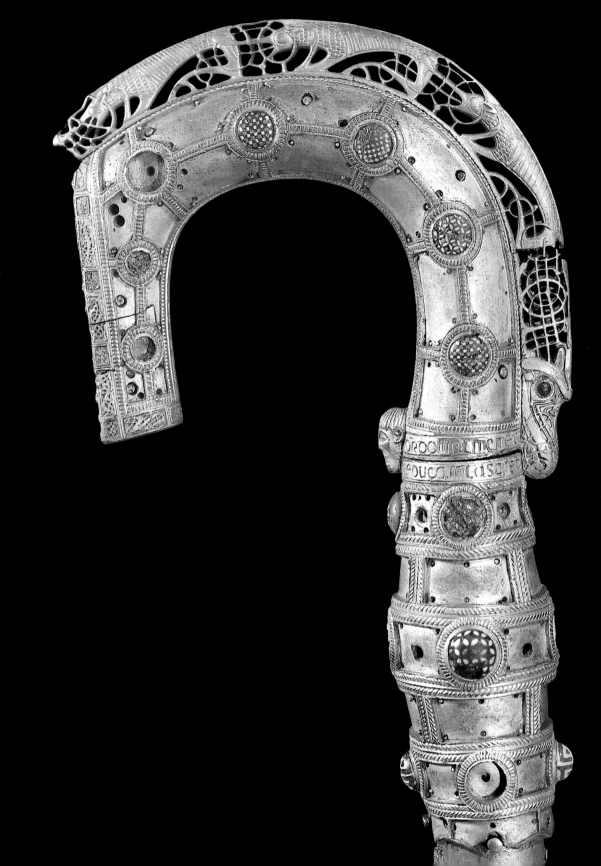

Cat. 89

89 Ivory and Brass Drinking Horn
The Kavanagh 'Charter' Horn

Borris, Co. Carlow
NMI: 1976:2
12th and 15th centuries A.D.
H. 42.0 cm.
Refs: Vallancey 1786 - Ryan 1833, 382 - Wilde 1861, 266 -
Bridge 1905, 135-6 - Ó Floinn 1981.

Formerly preserved at Borris House, Co. Carlow, by the
Kavanagh family who claimed direct descent from the
kings of the province of Leinster.
The horn is of elephant ivory, facetted with sixteen sides.
It bears the marks of earlier mounts around the rim and
tip, now covered by mounts of late medieval date. The
first of these is flanged and fits over the mouth of the
horn. Its lower scalloped edge is decorated with a
debased egg-and-dart motif and it is inscribed in Gothic
script:
TIGERNANUS. O. LAUAN. ME, FECIT. DEO GRA-
CIAS.IHS.
The surname O'Lavan was not common in the province
of Leinster and there is no known historical connection
between this family and the kings of Leinster.
The central mount is facetted with scalloped edges
bordered by strips imitating twisted wire. A pair of
hinged straps link the central and rim mounts.

The tip of the horn is covered with a closed ferrule with
scalloped upper edge.
Attached to the central mount are a pair of legs in the
form of webbed bird's feet. The upper ends of the feet are
secured to the mount by pins which fit into tubular
sockets soldered to the side. They are secured in place
with a pair of diagonal struts. An unusual feature of the
design is that when the horn is removed, the metal
mounts are free-standing.
There are many references to decorated horns in church
treasuries in twelfth-century Ireland donated by wealthy
patrons. Drinking horns of aurochs with metal mounts
are known from Ireland in the 8th and 9th centuries and a
complete 12th century Irish example is preserved in the
Musée du Cinquantenaire in Brussels (Henry 1970, 106).
The Kavanagh 'Charter' horn is traditionally regarded as
symbolic of the kingship of Leinster - a title claimed by its
hereditary owners since the 12th century. A 'horn of
Leinster' is recorded in a 12th century text associated with
this family and the ivory portion of the horn could well
date to this period. The late medieval mounts are similar
to those on drinking horns of the 15th century found
throughout north-western Europe. During the 14th and
15th centuries many Irish families revived their kingship
titles. The Kavanagh family were no exception and one of
the Kavanagh chieftains may have commissioned the
redecoration of the horn. In addition to the refurbishing
of the horn, a metal shrine for the 9th century Book of
Mulling was redecorated at the behest of another
Kavanagh chieftain Art Mac Murrough in 1403 A.D.

R.Ó F.

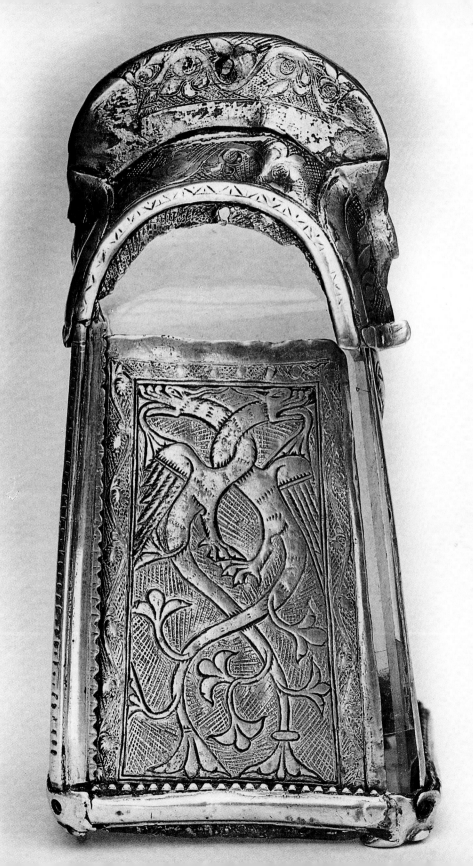

Cat. 90b

90 a-b 'Clogán Óir - Bronze Bell Shrine of St. Senan (a) with Silver Casing (b)

Scattery Island, Co. Clare
NMI: R. 1759/1919:1
(a) Late 11th century A.D.; (b) 15th century A.D.
(a) H. 12.2 cm; W. 6.0 cm; T. 4.8 cm
(b) H. 12.5 cm; W. 6.5 cm; T. 8.6 cm
Refs: Ellacombe 1872, 370-72 and Pls. ix-xii - Westropp
1900 - Westropp 1915, 367-61 - Armstrong 1919 -
Crawford 1923, 159 - Raftery 1941, 157 and Pl. 82 -
Graham-Campbell 1980, 150.

This bell shrine and later silver casing, traditionally
known as the *Clogán Óir* - 'little bell of gold' - is
associated with the 7th century Saint Senan, the founder
of a monastery on Inish Cathaig (Scattery Island) in the
estuary of the river Shannon. The bell was retained by
the descendants of the custodians of the monastery - the
O'Cahane family - until the beginning of this century.
The original bell for which this shrine was made is now
lost.
(a) The bronze shrine was cast in two pieces - a rectan-
gular tapering body and a curved top, the two elements
are at present secured by a modern iron pin but were
originally riveted. The main faces of the body are divided
into four fields by a cross with expanded terminals
outlined with a strip of inlaid silver which also surrounds
each main face. The circular field at the centre and the
triangular fields at the ends of each cross are empty save
for one which contains a fragment of green glass. The
areas between the arms contain cast panels of poorly
executed zoomorphic interlace surrounded by a border of
inlaid niello, now mostly missing.
The sides are set with plain strips of bronze surrounded
by a keyed groove for a silver inlay and flanked by rows
of ring and dot ornament. The corners carry roll-
mouldings rebated near the base presumably for
attachment to a base, now missing.
The curved top consists of a crest of semi-circular shape.
The crest is divided into triangular panels and terminates
in a pair of stylized animal heads. The panels of zoomor-
phic interlace are outlined by strips of silver and niello.
Other panels on the crest contain a fern-like motif and a
quadruped viewed in plan seen also on the base of the
shrine of St. Lachtin's Arm (80). All panels on the crest
(apart from those on the semi-circular sides) were
covered in gold foil held in place by stitching, traces of
which still remain. One panel shows traces of its original
covering of silver foil.

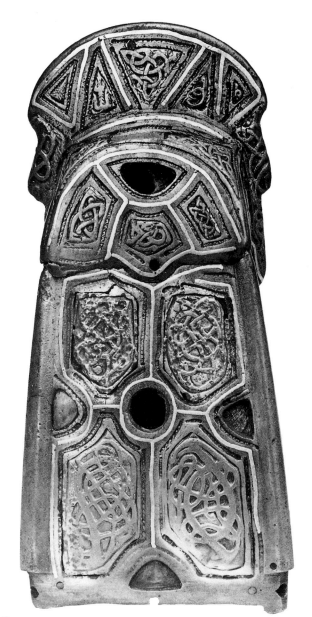

Cat. 90a

(b) The casing is of silver, gilt and the figures engraved on
it are highlighted with niello. Three of the side plates
remain, the principal face engraved with a pair of
dragons with intertwined necks and floreated tails. To
the left a lion rampant set against a curling plant is
surmounted by a *repoussé* head of a bishop and to the

187

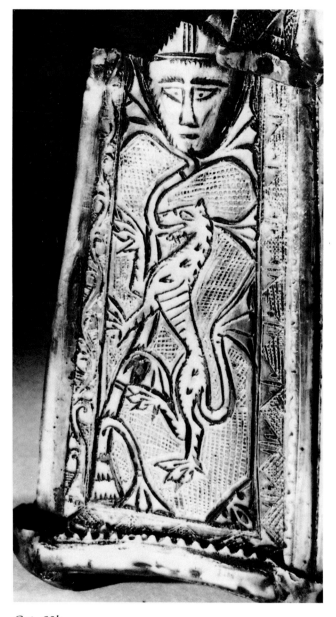

Cat. 90b

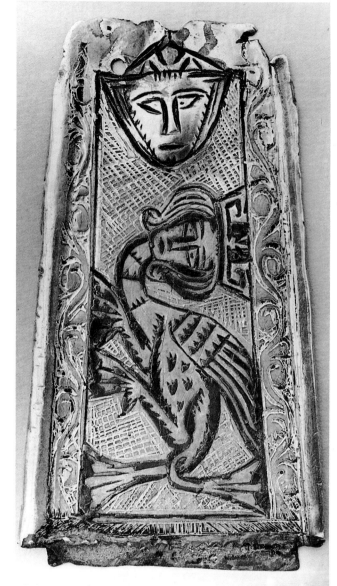

Cat. 90b

right, a mythical figure known as a Manticora (a dragon
with human head) with floreated crown and above it a
repoussé head of a female. These figures are all executed
against a gilt cross-hatched background and bordered by
panels of scroll-work. Plant motifs also occur on the crest

which is bordered by a geometric pattern common on late
Gothic metalwork.
The decoration on the bronze panels, although worn, is
poorly executed, and many of the interlaced animals are
reduced to a meaningless jumble of lines. The animals

with interlaced manes and moustaches at the ends of the crest may be compared to that at the base of the crook of the Lismore crozier (81) and those on the crest of St. Patrick's bell shrine (79b). The use of irregular geometric panels and silver and niello inlays link the piece to the crozier of St. Mura (Raftery 1941, pl. 90) and another from Co. Kilkenny (Raftery 1941, pl. 86, 1). The shape of the panels and the dense knots of snake-like animals have been compared to a trial piece from Dublin (Graham-Campbell 1980, 150).

The ornament on the late medieval casing is typical of the stock of motifs derived from the medieval bestiaries. Very similar animals are to be found on the carved wooden misericords in Limerick Cathedral which include representations of the Manticora and animals with their necks entwined (Westropp 1892). R.Ó F.

Cat. 91

91 Ivory Chessman

Co. Meath
NMI: P.1041
12th century A.D.
H. 7.25 cm; W. at base 3.3 cm
Refs: O'Donovan 1847, lxii-lxiv - Westwood 1876, 289 -Joyce 1913, 479 and fig. 338 - Liddell 1938, 133

This gaming piece is said to have been found in a bog in Co. Meath along with several others some time before 1817.

It represents a carved figure of a queen from a chess set. The object is of ivory or polished bone and contains a lead core with a small iron spike, presumably for attachment to the playing surface.

The figure is crowned and wears a shoulder-length veil over a mantle. The edges of the latter are folded back revealing a decorative border of dots and crosses. The left hand is raised to the cheek and is supported at the elbow by the right hand. The figure is seated in a high-backed chair with projecting arms. The chair back is decorated with a pair of two-legged dragons with backward looking heads. Their fish-like tails are intertwined and the mouths of the animals are joined by a beaded scroll. Across the back of the figure are carved the letters S, P and possibly K in Lombardic script. The perforation through the neck of the figure is secondary.

The figure undoubtedly belongs to the same workshop tradition which produced the group of 78 walrus ivory chessmen found in 1831 on the Isle of Lewis in Scotland where an exact parallel for the Co. Meath figure occurs (Goldschmidt 1926, No. 191). Only two other figures are known from the same workshop - one in the Bargello in Florence, the other found in Öland in Sweden. The decoration of these chessmen is Romanesque in style and the pieces were manufactured somewhere in the Viking world in the second half of the 12th century.

As the Co. Meath piece was found before the Lewis chessmen were discovered, the find circumstances would appear to be genuine and suggest that this piece perhaps represents the sole survivor of a similar set, now lost.
 R.Ó F.

Bibliography

ABBOT, T.K. 1892 — The Library, in: *The Book of Trinity College, Dublin*, Belfast 1892, 147-182.

ALEXANDER, J.J.G. 1978 — *A Survey of Manuscripts Illuminated in the British Isles. Vol. 6, Insular Manuscripts 6th to 9th century.* London 1978.

ANONYMUS 1836-40 — *Proceedings of the Royal Irish Academy*, I, (1836-40), 274-276.

ANONYMUS 1839 — *Vetusta Monuments*, Vol. VI. London 1869, 1-2, Pl. 19.

ANONYMUS 1852 — *Descriptive Catalogue of the Collection of Antiquities exhibited in the Museum, Belfast*, Belfast 1852.

ANONYMUS 1858-59 — Proceedings and Papers, *Journal of the Royal Society of Antiquaries of Ireland*, 5, (1858-59), 239-252.

ANONYMUS 1861 — Discovery of an Antient Crown and Collar, *The Western Star*, Ballinasloe, June 29th, 1861.

ANONYMUS 1870-73 — *Proceedings of the Society of Antiquaries of London*, V, (1870-73), 457.

ANONYMUS 1879-82 — *Journal of the Royal Society of Antiquaries of Ireland*, 15, (1879-82), 344-346.

ANONYMUS 1925 — La Tène Sword Hilt, *Journal of the Royal Society of Antiquaries of Ireland*, 15, (1925), 137-8.

ANONYMUS 1934 — Un Nouveau 'gorget' irlandais, *Revue Archéologique*, Ser. 6, 3-4, (1934), 68.

ARMAGH 1913 — *Liber Ardmachanus*, Dublin 1913.

ARMSTRONG, E.C.R. 1904 — *Musical Instruments. Part I. The Irish and the Highland Harps*, Edinburgh 1904.

ARMSTRONG, E.C.R. 1914-16 — Catalogue of the Silver and Ecclesiastical Antiquities in the Collection of the Royal Irish Academy, *Proceedings of the Royal Irish Academy*, 32c, (1914-16), 287-312.

ARMSTRONG, E.C.R. 1915a — Four Brooches Preserved in the Library of Trinity College, Dublin, *Proceedings of the Royal Irish Academy*, 32c, (1915), 243-48.

ARMSTRONG, E.C.R. 1915b — Processional Cross, Pricket Candlestick and Bell, found together at Sheephouse, near Oldbridge, Co. Meath, *Journal of the Royal Society of Antiquaries of Ireland*, 45, (1915), 27-31.

ARMSTRONG, E.C.R. 1917 — The Great Clare Find of 1854, *Journal of the Royal Society of Antiquaries of Ireland*, 47, (1917), 21-36.

ARMSTRONG, E.C.R. and LAWLOR, H.J. 1917-1919 — The Domnach Airgid, *Proceedings of The Royal Irish Academy*, 34c, (1917-1919), 96-126.

ARMSTRONG, E.C.R. 1919 — The Bell Shrine of St. Senan, known as the Clogán Óir, *Journal of the Royal Society of Antiquaries of Ireland*, 49, (1919), 132-135.

ARMSTRONG, E.C.R. 1920 — *Guide to the Collections of Irish Antiquities: Catalogue of Irish Gold Ornaments in the Collection of the Royal Irish Academy.* Dublin 1920, Reprinted 1933.

ARMSTRONG, E.C.R. 1921 — An imperfect Irish Shrine recently purchased by the Royal Irish Academy, *The Antiquaries Journal*, I, (1921), 48-54.

ARMSTRONG, E.C.R. 1921-24 — Some Irish Bronze Age Finds, *Proceedings of the Royal Irish Academy*, 36c, (1921-24), 134-149.

ARMSTRONG, E.C.R. 1922a — Notes on Some Irish Gold Ornaments, *Journal of the Royal Society of Antiquaries of Ireland*, 52 (1922), 133-142.

ARMSTRONG, E.C.R. 1922b — Irish Bronze Pins of the Christian Period, *Archaeologia*, LXXII, (1922), 71-86.

ARMSTRONG, E.C.R. 1923 — The La Tène Period in Ireland, *Journal of the Royal Society of Antiquaries of Ireland*, 53, (1923), 1-33.

BALL, V. and STOKES, M. 1892 — On a Block of Red Enamel said to have been found at Tara Hill with observations on the use of red Enamel, *Transactions of the Royal Irish Academy*, 30, (1892), 277-294.

BATESON, J.D. 1973 — Roman Material in Ireland: A Reconsideration, *Proceedings of the Royal Irish Academy*, 73c, (1973), 21-98.

BERNARD, REV. J.H. 1893 — On the Stowe St. John, *Transactions of the Royal Irish Academy*, 30, (1893), 313-324.

BØE, J. 1940 — Norse Antiquities in Ireland, in: Shetelig, H., (ed.), *Viking Antiquities in Great Britain and Ireland*, Part III. Oslo 1940.

BOURKE, C. 1980 — Early Irish Hand-Bells, *Journal of the Royal Society of Antiquaries of Ireland*, 110, (1980), 52-66.

BRADY, DR. W.M. 1864 — *Records of Cork, Cloyne and Ross*, Vol. III, Dublin 1864.

BRAUN, J. 1932 — *Das Chrisliche Altargerät . . .* München 1932.

BRIARD, J. 1965 — *Les Dépôts Bretons et L'Age du Bronze Atlantique.* Rennes 1965.

BRIDGE, J.C. 1905 — Horns, *Journal of the Chester Archaeological Society*, II, (1905), 85-116.

BROWNE, A. 1800 — An Account of some Ancient Trumpets, dug up in a Bog near Armagh, *Transactions of the Royal Irish Academy*, 8, (1800), 11-12.

BUCKLEY, J.J. 1915 — Some Early Ornamental Leatherwork, *Journal of the Royal Society of Ireland*, 45, (1915), 300-309.

BUCKLEY, J.J. 1937 — The "Ballylongford" Crucifix, *Journal of the Royal Society of Antiquaries of Ireland*, 67, (1937), 117-118.

BUCKLEY, J.J. 1939 — *Irish Altar Plate*, Dublin 1939.

BYRNE, F.J. 1967 — The Stowe Missal, 38-50, in: *Great Books of Ireland* (Thomas Davis Lectures), Dublin 1967.

CAULFIELD, R. 1882 — *Annals of the Cathedral of St. Colman, Cloyne*, Cork 1882.

CLARKE, R.R. and HAWKES, C.F.C. 1955 — An Iron Anthropoid Sword from Shouldham, Norfolk with related continental and British Weapons, *Proceedings of the Prehistoric Society*, 21, (1955), 198-227.

COFFEY, G. 1893-6 — Notes on the Classification of Spearheads of the Bronze Age found in Ireland, *Proceedings of the Royal Irish Academy*, 3, (1893-6), 486-510.

COFFEY, G. 1902-4 — Some Monuments of the La Tène Period Recently Discovered in Ireland, *Proceedings of the Royal Irish Academy*, 26c, (1902-4), 257-266.

COFFEY, G. 1908-1909 — The Distribution of Gold Lunulae in Ireland and North-Western Europe, *Proceedings of the Royal Irish Academy*, 27c, (1908-1909), 251-258.

COFFEY, G. 1909 — *Guide to the Celtic Antiquities of the Christian Period preserved in the National Museum, Dublin*. Dublin 1909.

COFFEY, G. 1913 — *The Bronze Age in Ireland*, Dublin 1913.

COGHLAN, H.H. 1945 — Some Perforated Stone Hammers in the Collections of the National Museum, Dublin, *Journal of the Royal Society of Antiquaries of Ireland*, 75, (1945), 224-247.

COLES, J.M. 1962 — European Bronze Age Shields, *Proceedings of the Prehistoric Society*, 28, (1962), 156-190.

COLES, J.M. 1963 — Irish Bronze Horns and their Relations with Northern Europe, *Proceedings of the Prehistoric Society*, 29, (1963), 326-356.

COLES, J.M. 1968 — The 1857 Law Farm Hoard, *The Antiquaries Journal*, 48, (1968), 163-174.

CRAWFORD, H.S. 1913 — Descriptive List of Early Cross-Slabs and Pillars, *Journal of the Royal Society of Antiquaries of Ireland*, 48, (1913), 326-334.

CRAWFORD, H.S. 1923 — A Descriptive List of Irish Shrines and Reliquaries, *Journal of the Royal Society of Antiquaries of Ireland*, 53, (1923), 74-93 and 151-176.

DAY, R. 1890-91 — The O'Neill Badge, *Journal of the Royal Society of Antiquaries of Ireland*, 21, (1890-91), 282-283.

DE PAOR, M. and L. 1958 — *Early Christian Ireland*, London 1958, Reprint 1978.

DE PAOR, M. 1977 — The Viking Impact, in: Cone, P., (ed.), *Treasures of Early Irish Art, 1500 B.C. to 1500 A.D.*, New York 1977.

DUIGNAN, M.V. 1976 — The Turoe Stone. Its place in insular La Tène Art, in: Duval, P.M., and Hawkes, C., (ed.), *Celtic Art in Ancient Europe: Five Protohistoric Centuries*, 201-217, London 1976.

DUNRAVEN, Earl of 1869 — On an Ancient Chalice and Brooches lately found at Ardagh in the County of Limerick, *Transactions of the Royal Irish Academy*, 24, (1867-74), 433-454.

DURROW 1960 — *Evangeliorum quattuor Codex Durmachensis*, 2 Vols., Olten and Lausanne, 1960.

ELBERN, V. 1963 — Der eucharistische Kelch im frühen Mittelalter, *Zeitschrift des Deutschen Vereins für Kunstwissenschaft*, 17, (1963), 1-76.

ELBERN, V. 1965 — Eine Gruppe insularer Kelche des frühen Mittelalters, in: Schlegel, U. and Zoege von Manteuffel, C., (eds.), *Festschrift für Peter Metz*, 115-123, Berlin 1965.

ELLACOMBE, H.T. 1872 — *The Church Bells of Devon*, Exeter 1872.

EOGAN, G. 1964 — The Later Bronze Age in Ireland in the Light of Recent Research, *Proceedings of the Prehistoric Society*, 30, (1964), 268-351.

EOGAN, G. 1965 — *Catalogue of Irish Bronze Swords*, Dublin 1965.

EOGAN, G. 1967 — The Associated Finds of Gold Bar Torcs, *Journal of the Royal Society of Antiquaries of Ireland*, 97, (1967), 129-175.

EOGAN, G. 1968 — Lock-rings of the Late Bronze Age, *Proceedings of the Royal Irish Academy*, 67c, (1968), 93-148.

EOGAN, G. 1972 — Sleeve-fasteners of the Late Bronze Age, in: Lynch, F. and Burgess, C., (eds.), *Prehistoric Man in Wales and the West*, 189-210, Bath 1972.

EOGAN, G. 1974a — Report on the Excavations of some Passage Graves, Unprotected Inhumation Burials and a settlement site at Knowth, Co. Meath, *Proceedings of the Royal Irish Academy*, 76c, (1974), 11-112.

EOGAN, G. 1974b — Pins of the Irish Late Bronze Age, *Journal of the Royal Society of Antiquaries of Ireland*, 104, (1974), 74-119.

EOGAN, G. 1981 — The Gold Vessels of the Bronze Age in Ireland and Beyond, *Proceedings of the Royal Irish Academy*, 81c, (1981), 345-382.

EOGAN, G., forthcoming — Ribbon Torcs in Britain and Ireland, in: Clarke, D., and Grieve, A.C., (eds.), *From The Stone Age to the 'Forty-Five'*, 87-117, Edinburgh.

EVANS, A.J. 1881 — *The Ancient Bronze Implements of Great Britain and Ireland*, London 1881.

EVANS, A.J. 1897 — On a votive Deposit of Gold Objects found on the North-West Coast of Ireland, *Archaeologia*, 55, (1897), 391-408.

EVANS, E.E. 1933 — The Bronze Spearhead in Great Britain and Ireland, *Archaeologia*, 83, (1933), 187-202.

FOX, C. 1958 — *Pattern and Purpose*, Cardiff 1958.

FRAZER, W. 1891 — On a Polished Stone Implement of Novel Form And Its Probable Use, *Proceedings of the Royal Irish Academy*, 17c, (1889-91), 215-220.

FRAZER, W. and JOHNSON, E. 1893-96 — On Five Gold Fibulae lately discovered in the South of Ireland and on the Art Processes used in their Manufacture, *Proceedings of the Royal Irish Academy*, 19c, (1893-96), 776-783.

FRAZER, W. 1899 — On "Patrick's Crosses" - Stone, Bronze and Gold, *Journal of the Royal Society of Antiquaries of Ireland*, 30, (1899), 35-43.

FUGLESANG, S.H. 1980 — *Some Aspects of the Ringerike Style*, Odense 1980.

GLEESON, D.F. 1934 — The Discovery of a Gold Gorget at Burren, Co. Clare, *Journal of the Royal Society of Antiquaries of Ireland*, 64, (1934), 138-139.

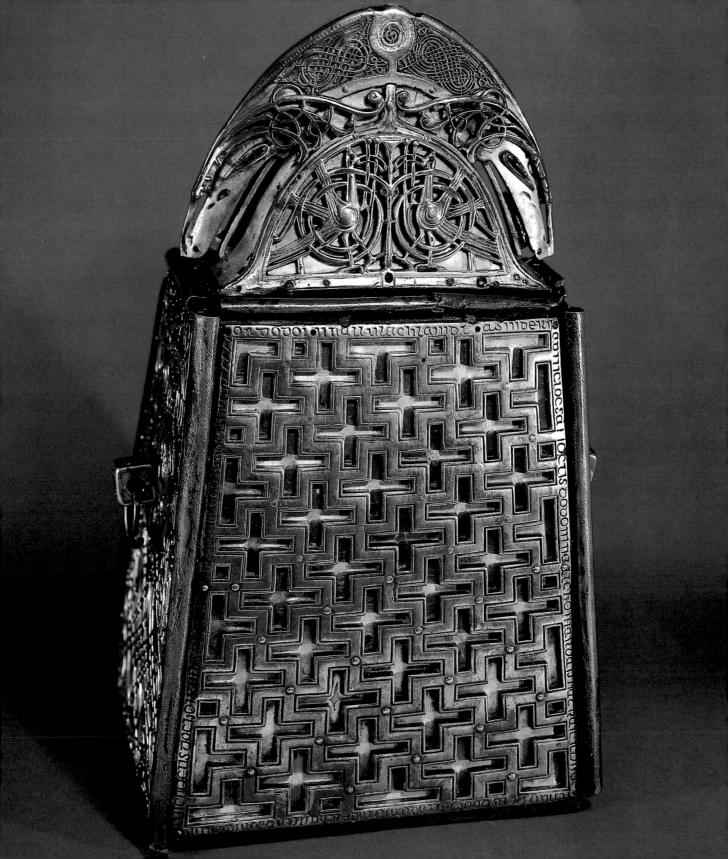

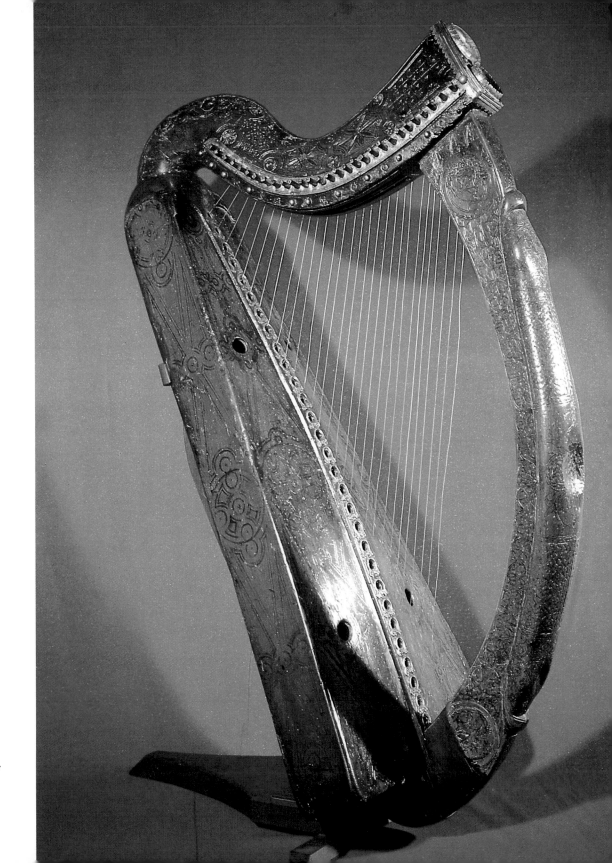

GOGAN, L.S. 1932 — The Ardagh Chalice, Dublin 1932.

GOLDSCHMIDT, A. 1926 — Die Elfenbeinskulpturen aus der Romanischen Zeit. XI.-XIII. Jahrhundert. Band 4, Berlin 1926.

GOMME, G.L., (ed.) 1886 — The Gentleman's Magazine Library: Archaeology; Part 1, London 1886.

GOUGAUD, D.L. 1920 — The Earliest Irish Representations of the Crucifixion, Journal of the Royal Society of Antiquaries, 50, (1920), 128-139.

GRAHAM-CAMPBELL, J. 1972 — Two Groups of Ninth Century Irish Brooches, Journal of the Royal Society of Antiquaries, 102, (1972), 113-129.

GRAHAM-CAMPBELL, J. 1975 — Bossed Penannular Brooches: a Review of Recent Research, Medieval Archaeology 19, (1975), 33-47.

GRAHAM-CAMPBELL, J. 1976 — The Viking Age Silver Hoards of Ireland, in: Almqvist, B., and Greene, D., (eds.), Proceedings of the Seventh Viking Congress, Dublin 1973, Dublin 1976.

GRAHAM-CAMPBELL, J. 1980 — Viking Artefacts: A Select Catalogue, London 1980.

GRAHAM-CAMPBELL, J. 1981 — The Look of The English, in: Roesdahl, E., et al., 1981.

GRAVES, REV.J. 1874 — The Church and Shrine of St. Manchan, Journal of the Royal Society of Antiquaries of Ireland, 13, (1874), 134-150.

GREENE, D. 1972 — The Chariot as described in Irish Literature, in: Thomas, C., (ed.), The Iron Age in The Irish Sea Province, 59-75, London 1972.

GWYNN, A. and GLEESON, D.F. 1962 — A History of the Diocese of Killaloe, Dublin 1962.

GWYNN, E. 1916 — The Stowe Missal, Irish Church Quarterly, 9, (1916), 119-133.

HARBISON, P. 1980 — A lost Crucifixion Plaque of Clonmacnoise type found in Co. Mayo, in: Murtagh, H., (ed.), Irish Midland Studies. Essays in commemoration of N.W. English, 24-38, Athlone 1980.

HARBISON, P. forthcoming — The Athlone Crucifixion Plaque.

HARTMANN, A. 1970 — Prähistorische Goldfunde aus Europa, Berlin 1970.

HARTNETT, P.J. 1957 — Excavations of a Passage Grave at Fourknocks, Co. Meath, Proceedings of the Royal Irish Academy, 58c, (1957), 197-277.

HAWKES, C.F.C. and SMITH, M.A. 1957 — On Some Buckets and Cauldrons of the Bronze and Early Iron Ages, The Antiquaries Journal, 37, (1957), 131-199.

HAWKES, C.F.C. 1961 — Gold Earrings of the Bronze Age, East and West, Folklore, 72, (1961), 438-474.

HAWKES, C.F.C. and CLARKE, R.R. 1963 — Gahlstorf and Caistor-on-Sea: Two Finds of Late Bronze Age Irish Gold, in: Foster, I.Ll., and Alcock, L., (eds.), Culture and Environment: Essays in Honour of Sir Cyril Fox, 143-250, London 1963.

HAWORTH, R. 1971 — The Horse Harness of the Irish Early Iron Age, Ulster Journal of Archaeology, 34, (1971), 26-49.

HENCKEN, H. O'NEILL 1941 — Ballinderry Crannóg No. 2, Proceedings of the Royal Irish Academy, 47c, (1941), 1-76.

HENCKEN, H. O'NEILL 1950-51 — Lagore Crannóg: An Irish Royal Residence of the 7th to 10th Centuries A.D., Proceedings of the Royal Irish Academy, 53c, (1950-51), 1-247.

HENRY, F. 1936 — Hanging Bowls, Journal of the Royal Society of Antiquaries of Ireland, 66, (1936), 209-246.

HENRY, F. 1940 — Irish Art in the Early Christian Period, London 1940.

HENRY, F. and MARSH-MICHELI, G.L. 1962 — A Century of Irish Illumination (1070-1170), Proceedings of the Royal Irish Academy, 62c, (1961-63), 101-164.

HENRY, F. 1965 — Irish Art in the Early Christian Period to A.D. 800, London 1965.

HENRY, F. 1967 — Irish Art During the Viking Invasions, 800-1020 A.D., London 1967.

HENRY, F. 1970 — Irish Art During The Romanesque Period, 1020-1170, London 1970.

HENRY, F. 1974 — The Book of Kells, London 1974.

HERITY, M. 1974 — Irish Passage Graves, Dublin 1974.

HERITY, M. and EOGAN, G. 1977 — Ireland in Prehistory, London 1977.

HEWSON, G.J. 1879-82 — On a Processional Cross of the Fifteenth Century, found near Ballylongford, Co. Kerry, Journal of the Royal Society of Antiquaries of Ireland, 15, (1879-82), 511-521.

HILLS, C. 1980 — Anglo-Saxon Chairperson, Antiquity, 54, No. 210, (1980), 52-54.

HODGES, H.W.M. 1956 — Studies in the Late Bronze Age in Ireland, Ulster Journal of Archaeology, 19, (1956), 29-56.

HOLMES, P. 1979 — The Manufacturing Technology of the Irish Bronze Age Horns, in: Ryan, M. (ed.), The Origins of Metallurgy in Atlantic Europe, Proceedings of The Fifth Atlantic Colloquium, 165-188, Dublin 1979.

HUBAND SMITH, J. 1854 — The Shrine of St. Patrick's Hand with notices of some similar Reliquaries, Ulster Journal of Archaeology, 2, (1854), 207-215.

HUGHES, K. 1972 — Early Christian Ireland: introduction to the Sources, London 1972.

HUNT, J. 1952 — The Limerick Mitre and Crozier, Dublin 1952.

HUNT, J. 1974 — Irish Medieval Figure Sculpture, 2 Vols., Dublin 1974.

JACOBSTHAL, P. 1944 — Early Celtic Art, Oxford 1944.

JOHANSEN, O.S. 1973 — Bossed Penannular Brooches, Acta Archaeologica, 44, (1973), 63-124.

JOPE, E.M. 1954a — An Iron Age decorated Sword-Scabbard from the River Bann at Toome, Ulster Journal of Archaeology, 17, (1954), 81-91.

JOPE, E.M. 1954b — The Keshcarrigan Bowl and a Bronze Mirror-handle from Ballymoney, Co. Antrim, Ulster Journal of Archaeology, 17, (1954), 92-6.

JOPE, E.M. and WILSON, B.C.S. 1957a — A Burial Group of the First Century A.D. near Donaghadee, Co. Down, *Ulster Journal of Archaeology*, 20, (1957), 73-95.

JOPE, E.M. and WILSON, B.C.S. 1957b — The Decorated Cast Bronze Disc from the River Bann near Coleraine, *Ulster Journal of Archaeology*, 20, (1957), 95-102.

JOPE, E.M. 1960 — The Beginning of La Tène Ornamental Style in the British Isles, in: Frere, S.S., (ed.), *Problems of The Iron Age in Southern Britain*, 69-83, London 1960.

JOYCE, P.W. 1913 — *A Social History of Ireland*, 2nd ed., Vol. II, Dublin 1913.

KAVANAGH, R.M. 1977 — Pygmy Cups in Ireland, *Journal of the Royal Society of Antiquaries of Ireland*, 107, (1977), 61-95.

KELLS, 1950 — *Evangeliorum quattuor Codex Cenannensis*, Vol. I and II, Berne 1950.

KELLS 1951 — *Evangeliorum quattuor Codex Cenannensis*, Vol. III, Berne 1951.

KENDRICK, T.D. and SENIOR, E. 1937 — St. Manchan's Shrine, *Archaeologia*, 86, (1937), 105-118.

KENNEY, J.F. 1929 — *The Sources of the early history of Ireland: Ecclesiastical*, New York, 1929 (Reprint Shannon, 1968), 693-99.

KERMODE, P.M.C. 1907 — *Manx Crosses*, London 1907.

KILBRIDE-JONES, H.E. 1935-37 — The Evolution of Penannular Brooches with zoomorphic Terminals in Great Britain and Ireland, *Proceedings of the Royal Irish Academy*, 43c, (1935-37), 379-455.

KILBRIDE-JONES, H.E. 1980a — *Celtic Craftsmanship in Bronze*, London 1980.

KILBRIDE-JONES, H.E. 1980b — *Zoomorphic Penannular Brooches*, London 1980.

LEEDS, E.T. 1930 — A Bronze Cauldron from the River Cherwell, Oxfordshire, with notes on cauldrons and other bronze vessels of allied types, *Archaeologia*, 80, (1930), 1-34.

LEEDS, E.T. 1933 — *Celtic Ornament in the British Isles*, Oxford, 1933.

LEISNER, V. 1965 — *Die Megalithgräber der Iberischen Halbinsel: Der Westen*, Band 1-3, Berlin 1965.

LEWIS, S. 1980 — Sacred calligraphy: the Chi-Rho page in the Book of Kells, *Traditio*, 36, (1980), 139-159.

LIDDELL, D.M. 1938 — *Chessmen*, London 1938.

LINDISFARNE 1956 — *Evangeliorum quattuor Codex Lindisfarnensis*, Vol, I, Olten und Lausanne, 1956.

LINDISFARNE 1960 — *Evangeliorum quattuor Codex Lindisfarnensis*, Vol. II, Olten und Lausanne, 1960.

LINDSAY, W.M. 1913 — Irish Cursive Script, *Zeitschrift für Celtische Philologie*, 1-10, (1913), 301-08.

LIONARD, P. 1960-1 — Early Irish Grave Slabs, *Proceedings of the Royal Irish Academy*, 61c, (1959-61), 95-170.

LLOYD PRAEGER, R. 1937 — *The Way That I Went*, Dublin 1937.

LLOYD PRAEGER, R. 1942 — The Broighter Gold Ornaments, *Journal of the Royal Society of Antiquaries of Ireland*, 72, (1942), 29-32.

LOWE, E.A. (ed.) 1972 — *Codices Latini Antiquiores, Part II, Great Britain and Ireland*, Oxford 1972.

LOWERY, P.R., SAVAGE, R.D.A. and WILKINS, R.L. 1971 — Scriber, Graver, Scorper, Tracer: Notes on Experiments in Bronzeworking Technique, *Proceedings of the Prehistoric Society*, 37, (1971), 167-182.

LUCAS, A.T. 1973 — *Treasures of Ireland: Irish Pagan and Early Christian Art*, Dublin 1973.

MAC ADAM, R. 1860 — Ancient Irish Trumpets, *Ulster Journal of Archaeology*, 8, (1860), 99-110.

MACALISTER, R.A.S. 1917-1919 — Teamair Breg: A Study of the Remains and Traditions of Tara, *Proceedings of the Royal Irish Academy*, 34c, (1917-1919), 231-399.

MACALISTER, R.A.S. 1935 — *Ancient Ireland*, London 1935.

MACALISTER, R.A.S. 1945 — *Corpus Inscriptionum Insularum Celticarum*, Dublin 1945.

MACALISTER, R.A.S. 1949 — *The Archaeology of Ireland*, London 1928, Revised Edition, 1949.

MAC DERMOTT, M. 1954 — An Openwork Crucifixion plaque from Clonmacnoise, *Journal of the Royal Society of Antiquaries of Ireland*, 84, (1954), 36-40.

MAC DERMOTT, M. 1955 — The Kells Crozier, *Archaeologia*, 96, (1955), 59-113.

MAC DERMOTT, M. 1956-7 — The Croziers of St. Dymphna and St. Mel and 10th Century Irish Metalwork, *Proceedings of the Royal Irish Academy*, 58, (1956-7), 167-96.

MAC NIOCAILL, G. 1961 — Fragments d'un coutumier monastique irlandais du VIIIe-IXe Siècle, *Scriptorium*, 15, (1961).

MAHR, A. 1932a — *Christian Art in Ancient Ireland*, Vol. I, Dublin 1932.

MAHR, A. 1932b — Das Irische Kunstgewerbe, in: Bossert, H.Th., (ed.), *Geschichte des Kunstgewerbes*, Band V, 1-45, Berlin 1932.

MAHR, A. 1937 — New Aspects and Problems in Irish Prehistory: Presidential Address for 1937, *Proceedings of the Prehistoric Society*, 3, (1937), 262-436.

MAHR, A. 1939 — *Ancient Irish Handcraft*, Limerick 1939.

MAHR, A. 1941 — The Early Christian Epoch, in: Raftery, J., (ed.), *Christian Art in Ancient Ireland*, Vol. II, Dublin 1941.

MANNING, C. and EOGAN, G. 1979 — A Find of Gold Torcs from Coolmanagh Co. Carlow, *Journal of the Royal Society of Antiquaries of Ireland*, 109, (1979), 20-27.

MARTENSSON, A.W. 1968 — Aus dem Frühmittelalterlichen Lund-Ein Stock und eine Spange, in: Martensson, A.W., (ed.), *Res Medievales*, Lund 1968.

MARTIN, M. 1976 — Römische und Frühmittelalterliche Zahnstocher, *Germania*, 54, (1976), 456-460.

MARYON, H. 1938 — The Technical Methods of the Irish Smiths in the Bronze and Early Iron Ages, *Proceedings of the Royal Irish Academy*, 44c, (1937-38), 181-228.

MCCARTHY, B. 1885 — On The Stowe Missal, *Transactions of the Royal Irish Academy*, 27c, (1885), 135-267.

MCGREGOR, M. 1976 — *Early Celtic Art in North Britain*, Leicester 1976.

MEGAW, J.V.S. 1968 — Problems and non-problems in palaeo-organology. A musical miscellany, in: J.M. Coles and D.D.A. Simpson, (eds.), *Studies in Ancient Europe: Essays presented to Stuart Piggot*, 333-358, Leicester 1968.

MEGAW, J.V.S. 1970 — *Art of the European Iron Age: a Study of The Elusive Image*, Bath 1970.

MEGAW, J.V.S. and SIMPSON, D.D.A. 1979 — *Introduction to British Prehistory*, Leicester 1979.

MICHELI, J.L. 1939 — *L'enluminure du haut Moyen Age et les influences irlandaises*, Brussels 1939.

MITCHELL, G.F. 1977 — In: Cone, P., (ed.), *Treasures of Early Irish Art, 1500 B.C. to 1500 A.D.*, New York 1977, (catalogue entries).

MONCK MASON, H. 1818-19 — A Description of a rich and ancient box containing a Latin copy of the gospels which was found in a mountain in the county of Tipperary, *Transactions of the Royal Irish Academy*, 13, (1818-19), 175-180.

MULCHRONE, K. and FITZPATRICK, E. 1943 — *Catalogue of the Irish Manuscripts in the Royal Irish Academy*, Dublin 1943.

MULLER-WILLE, M. 1974 — Das Krummsiel von Elstrup (Alsen), *Acta Archaeologica*, 45, (1974), 144-154.

NASH-WILLIAMS, V.E. 1950 — *The Early Christian Monuments of Wales*, Cardiff 1950.

NATIONAL MUSEUM OF IRELAND 1973 — *Viking and Medieval Dublin*, (Exhibition Catalogue), Dublin 1973.

NÍ CHATHÁIN, P. 1980 — The Liturgical Background of the Derrynaflan altar service, *Journal of the Royal Society of Antiquaries of Ireland*, 110, (1980), 127-48.

NORDENFALK, C. 1977 — *Celtic and Anglo-Saxon painting*, New York 1977.

O'CONNOR, C. 1818-19 — *Bibliotheca Ms. Stowensis: a descriptive catalogue of the manuscripts in the Stowe Library*, Vol. I, appendix, Buckingham 1818-19.

O'CURRY, E. 1861 — *Lectures on the Manuscript Materials of Ancient Irish History*, Dublin 1861.

O'CURRY, E. 1873 — *On the Manners and Customs of the Ancient Irish*, Vol. 3, Dublin 1873.

O'DONOVAN, J. 1847 — *The Book of Rights*, Dublin 1847.

Ó FLOINN, R. 1981 — The Kavanagh 'Charter' Horn, in: Ó Corráin, D., (ed.), *Aspects of Antiquity: Essays in Honour of M.J. O'Kelly*, 268-278, Cork 1981.

Ó FLOINN, R. 1982 — The Shrine of the Book of Dimma, *Éile*, I, (1982), 25-39.

O'KELLY, M.J. 1961 — The Cork Horns, the Petrie Crown and the Bann Disc, *Journal of the Cork Archaeological and Historical Society*, 66, (1961), 1-12.

O'MEADHRA, U. 1979 — *Early Christian, Viking, and Romanesque Art: Motif Pieces from Ireland*, Stockholm 1979.

O'NEILL, H. 1863 — *The Fine Arts and Civilisation of Ancient Ireland*, Dublin 1863.

O'RAHILLY, T.F. 1926-28 — The History of the Stowe Missal, *Eriu*, 10, (1926-28), 95-109.

ORGAN, R. 1973 — Examination of the Ardagh Chalice - A Case History, in: W.J. Young, (ed.), *Application of Science in Examination of Works of Art*, 238-271, Boston 1973.

Ó RÍORDÁIN, A.B. and RYNNE, E. 1961 — A Settlement in the Sandhills at Dooey, Co. Donegal, *Journal of the Royal Society of Antiquaries of Ireland*, 91, (1961), 58-64.

Ó RÍORDÁIN, A.B. 1968 — Food Vessels in Irish Passage Graves, *Journal of the Royal Society of Antiquaries of Ireland*, 98, (1968), 163-169.

Ó RÍORDÁIN, A.B. 1971 — Excavations at High Street and Winetavern Street, Dublin, *Medieval Archaeology*, 15, (1971), 73-85.

Ó RÍORDÁIN, A.B. 1976 — The High Street Excavations, in: Almqvist, B., and Green, D., (eds.), *Proceedings of the Seventh Viking Congress*, 135-140, Dublin 1976.

Ó RÍORDÁIN, S.P. 1947 — Roman material in Ireland, *Proceedings of the Royal Irish Academy*, 51, (1947), 35-82.

Ó RÍORDÁIN, S.P. 1955 — A Burial with Faience Beads at Tara, *Proceedings of the Prehistoric Society*, 21, (1955), 163-173.

PETERSEN, J. 1940 — British Antiquities of the Viking Period Found in Norway, in: Shetelig, H., (ed.), *Viking Antiquities in Great Britain and Ireland*, Oslo 1940.

PETRIE, G. 1832a — Irish Antiquities, *Dublin Penny Journal*, No. 20, I, (1832), 156-157.

PETRIE, G. 1832b — The Ancient Irish Bulla, *Dublin Penny Journal*, No. 23, I, (1832), 180.

PETRIE, G. 1833 — Ancient Irish Trumpets, *Dublin Penny Journal*, No. 56, Vol. II, (1833), 27-30.

PETRIE, G. 1839a — On the History and Antiquities of Tara Hill, *Transactions of the Royal Irish Academy*, 18, (1839), 25-232.

PETRIE, G. 1839b — An Account of an Ancient Irish Reliquary, called the Domnach Airgid, *Transactions of the Royal Irish Academy*, 18, (1839), 14-24.

PETRIE, G. 1841 — On two Gold Torcs found at Tara, *Proceedings of the Royal Irish Academy*, 1, (1841), 274-276.

PETRIE, G. 1845 — *The Ecclesiastical Architecture of Ireland*, Dublin 1845.

PETRIE, G. 1878 — *Christian Inscriptions in the Irish Language*, M. Stokes, (ed.), Vol. 2, Dublin 1878.

POWELL, T.G.E. 1973-74 — The Sintra Collar and the Shannongrove Gorget: aspects of Late Bronze Age goldwork in the west of Europe, *North Munster Antiquarian Journal*, XVI, (1973-74), 3-13.

RAFTERY, J. 1937 — Abstract, in: Mahr, A., New Aspects and Problems in Irish Prehistory, *Proceedings of the Prehistoric Society*, 3, (1937), 409-411.

RAFTERY, J. 1940 — Hoard of Gold Objects from Co. Kerry, *Journal of the Cork Historical and Archaeological Society*, 45, (1940), 56-57.

RAFTERY, J. 1941 — *Christian Art in Ancient Ireland*, Vol. II, Dublin 1941.

RAFTERY, J. 1951 *Prehistoric Ireland*, London 1951.

RAFTERY, J. 1959 *Frühe Irische Kunst*, (Exhibition Catalogue), Düsseldorf 1959.

RAFTERY, J. 1960 A Hoard of the Early Iron Age, Interim Report, *Journal of the Royal Society of Antiquaries of Ireland*, 90, (1960), 1-5.

RAFTERY, J. 1961 The Derrinboy Hoard, Co. Offaly, *Journal of the Royal Society of Antiquaries of Ireland*, 91, (1961), 55-58.

RAFTERY, J. 1963 Ogam, *Ireland of The Welcomes*, 12, No. 1, (1963), 23-25.

RAFTERY, J. 1967 The Gorteenreagh Hoard, in: Rynne, E., (ed.), *North Munster Studies*, Limerick 1967.

RAFTERY, J. 1970a Two Gold Hoards from Co. Tyrone, *Journal of the Royal Society of Antiquaries of Ireland*, 100, (1970), 169-174.

RAFTERY, J. 1970b A Bronze Age Hoard from Ballytegan, Co. Laois, *Journal of the Royal Society of Antiquaries of Ireland*, 100, (1970), 85-100.

RAFTERY, J. 1971 Irish Prehistoric Gold Objects: New Light On The Source of the Metals, *Journal of the Royal Society of Antiquaries of Ireland*, 101 (1971) 101-105.

RAFTERY, J. 1980 *Artists and Craftsmen: Irish Art Treasures*, Dublin 1980.

REEVES, W. 1850 *Five Chromo Lithographic Drawings Representing an Irish Ecclesiastical Bell which is supposed to have belonged to St. Patrick*, Belfast 1850.

REEVES, W. 1886 On the Bell of St. Patrick, called the Clog an Edachta, *Transactions of the Royal Irish Academy*, 27 (1877-86), 1-30.

RIMMER, J. 1977 *The Irish Harp*, Cork 1977.

ROE, F. 1966 The Battle Axe Series in Britain, *Proceedings of the Prehistoric Society*, 32, (1966), 199-245.

ROE, F. 1968 Stone Mace-heads and the latest Neolithic Cultures of the British Isles, in: Coles, J.M., and Simpson, D.D.A., (eds.), *Studies in Ancient Europe*, 145-172, Leicester 1968.

ROESDAHL, E. et al. 1981 *The Vikings in England*, London 1981.

ROMILLY-ALLEN, J. 1903 *The Early Christian Monuments of Scotland*, Edinburgh 1903.

RYAN, J. 1833 *The History and Antiquities of the County of Carlow*, Dublin 1833.

RYAN, J. 1961 The Mass in the Early Irish Church, *Studies*, 50, (1961), 371-84.

RYAN, M. 1975 Urn Burial at Ballintubbrid, near Blackwater, Co. Wexford, *Journal of the Royal Society of Antiquaries of Ireland*, 105, (1975), 132-146.

RYAN M. and CAHILL, M. 1981 *Gold aus Irland*, (Exhibition Catalogue) Frankfurt 1981.

RYAN, M. 1982 The Roscrea Brooch, *Eile*, I, (1982), 7-24.

RYAN, M. 1983 The Chalice in Ryan (ed.), *The Derrynaflan Hoard I: A Preliminary Account*, National Museum, Dublin 1983.

RYAN, M. forthcoming A Gold Box from Ballinclemesig, Co. Kerry, *Journal of the Kerry Historical and Archaeological Society*, No. 14.

RYAN, M. forthcoming The Derrynaflan and other Irish Eucharistic Chalices, in: Richter, M., and Ní Chathain, P., (eds.), *Ireland and Europe in the Early Middle Ages*.

RYNNE, E. 1961 The Introduction of the La Tène into Ireland, *Bericht V. Internationaler Kongress für Vor- und Frühgeschichte, Hamburg 1958*, 705-709, Berlin 1961.

RYNNE, E. 1963 Bronze Age Burials at Drung, Co. Donegal, *Journal of the Royal Society of Antiquaries of Ireland*, 93, (1963), 169-79.

SALIN, B. 1904 *Die Altgermanische Thierornamentik*, Stockholm 1904.

SAVORY, H.N. 1941 Some Unpublished Late Middle Bronze Age Pottery from West Wales, *Archaeologia Cambrensis*, 96, (1941), 31-38.

SHEE-TWOHIG, E. 1981 *The Megalithic Art of Western Europe*, Oxford 1981.

SHETELIG, H. 1948 The Norse Style of Ornamentation in the Viking Settlements, *Acta Archaeologica*, XIX, (1948), 69-113.

SMITH, R.A. 1913-14 Irish Brooches of Five Centuries, *Archaeologia*, 65, (1913-14), 223-250.

SMITH, R.A. 1917-18 Irish Serpentine Latchets, *Proceedings of the Society of Antiquaries of London*, 30, (1917-18), 120-31.

SMITH, R.A. 1918-19 Circular Bronze Shields, *Proceedings of the Society of Antiquaries of London*, 31, (1918-19), 145-151.

STEER, K.A. and BANNERMAN, J.W.M. 1977 *Late Medieval Monumental Sculpture in the West Highlands*, Edinburgh 1977.

STOKES, M. 1871 Observations on two Ancient Irish Works of Art, *Archaeologia*, 43, (1871), 131-150.

STOKES, M. 1883 On Two Bronze Fragments of an unknown Object, portions of the Petrie Collection, in the Museum of the Royal Irish Academy, *Archaeologia*, 48, (1883), 473-480.

STOKES, M. 1892-96 Observations on the use of Red Enamel in Ireland, *Transactions of the Royal Irish Academy*, 30, (1892-96), 281-293.

STOKES, M. 1932 *Early Christian Art in Ireland*, Dublin 1932.

STOKES, W. (ed.) 1881 *On The Irish Passages in the Stowe Missal*, Calcutta 1881.

STUART, J. 1819 *Historical Memoirs of the City of Armagh*, Newry 1819.

STUBBS, J.W., et al. 1892 *The Book of Trinity College, Dublin*, Belfast 1892.

TAYLOR, JOAN J. 1968 Early Bronze Age Gold Neck Rings in Western Europe, *Proceedings of the Prehistoric Society*, 24, (1968), 259-265.

TAYLOR, JOAN J. 1970 Lunulae Reconsidered, *Proceedings of the Prehistoric Society*, 36, (1970), 38-81.

TAYLOR, JOAN J. 1979 — The Relationship of British Early Bronze Age Gold Work to Atlantic Europe, in: Ryan, M., (ed.), *The Origins of Metallurgy in Atlantic Europe, Proceedings of the Fifth Atlantic Colloquium*, 227-250, Dublin 1979.

TAYLOR, JOAN J. 1980 — *Bronze Age Goldwork of the British Isles*, Cambridge 1980.

TODD, J.H. 1850-53 — On Ancient Irish Reliquaries, *Proceedings of the Royal Irish Academy*, 5c, (1850-53), 461-464.

TODD, J.H. 1856 — On the Ancient Irish Missal and its silver box etc. …, *Transactions of the Royal Irish Academy*, 23, (1856), 3-37.

VALLANCEY, C. 1786 — *Collectanea de Rebus Hibernicis*, Vol. II, Dublin 1786.

WADDELL, J. 1970 — Irish Bronze Age Cists: A Survey, *Journal of the Royal Society of Antiquaries of Ireland*, 100 (1970), 91-139.

WADDELL, J. 1976 — Cultural Interaction in the Insular Early Bronze Age: Some Ceramic Evidence, in: de Laet, S.J., (ed.), *Acculturation and Continuity in Atlantic Europe*, 284-295, Ghent 1976.

WAKEMAN, W.F. 1903 — *A Handbook of Irish Antiquities*, Dublin 1903.

WALLACE, P.F. 1979 — The Archaeological Significance of Wood Quay, Dublin, *An Cosantóir*, 39, No. 5, (May 1979), 141-7.

WALLACE, P.F. 1981 — Wood Quay, Dublin, *Popular Archaeology*, 2, No. 9, (March 1981), 24-27.

WALLACE, P.F. 1982 — The Origins of Dublin, in: Scott, B.G., (ed.), *Studies on Early Ireland: Essays in Honour of M.V. Duignan*, 129-142, Belfast 1982.

WARNER, G.F. (ed.) 1906 — *The Stowe Missal*, Vol. I, London 1906.

WARNER, G.F. (ed.) 1915 — *The Stowe Missal*, Vol. II, London 1915.

WARNER, R.B. 1982 — The Broighter Hoard: A Reappraisal, and the Iconography of the Collar, in: Scott, B.G. (ed.), *Studies On Early Ireland: Essays in Honour of M.V. Duignan*, 29-38, Belfast 1982.

WATERER, J.W. 1968 — Irish Book-Satchels or Budgets, *Medieval Archaeology*, 12, (1968), 70-82.

WESTROPP, T.J. 1892 — Carvings in St. Mary's Cathedral, Limerick, *Journal of the Royal Society of Antiquaries of Ireland*, 22, (1892), 70-79.

WESTROPP, T.J. 1900 — The Clog An Óir, or Bell Shrine of Scattery, *Journal of the Royal Society of Antiquaries of Ireland*, 30, (1900), 237-244.

WESTROPP, T.J. 1915 — Ancient Remains on the West Coast of Co. Clare, *Journal of the North Munster Archaeological Society*, No. 4, 2nd Series, (1915), 344-361.

WESTWOOD, J.O. 1876 — *A Descriptive Catalogue of the Fictile Ivories in the South Kensington Museum*, London 1876.

WHEELER, H.A. 1949-52 — The Tara Brooch, where was it found, *County Louth Archaeological Journal*, 12, (1949-52), 155-158.

WHITFIELD, N. 1974 — The finding of the Tara Brooch, *Journal of the Royal Society of Antiquaries*, 104, (1974), 120-142.

WHITFIELD, N. 1976 — The Original Appearance of the Tara Brooch, *Journal of the Royal Society of Antiquaries of Ireland*, 106, (1976), 5-30.

WILDE, W.R. 1857 — *A Descriptive Catalogue of the Antiquities of Stone, Earthen and Vegetable Materials in the Museum of the Royal Irish Academy*, Dublin 1857.

WILDE, W.R. 1861 — *A Descriptive Catalogue of the Antiquities of Animal Materials and Bronze in the Museum of the Royal Irish Academy*, Dublin 1861.

WILDE, W.R. 1862 — *A Descriptive Catalogue of the Antiquities of Gold in the Museum of the Royal Irish Academy*, Dublin 1862.

WILSON, D.M. 1958 — A Group of Penannular Brooches of the Viking Period, *Arbok Hins Islenzka Fornleifafélags*, 95-100, Flygirit 1958.

WILSON, D.M. and KLINDT-JENSEN, O. 1980 — *Viking Art*, London 1980.

WOOD-MARTIN, W.G. 1886 — *The Lake Dwellings of Ireland*, Dublin 1886.

Map of the counties of Ireland

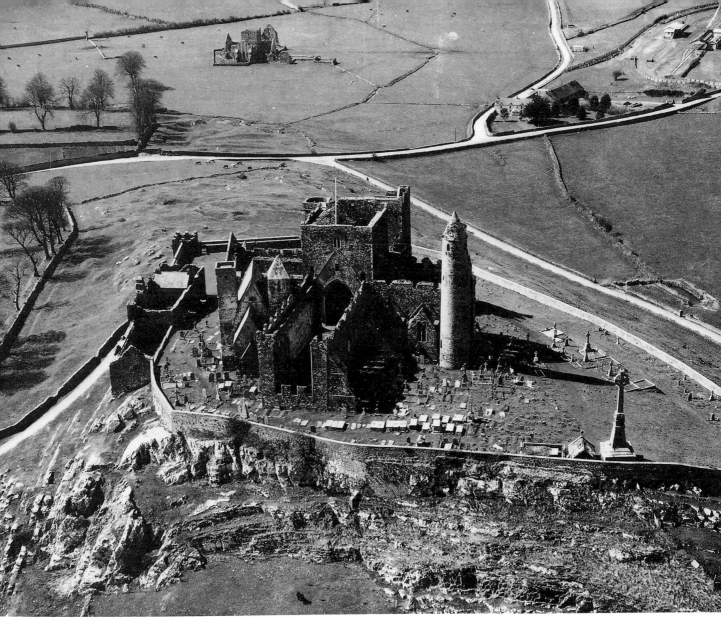

Rock of Cashel, Co. Tipperary, Royal site of the kings of Munster until the 12th century, then Cathedral of the Diocese of Cashel: round tower 12th century, ruins of the cathedral 13th century, romanesque chapel 12th century, in the background, Hore Abbey 15th century

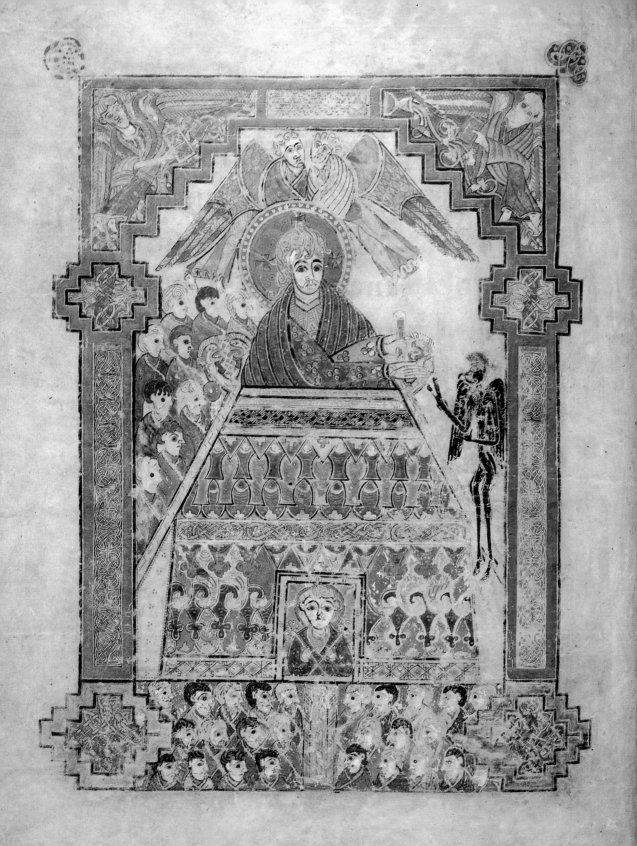

Glossary

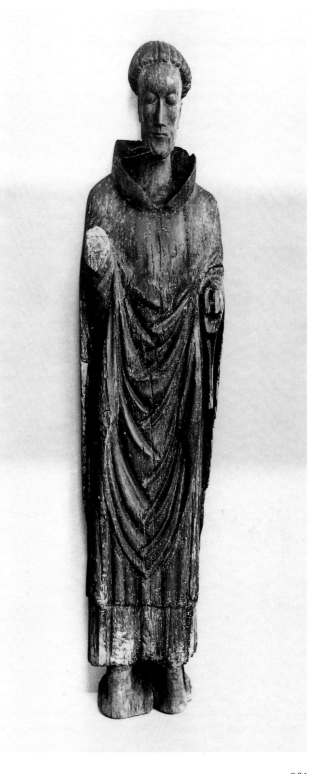

Beaded (wire)	Wire made by hammering in a specially prepared plate or swage or rolling on a suitably ridged surface so that it is formed into a series of connected bulbous shapes.
Brambled	A surface carefully roughened to produce an effect similar to the surface of the blackberry fruit.
Cabochon	An oval convex gem: smooth and not cut into facets.
Casting; core-casting	A method of hollow casting in which a core of sand or other material is used inside the mould to create a hollow in the cast object.
Casting; sand-casting	In its simplest form, the shape of the object is formed in a bed of sand which functions as a mould for the subsequent casting.
Chasing	A decorative metal process involving surface modelling of metal from the front with the aid of variously shaped punches and a hammer.
Crannóg	From the Irish word 'Crann', a tree; crannógs were artificial island dwellings in lakes and marshes built in Ireland from the Later Bronze Age to the 17th century A.D.
Cuir Bouilli	A method of moulding leather by pressing it into a wooden die or form. The shape is set and the leather hardened by immersing the object in very hot water.
Die-stamping	A method whereby repetition in design can be achieved by stamping a piece of metal with a die on which the motif has been engraved or cast.

◁ *Book of Kells, The Temptation of Christ, the building represents the Temple of Jerusalem, fol. 202v*

St. Molaise, oak carving ca. 1200 A.D. from Inishmurray, Co. Sligo (National Museum of Ireland)

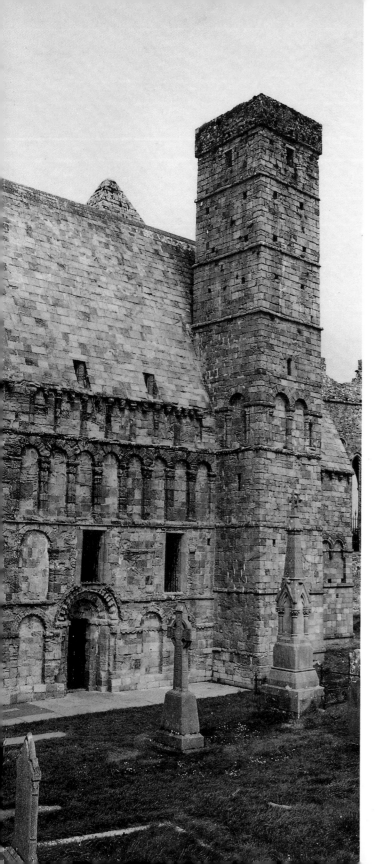

Enamel	A vitreous (glassy) material applied in powdered form to a metal background and then fused. Various metallic oxides are used to produce different colours.
Enamel; basse taille	A translucent enamel applied to a metal background on which designs have been executed in low relief.
Enamel; champlevé	The technique by which enamel is used to fill recesses which are either cut or cast in the metal background.
Enamel; cloisonné	The application of the enamel is confined to small 'cells' or compartments formed by wire or strips of metal.
Engraving	The decorative process of incising lines or textures on metal by the use of engraving tools called gravers, burins or scorpers.
False relief	Carving or casting in such a way that the pattern is of equal height to or lower than the surrounding surface of the piece.
Filigree	Ornament formed by soldering or fusing wire or strips of metal usually to a metal background.
Gilding	The application of a thin layer of gold to an object.
Granulation	The formation of small spherical drops of metal which are then applied to a backing by means other than soldering.
Kerbschnitt	Originally, a method of wood-carving, which left surfaces in relief by using sloping chisel cuts; later, adapted by metal workers who achieved the same effect by casting rather than cutting.
Millefiori glass	Originally, flower motifs produced by casing a cane of glass with several layers of differently coloured glass, rolling on a corrugated surface and cutting into short lengths. Other designs are produced by laying together rods of different colours and fusing them, the whole then being drawn, cut and set.

Romanesque chapel (Cormac's Chapel), Rock of Cashel, Co. Tipperary, consecrated 1134 A.D.

Niello	A compound of metallic sulphides, usually of silver or copper, often inlaid in silver and fused at a low temperature, the black niello contrasting with the silver background.
Penannular	Used to refer to objects, e.g. brooches, in which the ring is incomplete. Where the ring is complete or bridged 'pseudo-penannular' is used.
Repoussé	Decorative motifs in relief produced by beating from the back. Usually the design is finished from the front by chasing.
Ricasso	The thickened portion of a sword blade immediately below the hilt.
Stitching	A method of holding filigree or other panels of ornament in place. Using a graver a vertical cut downwards is made in the wall of the setting. The burr of metal displaced by the graver laps over the edge of the panel, thus holding it in place.

Base of the High Cross of Moone, Co. Kildare, 9th century A.D., showing the Three Children in the Fiery Furnace, the Flight into Egypt and the Miracle of the Loaves and Fishes.

Romanesque doorway, ca. 1160 A.D., Clonfert ▷ Cathedral, Co. Galway

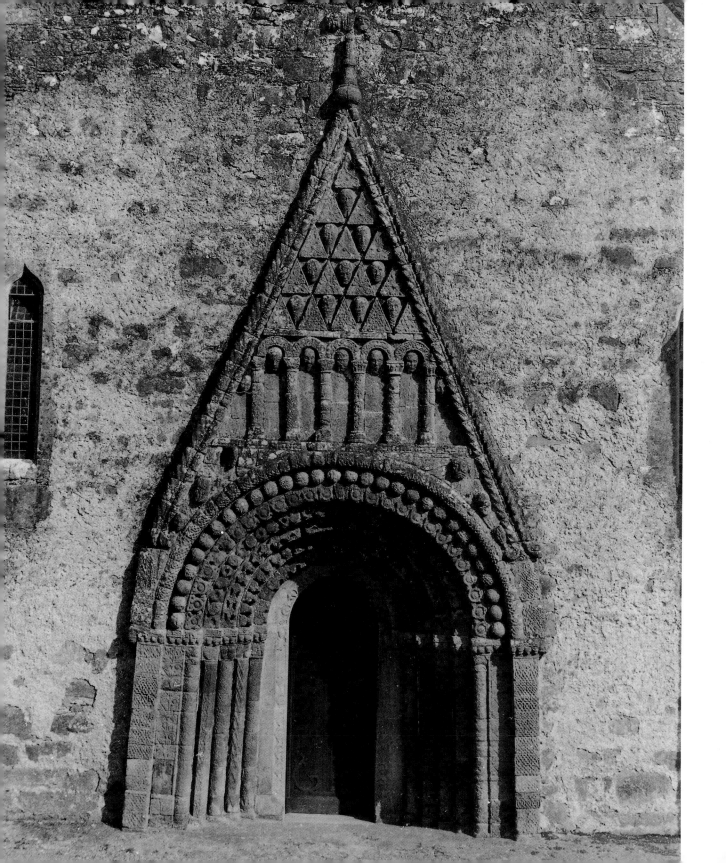

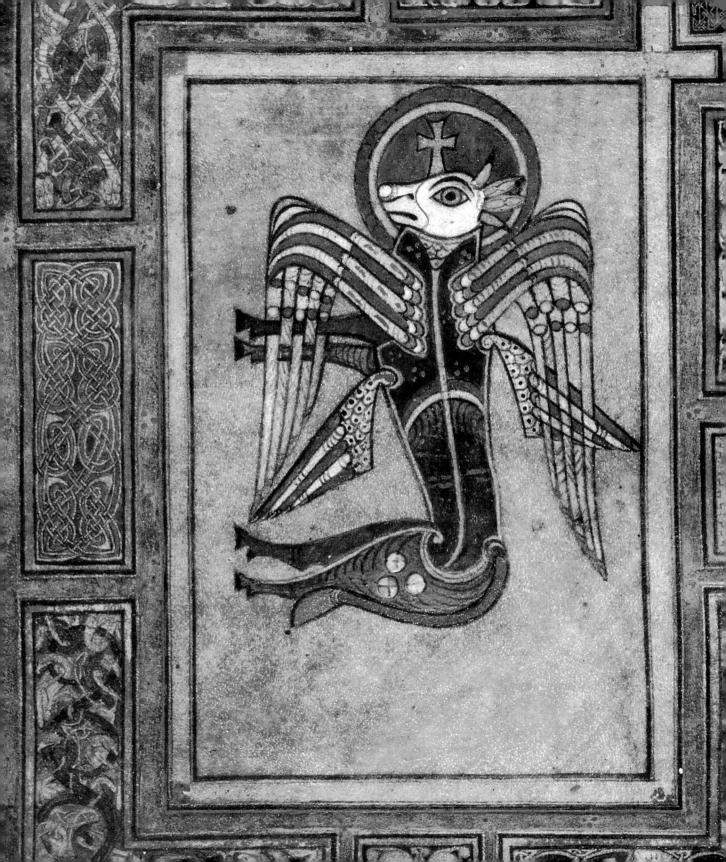